MICHAEL FREEMAN'S PHOTO SCHOOL FUNDAMENTALS

MICHAEL FREEMAN'S PHOTO SCHOOL FUNDAMENTALS

EDITOR-IN-CHIEF MICHAEL FREEMAN

Focal Press Taylor & Francis Group NEW YORK AND LONDON First published in the USA 2013 by Focal Press

Focal Press is an imprint of the Taylor & Francis Group, an informa business 70 Blanchard Road, Suite 402, Burlington, MA 01803, USA

Copyright © 2013 The Ilex Press Ltd. All rights reserved.

This book was conceived, designed, and produced by llex Press Limited, 210 High Street, Lewes, BN7 2NS, UK

Publisher: Alastair Campbell Associate Publisher: Adam Juniper Managing Editor: Natalia Price-Cabrera Specialist Editor: Frank Gallaugher Editor: Tara Gallagher Creative Director: James Hollywell Senior Designer: Ginny Zeal Design: Lisa McCormick Color Origination: Ivy Press Reprographics

No part of this book may be reprinted or reproduced or utilised in any form or by any electronic, mechanical, or other means, now known or hereafter invented, including photocopying and recording, or in any information storage or retrieval system, without permission in writing from the publishers.

Notices:

Knowledge and best practice in this field are constantly changing. As new research and experience broaden our understanding, changes in research methods, professional practices, or medical treatment may become necessary.

Practitioners and researchers must always rely on their own experience and knowledge in evaluating and using any information, methods, compounds, or experiments described herein. In using such information or methods they should be mindful of their own safety and the safety of others, including parties for whom they have a professional responsibility.

Product or corporate names may be trademarks or registered trademarks, and are used only for identification and explanation without intent to infringe.

Library of Congress Cataloging in Publication Data:

A catalog record for this book is available from the Library of Congress.

ISBN: 978-0-415-83578-7 (pbk) ISBN: 978-0-203-76660-6 (ebk)

Typset in Caecilia Com

Photo on front cover © Joss; back cover © lkukl, Daniella Bowker; page 2 © Samir Khadem, page 4 © Mikhail Basov. All other photography © Michael Freeman unless otherwise indicated.

Contents

- 6 Foreword
- 8 Student Profiles

16 Exposure

- 18 A Record of Tonalities
- 20 Right Versus Wrong Exposure
- 22 Underexposure & Overexposure
- 24 Creative Use of Overor Underexposure
- 28 ISO Speeds
- 30 Get the Shot with a High ISO
- 34 Lens Apertures
- 36 Demonstrate Depth-of-Field Control
- 40 The Math Behind the Numbers
- 42 Shutter Speed
- 44 Freeze the Action
- 48 Aperture & Shutter Speed: The Reciprocal Relationship
- 50 Exposure Modes
- 52 Histograms & Meters
- 54 How Light Meters See the World
- 56 In Search of Middle Gray
- 58 Metering Modes
- 60 Selective Metering Modes
- 62 Limit Yourself to Spot Metering
- 66 Color Temperature
- 68 White Balance Control
- 70 Set a Creative White Balance
- 74 Handling Extreme Contrast
- 76 Adjust with Exposure Compensation
- 80 High Dynamic Range Imaging
- 82 Combat the Contrast with HDR
- 86 The Zone System in a Digital World
- 88 Low-Key Images 90 Shoot the Shadows
- with a Low-Key Shot
- 94 High-Key Images
- 96 Hug the Highlights with a High-Key Shot

100 Light & Lighting

- 102 Bit-Depth & Tonality
- 104 The Sun Throughout the Day
- 106 Dealing with Strong Sunlight
- 108 Shooting into the Sun
- 110 Face the Sun Head-On

- 114 Golden Light
- 116 Clouds & Light
- 118 Weather Extremes
- 120 Your Choice of Rain, Fog, or Snow
- 124 Incandescent Light
- 126 Fluorescent Light
- 128 Vapor Discharge Light
- 130 Mixed Light
- 132 Camera-Mounted Flash
- 134 Balancing Flash to Ambient Light
- 136 Bounce, Diffuse, or Sync your Flash
- 140 Studio Flash
- 142 Continuous Light
- 144 Lighting Accessories
- 146 Home Studio
- 148 Positioning the Light
- 150 Light a Portrait
- 154 Soft Light
- 156 Enveloping Light
- 158 Bathe your Subject in Soft Light
- 162 Hard Light
- 164 Chiaroscuro
- 166 Kick It Up a Notch with Hard Light
- 170 Side & Edge Lighting
- 174 Bring Out the Texture
- 176 Personal Lighting Styles
- 178 Find Your Own Personal Lighting Style

182 Composition

- 184 Pick Your Subject
- 186 Filling the Frame
- 188 Horizontals & Verticals
- 190 Subject Placement
- 192 The Golden Ratio
- 194 Using Lines to Pull Attention196 Diagonal, Curved,
- & Imaginary Lines
- 198 Lead with Lines
- 202 Seeking a Balance
- 204 Symmetry
- 206 Strengthening with Triangles
- 208 Balance Your Composition
- 212 Color
- 214 Accentuating Color
- 216 Compose with Color
- 220 Pattern & Repetition
- 222 Follow a Pattern
- 226 Natural Frames
- 228 Negative Space

- 230 Of Light & Shadow
- 232 People
- 234 Capturing Couples
- 236 A Couple's Portrait
- 240 Focal Length
- 242 Wide-Angle Lenses & Perspective
- 244 Broaden your View with a Wide-Angle
- 248 Telephoto Lenses
- 250 Reach Out with a Telephoto

264 The Digital Workflow

272 Raw-Processing Tools

276 Post-Production Tools

278 Rotating & Cropping

282 Adjusting Exposure

290 Sharpening

304 Tone Curves

316 Levels

330 Layers

334 Blending

344 Glossary

350 Index

338 Panoramas

340 Stitch a Panorama

294 Sharpen Up a Shot

298 Noise Reduction

306 Color Correction

300 Clean Up a Noisy Shot

308 Black & White Conversion

310 Convert to Black & White

314 Dodging & Burning

318 Levels Adjustment

322 Color Adjustment

332 Adjustment Layers

336 Removing Unwanted Objects

326 Adjust Your Color

266 Raw-Processing Software

268 Post-Production Software

270 Raw-Processing Workspace

274 Post-Production Workspace

280 Correcting White Balance

284 Basic Image Optimization

288 Removing Spots & Blemishes

254 Panning

262

- 256 Motion Blur
- 258 Communicate Movement through Blur

Digital Editing

FOREWORD

About This Book

Photography is what I do and have done for most of my life, and like any professional, I work at it, trying to improve my skills and my ideas. I actually enjoy sharing all of this, because I love photography and want as many people as possible to do it—but do it well. This includes learning why good photographs work and where they fit in the history of the craft.

This book is inspired by the structure of a college course, and of the benefits of a collective learning environment. Here, we're setting out to teach the fundamentals of photography in a foundational course, before moving on to teach specialist areas—much as a student would study a set first-year course before moving on to studying elective subjects of their own choosing.

The goal of this book is not only to instruct and educate, but also to motivate and inspire. Toward that end, many of the topics will be punctuated by a challenge to get out and shoot under a specific scenario, demonstrating and practicing the skills that were covered in the preceding sections. Further, we feature the work of several real-life photography students as they respond to these challenges themselves. As they discuss and I review their work, we hope to make the material all the more approachable and achievable.

For you, the reader, this series provides, I hope, a thorough education in photography, not just allowing you to shoot better pictures, but also to gain the same in-depth knowledge that degree students and professionals do, and all achieved through exercises that are at the same time fun and educational. That is why we've also built a website for this book, to which I encourage you to post your responses to the shooting challenges for feedback from your peers. You'll find the website at **www.mfphotoschool.com**

FUNDAMENTALS

Student Profiles

Lukasz Kazimierz Palka

Lukasz is a Polish-born urban photographer based in Tokyo, Japan. He is known for his street photography and exploration of the metropolitan landscape and its natural environs. Lukasz established himself in Tokyo in 2009, and began shooting out of a curiosity about the city and its people. He has been documenting Tokyo for over two years, while also making excursions to China, Australia, and other nations in the eastern hemisphere.

Lukasz's photographic style has yet to crystallize, but can be described as "cinematic." He is inspired by films such as *Blade Runner* and sci-fi manga such as *Ghost in the Shell*. Through his work, he aims to show the world a glimpse of what he sees, casting a light on the moments that daily emerge and fade in our cities. His inspiration comes from one of the largest human conglomerations on earth: Tokyo.

Currently, Lukasz is a hustling freelancer, primarily a Photographer, Graphic Designer, and Educator. More of his work can viewed at www.lkazphoto.com

Nathan Biehl

Nathan was born in a small town nestled in the north woods of Wisconsin, USA. His current day job is as a graphic designer, and while his 9 to 5 is devoted to design, his free time is consumed by photography.

Nathan attended the University of Northern Iowa where he received a BFA in Printmaking. Originally, his photography served as a reference point for his prints, but soon after graduating it evolved into be his primary creative focus. While his educational background was in the arts, his only formal training in photography was an introductory class covering the basics of black-and-white photography. Nathan welcomes every chance to expand his photographic knowledge by pouring over any book, blog, or gallery he can find.

To view more of his work, visit **www.biehl.me**

Richard Gottardo

Richard is a creative modern wedding and fine art photographer based out of Toronto, Canada. Initially he began his career in the pharmaceutical industry working in a polio lab. As photography began to grow from more than just a passion and a hobby into something he could make a career out of, he left pharmaceuticals behind in order to begin a photography business.

Currently he is looking into opening a studio in Toronto. He got his first real taste of photography came while taking a miksang photography course in university. *Miksang* is a Tibetan word that means "seeing with a good eye" and being able to find beauty in everyday things. He has tried to keep to t his philosophy and photography for him has become way to escape the mundane and explore the beauty present all around us. His work can be found at **www.richardgottardo.com** FUNDAMENTALS

Kelly Jo Garner

Kelly Jo Garner is a photographer and web designer living in Nashville, Tennessee. Her professional interest in photography dates to 1994 when, during a trip to Russia, she captured a shot of a rich yellow building against a startlingly cerulean sky. "I had so many comments about that shot when it was developed and I showed it to friends and family," she says. "Ever since then, I've been hooked." Today, Kelly Jo photographs roller derby, portraits, weddings, still lifes, animals, casual street scenes, and anything else that strikes her fancy.

Kelly Jo can be reached at www.hungryphotographer.org or on Twitter @kellyjogarner

Sven Thierie

Sven Thierie is a graphic designer living in Leuven, Belgium. He is passionate about his work in advertising, but his favorite pastime has always been photography. During his many travels throughout Europe and North Africa, his camera is his "first mate," and an indispensable component of his travel experiences. A passionate observer of culture, he says that "Living in the center of Europe is very inspirational, personally and professionally, because of the huge numbers of cultures living and interacting so close to one another." In the future he wants to venture farther out into the world.

You can see more of Sven's work on his website: **www.sventhierie.be**

PROFILES

Nick Depree

Born in Christchurch, New Zealand, Nick traveled a lot at a young age before settling into University studies in Auckland where he completed a Bachelors degree and eventually a Doctorate in Chemical and Materials Engineering. Nick got into photography around 2006, quickly becoming comfortable with the technical aspects, and has since been more interested in developing his artistic and aesthetic side, while also enjoying trying various types of modern and vintage, digital and analog cameras.

Living in New Zealand provides great opportunities for landscape photography, which was Nick's early interest, but he found his productivity and quality of output greatly increased in the past two years with the opportunity for extensive travel through his research work. Exploring new cities and countries has become his passion, where he finds his best shots by walking the streets for long periods, being observant of his surroundings and patient for the right light or scene to appear. He also very much enjoys learning about the history and culture of new places, and photographing the details, foods, and historical locations he finds.

You can find his work at **www.ndepree.com**

FUNDAMENTALS

Adam Graetz

Adam Graetz draws his inspiration largely from the urban and suburban scenery in which he grew up. A perfectionist with an affinity for symmetry, he shoots mostly digital with a Nikon D7000, but also shoots film with a Nikon FM-2, preferring Fuji Superia for color and Kodak Trichrome for B&W. Travel plays a significant role in his work, and he always keeps his camera at the ready while exploring new territory.

"The idea of man vs nature often comes up in my work. Sometimes I juxtapose evidence of human civilization against naturally occurring elements; other times I seek to completely remove any signs of civilization in my photos, to make them completely natural."

You can find out more about Adam at his website, www.adamgraetz.com, and view his flickr photo gallery at www.flickr.com/photos/adamgee

Gillian Bolsover

Gillian chose photography because she wanted to see the world. Not just the far-flung corners of the globe that, granted, she has made good inroads into seeing; but to investigate more deeply the world at her doorstep. The camera is the excuse that lets you into the lives of others. Gillian's camera has taken her backstage at Bonnaroo Music Festival, to Marine Corps boot camp, into the lives of illegal immigrants facing deportation, and through Shanghai's traditional lane house communities.

After studying photojournalism and political science at undergrad, Gillian spent several years working as a photographer and multimedia producer at a daily newspaper in the US, before leaving to make her way in the wide world.

You can see more of Gillian's work at www.bolsoverphotos.com

PROFILES

13

Johnny Chang

Johnny's love of photography was born out of his penchant for observation. A camera in his hand, circa 2009, was a natural extension. It's brought him the joy of discovering new places and the hidden beauty of everything. Never limited to a genre, Johnny's style is constantly evolving. He strives to see many different perspectives, from high to low, without fear of being stepped on in the process. His inquisitive nature enables an intricate relationship with the inner workings of the camera, the lens, and the light. When his interest is piqued, he won't stop until he finds the right path—through a multitude of exposures, lighting manipulations, or processing directions.

You can view more of his work at: http://eruditass-photography.blogspot.com

Faith Kashefska-Lefever

Faith is a freelance photographer and photo restorer. "It is my way of helping old memories stay alive, and preserving pieces of family history," she says. "I love to use my photography as a way to show a different point of view. I am always asking, 'If a photo is worth a thousand words, what would you like yours to say?'"

Faith's education comes from two places: NYIP (New York Institute of Photography) and herself. If she is not snapping pictures or working on a restoration, she usually has her face in a book learning something new. All of her post-processing and digital manipulation is self taught.

To see more of Faith's work, check out www.fklgz.com

FUNDAMENTALS

Dan Goetsch

Dan Goetsch was born and raised in Fort Collins, Colorado. He eventually ended up hitting the ground running in the IT world just after college and life has been an adventure ever since. He found his new home in Portland, Oregon where he spent five years, and picked up his first digital SLR camera along with a passion for photography. He is a self-taught photographer who has gone from Auto mode to Manual and enjoyed every minute of the journey as he continues to learn and explore the craft. His superhero mantra would be "IT nerd by day, photographer by nights and weekends." Dan's passion for photography continues to grow stronger every day, and he looks forward to sharing his love of it with the world.

You can see his work at www.danielgphotography.com

Jennifer Laughlin

After taking a black-and-white photography class for fun, Jennifer Laughlin's interest in photography was stoked and she attended Randolph Community College in Asheboro, NC, graduating with a concentration in biocommunications photography. She has worked at the North Carolina Office of State Archaeology and TTW Photographic. Jennifer works with both film and digital equipment, using a Nikon D300 and a Mamiya C330 to capture her photos. Her specialty is macrophotography and she enjoys portraying the small details in her subjects. Jennifer currently resides in North Carolina with her husband and her two dogs.

You can find her work at jenniferlaughlin.blogspot.com

PROFILES

Guido Jeurissen

Born on the 19th of August, 1992, in Rotterdam, Holland, Guido Jeurissen is a young and learning photographer, filmmaker and musician. Even though Guido Jeurissen's work is a combination of a very wide range of styles, his personal style is often defined as "raw" and "documentary."

When Guido was admitted in 2010 to the Dutch art school Willem de Kooning Academie in Rotterdam, he started a study on filmmaking called Audio Visual Design. Even though his study is primarily based on filmmaking, he also learned a lot about photography.

Recently, Guido has been focusing much more on photography. He went back to the basics, and started working in dark rooms with black-and-white film. It's here where he noticed that the essence of photography is in the subject and not the picture itself. Black and white was the ultimate tool to do this. He loves the way analog black-and -white photography concentrates on the subject so much more, and how the background of an image is so much less distracting.

Black and white, however, is not the only thing for him. Guido has never forgotten about how color can make an image very powerful. The saturation of some colors can strengthen the image a lot—which he has been exploring with software like Adobe Photoshop and Adobe Lightroom.

Guido's creative mind is best shown in his videos, which can sometimes be absurd and surrealistic. His work has been exhibited at the International Film Festival Rotterdam (IFFR), Stukfest Festival Rotterdam, ASVOFF fashion Film Festival in Barcelona, and has been published on various websites. For more about Guido's work, please visit **www.guidojeurissen.com**

You can contact Guido at guidojeurissen@gmail.com

15

EXPOSURE

EXPOSURE

16

With all the measurement and processing advantages of digital photography, exposure has been made easy to take for granted. The automatic exposure functions on today's cameras are impressive pieces of technology, and indeed they are quite capable of producing excellent images all on their own (hence the Auto setting on virtually every single modern camera). There is something to be said for this, as it makes photography considerably more inviting and approachable, and is in no small part responsible for the democratization of photography that we've been enjoying for several decades (aided by autofocus, always-with-you cell-phone cameras, advanced post-production tools, and the ease of sharing and displaying digital images online).

Yet, there is a significant drawback to this trend toward automation. More and more, exposure is rigidly understood as something that is either right or wrong—a problem to be solved. There is an element of truth in this, insofar as there is, in the end, just one dosage of light, manipulated by shutter speed, aperture, and ISO (or film speed), just as it has been for over a century. For all that we wax philosophical about how to interpret exposure, the final decision is a straightforward combination of just three simple factors. The problem is that viewing exposure in such a clinical way robs you, as a creative artist, of a significant and, frankly, enjoyable component of your art. There is another open-ended, highly subjective side to exposure. Two

people can view the same scene and choose to represent it in entirely different ways-and we should be thankful for this, or else there would be little room left for innovation and expression. How you choose to capture a scene depends on your receptiveness to the subtle interplays of light and shadow, what you consider significant versus peripheral, the mood you want to impart to the viewer, and so on. Over time, these exposure decisions will form your personal aesthetic style. Some like it bright, some like it dark. Some need everything tack-sharp, others don't mind soft edges and a bit of blur. Photography is big enough to accommodate all these approaches, and exposure is the means by which you can achieve them.

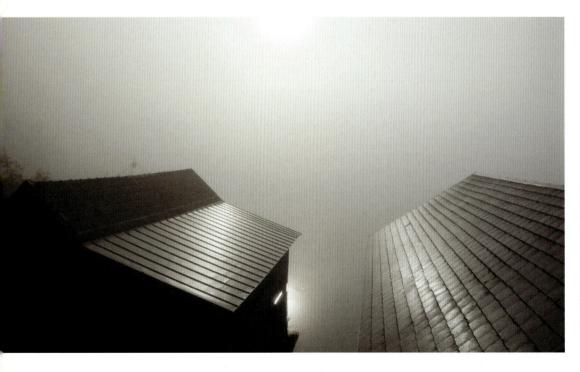

How and when to shoot

Even the timing of your shot is an exposure decision—do you wait for the sun to reemerge from behind a cloud, or (in this case) for the fog to pass? Or do you embrace the current conditions? Such questions require confidence equally in both your aesthetic sensibilities and technical prowess. And that will be the purpose of this book: To give you a thorough understanding of the exposure tools available, so that when the moment calls for it, you can not only determine the optimal settings for the best exposure, but also what that "best" exposure is, and what other options and interpretations potentially exist. As part of this, we will also be emphasizing the moment of capture over any postproduction workflows, with the goal being to capture optimal data in-camera. For one, doing so will give you the most leeway during post-production if you do go on to edit your files; but more importantly, this approach will reinforce the significance of your exposure decisions each step of the way, so you can work knowledgeably and effectively.

→ A coherent decision

Exposure is an inseparable part of every photographic decision. For instance, as this shot of a market is being composed, design choices as to where to line up various elements within the frame invariably impact the placement of shadows and highlights, which must be considered simultaneously and on-the-fly.

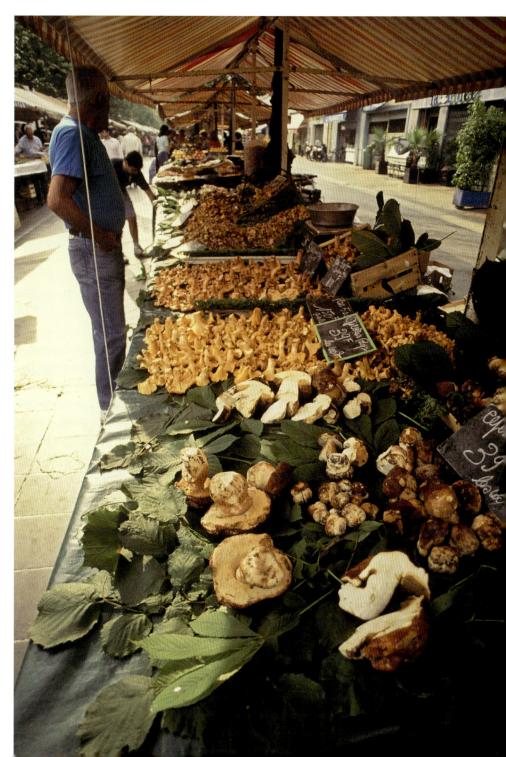

17

EXPOSURE

18

A Record of Tonalities

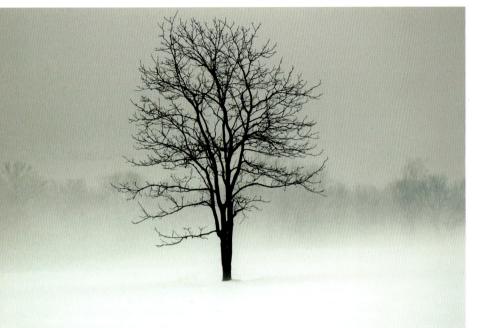

At its most basic, exposure is about one thing: Getting the ideal amount of light to the camera's digital sensor so that the scene is captured as closely as possible to the way that it looked to you at the time. Record too much light and the image is overexposed and the image is too bright-shadows are bland and highlights are completely without detail. Capture too little light and your image is underexposed—shadows are cast into dark blobs void of detail, and highlights and middle tones are muddled. In most (not all) cases, the ideal exposure lies somewhere between those two extremes.

In purely technical terms, your camera provides a nearly perfect vehicle for capturing a good exposure. Given the proper instructions (from you), it will do © Stephen VanHorr

just that. In fact, it was designed largely with that singular goal in mind: To record the tonalities of a scene so that they will appear as recognizably as possible in the final photograph.

Technically then, your goal (and the camera's function) is to record the values in a scene in a way that looks similar to what your eyes saw. In a winter landscape, for instance, you want the snow to look white, the dark tree trunks to be nearly black and most of the rest of the scene to fall between the two. Using just a light meter and few exposure controls, capturing such an exposure can be reduced to a very predictable process. A lot of clever engineering has gone into making the process quite painless, giving you time to concentrate on the creative side.

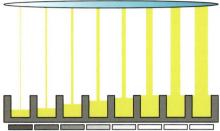

↑ Filling the photosites

Once the camera's shutter opens, the photosites (pixels) on the sensor's surface begin to fill with light. The more light, the fuller the well and the lighter the tone will be. But when completely full, the result is featureless white.

Simple settings, complex solutions

Understanding how basic camera settings control the amount and duration of light that reaches your camera's sensor is at the root of all exposures. Master this knowledge and no subject is beyond your control.

As you start out in photography, knowing how to carefully combine the settings of those exposure controls is an essential skill to master in order to create a good technical exposure. And as with any new skill, learning these fundamentals is at the core of creative growth. Great jazz musicians can't fly off into an inspired improvisation, can't twist and explore and return to a melody until they have mastered the basic skills of playing that melody first. Photography is very similar: You must know how a camera captures and records light before you can alter that response.

Human Versus Digital Dynamic Range

Unfortunately (or perhaps fortunately, depending on your point of view), the way that your camera sees the world and the way that it appears to your eyes and brain are two radically different things. For one, your eyes have an astounding and extremely rapid ability to see an extraordinary contrast range. It's nothing for your eyes to see detail in the darkest shadow of a rock at midday and then, in a flicker, find detail in the white petals of a sunlit flower. Your eyes and brain together are constantly and relentlessly adjusting to the brightness range or "dynamic range" of your surroundings. Focus on a shadow and your pupils open to accept more light. Glance into a sunlight patch, your

pupils close down instantly to control the burst of light. Given time to adjust to the changing conditions, your eyes can see across a dynamic range that is equal to more than 24 "stops" in camera terms.

Your camera, on the other hand, is limited to capturing the finite dynamic range of its sensor—with contemporary sensors a range of 10–14 stops of light, depending on the particular camera model. If you exceed that range at either end by trying to include too broad a range of darks and lights, something has to give: You will lose one end of the dynamic range or the other. There are methods, such as highdynamic-range imaging, for extending that range and we'll discuss those later in this book.

←↓ Tough decisions

While your eye has no trouble seeing details in both the shadow areas at the edge of this frame, and the bright highlights in the center, your camera often needs to choose either one or the other, which can result in an underexposure (below, left), or an overexposure (below, right). The challenge of a good exposure is to work within the fixed limitations of a camera's technology while at the same time exploiting the maximum emotional content from your subjects. And that is essentially what this entire book is about.

19

Controlling Exposure

Given the creative range that exposure can produce in a photograph, it's interesting that exposure is entirely a product of just three camera controls: ISO setting, lens aperture, and shutter speed. Every exposure, every creative effect, and every manipulation or exaggeration of the light is created by the careful and clever combination of those three settings.

ISO numbers are a relatively recent invention, but throughout the history of photography, the sensitivity of emulsions has been a factor, and these three controls haven't changed fundamentally since the earliest days. We can calculate exposure times in thousandths of seconds or use standardized apertures and ISOs, but the basic concepts remain the same.

EXPOSURE

Right Versus Wrong Exposure

20

One of the concepts that is important to eliminate, or at least try to suppress a bit as you begin to experiment with exposure, is that for every single possible photo, there is necessarily such a thing as a right or wrong exposure. While you certainly want to understand how to capture the tonalities in a scene so that you aren't sacrificing essential detail in the highlights or shadows, for instance, you don't need to adhere to anyone else's definition of what a correct exposure should look like. Exposure is no more about right or wrong than is the amount of milk you put in coffee, or the temperature of your beer.

While most of us see a colorful sunset as a cheerful and brilliant sky event, for example, there is nothing wrong with

grossly underexposing that scene to artificially over-saturate the colors. Nor is there anything wrong with providing too much exposure and creating a more lyrical high key interpretation (see page 94 for more on high-key exposures). Most great strides in art, in fact, have been achieved by those brave souls who have pierced through the realm of conventional barriers and expanded the territory of what is correct. Picasso, Van Gogh, Monet—all took the norms of art and tossed them in the trash. (Though you can be certain that all knew the standard techniques well before shattering them.)

Underexposed for drama

One man's underexposure is another's idyllic sunset. As you become comfortable with the nuances of exposure, its technically accuracy will take on a more subjective outlook. Were the entire world and all its scenery colored a consistent middletoned gray, there would be no need for this book, as your camera would never struggle to determine its exposure. Quite fortunately, the world is a bit more varied than that. Subjects present themselves in every color of the rainbow, illuminated by a wide variety of lighting conditions (which themselves have their own subtle colors—as we'll discuss on page 66), struck at angles that reveal contours and textures that can be highlighted or hidden at your discretion.

Overexposed for vibrancy

This shot required a creative override of the camera's metering system, which typically fights against letting massive areas of the frame blow out to pure white.

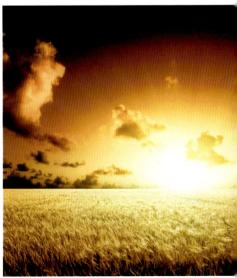

© lakov Kalinin

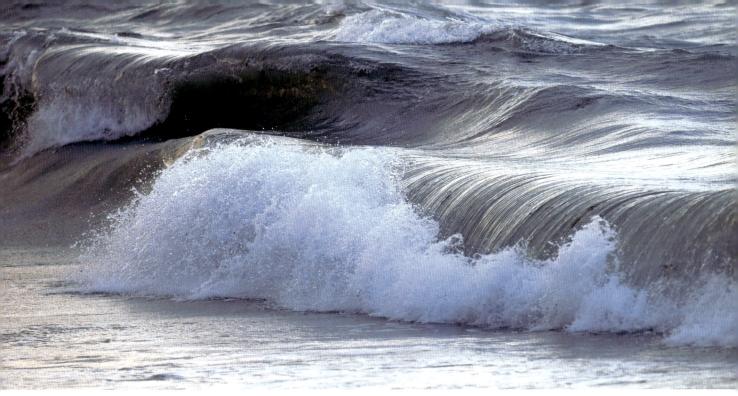

That discretion and creative choice over how you choose to capture and represent any given scene is your most powerful tool. Your camera, even with its highly advanced, built-in metering system, is only a computer, with no sense for the creative potential before it. It is entirely up to you to take control and learn when to override your camera's decisions and assert your own vision for your photography.

Some of that creative vision will be a matter of deviating from your camera's suggested exposure measurements recognizing that, in fact, you prefer this scene with heavy, blocked-up shadows and a resulting sense of brooding and dread, or another scene with so much pure bright white that you can just barely make out your subject emerging from an ethereal cloud. Other times, you will depend entirely on a precise exposure reading from your camera, but you will still need to carefully ensure that it is reading of the specific

↑ Not always shooting for a catalog

If the goal was to accurately represent the shape of an apple, this photo would be a failure. But the apple itself isn't what was important; rather, it was the interplay of light and shadow. © Elenathewise

↑ Countless possibilities

There are countless ways to capture this wave—a high shutter speed to freeze each drop, or a slower one for a more painterly effect; cold white balance to keep the blues of the water intact, or warm to infuse the image with a golden hue.

area of the scene off of which you want to base your exposure. There is never a place in this photographic journey in which you should not be asserting yourself as the ultimate decider of proper, ideal, or "right" exposure.

With that framework in mind, when the terms "good" or "bad" exposure are used in this book, we are only talking in the strictest technical sense. In terms of aesthetics, you are the only arbiter of right or wrong, good or bad, creative or imaginative.

Underexposure & Overexposure

EXPOSURE

22

Underexposure

Images that are underexposed, either intentionally or by poor exposure choices, are those that appear darker than they did to the eye (or than the viewer's experience suggests) because they haven't received enough light. Often, scenes can be underexposed by design to give them drama or mood. In the Venezuelan Andes scene below, for example, intentional underexposure was used to contrast the brilliance of the white buildings against the overshadowing of the dark mountain shapes. A slight underexposure can be a good toolfor saturating colors and

Through a glass, darkly

Intentional underexposure is a wickedly powerful tool for exaggerating or even fabricating the mood of a place. What the meter thinks is too little may be just enough. bringing highlights under control a good technique when shooting landscapes where you want to stress the intense colors of the sky without letting them overflow into pure white. Too much underexposure, however, tends to hide details and textures in shadow areas, and bunches up darker tonalities rather than revealing subtle nuances in the dark areas of a scene.

Generally speaking, even when you are underexposing for dramatic effect, it's rare that you want to lose all details in darker areas of a scene, partly because such an exposure will also drag highlights down—though again, this is a purely subjective decision. There is nothing wrong, for instance, with exposing for the delicate light tones of a clump of white tulips blossoms so that the highlights become closer to middle tones and the shadows become a field of black around them. In such a scene the tulips themselves would lose their bright delicacy and fall into a more neutral palette, but this can add to the unexpectedly dark mood of the scene. Often just the surprise factor of such extreme underexposure is enough to draw attention to an image.

The riches of saturation

Correct exposure is fine for family snapshots, but art comes from having the courage to depart from reality. Just a few stops of underexposure turn tulips from ordinary to elegant.

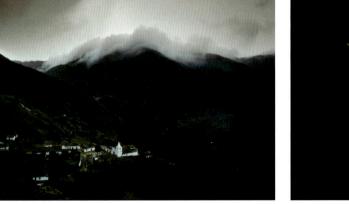

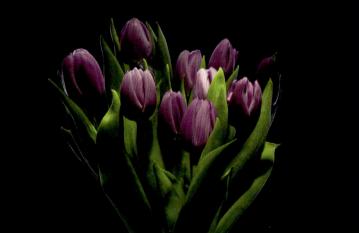

© Yurok Aleksandrovich

UNDEREXPOSURE & OVEREXPOSURE

23 |

Overexposure

Overexposure happens when a scene gets more light than is required for a "normal" exposure, and tones are recorded as lighter than they appear to the eye or to expectations. The danger of overexposing scenes is that, even when slight, detail may be completely lost in the lightest tones. There is a fine line between capturing the delicacy of a white swan feather, for example, and losing detail completely. Digital sensors are more prone to overexposure errors than is film and for that reason you'll often hear the advice that you should "expose for the highlights" when shooting digitally. By exposing so that highlight areas retain fine detail you avoid having "blank" areas in the lighter tones where there is simply no discernible detail or surface texture.

Creative use of overexposure with certain types of subjects can produce interesting visual effects and often establishes a light, cheerful interpretation, particularly with light-toned and pastel-colored subjects. If you're photographing a field of tall vellow grasses in brilliant sunshine, for example, a small amount of intentional extra exposure will exaggerate the dreamy, romantic quality of the scene. The danger of too much exposure, however, is that you'll lose so much detail in brighter-toned areas that the image will cross into the realm of abstraction or impressionism. That's not a problem if it's your intention, but often such scenes just look like they were made with sloppy exposure technique—it's a fine creative line.

In general, the rule in digital exposure is to expose for the highlights and correct for the shadows in editing.

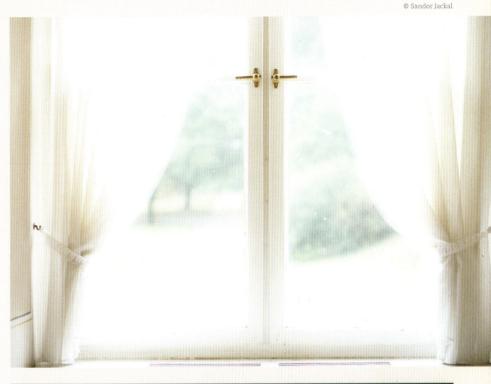

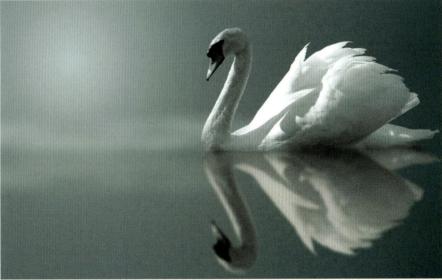

↑↑ Bright window light

Too much light? Depends on the mood you're trying to establish. A bit of overexposure adds lightness to the atmosphere of a photo, as well as the tonalities.

↑ Clipped wings

"Clipping" is a term used to describe highlights that have received too much exposure and lost all detail as a result. It's unavoidable in some situations, but should always be carefully monitored. © Joss

Creative Use of Over- or Underexposure

Verexposure as a choice

The dynamic range of the frame required a creative exposure decision one way or the other, and having the sledder emerging from a bloom of pure white on the right seemed more fitting. "Correct" exposure is the result of a combination of exposure settings that renders the world the way that most people perceive it: Light-toned subjects are bright but detailed, shadows are dim but accessible, and in terms of overall tonality, most things look pretty much as we perceive them day to day. But as you now know, with an intentional shift toward underexposure or overexposure, you can radically transform not only the look of a scene, but its emotional climate, as well. By making a wholesale shift toward lighter tones, for example, you can transform a morning meadow into a lifting, high-key melody; by subtracting exposure from an already dim scene of an industrial block you drag it down into a gloomy low-key dirge. And that is what your challenge is all about: using the extremes of exposure to value mood and expression above reality.

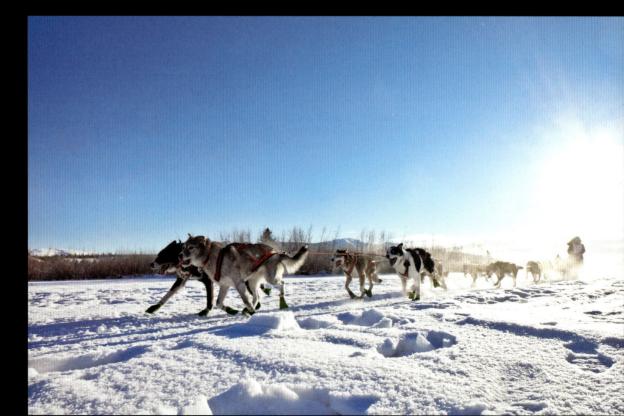

→ Capturing twilight While your camera's metering system will happily boost dropping light levels to maintain a consistent, bright exposure, we tend to expect an underexposed rendering of twilight shots, as that is how we perceive such scenes lighter than night, but darker

than day.

Challenge Checklist

- → Ignore the boundaries implied by the histogram and intentionally push tones past the brink.
- → Use your exposure compensation control to add or subtract exposure, or shoot in the manual mode to override meter suggestions.
- → Be sure to match your exaggerated moods to your choice of subject.
- → Shoot in Raw and experiment with radical exposure changes after the fact.

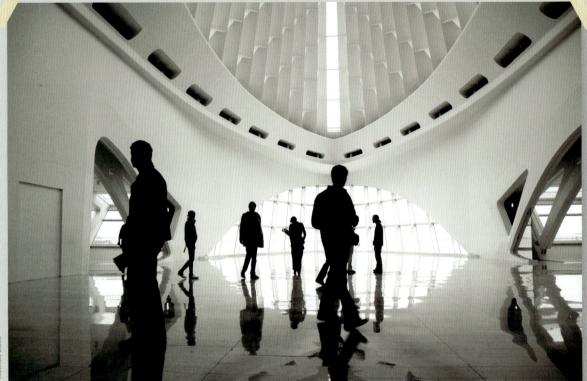

By exposing for the white walls of the hall's architecture, the figures fall into shadow as the light from outside becomes a brilliant white. f/4 at 1/50 second, ISO 200 with +1/3 exposure compensation. Nathan Biehl

An excellent example of deciding what the important tone is, and exposing for that. The white walls are indeed the key to everything here, and they need to be exactly as you have them-light but not fully white. And the exterior white looks, as you say, brilliant rather than overexposed. Michael Freeman

EXPOSURE

27

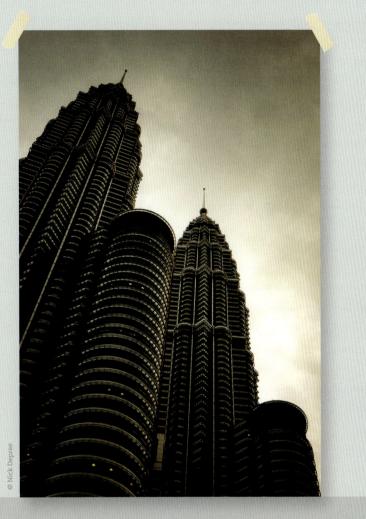

Petronas Towers, Kuala Lumpur. I underexposed the shot to give a dark tone and a different feel to the very recognizable landmark, which came out dark gray instead of the bright stainless steel normally associated with the towers. £/5.6 at 1/320 second, ISO 800. *Nick Depree*

This makes a good pairing with the picture opposite, as it too has above all a good *reason* for being exposed less than would be expected. The Petronas Towers are indeed overexposed in another sense, so it's a good decision to go for a different and more eye-catching treatment. *Michael Freeman* EXPOSURE

ISO Speeds

The ISO setting on your digital camera enables you to adjust the light sensitivity of the image sensor. Just as with film, the higher the ISO (the acronym stands for International Standards Organization) number, the more responsive the sensor is to light; and the lower the setting, the less sensitive it is. In bright light, therefore, you can use a lower ISO number and get a good, clean response; but if you find yourself shooting in a dim lighting situation (indoors by existing light, for example), you can raise the setting to increase the sensitivity of the sensor's response. So why not always use a high ISO? Because it comes with the price of noise, and so the highest image quality goes hand in hand with the lowest ISO.

Most digital cameras have both an automatic ISO mode and a manual setting. In the auto mode, the camera will evaluate the amount of ambient light and set the ISO speed for you. The auto setting is useful if the ambient light is changing quickly—ducking in and out of historic buildings, for example-and you don't want to be bothered changing the setting every few minutes. In the manual mode, vou have to make an assessment of the existing light and then set the ISO setting based on your own judgement. Also, all cameras have a default settings (typically ISO 100 or 200, depending on the camera model) that provides optimum image quality when there is an abundance of existing light.

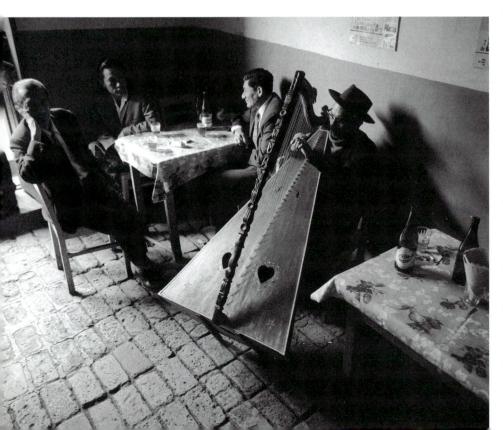

The beauty of having a variable ISO setting is that you can change it for literally every shot. In the film days, changing the ISO setting meant changing an entire roll of film. With a digital camera, however, you can be shooting at a low ISO setting in bright sunlight one moment and then switch to a faster setting when you head indoors to shoot by a very low level of existing lighting.

One important fact to keep in mind is that the sensitivity response of your sensor doubles each time you double the ISO. If you switch from the default setting of ISO 200 to a setting of ISO 400, for example, you double the sensor's response to light. Similarly, each time that you halve the ISO number you cut the sensitivity in half. And, as we'll delve into more in the coming pages, doubling (or halving) the camera's sensitivity can have significant technical and creative benefits in terms of specific exposure settings.

ISO settings typically range from about ISO 100 to ISO 3200 or 6400 in most consumer-level DSLR (and advanced zoom) cameras, with much higher settings in pro-model DSLR cameras. Top-end professional models now boast a maximum setting in excess of ISO 200,000—presumably for photographing fast-moving black panthers in the jungle on a moonless night.

A more sensitive response

By raising the ISO speed, your camera responds better to low-light situations and avoids the necessity of turning on flash, which can destroy the mood of intimate scenes like this cafe.

2

↑↑ **The price of speed** The price of increased sensor speed is an increase in image noise. It's a price worth paying if it means getting a shot you would otherwise lose.

© Daniel Seidel

ISO and Image Noise

The flexibility of being able to adjust the ISO sensitivity of your sensor does not come without a certain (albeit small) technological price-namely that of what is called digital noise. Noise is a random textured pattern that interferes with the image (reminiscent of the graininess of high-speed films, though caused differently) that occurs when you use an excessively high ISO speed. The actual amount of noise depends on several factors including the size and design of the sensor, and whether you've tried to pull up shadow detail in post-production. In general, however, the higher the ISO and/or the smaller the physical size of the sensor, the more likely you are to see objectionable noise.

Technically, noise is the result of electrical interference (often called "cross talk") between the photosites (pixels) on a sensor, and the more photosites there are on the sensor, the greater the noise. That is why smaller sensors that have more pixels typically produce more image noise than larger sensors. Larger sensors enable the pixels to be spaced farther apart and allow for greater isolation or filtering of their signals. The reason that noise increases at higher ISO speeds is because the analog-to-digital converter in your camera is magnifying the signal from each photosite, and that in turns magnifies the electrical interference that results in visible noise. Just how distracting noise is in an image is really a matter of personal taste, and also depends on the size of

↑ Into the night

It is important to keep perspective when evaluating your image for noise levels. What looks like a grainy mess at 100% magnification, may be perfectly fine at a reasonable viewing distance. Additionally, noise reduction is a powerful post-production tool that can often salvage shots, provided you have the time.

the enlargements that you intend to make. In general, however, you are better off with using the lowest ISO setting that will provide the aperture and shutter speed combinations that you require for a particular situation. Manufacturers continue to make great strides in reducing noise and increasing the range of available ISO speeds, and most often the ability to shoot pictures in extremely low-light settings far outweighs the minimal distraction of a small amount of noise.

29

Get the Shot with a High ISO

Not quite pure black

Concerts in dark venues are a classic high-ISO scenario. Fortunately, the subject is often rather accommodating of a grittier, noisier rendering, as it suits the visceral feeling of such scenes. Unless you're photographing troglodytes in the deep recesses of a subterranean sunless world, today there are few subjects that you can write off because there isn't enough existing light. With ISO speeds of 1600 and 3200 common and with some cameras boasting speeds up to the 200,000 range, you can pretty much always find a way to expose even the dimmest of subjects. There are, of course, prices to pay for such speeds, namely an increase in image noise and a related softening of details and natural textures. But considering the ability that such an extended ISO range gives you to record subjects that seem nearly devoid of ambient light, those are small prices to pay. And so for this challenge, take a look into the nighttime world or into the realm of dim interior spaces and use your highest ISO settings to wrest properly exposed images from them. Try most of all to bring back images of subjects that you thought were beyond capturing: city streets at midnight, the unlit interior of a cathedral, or your favorite band in the local basement pub.

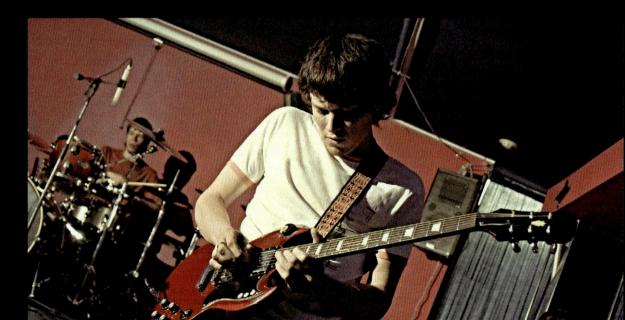

→ ISO as a failsafe

This shot required a fast shutter speed for a sharp shot (considering both the moving subjects on the ground and the long focal length of the lens used) and also a sufficiently narrow aperture for the depth of field to stretch from foreground all the way to the horizon. Add in the dropping light levels of dusk, and a high ISO (1600) was the only way to adequately capture the shot.

Challenge Checklist

- → Remember that each time you double the ISO speed, you are doubling the camera sensor's sensitivity to light.
- → Often metering in very dim locations is less reliable than just raising the ISO incrementally and viewing your results on the LCD. The trick is to find an ISO speed that will record adequately without image noise becoming obvious and oppressive.
- → Using a wide-aperture lens will help get more light to the sensor at the same ISO. If noise is a distraction, try shooting at a more moderate ISO with a wider aperture.

lathan Biehl

Lighting was minimal at the show and I was forced to shoot wide open with the ISO maxed to 6400. Luckily, a small lamp was able to briefly illuminate the drummer. *f*/1.8 at 1/50 second, ISO 6400. *Nathan Biehl*

I'm not sure from what you say whether you added the small lamp yourself, but however it appeared, it adds both color contrast and focuses attention on the key action. The shutter speed was sufficient to hold the drummer's face sharp, so the blur of the left hand is completely acceptable. *Michael Freeman*

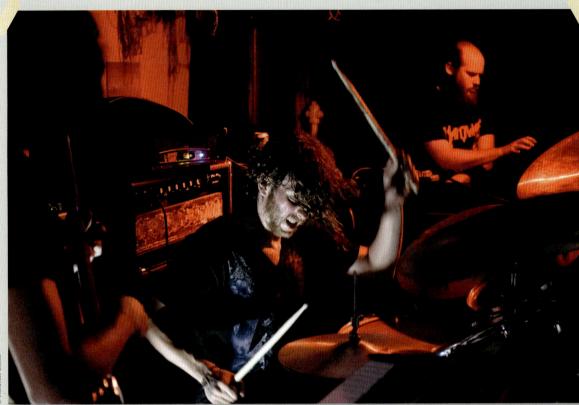

32

EXPOSURE

REVIEW

33

Under Pioneer Square, Seattle. The very dim tunnels under old Seattle required both ISO 3200 and bracing myself against a doorway to get a sharp shot with a slow zoom lens. f/3.5 at 1/5 second, ISO 3200. Nick Depree

Was f/3.5 the maximum aperture of your lens? In any case, its depth of field is sufficient for all except the top left corner pipes. A fifth of a second braced is good camera handling, and I imagine you work on your hand-holding skills—which is good practice for low-light shooting. *Michael Freeman* EXPOSURE

Lens Apertures

34

Regardless of whether you are using a simple compact digital camera or a sophisticated DSLR camera, the purpose of the lens aperture is exactly the same, to regulate the amount of light that is allowed to pass through the lens to the camera's sensor. The size of the aperture is referred to as the f-stop and is controlled either electronically or, on older lenses, by a mechanical ring on the lens known as the aperture ring. In simplest terms, the larger the aperture opening is, the more light that gets into the camera and onto the sensor; and the smaller the opening, the less light that reaches the sensor. If you were to close the lens aperture entirely, of course, no light would reach the sensor at all: and at the other end. there is a limit as to how wide a lens can open (its "maximum aperture"). That maximum aperture is different depending on each lens, and with many zoom lenses, the maximum aperture is variable, meaning that it will narrow as you zoom in closer and reach into longer focal lengths.

In order to be able to use lens aperture to control either exposure or focus, it's important that you have a sound understanding of how the f-stops are numbered and why. In fact, the more that you understand about the f-stop numbering system, the simpler the concepts become. The available number of full and partial f-stops on a given lens (or the electronic options for those settings provided by the camera) will vary by lens brand/model and by the camera's exposure system, but all lenses use the exact same sequence of full f-stops, illustrated along the bottom of these two pages.

The concept is far simpler to understand if you think of the aperture numbers as multiples of each other. Each f-stop in the sequence allows double the exposure of its neighbor on one side, and half the exposure of its neighbor on the other. This is why the numerical sequence looks a little strange at first—because it's a logarithmic sequence, with bigger apparent leaps between numbers the higher up you go. So, while the difference between 1.4 and 2 may look smaller than that between 11 and 16, in fact both steps are the same—halving the amount of light allowed through the lens. That sounds complicated only because you shouldn't think of f-numbers as a normal, numerical sequence. All you need to do is acquaint yourself with the standard f-stop sequence and you'll be ready to shoot with any camera.

↓ > Larger numbers = smaller openings If there's one concept you should take away from these pages it's that the larger the f-number is, the smaller the opening is, and vice versa. If you want to let in more light, switch to a larger opening.

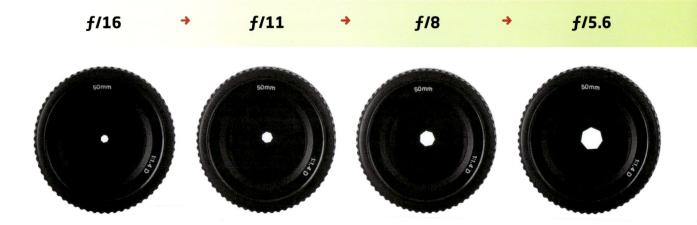

35

Controlling Depth of Field

In addition to its purely exposuredriven purpose of regulating the amount of light that reaches the sensor, the aperture also controls how much of the scene is in focus. When you focus your lens, you are moving a single, twodimensional plane of ideal sharpness closer to and farther away from the sensor. However, the vast majority of subjects are three-dimensional, extending in front of and behind that ideal plane of focus, and in order to capture them sharply, you likewise need to expand that plane into a three-dimensional zone of sharp focus.

The name for that zone is the depth of field, and it is directly controlled by the aperture: The wider the aperture (the lower the f-number), the shallower the depth of field; and the narrower the aperture (the higher the f-number), the deeper the depth of field. Use a narrow enough aperture, and you can fit everything in front of you in focus, from the foreground all the way to the horizon line. Use a wide enough aperture, and you can sharply isolate a portrait subject against a soft, blurred, out-of-focus background, concentrating attention only on what is important.

→ Pick your plane of focus

Changing your aperture will affect much more than just your exposure, and you must always be mindful of how much or how little depth of field a given aperture value will give you, and ensure that it is appropriate for your particular subject. In this shot, you can see that the bouquet of roses, situated midway into the scene, is sharp and in-focus, while the ropes extending in front of and behind the bouquet gradually fall out of focus in either direction. That is because a wide aperture (f/2) was used to create a shallow depth of field, and the lens was then focused to position the bouquet precisely within this depth of field, allowing the peripheral elements of the scene to fall off into the out-of-focus areas.

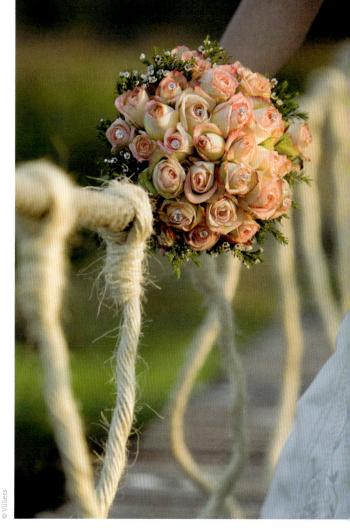

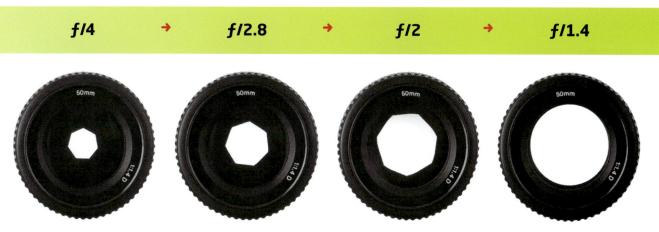

© SLDigi

Demonstrate Depth-of-Field Control

Fitting it all in

When looking for maximum lepth of field, focus about a hird of the way into the scene, is the depth of field extends lisproportionately in either lirection away from the plane of focus: 1/3 of the total depth of field extends in front of the ocused plane, while 2/3 of it extends beyond. Once you understand the forces that control depth of field—aperture, focal length, and subject distance—you have almost perfect control over what is or isn't in focus in a scene. You now know, for instance that by using a wide-angle lens and a small aperture, you can create images that are in continuously sharp focus from your toes to the horizon. And by reversing those factors and switching to a long-focal-length lens and a wide aperture, you can restrict depth of field to as little as a few inches or less. How you manipulate depth of field for this challenge is unimportant, but you must demonstrate that you understand the fundamental controls and how to combine them to achieve your goal. But more than merely controlling depth of field, show that you can match it also tc the appropriate subject: selective focus in a portrait, for example, or boundless sharpness in a rural landscape.

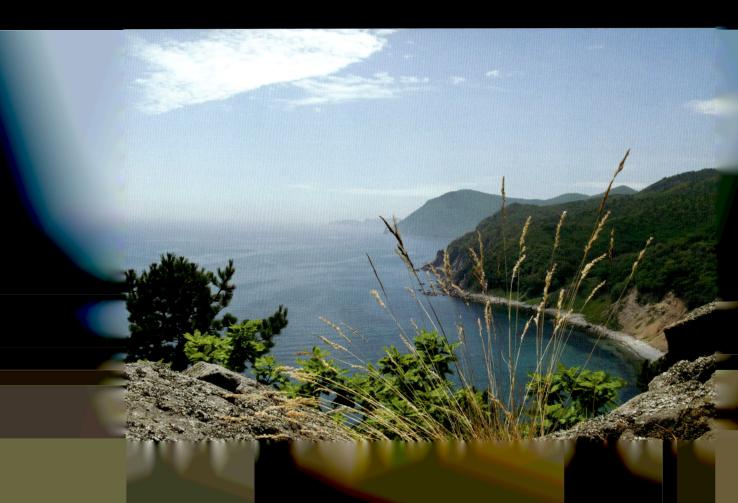

Blurred but visible

With careful composition, you can make even out-of-focus subjects a meaningful part of your shot.

Challenge Checklist

- → Remember that the higher the aperture number is, the smaller the lens opening and the more extensive the depth of field. If your shutter speeds get too long, be sure to mount the camera on a tripod.
- → Restricting depth of field in bright light isn't always possible because you may not have a shutter speed fast enough to allow wide aperture. But you can always add a neutral density filter to reduce the light entering the lens.
- → When using very shallow depth of field, be sure to focus carefully on that part of the subject you want in sharpest focus—the eyes in a portrait, for instance.
- → The depth of field preview feature of your DSLR will show you the scene at the shooting aperture, but you may have to let your eye adjust to see it clearly.

9 Darren Bak

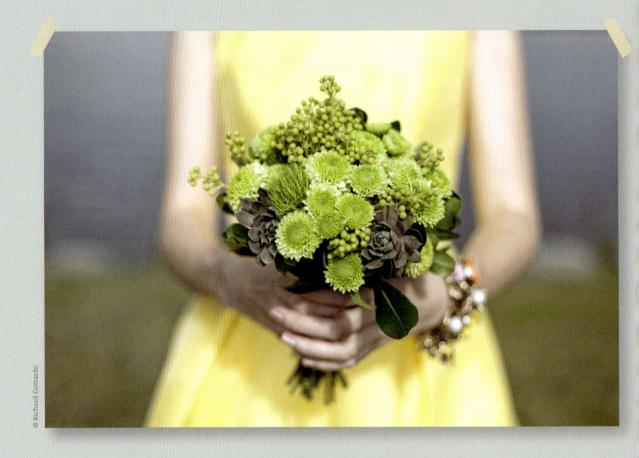

For this picture I wanted to make the flowers really pop while keeping a simple outline of the woman against a simple background. This was achieved by setting an aperture of *f*/1.4 on a canon 50mm *f*/1.4 lens and placing her in front of a small pond with no distracting elements in the background. *Richard Gottardo*

You're fortunate to have such a lens—f/1.4 is one of the fastest available, and this is certainly the way to make the most use of it, at full aperture and with good front-to-back depth to exaggerate the selective focus. The unfocused areas blend their pastel colors nicely.

EXPOSURE

39

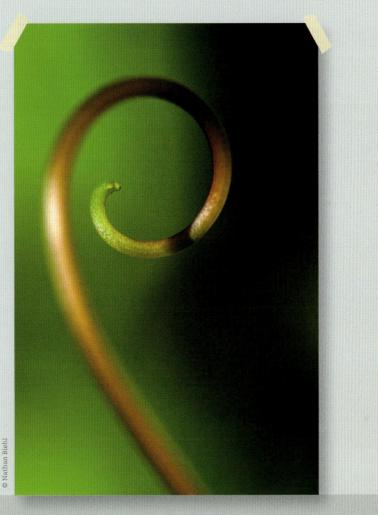

A macro lens provided the narrow depth of field required to isolate the tip of this tendril. Letting its stalk spiral out of the focus. f/9 at 1/400 second, ISO 200, with -1/3EV exposure compensation. Nathan Biehl

Good treatment, letting the spiral work itself out of focus. It looks as if you angled the tendril to maximize the sharp focus near the tip. I'm intrigued, though, to know why you set the aperture at a mid-setting of *f*/9 rather than maximum aperture. *Michael Freeman*

The Math behind the Numbers

10

Let's look in a little more detail at the relationship between numbers and size of aperture. The f-stop numbers represent the ratio of the physical aperture diameter to the focal length of the lens. For example, if you're using a 120mm lens and you're using an aperture of *f*/4, then the physical size of the aperture is 30mm or one-fourth of 120. If you moved to a larger aperture (again, a smaller f-number) such as *f*/2, the size of the lens aperture would be 60mm (because 60mm is one-half of 120mm).

You can easily figure the actual diameter of the lens opening by simply dividing the f-stop number into the focal length of the lens. If you're using a 300mm lens set at f/4, for example, the diameter of that f-stop is 75mm (4 x 75=300). If you switch to f/2, the diameter is 150mm (2 x 150=300). Now think about which aperture is larger and which will let in more light.

To visualize this, imagine looking at your lens opening sideways: If you were using a setting of f/2 it would fit exactly twice from the center of the front lens element to the focal plane (the sensor plane) of the camera.

© Gudellaphoto

↑ Consider the side effects of aperture In order to slightly underexpose this scene (so that the trees are rendered as silhouettes), a narrower aperture was used—which also extended the depth of field throughout the shot.

Know when to take your time

With static landscape shots, time is often on your side, and you will be able to experiment with a variety of different exposure settings.

Stops Versus f-Stops

Before we continue with our discussions of exposure, it's important to clarify that while f-stops refer to apertures specifically, "stops" is often used to refer to exposure more generally, and relate equally to ISO, aperture, or—as you'll see on page 42 shutter speed. So, when you hear that exposure is decreased "by three stops," this can mean a narrow aperture was set, but it can also mean a lower ISO or a faster shutter speed was used. In terms of the final exposure, there is no difference.

One very significant bit of aperture math that it's important to understand is that each time you shift from one f-stop to another f-stop that is either a whole-stop larger or a whole-stop smaller, you either double or halve the amount of light reaching the sensor. Suppose, for example, when you shift from a setting of f/8 to f/5.6 (an opening that is one whole-stop larger), you are doubling the amount of light that reaches the sensor. If you were to "close" the aperture by one stop and change from f/8 to f/II (again, that's a change of one full stop), you would cut the mount of light reaching the sensor in half.

As you may remember from our discussion of ISO speeds, the exact same relationship exists when you change between apertures. The doubling and halving of exposures occurs with each of the three exposure controls, including shutter speed—as you are about to learn—and is of course deliberate, making it easier and more practical to juggle the three settings. In other words, the relationship between the three controls is reciprocal. Though it may take some getting used to at the start, once you understand it you will rejoice in its simplicity, and exploit it for consistent, accurate exposures.

© Mat Hayward

An elegant relationship

11

Aperture and the amount of light reaching the lens have a profound relationship that is both simple and elegant: open the lens by one stop, the light doubles, close it by one stop, the light drops by a half. In order to maintain a consistent exposure, you must compensate for the f-stop changes with either an ISO or shutter-speed adjustment.

Making radical changes

One of the things that an adjustable aperture allows is a rapid response to changes in the quantity of light. If you're working with an autoexposure mode (see pages 50–51), those changes will take place instantaneously.

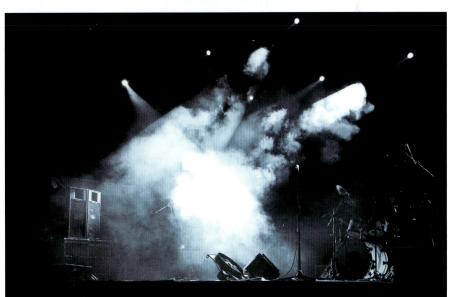

Shutter Speed

The third element in the exposure triad is shutter speed. Whereas aperture controls the amount of light that reaches the sensor, the shutter speed controls the duration of time that the sensor is exposed. As you might surmise, the longer the shutter is kept open, the more light that reaches the image sensor to build up the exposure. A good analogy for exposure length is that leaving your shutter open like leaving your garden hose running into your sink-the longer the faucet remains "open" the more water that fills the basin. Similarly, the shorter the duration of the exposure, the less light that hits the sensor (or water that fills your sink).

Easy choices

When you're working with an unmoving subject, choosing a shutter speed is easy: you just need it fast enough to prevent camera shake; and even if a longer speed is unavoidable (such as being required by a night shot), you just need a tripod to steady your camera.

The Shutter Speed Sequence

The shutter-speed settings on your camera represent either fractions of a second (1/60, 1/4, 1/2 second, etc.) or whole seconds (1, 4, 8 seconds, and so forth). Some cameras also have shutter speeds that represent full minutes, as well. Your camera manual will list the full shutter-speed range and progression that your camera offers.

Because these shutter speed settings represent the actual amount of time that the shutter remains open, most of us find the concept of shutter speeds far simpler to understand than aperture designations. If you set the shutter at I/I25 second, for example, that's precisely how long the shutter remains open: I/I25 of a second. While most of us can't necessarily comprehend just how long such a brief exposure is, we can understand that it's certainly much more brief than an exposure of, say, IO seconds. Unlike ISOs, with their exponential numbers-by-the-hundreds, and apertures with their logarithmic f-stops, shutter speeds work in the simple and straightforward measurements of time that we use every day.

Frozen in time

Candid moments like this shared laughter require a fast shutter speed (and a keen compositional eye).

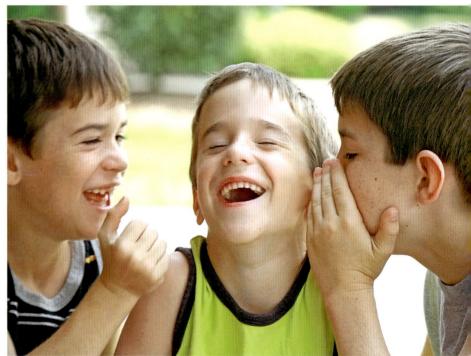

© Sonya Etchison

The Full-Stop Sequence

All cameras use a standard selection of shutter speeds that typically ranges from, say, 30 seconds or 60 seconds at one extreme to speeds as brief as 1/2000 or 1/4000 second at the other. Again, obviously, a shutter speed of 30 seconds is a much longer duration than one of 1/4000 second. In fact, one of the interesting things about the difference in shutter speeds is that you can actually hear the shutter opening and closing on most cameras, so detecting a long exposure from a short one is relatively easy. Try it.

Before electronics entered the world of camera design all cameras used a series of "whole" shutter speed increments that followed a standard progression such that typically included this group of shutter speeds: example, you double the amount of time that the sensor is exposed to light. Conversely, as you move from 1/250 second to 1/500 second, you halve the amount of time that the shutter remains open.

Those of you who are paying close attention should begin to see a pattern here of either halving or doubling exposure—and we'll discuss that very special and perfect reciprocal relationship (that is the basis of all exposure settings) in the coming pages.

Since cameras became more electronic and less mechanical, this absolute progression of whole shutter speed stops has been tinkered with, because fractional stops have been introduced. Some cameras, for instance, have a shutter speed of 1/320 second that falls (roughly) midway between 1/250 second and 1/500 second. While these new intermediary stops can be useful in fine-tuning shutter-speed response, to understand the mathematical theory of exposure, you will probably find it simpler to concentrate on the wholestop sequence.

43

You might also find that many cameras also feature a shutter speed designated as "Bulb" and that setting allows you to keep the shutter open for as long as you like (the term is a quaint reminder that shutters in old cameras were activated hydraulically, by squeezing a rubber bulb). Once you press the shutter release button in the Bulb position, the camera's shutter will remain open until you press it again. This setting is particularly useful for long time exposures—taking night scenes of traffic, or capturing the light trails of stars, for example.

30 seconds \rightarrow 15 seconds \rightarrow 8 seconds \rightarrow 4 seconds \rightarrow 2 seconds \rightarrow 1 second \rightarrow $\frac{1}{2}$ second \rightarrow $\frac{1}{4}$ second \rightarrow $\frac{1}{8}$ second $\frac{1}{15}$ second \rightarrow $\frac{1}{100}$ second \rightarrow $\frac{1}{100}$ second \rightarrow $\frac{1}{1000}$ second \rightarrow $\frac{1}{100$

These shutter speeds are referred to as "whole" stops because as you progress from one shutter speed to the next, you either double or halve the amount of time the light has to enter the camera. As you move an exposure of 1/60 second to one of 1/30 second, for

The shutter sequence

Though you're unlikely to see such a shutter speed dial on your modern camera, their presence on old film cameras was a testament to their significance in every shot.

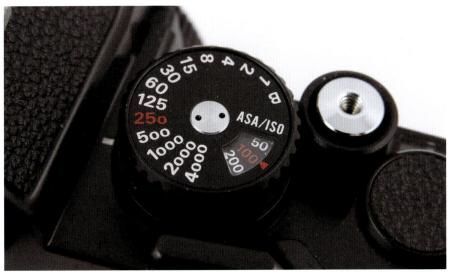

Freeze the Action

Catching the moment

Fast-moving subjects are going to push your autofocus system to its limits, but with sufficient light, you can narrow the aperture to increase the chance that the subject will fall within the depth of field. One of the most amazing aspects of being able to adjust the shutter speed is being able to use very brief shutter speeds to completely stop even the fastest subject motion. This challenge will not only test your knowledge of shutter speed settings and how they relate to moving subjects, but also demonstrate your understanding of the nature of action subjects. You'll need to remember, for instance, that subjects coming toward or going away from the lens are easiest to stop with moderate shutter speeds and those moving parallel to your sensor require faster shutter speeds. You will need to experiment with various subject and shutter-speed combinations and compare results to see what the minimum speed is for stopping action completely. And lastly, you'll need to know where to look to find subjects that are worthy of this challenge that test your skills as an action photographer. Where will you look? How will you get close to the action?

→ Make them come to you The climactic moments that make the best action shots can often be predicted, giving you time to move into an ideal position and test a few exposures while waiting for the action to come to you.

Challenge Checklist

- → If you can find a subject that repeats the same motion over and over again (a friend swinging a golf club, perhaps), run a test of several shutter speeds to determine which is the slowest speed that will still freeze the action.
- → Remember that the larger the image is on the sensor the faster the shutter speed you will need to get a sharp image, so as you zoom out to a longer focal length you'll need to increase shutter speed.
- → Approach your action subject from several angles to demonstrate for yourself how the direction of the action changes your ability to freeze motion.
- → Don't forget the reciprocal nature of ISO and shutter speed: if you need to boost the shutter speed by one stop, just double the ISO. If you want to go two stops faster, double it again.

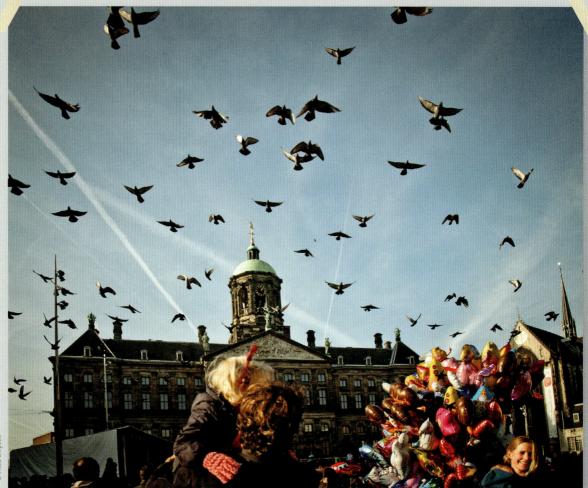

Dam Square, Amsterdam. Shooting in bright sunlight gave a shutter speed of 1/1600 second—more than fast enough to freeze the flock of pigeons as they flew overhead. *f*/5.6 at ISO 400. *Nick Depree*

Most birds-in-flight shots show some degree of motion blur in the wing tips, so it's interesting to see a completely frozen image here, and I imagine that's why you set the ISO higher than normal at 400. Good timing, as well, with the birds quite evenly distributed and more or less filling the sky. *Michael Freeman*

REVIEW 47

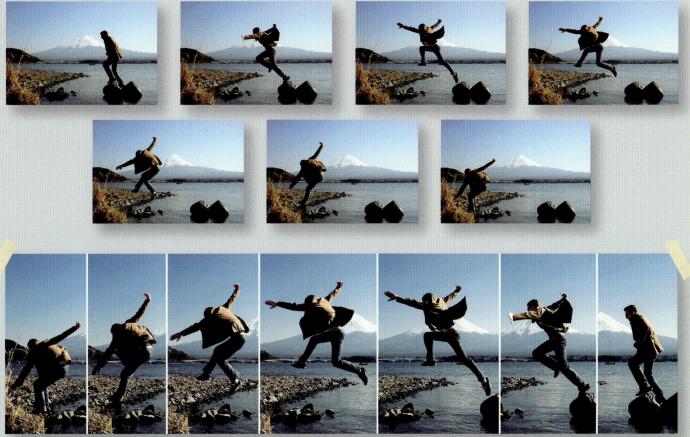

I set the aperture manually to f/8 to create a DOF roomy enough for the jumper to stay in focus throughout his epic maneuver. This also ensured a shutter speed of 1/640 second in the bright sunlight. ISO 200. Lukasz Kazimierz Palka

From the precision of the framing in the sequence, it looks as if you used a tripod. In any case, the action was well-planned, with an effective framing and sufficient room in the sky to allow for waving arms. Was this a one-off, or did you shoot it a few times? *Michael Freeman*

Aperture & Shutter Speed: The Reciprocal Relationship

As we noted, the "whole" steps up or down in both aperture and shutter speed have a similar effect on the exposure. If you make a change in one direction by a full stop in either shutter speed or aperture, you can maintain exactly the same levels of light being recorded on the sensor if you make an equal but opposite change in the other setting. This reciprocal relationship, in fact, is the basis for all changes in exposure settings.

48

You control the focus

Here the photographer opted for a wide aperture to limit depth of field—an option that suits the subject by making her stand out in relief against a blurred background. Let's assume, for example, that you meter a scene and the camera tells you that the ideal exposure setting is 1/125 second at f/8. But what if you want to use a faster shutter speed of 1/500 second to stop fast action? That's an increase in shutter speed of two full stops. If you were to leave the aperture at the same f/8 setting, the image would be underexposed by two stops. But if you were to open the lens by two stops to f/4 (to allow in more light) you

Extending your depth of field

By choosing a small lens aperture and adjusting the shutter speed accordingly, the photographer was able to exploit almost infinite depth of field in showcasing the foreground of the Taj Mahal. would get the exact same exposure. (Look at the aperture sequence on pages 34-35 and you'll see that f/8 to f/5.6 to f/4 is two stops.)

This relationship works in the opposite direction too, naturally. If you were given a meter reading of 1/125 second at f/4, but wanted to shoot at an aperture setting three stops smaller (f/11), to get more depth of field, you could simply set that aperture and slow the shutter by three stops. The equivalent setting would be 1/15 second at f/11. Again, the full-stop sequence for slowing down shutter speeds would be: 1/125 to 1/60 to 1/30 to 1/15 second, or three stops.

This perfect reciprocal relationship lies at the heart of not just exposure, but photography in general. Metering a scene (as explained on page 52) is one thing, but recognizing the full range of possible ways to interpret your exposure, through shutter speed, aperture, and even ISO, cuts straight to the creative side of taking pictures.

Martin M303

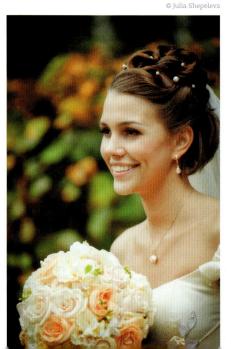

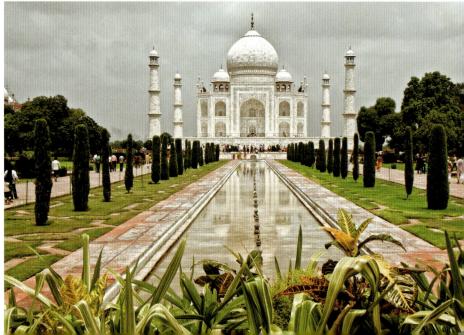

Beware the Consequences

As you make shifts in either the aperture or shutter speed settings you must remain aware that such changes can create significant visual changes. As you switch to a faster shutter speed and increase aperture size, for example, although the overall exposure may remain the same, you are changing the depth of field for the shot. If depth of field is an important consideration for the shot, this must be taken into account. If on the other hand you were to use a smaller aperture and had to slow the shutter speed to get an equivalent amount of light into the camera, you might have to take into account changes in how subject motion (if any) is recorded.

Last Resort: Change the ISO

What happens if you want to increase the shutter speed by, say, two full stops but don't want to open the lens because you want to maintain the same level of depth of field? The only solution in this case would be to raise the ISO setting by two stops. By raising the ISO two full stops (as an example: 200 to 400 to 800, or two stops) you could maintain the same aperture and still raise the shutter speed by two stops.

Cause and effect

As you scroll through various combinations of shutter speed and aperture you must remain aware that certain aspects of a scene will change with each pairing. In a scene like this seascape, either the depth of field or the motion of the water will be affected by exposure changes—or both.

© David M Schrader

49

50

EXPOSURE

Exposure Modes

All but the simplest digital cameras have enough exposure modes (and specialty exposure modes known as scene modes) to make your eyes spin. But once you have a good understanding of what each of the exposure controls does, it's much easier to sift through the various exposure modes on your camera and choose the one that is best for a particular situation. Each of the primary exposure modes is designed to solve a particular problem and, while you will eventually find yourself just relying on one or two for most of your picture-taking needs, it's a good idea to experiment with each of them early on and get to know their advantages. Here briefly are each of the modes and some of the reasons that you might use them:

Automatic

Also known as the "green mode" (because it's typically colored green on the exposure-mode dial) this is the all-encompassing fully automatic mode. The camera typically sets its own ISO (based on its interpretation of the ambient lighting situation) and also sets the shutter speed and aperture. This is fondly referred to as the "beginner" mode in some circles for obvious reasons: you don't need to know a thing to use it other than how to turn on the camera and press the shutter button. The flash will also typically turn itself on when the camera senses that the lighting level has dropped below what it deems acceptable. The nice part of this mode is that you can just concentrate on the viewfinder and ignore all technical decisions. But the obvious downside is that you've surrendered all creative control. For example, you have no control whatsoever over depth of field or subject motion. Usually white balance is often chosen for you, as well. The one override that you may have available to you even in this mode is exposure compensation (see page 75).

Program Automatic

The flexibility of this mode varies from one camera model to the next, but typically the camera still sets both aperture and shutter speed for you. The difference is that you can (often must) set the ISO yourself. The primary advantage in this mode is that, with most cameras, there is a command dial that lets you scroll through the various equivalent aperture and shutter speed combinations. If, for example, the camera sets an exposure of 1/125 second at f/8 and you know that you want more depth of field, you can scroll through the aperture settings to find a smaller aperture. You can also set the white balance manually when using this mode, and make exposure compensation adjustments as you see fit. Another subtle difference is that the flash won't pop up automatically and you will probably have to flip it on manually.

SETUP DE CON

↑ Exposure Mode Dial

Most digital cameras have an exposure-mode dial like this one, though some simpler cameras list modes as menu options. In both cases the icons are typically the same and enable you to quickly match your camera's exposure response to your subject.

Shutter Priority

This is the mode to choose when making creative decisions regarding subject motion is your primary concern, because here you select the shutter speed and the camera chooses the correct corresponding aperture setting. This is the mode favored by sports and action photographers because it enables them full control over how the camera is responding to and capturing subject motion-if the action is fast and needs to be frozen, a fast shutter speed is set; if the intent is to blur the subject as it is moving, longer shutter speeds can be explored until the optimum amount of blur is reached.

© Akalong Suitsuit

↑ All modes lead to Rome

Or, in this case, all modes may lead to a great night shot of the Rhine near Köln, Germany. Any of the main exposure modes could capture this shot, but you have to decide which works best for your vision.

One caution to keep in mind here is that as you select the shutter speed, you must keep an eye on the shifting depth of field (if that is a concern). If, for example, you select a very fast shutter speed of 1/2000 of a second, the camera will likely be forced to select a very wide aperture setting, and this means almost no depth of field. Conversely, if you select a very slow shutter speed—to blur the gate of a racehorse or the flow of a mountain stream, for instance-the camera will select a relatively small aperture which will potentially create a situation where too much of the scene is brought into focus. Check sharpness with your depth-of-field preview button regularly.

Aperture Priority

Often your primary concern in choosing exposure settings is controlling depth of field. In those situations the Aperture Priority mode is ideal because it lets you select the aperture setting while the camera selects the appropriate shutter speed. If you know, for instance, that you want to restrict depth of field in a head-and-shoulders portrait, you can select a very wide aperture and the camera will match it with the right shutter speed for a good exposure. Or, if you happen to be shooting a wide-open landscape and want to have sharpness from near to far, then select a small aperture and, again, the camera will choose the right shutter speed setting.

One thing to keep in mind when using this mode is that if subject motion is an issue, you must keep track of the shutter speed that the camera is selecting. You may have to raise the ISO, for example, if by selecting a small aperture the camera is setting too slow a shutter speed and your subject is creating more blur or motion than you desire. Also, keeping the camera on a tripod when using small apertures will negate any chances of camera shake during long exposures.

Manual Mode

The Manual exposure mode provides the most control, but the least assistance from the camera. In this exposure mode

you are responsible for setting both the aperture and the shutter speed. To use this mode you can use the camera's light meter (or a handheld meter) as a guide in selecting the exposure, but you are completely free to accept or ignore its recommendations as you see fit.

The Manual mode is very useful when you are fairly certain that the camera's meter is going to be misled by a complex or contrasty subject and you want to use your experience to override its settings. In photographing a scene that exceeds the sensor's known dynamic range (typically around 10 stops for a midrange camera), for example, the meter will provide an "average" reading of the scene. But in this case you may have to make a decision to abandon some shadow information to preserve highlights. Also, in all cases when you're using a handheld meter you will have to use the manual mode because otherwise the meter will ignore your settings and set exposure based on its own readings. There are also many extreme exposure situations-making extremely long exposures to capture star trails, for example—when the only way to set such exposure times is to use the Manual mode.

52

EXPOSURE

Histograms & Meters

In order for you to get the best results from your camera's light meter, of course, it's important that you understand exactly how it performs it's primary chore—and that you understand both its areas of expertise and its short comings. Knowing how your meter measures light and what

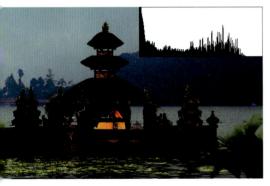

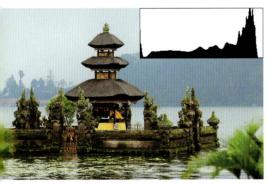

its limitations are will help you to manipulate and interpret its results and decide when it's time to intervene. And knowing what your sensor's limitations are in dealing with the existing light is vitally important. Knowing, for instance, that your camera's imaging sensor has a vastly more limited dynamic range (range of contrast) than your eyes and brain do is supremely important in interpreting the information provided by your meter.

Reading the Histogram

Perhaps the most valuable tool available to you as a digital photographer is the luminance histogram. This chart horizontally maps the tonal values of a scene from pure black at the far left to pure white at the far right—on a scale of o to 255. The vertical axis shows the number of pixels in each particular tone. As you know from our discussion on dynamic range, your camera sensor is limited in its ability to capture only a certain range of tonal values. These stops can be very bright (mostly highlights) or

KK← Finding the middle ground

The top image is overexposed, with hardly any detail in the sky and background. This is visible in the large amount of pixels bunched up against the far-right side of the histogram. Likewise, the middle image is underexposed, with most of its pixels slammed up against the far left. The bottom image is properly exposed in the sense that all of the pixels taper off before overexposing the highlights, and the few pixels cut off in the blacks are not too much of a worry. The majority of the data is safely captured between the extremes of the chart. very dark (mostly shadows), but what they can't be is very far apart. If your camera has live view, you can observe the histogram as it calculates the exposure of your scene in real-time on either the LCD or electronic viewfinder. But even if your digital camera doesn't offer this feature, you can almost always activate the histogram as you review an already captured shot in playback. Time permitting, you can then observe if your tonal values are optimally distributed, adjust your exposure settings, and reshoot as necessary.

So what is the optimal histogram? The most important goal is to prevent your histogram from bunching up too much at the far ends, which indicates that detail is being lost in pure white or pure black. Ideally, your histogram should start at the bottom left corner, rise into a mountain, peaking in the middle of the chart (the mid-tones), and gracefully taper off back down to the bottom right corner.

Of course, not all scenes will give you the opportunity to create an optimal histogram, regardless of how delicately you expose the shot—but the histogram will still be an essential tool in helping you combat such high-dynamic-range, high-contrast conditions. We will cover these particular methods in greater detail over the coming pages, but for the time being, the important thing is to understand how your histogram works, and how it reflects the way your camera sensor measures light, and captures and records that light as image data.

53

TTL Meters

All in-camera light meters fall into one broad common category: TTL-type meters. Standing for Through-The-Lens, TTL metering means that the light is being measured (by a separate metering sensor) after it has passed through the lens and typically is measured at (or close to) the imaging sensor. This system creates an extraordinarily accurate means of light measurement because the light is being measured after it has passed through the lens and any lens filters that you might be using. What the meter sees in terms of illumination is exactly what the sensor will be recording.

Conversely, in pre-TTL cameras if you used a lens filter you had to take the amount of light that was absorbed by the filter into consideration when calculating your exposure. This compensation, known as the filter factor has been rendered virtually obsolete by TTL metering. While calculating the filter factor wasn't difficult, measuring the light after it passes through a lens filter is exceedingly more accurate.

Also, since the light is being measured internally, the meter does not have to make adjustments for other types of lens accessories like close-up extension tubes or telephoto extenders. Even the light from your electronic flash is measured—and the flash output controlled—after the light has bounced off your subject and passed through the lens.

The real beauty of the TTL system, then, is that no matter what lens or filter accessory you employ, the metering sensor doesn't have to

compensate (or have to assist it) in any way. For both you and the camera the process becomes one of speed, elegance, and simplicity.

↑ Flash made simple

The high-speed flash necessary for capturing these water droplets requires delicate calculations—that fortunately occur in an instant thanks to automated TTL metering.

How Light Meters See the World

In preparing to meter any scene, it's important to acknowledge a very significant difference between the way that you see the world and the way that your meter sees it. While you're happily experiencing and photographing the world in all of its splendid Technicolor glory, what your meter is actually seeing—and attempting to record—is a visual story told in a palette of grays. Or more accurately, a world of one gray: a tone referred to in photography as 18-percent gray, or more commonly, middle gray.

Indeed, whether they are built into your camera or handheld (and we'll talk about handheld meters later in this chapter), all meters are programmed to see and record the world around them as that single shade of middle gray. And in the world of photographic tonal values, that gray lies precisely halfway between absolute black and pure white. (And incidentally, the reason that it is 18-percent gray and not 50-percent gray is because the math is based on an algorithmic scale, not a linear one.) While this may seem like a rather

limited point of view it is, in fact, the basis for all exposure measurement and it's a system that works with impressive precision and reliability. When you aim your camera at a red apple, for example, the meter sees a gray apple. When you meter from the blue sky, the meter sees a gray sky. And if you're photographing a summer

↑ Metering sensors are colorblind

Learning to see each color, and indeed batches of different colors, as shades of gray will help you understand and better use your camera.

landscape of yellows, greens, blues, and reds what your meter wants to do is average all of those different tonalities into one big canvas of middle gray.

→ Measuring brightness

This diagram shows how brightness measurements relate to f-stops, with middle gray at the center, and deviations into light and dark indicated by + or f-stops, respectively.

The reason that this system works so well is that whatever you aim your meter at, will be recorded as middle gray. If you are careful to meter a subject that happens to be middle gray then that subject will be exposed perfectly and all of the other tones will naturally fall into their proper place. Those tones that are lighter than middle gray will record lighter and those that are darker will record darker. A perfect system.

In the section on the zone system (see pages 86–87) we'll talk about how you can transpose any metered tone to any other tone that you like, but for now the important thing to remember is this: whatever you meter will be recorded as a middle gray and so if you meter a subject that is middle-toned, the entire scene will be correctly recorded. Again, this is not to say, however, that all of the tones can be recorded because some may lay outside of your sensor's ability to record them.

The key to setting a perfect exposure then is to find a subject that provides that ideal middle-toned value to meter.

A still-life scene

Daylight coming through a window, falling on a variety of colors each with differently reflective surfaces, with shadows bunched up at the top of the frame. In such a diverse scene, you can either directly tell your camera which tone to treat as middle gray, or have your camera average all those tones together in order to calculate an even exposure for both the shadows and the highlights.

In Search of Middle Gray

While it may seem an elusive task to find a reliable middle tone in any scene, it's actually much simpler than you might imagine. Most outdoor scenes, both natural and man-made, contain a number of nearly perfect middle tones for metering, including:

56

Clear Blue Sky

A dark blue sky on a sunny day makes setting exposure for landscapes very easy. Blue skies are particularly useful when the scene itself contains large areas of light or dark that might otherwise fool the meter. Metering the sky is also useful when you are photographing a landscape in very contrasty lighting, or when the scene is backlit by strong sunlight. But it does need to be a clear day with a distinctly rich, blue sky, clear of any haze or cloud cover that could skew your reading.

Light Green Foliage

Whenever you're photographing a scene that has a lot of green grass or light-green foliage, you can set a very accurate exposure by metering those green areas. Again, this can be particularly useful if you're photographing a landscape that contains tones that might fool your meter. If you're photographing a dark, rocky outcropping with green trees, just meter from the foliage and the rest of the tones will fall into place. If you find your scenes metered this way are coming out too light, use your exposure compensation feature (see page 75) to reduce the exposure by about 2/3of a stop.

Abundant green for an easy scene

One nice thing about photographing nature subjects is that you're often presented with plenty of green reflective surfaces off of which to meter an accurate, reliable middle gray.

↑ Catch the light

Regardless of which metering target you use to set your exposure, it is always important to make sure the area you are metering from is reflecting the prevailing light.

Gray or Red-Brick Buildings

Old, unpainted barns are ideal, naturally gray metering targets, as are the boards of an old wooden farm cart or a pile of weathered lumber. An old school house or the side of a red-brick store are likewise excellent—the key is to make sure they are reflecting the prevailing lighting conditions and not cast in shadow.

Dark Caucasian Skin

Different skin tones in fact appear remarkably similar to a metering system. Darker skin can often be metered directly, which can make portraits quite easy. Lighter caucasian skin tones typically need to have I to 1.5 stops added to the exposure in order to render a middle gray tone. Once you know the neutral gray value of your own skin, you can use it as a mobile metering subject that you'll always have with you.

Gray Card

One reliable method, if your shooting allows you to spend a little time preparing, is to carry with you a mid-toned gray card. These are available from good camera retailers, and are made so that they reflect exactly a mid-gray to the camera. It reflects 18% of the light reaching it, and the reason for this number is the non-linear response of the human eye.

Expose, then compose

For this scene, the camera was pointed down so the green grass occupied the full frame, then—keeping the shutter release half-way down—the scene was recomposed and shot.

Lock Selective Readings

In order to use any of these naturally occurring middle tones, of course, you will have to isolate them from the rest of the scene, either by using a selectivearea metering mode (see the next section), zooming in to fill the frame with just that subject, or simply by moving closer to it. Whenever you meter selectively, however, it's important that you lock that reading in before you recompose and shoot the final scene. If you don't, then the meter will simply override all of your hard work and set the reading it would have originally chosen. Virtually all digital cameras allow you to lock a meter

reading by keeping the shutter button half-pressed. As long as you continue to keep your finger on the trigger, the meter reading will remain fixed.

57

Because this feature typically also locks focus, however, it is only useful if the subject that you are metering and the one you are shooting are the same distance from the lens. That rarely being the case, you may have to switch your camera to the Manual Exposure mode (see page 51) and set the exposure directly. Some cameras have a separate exposure-lock feature that allows you to meter independent of the focusing system (see your manual to see if yours does).

Metering Modes

58

All digital cameras contain reflectedlight, TTL-type meters that utilize at least one of three different types of metering "modes" in order to calculate exposure either from the entire scene, or from some specific part of it. Compact cameras typically offer only one metering mode, while more advanced cameras (advanced zooms or DSLR cameras) may offer all three. The difference in how each mode operates is based largely on how much of the scene the meter is viewing. Switching from one metering mode to another is very simple-normally just the press of a button or the turn of a dial. It's worth trying out each mode so that when the need arises, you're comfortable with how to access it and how to use it.

Matrix Metering

Also known as multi-segment or evaluative metering (depending on your particular camera manufacturer), in this mode the camera looks at the entire scene and considers the lighting as it reflects from numerous specific areas throughout the frame. This is the default mode used in almost all digital cameras, from basic compact cameras to the most sophisticated DSLR models. It is far and away the most complex and sophisticated form of light metering and is exceedingly accurate in even the most complex situations.

In this mode the meter divides the frame into a set pattern or grid of areas that can range from a very basic half dozen or so segments to more than a thousand on some high-end DSLR cameras. Once you activate the meter

by partially depressing the shutter release, the camera analyzes the amount of light coming from each of those segments and then compares the pattern of illumination to a library of subjects that have been stored in the camera's onboard computer. On some cameras the meter may be comparing the scene to as many as 30,000 exposures that are stored in the camera's memory. In programming the data bank for these meters, the manufacturers include a vast array of both common and complex scene examples-landscapes, portraits, close-ups, etc.

Even exposure

Had only the sand been metered, the camera would likely have underexposed this beach scene. However, including the sky, sea, and particularly the green grass elements helped the onboard computer recognize the scene for what it was and properly expose for it.

By making this comparative analysis of the scene, the camera is able to make a fairly educated guess about exactly what the subject is that you're photographing—and which parts are likely to be most important. If the camera sees a tall, relatively dim vertical area that is surrounded by a bright field of illumination, for example, it may conclude that what you're photographing is another person standing on a bright sandy beach (or a snowy field). It then calculates an exposure that will moderate the brighter areas while providing adequate exposure for the face. It's quite an amazing exercise in high-intellect technology and it works stunningly well (when properly used).

In creating its exposure, the matrix meter will take many related bits of information into account (in addition to brightness levels), including the distance to the subject (based on focusing information provided by the lens—though this also varies from manufacturer to manufacturer), the direction and intensity of the light, the contrast, RGB values for each segment, and the color of the subject. The camera then goes through a complex routine based on a series of advanced algorithms to set the exposure—and it does all of this in fractions of a second.

→ Recognize when Matrix is appropriate

Never forget that your camera is still just a computer. It is up to you to use Matrix metering appropriately, and know which scenes for which it is best suited. For instance, this landscape shot, with blue sky, green mid- and foreground elements, and plenty of sunlight is perfectly suited for Matrix metering. Ultimately, the key to using Matrix metering is to become so familiar with the way it works in your particular camera that you can anticipate the lighting situations where it might have difficulty, or need compensation input from you.

🛛 Fotolia---EF-EL

59

Selective Metering Modes

Center-Weighted Metering

One of the downfalls of matrix metering (and to be honest, the downfalls are mild and relatively rare) is that the meter is always considering the entire frame. In most situations this is not only acceptable but quite useful since it takes all parts of a scene into consideration. There are situations, however, when the most important subject—the one that you want metered accurately—takes up only a small portion of the frame, and this is where center-weighted metering can be very useful. Though it still considers the illumination information from the entire frame, the center-weighted metering mode biases or "overloads" its readings to a small central portion of the frame. The center-weighted area is indicated by a circle in the viewfinder and typically the meter concentrates from 60 to 80 percent of its readings from that central area. If, for example, the frame is divided into a 70/30 split where 70-percent of the information that is being considered is within that central circle, then the rest is based on the other 30-percent of the frame.

Center-weighted metering is ideal for situations where a relatively small, important subject is surrounded by a excessively bright or dark background. If you are taking an informal portrait of a cross-country skier against a field of bright white snow, for instance, you can use this mode to meter directly from the skier and thereby reduce the meter's consideration of the surroundings. Similarly, if you are photographing a strongly backlit flower surrounded by bright foliage, you can read directly from the blossom and get a much more accurate exposure for the flower.

© Sylwia Schreck

↑ Don't worry about the edges

Center-weighted metering mode allowed the edges of the frame to be pushed into the highlights, in order to capture the full tones of the inner folds of these rose petals.

Skin versus snow

While it doesn't completely ignore the edges of the frame, center-weighted metering mode recognizes that whatever is in the center (in this case, the portrait subject) is what's important.

Spot Metering Mode

Spot metering takes the idea of centerweighted metering to the ultimate extreme and reads an even smaller area of the frame—usually an area that is between one and five percent of the viewfinder area. On most cameras this area is indicated at the center of the frame, but on some DSLR cameras it is a floating area and you can change its placement.

One significant difference between center-weighted and spot metering, however, is that in the spot-metering mode the camera is not taking any other portion of the viewfinder into consideration. Rather, the meter reads exclusively from the indicated spot area. Spot metering is particularly useful when the important subject takes up a very small part of the frame-but when you meter off such a small area, it's important that you've carefully chosen the optimal area to read. Remember that the reading is telling you what settings will reproduce that small area as a mid-tone.

One other benefit of spot metering is that you can use this mode to compare several (or many) very specific tonalities within a scene. This enables you to measure the true dynamic range of a scene by measuring both its brightest areas and its darkest. You can also use a spot reading to place a very small and specific subject at middle gray (and this is the basis of metering using the Zone System—see pages 86–87).

Again, with both center-weighted and spot metering modes, it's critical that you use your camera's exposure-lock function to hold that reading if you recompose the scene after metering.

↑ Spot-metered silhouettes

Silhouettes are a situation in which you don't want to meter off your subject at all. Here, the colored background was spot-metered, leaving the two figures completely underexposed.

Spotlit subjects

© Garret Bautista

Spot metering is excellent for dramatically capturing spotlit subjects, ensuring only the brightest area is properly exposed and letting the rest of the frame fall off into shadow. (POSURE

Limit Yourself to Spot Metering

Mont Saint-Michel

Many monuments and iconic buildings are lit in such a way that spot-metering off their surfaces creates an exposure that accentuates their specific structure while the rest of the frame is left more subdued. Handle this challenge well and you'll have given yourself a bit of knowledge and experience that will see you through some very tricky metering situations. As you know by now, your camera's spot meter is designed to read a very finite area of the frame often an area that's only a few degrees in angle of view. But isolating those few degrees can be the only way to precisely meter the important areas of a complex scene. By combining your ability to read such a small area with your knowledge that your meter wants to render that area as a neutral gray (Zone V if you're following the Zone System), you'll know exactly how to set exposure for the most important part of the scene. Whether the surroundings are overly bright, very dark or even intensely dappled with both, by metering just the key subject area you have taken control over setting the best possible exposure.

→ Quick fix for a backlight The strong backlighting in this portrait shot could easily have resulted in a massive overexposure. But by spot metering off the leaves held in the shadow of the front figure, an accurate metering was easily achieved.

Challenge Checklist

- → In a high-contrast scene, use your spot meter to isolate just the subject that you want to read. You must be exceedingly careful in aiming the lens as you meter, since a slight jiggle to the left or right will completely throw off the accuracy of your reading.
- → Put your camera in the Manual exposure mode so that you can recompose the scene after metering your subject. Alternately you can use the exposure lock feature, but on many cameras the exposure lock and focus lock are combined, so it will really depend on how you need to handle both exposure and focus.
- → To read the dynamic range of a scene, take spot readings of the brightest and darkest areas. The difference between those areas in full stops is your dynamic range.

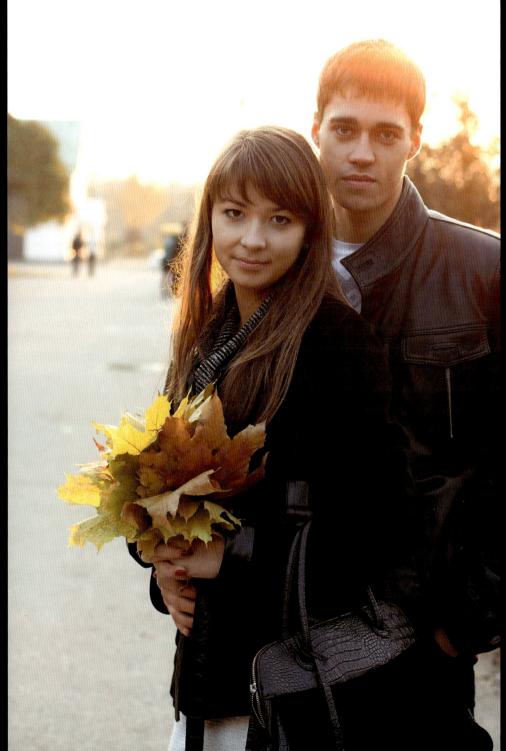

Church of Our Lady (Onze-Lieve-Vrouwekerk), Bruges. With a very dim foreground and very bright background, I spot-metered on the statue's face as my chosen point of interest, and let the backlight bloom around her. *f*/5 at 1/50 second, ISO 1600. *Nick Depree*

...And the result is very interesting! This is a good and slightly unusual use of spot metering in a highdynamic-range situation, and it works beautifully. The head, glowing and overblown around the edges, looks ethereal. Not the exposure that many people would have chosen, and all the more impressive for it. *Michael Freeman*

REVIEW

65

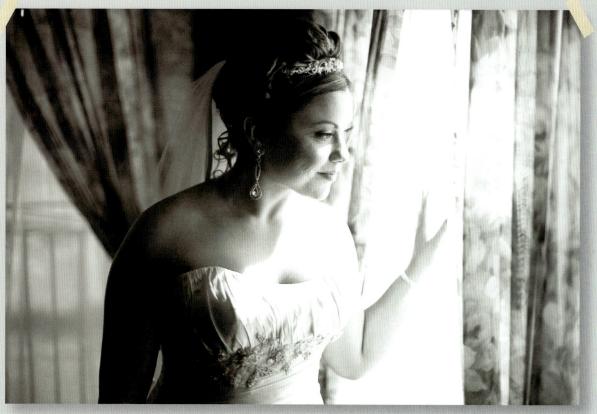

This shot would be very difficult to get without using spot metering. The bright, harsh light coming from the window would cause the camera to underexpose the rest of the shot to compensate. Spot metering was used in order to maintain proper exposure on the brides face while blowing out the light coming from the window. *Richard Gottardo*

Yes, an excellent case of your identifying the key tones on the face and making sure that they reproduced normally. The blownout window highlights simply add a glowing effect to the shot, as in the other picture opposite. *Michael Freeman*

Color Temperature

All light sources produce a unique color of light, and they are rated by their color temperature in degrees Kelvin (a system named after William Thomson, also known as Lord Kelvin (1824-1907)—though it's not likely that anyone will ever ask you). Color temperature numbers increase as the color of light goes from red to blue or from warm to cooler. Sunlight in the middle of the day, for instance, ranges from about 5000–5400K (depending on the latitude and exact hour) and is considerably more blue than tungsten lighting which is at about 3200K. Every light source that emits by burning (such as the sun or a tungsten filament) has a unique color temperature, though in most cases those temperatures vary to some degree—as lamps get older, or as the sun rises and sets, for example.

66

To the human eye, however, all ambient lighting—natural or artificial—seems acceptably white to us after a relatively short period of exposure to it. Whether you walk out into the golden light of morning or the bright much more blue light of noon, all light seems acceptably "white" to your brain. That is because the color receptors in your brain are constantly compensating and correcting for variations in the color temperature of light. And again, this happens so naturally and so quickly that we rarely take notice.

The same exact correction takes place when you walk from natural sunlight into an artificially lit room: The color of artificial incandescent lighting is much warmer in color than most daylight, for example, but once you're immersed in that lighting, you barely notice its warmth. We've all taken a walk in the blue light of twilight and noticed the reddish warmth of the artificial light spilling out from windows. Yet if you were to walk into any of those rooms, your eyes would immediately make an adjustment and in a matter of seconds you'd be seeing that light as a completely neutral color source. Your brain's ability to create a constant color of lighting helps you to walk through the world with a relatively constant sense of the neutrality of light (as false a reality as that may be).

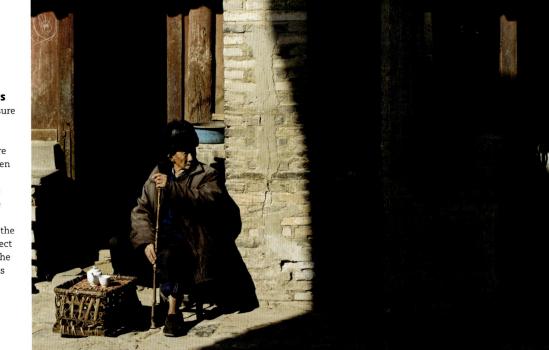

→ Balancing light sources

As if dealing with the exposure for high-contrast lighting conditions wasn't enough, in scenes such as this, where there is an even split between bright daylight and dark shadow, your white balance setting (as explained on the following pages) becomes extremely important. Here, the more significant daylit subject has been given bias, while the shadow area to the right has been forced to take on a slightly blue color cast.

↑ White-balanced white

In this all-white room, it is exceptionally important to take an accurate reading of the ambient color temperature. Fortunately, the illumination, while artificial, is nevertheless consistent.

Daylight versus tungsten

In order for the outdoor scene in the window to have its blues and greens rendered faithfully, the interior of this room had to take on a much warmer color cast—particularly near the light source at the upper right of the frame.

The practical scale of color temperature

For photography, the important light sources for which color temperature has to be calculated range from domestic tungsten to blue skylight. Precision is difficult, particularly

with daylight, because weather and sky conditions vary so much. There are also differences of opinion on what constitutes pure white sunlight.

К	Natural source	Artificial source
10,000	Blue sky	
7500	Shade under blue sky	
7000	Shade under partly cloudy sky	
6500	Daylight, deep shade	
6000	Overcast sky	Electronic flash
5200	Average noon daylight	Flash bulb
5000		
4500	Afternoon sunlight	Fluorescent "daylight"
4000		Fluorescent "warm light"
3500	Early morning/evening sunlight	Photofloods (3400K)
3000	Sunset	Photolamps/studio tungsten (3200K)
2500		Domestic tungsten
1930	Candlelight	

68

White Balance Control

Neons and fluorescents

Commercial spaces typically use an array of artificial light sources in order to create a dynamic aesthetic. While it may appeal to the naked eye, it can wreak havoc on your digital images. You will often have to experiment with a few different white balance settings, none of which can perfectly match all the different light sources; but perfection isn't always necessary, as the viewer often expects to see artificially vivid colors in such spaces.

Your camera's sensor, however, records the color temperature exactly as it is, without the compensation that our brains supply. All camera sensors have a default color balance (typically set at around 5500K to match daylight) and anything that varies from that will record with a clear and obvious color cast. The shifts aren't necessarily "wrong" and often they reflect the colors of the world in a very real way. The deep blue of a twilight sky, for example, records more blue because it is, in fact, bluer. Unless you tell the camera to make a correction back to "white" light, it will record the light exactly as it exists.

In the film days, you had to buy a film that matched the color temperature of your primary light source. If you were using daylight as the main source, for example, you simply bought daylightbalanced film. If you were using tungsten, however, you bought tungsten-balanced film. And if you were using an off-beat light—like fluorescent lamps—you would have to filter the lens to match the film you were using.

Digital cameras, on the other hand, have a built-in white-balance control that lets you assign a color temperature so that you can either "correct" the ambient lighting or exaggerate its color. The white balance, in effect, enables you to tell the camera exactly what type of lighting that you are using daylight, tungsten, fluorescent, etc. Most DSLR cameras even have a further refinement that lets you tweak the color temperature of a given source (setting 3150K instead of 3200K for tungsten, for instance).

The white balance control is a terrific tool when you want to eliminate the color cast of a particular light source. If you're shooting in a nightclub, for example, and the lights have a very red bias, you can simply adjust the white balance back toward either a slightly less-red coloration or a completely neutral look. (1) Automatic white balance adjusts the color response of the camera continuously and automatically without any help from you. As you change from one light source to another, the camera responds instantly. Typically the auto response will operate in a range of (roughly) 3500–8000K, but see your camera manual for the specific range.

(2) Source-specific white balance presets let you dictate exactly how you want the camera to respond by telling it the type of existing light. These vary from camera to camera, but the most common presets include daylight, shade, flash, tungsten, and fluorescent.

(3) Manual or Custom WB mode is the most precise means of setting white balance, because in this mode you take a test shot under certain lighting conditions and then set that temperature manually. The specific steps for creating such settings varies by camera, but the general idea is constant: First you take a clean, white surface and photograph it in the same exact lighting conditions as your subject—taking care not to have any shadows in the shot, and making the white target fill up the full frame; then, you instruct your camera to use that shot as the custom WB setting. Then, for all subsequent shots, the camera will use precisely the white balance setting that rendered your target subject pure white. With some cameras, you can save multiple custom white balances, and rapidly switch between them as you move from one light source to the next.

© U.P.images

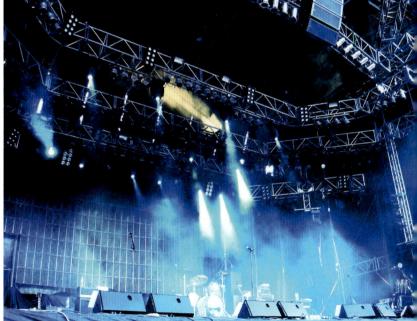

Street shooting

Auto white balance can be a huge aid when you are out shooting in rapidly changing, dynamic situations. Between calculating accurate exposures, arranging careful compositions, and looking for decent subjects, you have plenty to worry about besides fixing color casts. Just make sure it's getting it in the ballpark.

↑ Stage lighting

Elaborate stage lighting setups often require either a custom white balance to get accurate whites, or a more lax attitude toward accurate whites in general, and using the color casts for creative effect.

69

Set a Creative White Balance

Don't fight it

Since sodium vapor is almost impossible to white balance for anyway, indulging in its rich, golden yellow color cast can give roadways and street scenes a supernatural effect. White balance is an amazing tool that lets you step into any lighting situation and then balance the sensor's color response to that specific light source. But this control can also be used as a creative weapon to intentionally mislead the sensor about the color of the ambient lighting. Because the "cloudy day" setting adds warmth, you can also use it in the neutral light of a midday sun to add a feeling of warmth—to a portrait, perhaps. By telling the camera that you're shooting in tungsten light when, in fact, you're shooting in clear sunlight, it will supply extra blue color to the mix. This combination produces a day-for-night Hollywood effect and it's one of the ways that you might respond to this challenge. Think about the color of the light source and how adding light of a different color (or more of the same color) might affect the outcome. What creative visions do you see?

С

→ Feeling blue

While white balancing off the snow or ice would have given an accurate coloring, the result wouldn't have had the same chilling effect that this blue color cast gives, which was achieved with a tungsten WB setting.

Challenge Checklist

- → If you want to experiment with the full spectrum of white-balance options, just shoot in Raw and you can adjust the white balance during editing.
- → Use a little reverse psychology when intentionally setting a creative white balance: You know that the tungsten setting will add more blue to cool off tungsten lamps, but what would happen if you went the opposite direction and added even more warmth?
- → One of the goals of a correct white-balance setting is to render white subjects as close to a pure, un-tinted neutral tone as possible, but don't be restricted here by correctness. If a white church comes out as blue in your twilight effect, so be it.
- → If your camera has the capability, experiment with adjusting the color balance using the color picker found in the white balance menu.

ARBUCKS CO

© Lukasz Kazimierz Palka

Here, I set the white balance to fluorescent and cranked the fine adjustment to Maximum Cool to match the girl's demeanor. It also plays beautifully with Tokyo's night lighting, which is a mix of fluorescent and incandescent lamps. f/2 at 1/200 second, ISO 3200. Lukasz Kazimierz Palka

Central Tokyo night-life districts like Shibuya and Roppongi are the quintessential "city-lights" settings, and you made a good choice for exaggerating the color. In particular, by pushing the color in the darker foreground area you give it a visual prominence that it might otherwise have lost to the coffee shop behind. Michael Freeman

EXPOSURE

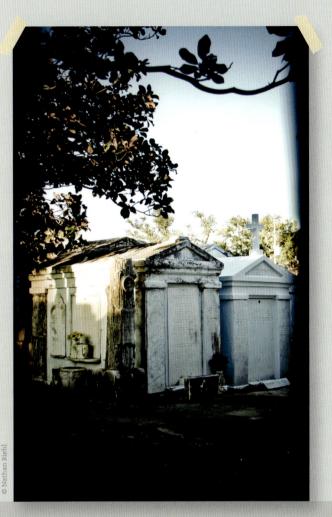

To evoke a more somber mood fit for this New Orleans cemetery, the white balance was pushed toward a cooler low color temperature. *f*/4.2 at 1/125 second, ISO 100. *Nathan Biehl*

This is effective for an atmospheric old southern cemetery, giving just the right amount of unexpected color without seeming exaggerated. The out-of-focus edge at right bothers me, though—not that it's out of focus so much as it's so close to the frame edge. I would crop that and then the bottom to preserve the aspect ratio. *Michael Freeman*

73

Handling Extreme Contrast

74

As we discussed earlier, your eyes are able to see and manage a far broader dynamic range than can your digital camera's sensor. Given just a few seconds to adjust, your eyes are able to see and resolve great detail in both the darkest shadows and brightest highlights—a range that approaches the equivalent of nearly 24 stops of light. And because when you view a scene, your eyes are continuously shifting from one portion of a scene to another, your brain is able to process that range of contrast almost instantly. Pity your poor sensor, however, limited to a finite range of tonalities—and a range, quite honestly, that's often not adequate to the task at hand.

In fact, with the exception of very low-contrast situations (a foggy or overcast day, for example), most daylight situations in full sun are already pushing the limits of what your camera can handle. And once you get beyond those limits, important decisions have to be made about what is to be safely preserved and what must be jettisoned beyond the far edges of your histogram. Knowing how to make those sacrifices, what tools are available to deal with extreme circumstances. and which choices work best photographically will help keep you from throwing the baby out with

Consider what's important

If the purpose of this photograph had been to accurately represent the full textural detail of each of these dark chairs, it would be a failure. But instead, the purpose was to create a graphic image of strong contrasts, and so the shadows in the seats were allowed to fall into pure black.

the bathwater, or, in this case, losing important subject detail for the sake of exposure. Fortunately, there are ways to not only record your subject accurately, but also to take creative advantage of the challenges at hand.

Contrast Control: Tools & Techniques

As you venture into the world of more complex exposure challenges it's important to know that there are a number of tools and techniques that you can use to help you solve the contrast riddle. Some of these solutions are camera-based (exposure compensation, for instance) while others rely on accessories and light modifiers. Not every tool works in every situation, of course, so it pays to experiment and be familiar with each of them.

Exposure Compensation

Very often the solution to an exposure problem is by adding or subtracting exposure from the metered exposure setting. The simplest way to do this is by using your camera's exposure compensation feature. This feature lets you add or subtract exposure regardless of what exposure mode you're using or what metering mode is measuring the light. Typically, you can add or subtract exposure by anywhere from three to five stops in one-third stop increments.

Exposure compensation is often used in conjunction with specific types of selective metering such as Center-Weighted or Spot metering (see pages 60–61). By carefully measuring specific areas of a scene and then using exposure compensation to adjust the overall exposure, you can manipulate the tonal values of specific areas within a scene to suit your needs.

Keep in mind, however, that exposure compensation can't magically add or subtract exposure without affecting one of your exposure controls. In Aperture Priority mode, exposure compensation will adjust the shutter speed; and in Shutter Priority mode, it will adjust the aperture. This has two important consequences: one, you need to consider the affect a change in one or the other exposure control will have

$\downarrow \rightarrow$ A simple fix

The abundance of direct sunlight made the original photo, on the right, underexposed. A simple exposure compensation of +1.5EV brightened up the umbrella and livened up the shot.

on your shot, in terms of either depth of field or how motion is captured; and two, there is no such thing as exposure compensation when you are in Manual exposure mode, as you are controlling every aspect of the exposure. If you want to brighten or darken a scene, you have to directly do so by changing the shutter speed or aperture (or ISO).

75

Adjust with Exposure Compensation

Edinburgh Castle

The camera wanted to expose this shot so the castle was bright and evenly lit, but the original impression was much darker and moodier, which was mimicked by a negative exposure compensation. Easily one of the handiest controls built into your camera is the exposure compensation control. Using this control saves many tedious moments of having to meter a scene in the Manual exposure mode and then pulling the camera away from your face to reset the controls. Exposure compensation shines most when you combine it with your knowledge and experience in setting exposure for difficult but common subjects. For this challenge, you will need to find a subject that would typically fool the status quo of the meter. If you're photographing snowscape scenes, for example, use the compensation control to see just how much extra exposure is needed to record the snow as a clean white with texture and detail. Getting to know how much compensation is purely a matter of trial and error—so here's your chance to build your experience.

→ Making the whites white

The abundance of light tones in this sunset beach shot pulled the camera's metering system into underexposing, in an attempt to render the white sands a neutral gray. A stop of positive exposure compensation was all that was required to push the tones back into the highlights.

Challenge Checklist

- → Your metadata will record how much compensation you used for each shot, so no need to keep notes. But do compare various amounts of compensation to your results and take note of those comparisons.
- → Remember, to record dark subjects at their true tonality you must subtract exposure from the metered reading; conversely to bring subjects to their natural light tonality, add exposure. Your meter sees the world as gray, and that is your starting point.
- → Don't forget to zero out your compensation when you're done, otherwise you'll surely forget and start your next day's shooting with the compensation set to add or subtract light.

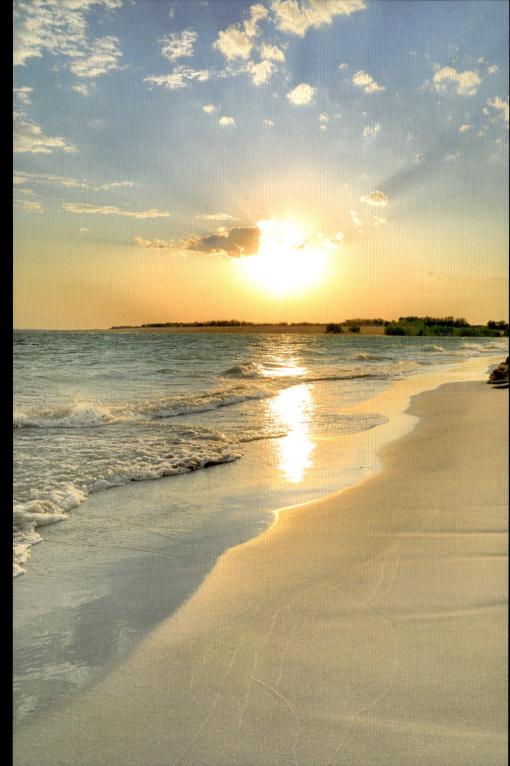

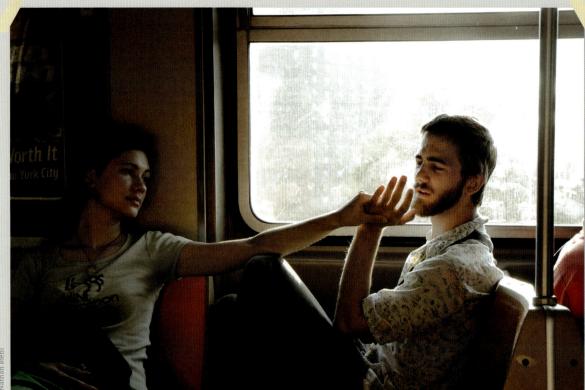

To compensate for the direct sun through the train's window, I set the exposure compensation to +2.7EV to reveal the couple's features. f/4.2 at 125 second, ISO 200. Nathan Biehl

That's certainly the right choice of compensation-holding his face while not losing too much of her face in the shadow. You don't say what prompted you to that exact figure of +2.7. Was that experience, an informed guess, or did you try different amounts of compensation in other frames? Michael Freeman

79

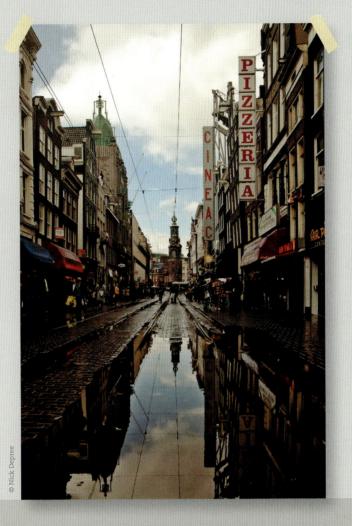

Regulierbreestraat, Amsterdam. With a bright sky, dark buildings, and reflective foreground in the rain puddles, I checked the LCD and made an adjustment of -1.3EV to retain detail in the highlights, particularly in the sky. *f*/8 at 1/1600 second, ISO 800. *Nick Depree*

I can see you had time to work this out, so you took the opportunity, and rightly identified the brighter areas of the clouds as being important to hold back from clipping. Reflections are typically at least a stop darker, so no issue there. Michael Freeman EXPOSURE

High Dynamic Range Imaging

80

One of the more innovative approaches to solving the extreme contrast riddle has been the ascent of an extremely popular technique called High Dynamic Range Imaging (HDRI). HDRI is simply a process whereby the entire dynamic range, however high, is captured in a sequence of different exposures, and then all of them are combined into a single image file. So far, so good, but this combined image file (saved in a special format such as RGBE or OpenEXR) can still not be viewed on a normal computer or television screen. It needs a second stage of being converted back to a viewable image by a process known as tonemapping, in which you decide where exactly to distribute the full tonal data that you've collected throughout the limited dynamic range capacity of a given viewing platform (i.e., a paper print or a digital display).

The simplest way to capture the requisite exposures is to set your camera to its Autoexposure Bracketing mode, in which the camera will take a series of shots (i.e., a bracket) with only one being at the proper exposure (as determined by the metering system), and the others covering some predetermined range of over- and underexposure. You can usually set precisely the range covered by your bracket in your camera. Typically, a three-shot +/-3EV bracket is sufficientthis means that the first exposure will be properly metered, the second will be overexposed by +3EV, and the third will be underexposed by -3EV. The effect is that you have now expanded your dynamic range by six stops: 3 in the highlights, and 3 in the shadows. Depending on your camera's abilityand the amount of processing power available in your computer-you can

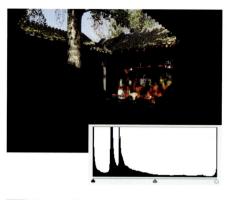

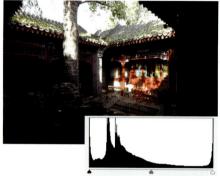

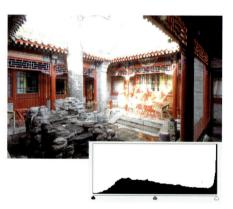

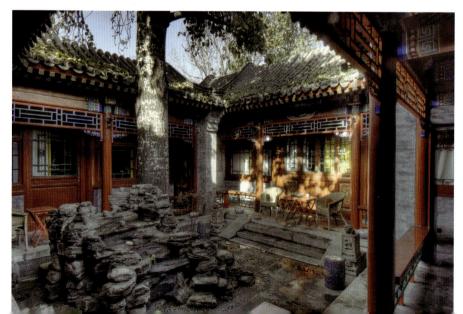

←↑ Three-exposure bracket

This courtyard of an old hutong dwelling in Beijing presents a classic high-dynamic range situation: Bright midday sun is streaming in through the open area at the top of the frame, casting deep, black shadows along the left half and far right of the frame. As the intent of the photograph is to accurately represent this architectural space, a dramatic interpretation is inappropriate; so the best exposure option was to bracket three exposures—one for the highlights, one for the mid-tones, and one for the shadows—which were then combined into a single image in Photoshop. shoot extremely wide brackets of, say, a seven shots at +/- 3EV, but this is almost always going to be overkill. Usually, expanding your camera sensor's native dynamic range two or three stops in either direction is sufficient, and the resulting files will be much easier to process.

HDR Processing

There is no shortage of post-production software options available for combining your bracketed exposures into a single HDR image, from dedicated programs like Photomatix (www.hdrsoft.com) to built-in tools and plugins available in Adobe Photoshop or Lightroom. Regardless of the software used, the basic process is quite straightforward, and is fundamentally a matter of deciding where to put what information from which exposure in the final image. For instance, in Photoshop you are given three basic options: Equalize Histogram, which globally spreads out all the exposure information gathered across the full frame; Highlight Compression, which attempts to restore blown-out highlights of one exposure with detail from another; or Local Adaptation, which gives you the most control and allows you to construct a custom tone curve to most accurately spread out your exposure information across various areas of the frame

If you begin to explore HDR imaging in full, you will soon realize that the abundance of information captured across multiple images can be combined in many more ways than one, and that given such a wealth of exposure options, your rendition of your final image quickly becomes a

matter of personal, creative interpretation. It becomes very easy to push what was a normal scene far into the bounds of heavily processed, surrealistic artistry. However, it's strongly recommended that you begin by performing the most photorealistic processing that you can. For one, that is much closer to the purpose of this book (i.e., using HDRI as an exposure tool, first and foremost); and second, because it is all too easy to get carried away with surrealistic interpretations, it's best to establish a firm foundation before moving on to higher levels of experimentation.

↑ Improvised ND filter

This sunset scene required heavy underexposure to capture the rich tones of the sky in the upper half of the frame, but need a boost to the exposure in order to get any detail in the foreground marshes. An ND filter would have been ideal, but—as you've no doubt discovered—you won't always have the perfect gear on-hand for every shot. In such a case, a manual, two-exposure bracket was the practical choice: one for the sky, one for the marshes.

EXPOS

Combat the Contrast with HDR

+ Balancing land and sky

The severe underexposure required to capture the rich, saturated tones in the sky meant the foreground dock would have to be almost pure black. So a simple HDR combination of one shot exposed for the sky, and one shot exposed for the foreground, meant all the tones could fit into a single, final image. Although the sensor in your digital camera has a finite dynamic range, that only means it can only record a certain tonal range in one frame. And that is the secret to this challenge: You will make separate exposures for two or more distinct tonal regions of your scene and then combine them into one HDR image in editing. The final photo will contain a tonal range that greatly exceeds the limitations set by your camera. So for this challenge, rather than turn away from extreme contrast, you'll want to seek it out—and the wider the contrast range, the better. You must then use your editing skills to combine the images using your normal editing program, or a dedicated software like Photomatix. But either way, your goal is the same: Tame the contrast by expanding the dynamic range of your images.

Not d grapme take shot demonstrates a s use of HDR, in which hot is exposed for the le and pillars, with a d capturing detail in aphic pattern along the ed roof at the upper-left frame.

Challenge Checklist

You'll definitely need your ripod for this challenge because the multiple rames must fall into berfect register.

Due fast way to fire off several shots at various exposures is to use your uutoexposure bracketing eature. Just be sure that he primary exposure is set correctly for the nid-tones, and then oracket widely enough o capture images of both the shadow and highlight areas.

f your camera has a built-in HDR mode, ry it. But try to create he multiple exposure nanually too, and then ompare the results.

To capture the sun as well as the shadows in the fog and buildings, three images were captured: one 2 stops underexposed for the highlights, one normal exposure for the mid-tones, and one 2 stops overexposed for the shadows. These pictures were then merged together to form one HDR image. *Richard Gottardo*

I have to say I really like this, and I'm no fan of steroidal HDRI. The shadows on the high fog layer are what makes it special, and so yes, some HDR techniques were essential. What I would like to know is how you approached the tonemapping—local or global, and what settings? *Michael Freeman*

85

Atomium, Brussels. HDR worked well for this shot to expand the detail reflected in the steel spheres, giving a nice metallic look and strong sky behind. *Nick Depree*

Yes, it pulled out the reflected detail well, and yet still retains a natural, photorealistic look. Again, I'm curious about how you achieved this effect, in terms of your tonemapping workflow. *Michael Freeman* EXPOSURE

The Zone System in a Digital World

86

One of the pioneers of creative exposure was the American landscape master Ansel Adams. In addition to redefining nature photography through his powerful wilderness compositions, Adams, perhaps more than any photographer before him, elevated the principles of exposure to a high skill. It was his articulate writings on the topic of vision, exposure, and their interrelationships that have now given generations of photographers a thorough understanding of the power of exposure.

In 1939–40, Adams and fellow photographer Fred Archer created an exposure method called the Zone System—a system that provided a means by which one could use the tools of exposure to predictably translate their personal vision to the final print. As even Adams explains, however, it wasn't so much an invention as a "codification of the principles of sensitometry." Adams also coined the term "visualization" (often misquoted as "pre-visualization") to describe this process of translating one's vision to the final print. Finally, Adams used the Zone system in conjunction with under- and overprocessing, which with film and when combined with the appropriate amount of over- and underexposure, respectively, altered the contrast of the negative. The digital equivalent is much simpler—i.e., at its most basic, altering the tone curve.

Though originally developed for use as an aid in exposing and printing black-and-white negative films, the core aspects can be adapted very well to digital photography. And though many books have been written on the Zone System and some have made it

appear hopelessly complex, it isn't. In fact, understanding and applying the basic premise can make getting a good exposure—even with your digital camera-a very simple process. Moreover, it creates a reliable and fast method for placing tones exactly where you want them in your photos. The fundamental concept of the Zone System is that the world around us could be divided into 10 distinct tonal values (though there are a couple of variations of the system that use either 9 or 11 values). The values range from zone "o" which is pure black with no detail to zone "IX" which is pure white with no texture at all. The middle tone in this system is Zone V and it represents a midway point that is exactly halfway between pure black and pure white. As we discussed briefly earlier, this middle zone is what photographers refer to as "middle gray."

© Dmitry DG

© Florelena

© Kaowenhua

Zones III, V, and VII

Digital photography saves you a lot of time concerning yourself with all 10 distinct tonal regions and their associated definitions. In fact, once you understand the principles of the zone system, you can concentrate mostly on just these three zones. They are significant in that each maintains texture and detail, and that Zones VII and III (far left and far right) will always fall on either side of your metered target (Zone V-the leaves in the center).

Here is the interesting aspect of the 10 distinct tonal representations on the Zone System scale: Each zone in the scale represents a tone that is either half as bright or half as dark as the one adjacent to it (depending on which direction you're moving). As you should remember from our discussion of basic exposure controls, each time that you move from one exposure stop to the next, you either halve or double the amount of light getting to your sensor. And as you have probably guessed (and correctly so), each time that you change exposure by one stop (again, either aperture or shutter speed) you shift every value on the Zone System scale to the next value. In other words, every zone on the scale is exactly one stop away from the one next to it. By shifting exposure, you can shift exactly where specific tones land in that 10-stop tonal range. If, for example, you meter a subject of a particular value (let's just say a red apple), you are placing it on Zone V. But if you open the lens by one stop (or slow the shutter by one stop) the apple would be placed one tonal step lighter. Instead of being placed on Zone V, it will now be shifted to Zone VI. The reverse is also true: Close the lens by one stop (or make the shutter speed one stop faster) and the apple is now placed on Zone IV—exactly one stop darker. You can see the power this gives you over the tonal placement of any subject—and it is an exacting science.

The beauty of this system is that you know that whatever you meter is going to land on Zone V. To make it darker, all you have to do is underexpose from that meter reading. To make it lighter, increase exposure. It doesn't matter whether you adjust shutter speed or aperture, but for each stop that you alter the exposure, you shift every tone either up or down the tonal scale. Your creative decision is on the initial placement of your mid-tone; then all the other tones fall into their respective zones. That's the Zone System workflow: Place, then fall. Combine judicious mid-tone placement with a full understanding of where the rest of the tones will fall as a result, and you'll master the Zone System in no time.

87

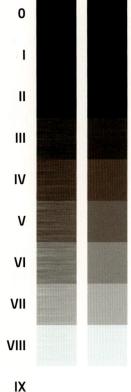

The Zones

An alternative version of the Zone System has 11 zones instead of the 10 shown here, and yet another has 9. Note that we show two versions of the scale here, one of solid tones, the other with an added texture. One school of thought holds that textured zones are closer to the reality of a scene, and so easier to judge.

ZONE 0	Solid, maximum black. 0,0,0 in RGB. No detail. In digital photography, the black point goes here.
ZONE I	Almost black, as in deep shadows. No discernible texture. In digital photography, almost solid black.
ZONE II	First hint of texture in a shadow. Mysterious, only just visible. In digital photography, the point at which detail begins to be distinguished from noise.
ZONE III	Textured shadow. A key zone in many scenes and images. Texture and detail are clearly seen, such as the folds and weave of a dark fabric.
ZONE IV	Typical shadow value, as in dark foliage, buildings, landscapes.
ZONE V	Mid-tone. The pivotal value. Average, mid-gray, an 18% gray card. Dark skin, light foliage.
ZONE VI	Average Caucasian skin, concrete in overcast light, shadows on snow in sunlit scenes.
ZONE VII	Textured brights. Pale skin, light-toned and brightly lit concrete. Yellows, pinks, and other obviously light colors. In digital photography, the point at which detail can just be seen in highlights.
ZONE VIII	The last hint of texture, bright white. In digital photography, the brightest acceptable highlight.
ZONE IX	Solid white, 255,255,255 in RGB. Acceptable for specular highlights only. In digital photography, the white point goes here.

Low-Key Images

88

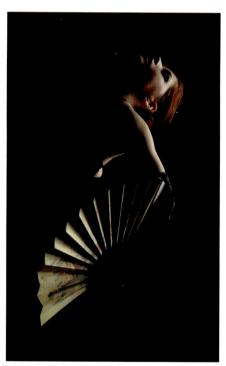

Playing off the shadows

In this shot, there is just a faint trace of highlights along the model's upper arm and cheekbone. The colors all fall in the mid-tones or darker, and as they contrast against the pure black background and shadows they appear richer and bolder without actually undergoing any saturation boost.

> St. John's Chapel, Tower of London

Here, the deep shadows on this Norman chapel are allowed to contrast with the flaring sunlight through the window, in order to reproduce the actual sensation of this medieval architecture. Recovering the shadows, or filling them in with lighting, would have been out of character. In most situations, the choices that you make in either accepting or altering the exposure settings your meter indicates are decisions made to place the tonalities of specific subjects where most viewers would feel that they normally belong. You're simply tweaking the exposure to correct for "Zone V" metering—adding exposure to keep white subjects white, for instance, or reducing exposure to keep dark subjects dark. But there are times when diverging more aggressively from a middle-of-the-road exposure creates some very dramatic images. Typically, such extreme variations—either toward under- or overexposure—are made to enhance a specific type of subject or to exaggerate an emotional climate. There is, of course, always the choice that if you get too extreme in your variations that people will view your exposures as mistakes rather than creative choices, but it's only by experimenting that you can find the parameters of your own creativity.

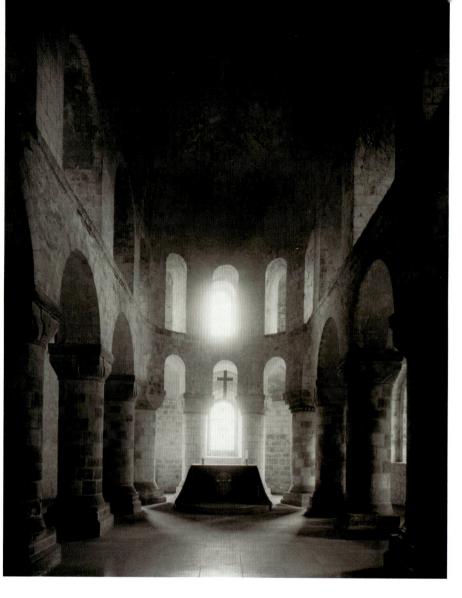

Any time that a photograph is dominated by primarily darker tones and has a limited number of light or middle-toned areas, it's referred to as a low-key image. Low-key images can (and usually do) have highlights and, in fact, often need the contrast of limited brighter tones to establish contrast and better exhibit the richness of the darker regions. The overall tonal range, however, tends to be quite dark and very subdued—a portrait set against a dark shadow background or a still life made up of deep, rich colors.

Low-key photos tend to elicit a more brooding or melancholy emotional response because of their inherent darkness, and are often seen as mysterious or intriguing. Our eyes are curious about and tend to linger longer in dark-toned images because our brains are searching for clues about the missing brighter areas. Again, low-key lighting is a staple in Hollywood whenever a brooding or ominous mood is desired.

Extreme Underexposure

Imagine that you're photographing an approaching thunderstorm. Recording the tones as they appear may be enough to show that what you're photographing is a storm-laden sky. You can, however, greatly exaggerate that mood and intensify the drama of the moment if you intentionally underexpose the scene by two or three stops. By doing so, you will significantly reduce the scene to one of gray, almost black skies, and large areas of deep shadow. The entire image—including all but the brightest highlights—will shift into a palette of deep grays.

Engaging product shots

Though it might seem counterintuitive to hide the main subject in a product shot, it is an effective technique for pulling in the viewer's attention—one well-used by art directors.

Storms above the Isle of Skye

There isn't a single highlight in this stormscape, though the clouds, waterfall, and midground elements appear brighter by comparison. Limiting the palette to the left side of the histogram, elicits tension from the view. The trick to recording very low-key scenes, however, is to not go so dark that you can't resolve a certain amount of minimal shadow detail during editing. If details in storms clouds are lost, it's probably of no concern, but if foreground details are reduced to pure black then you've lost all sense of texture and detail, and your image will lack a sense of place and context.

89

Such deep underexposure can also be used to subdue more colorful subjects, as well, in order to draw out the richness of the colors and also use darkened shadows to enhance surface textures. In photographing a street produce market, for instance, a "normal" exposure will record a colorful and cheerful scene. But by reducing the exposure several stops, shadows begin to dominate, people fall into dark shapes and the colored produce seem to be oddly abstract shapes. By making an extreme shift in exposure you've completely altered the mood of the moment—which is entirely your creative right as a photographer.

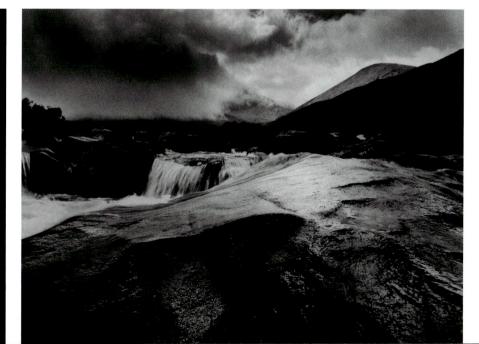

Shoot the Shadows with a Low-Key Shot

Contrast is key

It's ironic how often a low-key shot is composed around a light source, but a shadow isn't a shadow without a contrasting area of light. Dark and dreary, dank and gloomy, that's one way to think of a low-key shot. These images, built from the heavy building blocks of subjects lost in the shadow world are striking because of their heavy bias toward seemingly murky tonal combinations. But low-key scenes can also have a dramatic regal flair—a palette and lighting style through which Rembrandt brought illumination to his vision. In completing this challenge you will no doubt discover that even the darker side of the tonal scale has its emotional light. Finding fodder for such ideas is not easy, it takes an ability to look on the darker side of the road. You have to see strength and emotion in places that are not screaming for your attention. But once you learn to design from the mid-tones down and embrace the shadow world, you'll find much visual magic hidden in those secret lairs.

90

Just It a mystery
ple more stops of
sure and it would have
possible to see into the
vays and windows, but
tg them pure black has
ch more engaging and
erious effect.

Challenge Checklist

.ow-key images are not entirely without nighlights. Often a sliver of highlight draws greater attention to the dark Dalance of such scenes. ndeed, even a white rose can be photographed using a low-key recipe Dy grossly underexposing t's natural brightness.

f you're shooting a portrait indoors, use a sheet of black seamless paper as your background and you're halfway home. Dress your subject in leep tones and you'll 'urther enhance the ow-key effect.

Jnderexposing andscapes on an already gloomy weather lay is a great way to exaggerate the mood of such scenes. A quick shortcut: Take a reading from a mid-tone and then use two or more stops of hegative compensation.

Do a Google image search on "low-key images" and see what others have done with the concept; t's a good starting place or your own ideas.

One World Trade Centre, New York City. This low-key shot on a misty day reveals the shape of the building behind the fog layer, giving an atmospheric view of a building project charged with emotion for many people. f/5.6 at 1/1250, ISO 400. Nick Depree

The suggestion of cranes and equipment at the top of the building seems just right to me—the eye is drawn there to find out what exactly is going on. Lighter than this would have been a bit too obvious, and darker would not draw the attention upward. *Michael Freeman*

EXPOSURE

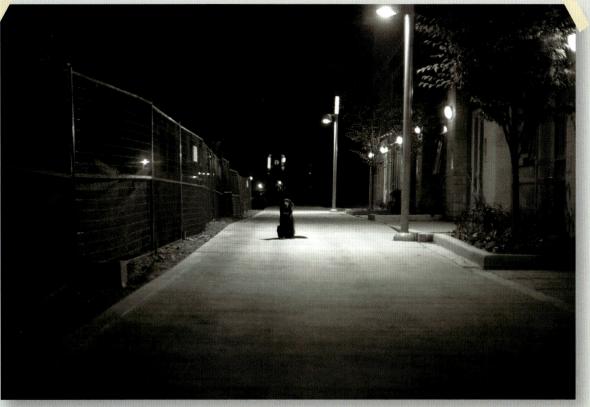

For this shot I want to emphasize the lonely feeling of the dog sitting alone. This was achieved by placing him underneath a street lamp in order to get some light on the dog while retaining the shadows throughout the rest of the frame. *Richard Gottardo*

Definitely a worthwhile idea, although for me the effect is weakened somewhat by the placement of the dog (I assume he obeyed instructions). If he had been a couple of feet closer and to camera right (closer to the streetlamp), his head would not have been as lost in the background shadows as it is. *Michael Freeman* EXPOSURE

High-Key Images

94

A high-key image is one where the overwhelming balance of tones range between lighter mid-tones and the very whitest highlights. In exposing for high-key scenes, it's fine to let some of the brightest images wash-out completely, as this tends to enhance the airy and romantic look of the pictures. Again, it's not a fault to have a certain number of mid-tone or darker areas, but high-key images do work better when their contrast is moderate and dark tones are kept to a minimum. High-key images definitely tend to have a cheerful, upbeat quality to them. The technique is particularly well suited to portraits, both formal and informal, because it gives them a gentle, dream-like quality.

High-key high fashion

There are two immediate side effects to this portrait's use of high-key lighting: the skin is so blown out that it needs no retouching in order to appear smooth; and the reds of the lips and fingernails are accented and emboldened.

↑ Cheery interiors

When photographing interior spaces particularly domestic ones—it is often desirable to represent them positively, with a feeling of cleanness and comfort. Letting an abundance of light spill through the rooms achieves this.

Extreme Overexposure and High-Key Imaging

It's typically harder to find subjects that work well with overexposure because usually it means sacrificing a high percentage of highlights and lighter tones. Therefore, the idea of gross intentional overexposure works best with subjects that are atmospherically or emotionally matched to the technique-yellow and white flowers swaying in a summer breeze, for example, or girls in white-cotton dresses dancing through a meadow. In these situations, mood trumps highlight detail and if you capture the right moment, then the airiness of the scenes can have quite a powerful emotional impact.

Again, by allowing lighter areas to blow out, you are inviting critiques from people who will see the images as simple mistakes. But if you were to scan the calendar and greeting card racks you would see that this is actually a very popular technique in establishing a bright, cheerful, and upbeat mood in photos. In other words, art directors often see this as a welcome technique for creating a clean, positive representation of a given subject.

One interesting byproduct of giving extra exposure is that colors tend to shift toward a more pastel range that further increases the welcoming mood of such images. While this is a delicate craft, as almost all hues weaken with increasing brightness, the eye will pay correspondingly more attention to subtle nuances of tone and contrast and these subtleties are very much where high-key photography thrives.

The more that you increase exposure, however, remember that you are also tossing aside things like surface and edge detail as well as texture in the lighter regions. You are also shifting what would normally be the darker areas into a range of middle tones or even above-middle tones. Accordingly, the high-key technique is not appropriate for accurate representations of subjects with significant detail in

Not quite clipped

Illuminated by a studio flash aimed directly toward the camera from behind a sheet of Plexiglas, these orchids are bright, but not blown out (or "clipped"), and you can clearly follow the distinct lines around the edges of each petal, tracing the overall shape of the flowers.

Definitely clipped

Here, the exposure was increased by just one stop, but the difference is dramatic. The petals appear translucent, with a shift toward brighter pastels. Indeed, this high-key shot sacrifices shape in order to stress color and light.

shadow areas. Also, if your subjects are backlit (daffodils backlit by a low-raking sun, for instance), you will also begin to lose shape as the edges are eroded by backlighting. If you push this effect far enough, you can obliterate large mounts of edge detail, and have your subject appear to be floating in mid-air, bursting forth out of the clouds.

95

Hug the Highlights with a High-Key Shot

Show off the subject

The challenge of adequately lighting a close-up shot is often remedied by simply going overboard and bathing the subject in a soft, enveloping light for a high-key interpretation. With their cheerful tones and luminescent glow, it's no wonder that high-key images are the staple of the greeting card and calendar industries: How can you turn away from pictures that beckon you with their brightness? That is the charm of photos that are created from a wash of bright tonalities spun together with joyful abandon and an aura of purity is the glue that holds them together. One of the keys to mastering this challenge will be your ability to see or create compositions that are dominated almost entirely by tones that are lighter than middle gray. And one way of exaggerating their glow is to abandon detail in some of the brightest ranges intentionally abandoning detail and texture in favor of establishing an upbeat and innocent mood.

→ Soft contours

High-key interpretations invite the viewer to appreciate what little textural details remain, and so a subtly overexposed approach can often be more effective than a proper exposure.

Challenge Checklist

- → If you're thinking of setting up a high-key still life, picture yourself in a market picking props. What would you choose? Eggs? Gardenias? White pottery?
- → Don't panic when the highlights begin to run off the right edge of your histogram with high-key images—remember that you're allowing some detail to escape in favor of setting a mood.
- → Shooting a portrait? Use a white bed sheet as your backdrop and second one as a wrap for your model. Just be sure to use plus compensation from whatever you meter to push the tonal range up several zones.

This shot was taken on an extremely bright sunny day. Exposure was taken on the models face while blowing out the background and using a 42-inch white reflector to fill in the harsh shadows from the mid day sun. *Richard Gottardo*

Excellent. The big reflector (the eyeballs tell us how large it is) helps to give the image the look of a controlled studio shot, combined of course with the high-key exposure which typically has the effect of cleaning up and simplifying everything tonally. *Michael Freeman*

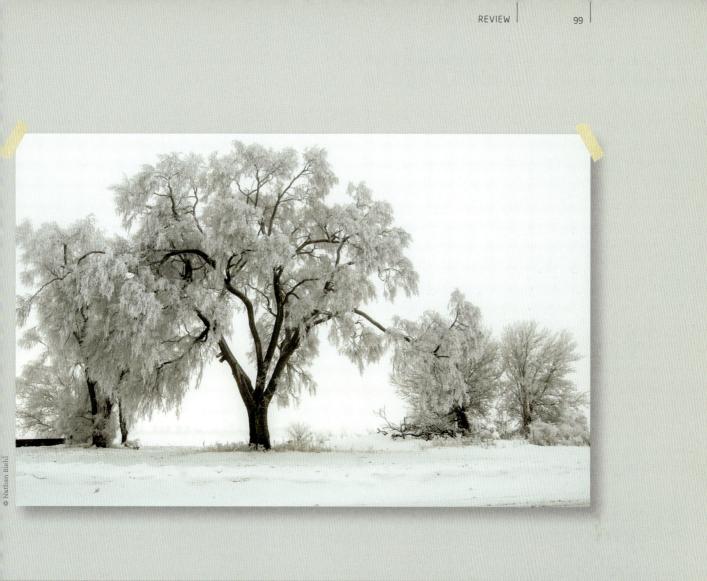

Referencing the histogram, I was able to the retain details in the frost and snow while keeping the overall brightness of the scene intact. *f*/9 at 1/250 second, ISO 200 with -1EV exposure compensation. *Nathan Biehl*

An attractive white-on-white situation to begin with, and you've maintained the delicacy that's important. It would be interesting to know how far you could push that delicacy by increasing the exposure, in order to make the frost-laden branches even more ethereal. *Michael Freeman* LIGHT & LIGHTING

LIGHT & LIGHTING

It's easy to underestimate the significance of light, as it's basically ubiquitous in our waking lives. If we aren't outside during the day being guided by the sun, we're constantly battling back the darkness with our own artificial lights. Even scenarios we consider quite dark will almost always have some source of light in them, like a path through the woods at night being ever so faintly illuminated by the moon above. As such, most people take light for granted. Either it's there or not; the lamp is turned either on or off. And if it's there, it's either bright or dim, simple as that.

100

Photographers, of course, know there's quite a lot more going on, and that's what makes light and lighting such an interesting and fundamental element of photography. Light is rather like our own photographic language, and becoming fluent in it is an essential step in building your repertoire of photographic skill. Photographers sometimes speak of their ability to "see" or "read" light. On the surface, this is a rather obvious statement; of course you can see light, everyone does. But what they are referring to is their particular ability to observe the fine and subtle qualities of light, then capture them and make them work creatively in an image. Photographers notice the color of different light sources, the density and length of shadows, the angles of light and corresponding times of day-the list goes on and on.

When it comes to making photographs, light is the single element that will always make a difference in the shot. A subject or scene may be boring or totally commonplace in one kind of light, but change the angle or intensity, and suddenly it's something more than it was before. Sometimes the light is so striking that it becomes the subject of the photograph itself. It's probably impossible to isolate precisely what kind of light is flattering or aesthetically pleasing and why (though there are general trends to look out for, such as the golden light at the beginning and end of the day); such universalities are hard to come by in art. But you will learn to recognize the exceptional qualities of light when you see them, and to make the most of those situations as you encounter them.

Shoe shadows

An appreciation for the nuances of light and the dynamism that it can contribute to a photograph is absolutely invaluable. It opens up a whole world of potential images, sometimes in the places you least expect.

101

In most situations, there is usually some degree of control over the light, and thus corresponding decisions that have to be made in order to achieve the shot. But even in those photojournalistic or naturalistic situations where there's either no time or no desire to influence the light directly, you still have decisions to make as to how your camera responds to and records that light. How dense do you want your shadows? Do you need to preserve detail in the highlights? Should you color balance for the warm tungsten lights or the daylight coming through the window? Gradually, as you become fluent in the language of light, these questions will be less like obstacles to overcome, and more like creative tools you can use to achieve your particular vision.

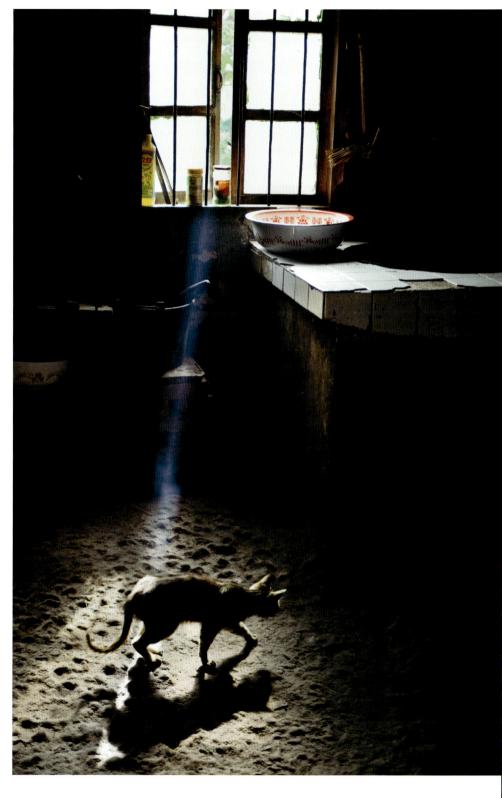

A fleeting moment

Some scenes will immediately strike you for their unique lighting conditions. Such conditions are often fleeting particularly if they are the result of natural light—so it is essential that you learn to recognize them instantly and capture them quickly.

102

LIGHT & LIGHTING

Bit-Depth & Tonality

In digital imaging, each and every tone and color value is assigned a definite, discrete numerical value (as opposed to film, which exists in an analogue continuum). The basic unit for computing is called a "bit," short for "binary digit." These bits are either on or off, ones or zeroes, black or whitethere is no in-between (hence the "binary" terminology). So a single bit could indicate that a pixel is either pure black or pure white, but that doesn't leave any room for the infinite gradations of gray in between these two extremes. To fill in the gaps, we can put a string of bits together and combine them to give us a greater number of intermediate values. If we put 8 bits together, that gives us 256 (2⁸) discrete

values in which we can store information. When applied to digital images, that range of values is called the "bit-depth" of the image.

When a digital camera records an image, the camera's imaging sensor assigns a numerical value to each pixel, usually in a range from o-255. Now you can see where that number comes from: The image file (in this case) is constructed using 8 bits. Now that may not seem like a lot; certainly we can perceive more than just 256 colors and shades in an image. But also recall that each pixel is interpolated out of the data from three different photodiodes, one per primary color. So in fact, a color channel contains 256 x 256 x 256

different levels of information, resulting

in 16.7 million possible colors, far more

than we are able to perceive with the

While 16.7 million colors may seem

more than adequate for all our image

for instance, a wide-angled shot that

contains a vast expanse of blue sky

and a horizon line with some darker

needs, that is not always the case. Take,

human eye.

Lots of skyline

The gradual lightening of the blue sky as it moves from the top of the frame toward the horizon is a large part of what makes this image work. Had the image not been saved with sufficient bit-depth, that delicate gradient could easily have appeared as a series of stripes across the sky, with obvious jumps across tonal values.

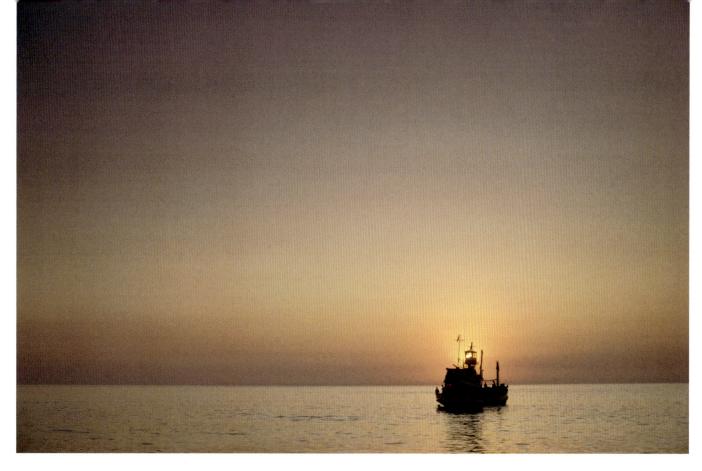

Increasing Bit-Depth

We can mitigate this banding effect by working in a greater bit-depth. The 8-bit format we've been discussing so far is just the base level for building digital image files—used by JPEGs, in-camera histograms, and most LCD displays. If you shoot in the Raw format, today's imaging sensors are capable of saving images in 12- or 14-bit formats. This gives you 65,536 discrete values per channel, or 281 trillion colors to work with—quite enough to protect even the most subtle of gradients from exhibiting banding.

Of course, Raw files must be processed before they can be displayed, and if you plan on manipulating them further in image-processing software, you should make sure that you continue to work in a large enough bit-depth. In Photoshop, go to Image > Mode and make sure that either 16- or 32-bits/ channel is selected. However, keep in mind that most displays and printers will still only use 8-bits per channel, so you will need to save the file back down before displaying or printing the image—but don't worry, you are still making use of the greater original bit-depth and range of tonality; you are just doing a better job of distributing that tonality across the areas of the frame that need it most.

It's worth noting that there is a clear distinction between dynamic range and bit-depth: While we can increase the number of discrete values into which a given range is divided, we are not actually expanding that range. Which is to say, working in greater bit-depths

Plenty of Space

Not every scene requires a full 281 trillion colors in order to capture an accurate representation and sometimes, if you are going for a highcontrast look, you'll be throwing out a lot of those in-between values anyway. The key is to recognize which scenes exhibit a large gradient that requires greater bit-depths and shoot accordingly. Of course, shooting in Raw is generally a good idea regardless, as you will always have the option to make use of the greater range of tonality if it's needed.

does not increase the dynamic range of the sensor—black is still black and white is still white. Rather, greater bit-depths simply give us more room to exhibit the differences between those extremes. LIGHT & LIGHTING

The Sun Throughout the Day

The time of the day will be the most important factor contributing to the role of sunlight in your photography. Sunlight shines at a very low angle early and late in the day, gradually rising to a harsh, high-angled light around noon (depending on Daylight Saving Time, of course).

104

Dawn and Dusk

If you've ever raced against time to a scenic vista in order to view a sunset, you know how quickly light can change as the sun approaches the horizon. The movement of the sun, while barely perceptible across the

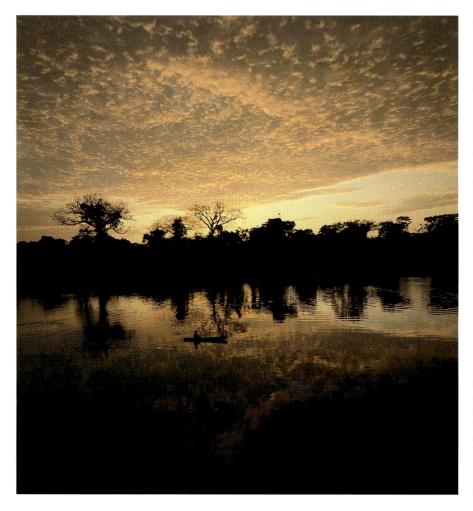

vast expanse of a full sky, seems expedited at the beginning and end of the day. In reality, the sun moves at a constant speed, of course; it is merely the stationary reference point of the horizon line that lets us perceive its motion. But the quality of its light does indeed change rapidly, affected by the extreme angle at which it is shining on a scene. These changes can be unpredictable and dramatic, and you must work quickly to observe their effects and make use of them.

The sun appears red at the beginning and end of the day because its light is passing through more atmosphere, which scatters the blue and violet wavelengths. Additionally, any clouds that are present along the horizon have a farther distance to travel before they get out of the way, so there is a greater likelihood that red sunlight will be diffused through radiant, fiery cloudscapes.

Sunset silhouettes

Sunsets are a traditional favorite time for photography, but as a subject in itself, a sunset alone can be rather commonplace. Using the brilliant lighting conditions of dusk as a backdrop for another subject, however, allows you to flex your creative muscle. Here, the brilliant skyline is reflected in a lake, casting the lone boat and tree line in a moody silhouette.

Midday Sun

At noon, the sun reaches its zenith and is at its brightest intensity. It is also at its most perpendicular angle to the earth, and so the shadows it casts are particularly harsh, creating highcontrast exposure situations. Delicate metering is essential in order to capture the full dynamic range of such scenes. In landscapes, various filters can help capture the high-intensity blue of the sky while still preserving the mid-toned greens of rolling hills and shadows cast by trees or buildings. Portraits can be particularly challenging, as the direction of this sunlight casts unflattering shadows down on a subject's face. These shadows can be filled in by flash or reflectors, or mitigated by diffusers.

On the other hand, if you embrace the contrast, midday sun can create punchy, dynamic images. Black-andwhite photography is particularly suited to such conditions, as shadows and highlights are often expected to lack detail and be rendered pure black or white, respectively. But embracing high contrast usually means accepting and composing with dense, featureless shadows.

The Space Between

Recognizing the particular challenges presented by the extremes of light throughout the day, it follows that the light in between these times, during mid-morning and afternoon, is often easier to photograph. Not too high and not too low, this sunlight is perceived by the human eye to be both attractive (good for a variety of subjects) and neutral white (making white balance adjustment a simple matter).

Strong contrasts

Black-and-white photography invites the use of strong contrast, and harsh shadows can be a compelling element of the composition, even if detail is lost in them.

Mid-morning

Mid-morning sun is neutral enough to let subjects stand on their own. Here, the light is not so bright as to overwhelm the delicate yellows and greens in the trees, nor so angular as to make the shadows a major part of the composition.

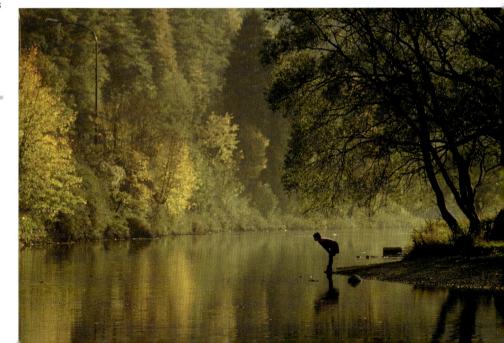

Dealing with Strong Sunlight

106

It is all well and good to speak of the patience required for photographing a scene in ideal sunlight, but as a photographer, you are not completely at the mercy of nature. On the contrary, you possess a variety of tools and techniques to manipulate the light given to you so that it is optimal for any given subject.

Graduated Filters

In many landscape shots, the top of the frame is dominated by an extremely bright skyline, which is much brighter than the mid-tones and shadows occupying the bottom half of the frame. To squeeze all this dynamic range onto your camera's sensor, you can use a graduated (grad) filter to block some of the brightest light at the top, while allowing progressively more light to pass through as it moves down the

frame. The most common is a neutral density filter, which blocks a certain amount of light without adding any color cast. Typically, you can slide these filters up and down within a holder mounted on the end of your lens, in order to line up the gradation level appropriately with the horizon of your scene. The effect can be readily observed in the histogram: As the filter slides down over the lens, the right side of the histogram will gradually approach the right edge. The goal is to get the highlights as close to this right-side edge as possible without clipping them off.

Filter effects

Grad filters help balance bright skies against shadowed foregrounds, and can also be used to add a color cast. This composite image shows the effects of various grad filters, from left to right: no filter, neutral density, blue, and yellow. Much more cloud detail is captured with filters.

Polarizers

Another method of blocking some of the light in a scene in order to prevent overexposure is the use of a circular polarizing filter. These filters will darken skies and make clouds pop, and are most effective at right angles to the sun. By rotating the filter on the end of your lens, you can adjust the effect of the polarizer to suit your particular exposure situation. Be sure to pay attention to the other effects it has on your scene, as polarizers also reduce reflections from glass and water, and cut through atmospheric haze.

Saturated skies

A polarizing filter makes the clouds pop against a vivid blue sky, and also keeps bright sunlight from reflecting off the water. Note that the wide-angle lens means the intensity of the polarizing effect varies across the frame, with the blue sky getting progressively more saturated toward the upper-left corner.

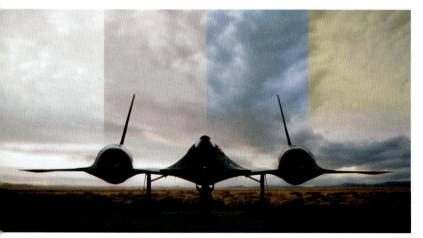

© Andre Nantel

Rounding out the light

The light shining on this beach scene was strongly directional, so a collapsible silver-fabric reflector was used from off-camera right to fill in the shadows on the backs of these painted stone objects (by artist Yukako Shibata).

Filling in Shadows

Whereas neutral density and polarizing filters mitigate high-contrast lighting conditions by decreasing the intensity of the highlights, another option is to increase the intensity of the shadows and bring them closer to the highlights. This is called "filling in" the shadows, and can be accomplished in several ways. First, you can fire a flash and directly add light to the scene. This use of fill flash is effective, as the color temperature of flash is close enough to daylight that the two can usually be mixed without looking unnatural. However, it takes a delicate touch to balance the amount of fill flash with the ambient light—fully discussed on page 134.

Reflectors

At its simplest, a reflector is any surface that can bounce daylight onto a subject. You can direct where the reflected light falls by adjusting the angle of the reflector. White reflectors bounce the most light and are therefore the most common, though golden and silver reflectors can also be used if you want to add a particular color to your subject. By allowing you to directly observe their effects in real time before the shot is taken, reflectors can be much easier to use than fill flash. Lightweight and cheap, most reflectors also collapse for easy storage, making them an essential piece of equipment.

Diffusers

A diffuser is anything that scatters light from a given source such that it falls more evenly across a subject. In outdoor portraiture, for instance, positioning a large, semi-transparent panel in between the sun and your subject will distribute the sun's light evenly across their face, lifting shadows and toning down highlights.

- Natural diffusers

This portrait uses the natural diffusion of light through a bamboo forest to soften the shadows cast on the subject's face. The single streak of direct sunlight also adds dimensionality and ambience—but needs to be delicately color corrected in relation to the rest of the face, lest the subject appear too blue (from the color temperature of the shade). LIGHT & LIGHTING

Shooting into the Sun

Pointing your camera at the sun for a shot is a condition that excellently marks the difference between the science and art of photography. Technically, everything about this shooting scenario is wrong: Images strongly tend toward overexposure, color detail is easily lost, and textures are rendered flat. But creative and delicate manipulation of these conditions can deliver some of the most atmospheric and successful images.

Skilled manipulation of manual camera settings is vital when shooting into the sunlight. If the sun is visible in the frame, the extremely high dynamic range will mean you have to make a judgement call as to exposure—either your subject will be illuminated and your skies will be blown out to pure white, or your skies will be properly exposed around a shadowed, silhouetted foreground. Matrix metering will tend to assume overexposure and overcompensate by making the whole image too dark. Spot metering, on the other hand, lets you precisely indicate which area of the frame will be properly exposed. In any case, delicate use of the histogram is essential to achieving the look you want.

If you frame the shot such that the sun is masked by an element in the scene, that element (which will likely be underexposed and appear as a silhouette) will be framed in a light radiating out from its edges. This edge or "rim" lighting accentuates the shape of that element and lends a strong graphic emphasis to the image. Shooting into the sun is technically known as backlighting, although unlike in a studio, the height of the backlight is chosen for you by the position of the sun. For this reason, many outdoor backlit shots are taken at dawn or dusk when the sun is at its lowest. At other times of day the photographer can lay on the ground and shoot at an upward angle in order to backlight a subject.

Runway at dawn

Peaking through a gap in this airplane fin, the sun is given a definite shape that would otherwise be lost in overexposure. The underexposed, angular shape in the foreground becomes a strong graphic element, keeping the scene from being just another sunset photograph.

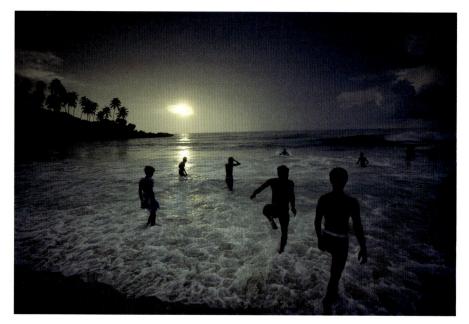

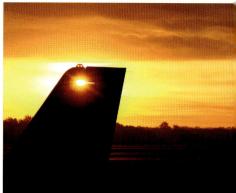

© Frank Gallaugher

Facing dusk

Allowing these subjects to be cast as underexposed silhouettes greatly enhances the mood of this image, and means the distant sky can fit into the exposure and contribute to the atmosphere.

108

Flare

Any time you shoot into the sun, you are inviting excess light to be reflected off the many interior surfaces of your lens, creating streaks and artefacts known as flare. The wider the aperture used, the more prone to flare the resulting image will be. You can mount a lens hood on the end of your lens to help mitigate the presence of flare by shading the edges of the frame and keeping light from striking the front lens element at too extreme an angle. The hood itself is often lined with nonreflective material such as black felt, and can be either bowl or petalshaped—the latter taking into account your sensor's aspect ratio. However, no lens hood is perfect, and even the best ones have little effect when the sun is directly in frame. Post-production will give you the opportunity to manually remove small amounts of flare, depending on how prevalent it is in the final image.

Creative Use of Flare

Technically, flare is an aberrationan error in the way a lens renders the light of a particular scene. That said, iudicious and intentional use of flare can deliver some very pleasing effects. In particular, flare can work well to add a cinematic quality to a shot. The difficulty is that it is impossible to judge how images will turn out until they have been taken, and often the frame will be so bright it can be difficult to compose the shot. A useful technique is to shield a portion of the lens with your hand, adjust your composition and focus to your liking, then take your hand away before firing the shutter.

Proper Equipment

In addition to improving image quality and preventing unwanted flare, lens hoods can also protect the front lens element from bumps and scrapes.

Pentagonal flare

The impromptu still-life makes use of strong backlit colors, but the line of flare artifacts (pentagonal from the aperture shape inside the lens), instead of being a problem, add to the graphics and colors, particularly because they occupy a central diagonal.

Challenge

→ Flare for effect Polygon stripes are hard to

avoid if you shoot straight into a bright sun, but they can be made to work. Remember that they spread out from the light source in a line, so positioning the sun here in the top corner made them run diagonally into the frame, making them distinct and, by implication, deliberate. From one point of view, we're all so used to seeing flare that it's no longer a mistake, but something to help the mood—and in Hollywood special effects, flare is often added artificially for just that reason.

Face the Sun Head-On

This challenge will help you come to grips with the full potential of direct sunlight. You'll be shooting directly into the sun, but carefully setting up the shot to prevent total overexposure. The easiest way to achieve this is to block the sun by positioning some element in between it and your camera. The object will be rendered as a silhouette, but the rest of the scene will still be able to hold detail.

What metering mode is appropriate will depend on your particular scene, but in any case, you will need to keep a close eye on your histogram and be ready to override any autoexposure readings with exposure compensation in order to make sure the camera records the scene as you want it to. Positioning is also key, especially if you plan on blocking the sun—as you must both line up some object in the sun's light path, while also making sure the rest of the frame has an interesting composition. Scouting ahead of time will help, as you won't have very much time to set up your shot before the sun moves to a new position.

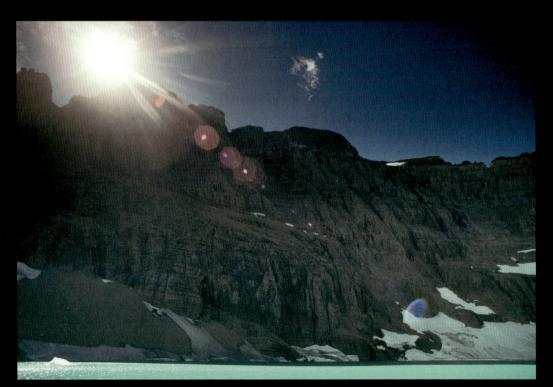

Radiant mist

Note that while they appear similar, these radiant beams of light are not flare artefacts, but rather ambient fog that is catching part of the light as the sun beams through it. By hiding the sun's actual disc behind the tree trunk, more of the tonal range of the beams has been captured, and there is less highlight clipping.

Challenge Checklist

- → If you have one available, mount a lens hood to limit flare and help you see the frame as you are composing.
- → If you are completely unable to avoid flare in your shot, don't fight it embrace the flare as a compositional element in itself and work with it, without allowing it to completely obscure other important elements.
- → Check your histogram after each shot and make sure your shadows and highlights aren't getting unintentionally clipped.

The sunglasses, water glass, and bottle were all transparent, and casting interesting shadows across the table, and with the sun in the background this was an easy shot to set up–I ended up adjusting the color temperature as well to mimic the scene as I saw it through magentatinted sunglasses at the time. *Sven Thierie*

Keeping the sunglasses in the composition was a nice touch sort of a clue to the viewer as to the interpretive meaning of the color cast. *Michael Freeman*

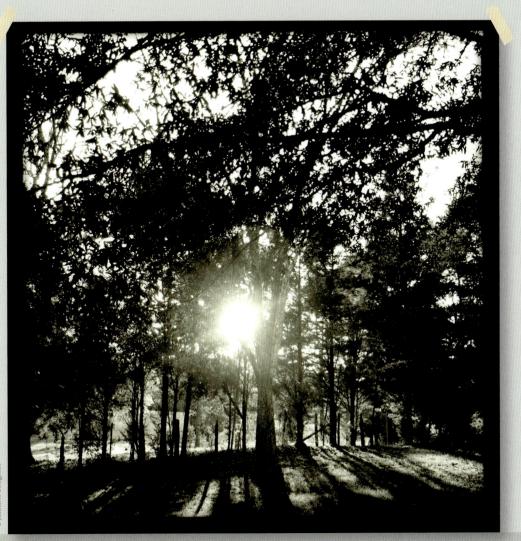

Shot as the sun set through the trees, whose long shadows are what originally caught my eye. I chose to shoot straight into the sun to create flare. Jennifer Laughlin

A nice balance of exposure between capturing a glow from the sun that actually *feels* like looking into it, with visible shadow detail in the grass. Black and white also does a good job of making the viewer concentrate on the shadows and tonality. *Michael Freeman*

REVIEW

113

114

LIGHT & LIGHTING

Golden Light

© Frank Gallaugher

• Urban reflections

Frontal golden light brings out rich, saturated colors, and the windows of this New York high-rise reflect the shimmering blue of a clear sky above.

Laotian temple

Golden light communicates a sense of majesty, and is well suited to many architectural subjects. In this shot of a Laotian temple, the golden light serves its purpose without having to cover the entire building; the shadows speak to the surrounding environment and prevent the photograph from being a cliché.

As discussed on page 104, the brief period of time when the sun is just above the horizon but still below about 20 degrees offers a distinctly warm, golden color of light—typically between 3500K and 4500K. The richness and saturation of the resulting colors, combined with long shadows cast by such a low-angled sun, create a signature look that is much beloved by photographers. Indeed, golden light is so popular that it almost risks becoming a cliché; and if your intention is to deliver images that are unique and distinguished, it may not be your first choice. But it is nevertheless an essential part of your photographic repertoire, and a safe bet for getting a memorable image.

Because we are accustomed to seeing the world this way for only a brief period of time each day, golden light imparts a sense of ephemerality and meaningfulness to a scene. Accordingly, you must work quickly to make the most of this light, which usually lasts for only an hour at the beginning and end of the day. Scouting locations and planning your composition ahead of time ensures you can concentrate on tackling whatever exposure scenario this light presents.

The Three-Angle Choice

In addition to its flattering tonality, golden light is also beloved by photographers for the variety of angles it offers for any given subject. While the low angle of the sun stays constant, you can control how that light strikes your subject by moving the camera to various positions. As discussed on page 108, shooting into the sun creates a backlit scenario, with opportunities for silhouettes or edge-lit portraits. In backlit shots, shadows dominate the frame, such that very few directly illuminated areas are available to give the image any local contrast, resulting in the loss of fine detail

If you turn completely around and shoot away from the sun, you have full frontal light that brilliantly reflects the natural colors of your subject, giving it an intense, grandiose appearance. Shadows get tricky with this angle, however, as your own shadow is now falling in toward the scene. This may not be an issue with a telephoto shot. but if you are shooting with a wideangle lens, you may need to either carefully compose the scene so that your shadow is kept out of frame, or blend your shadow into the existing shade cast by some other element—a tall tree or building, perhaps.

Additionally, if your subject is framed such that you cannot see its shadows at all, the frontal light can sometimes make your image appear flat, as it doesn't offer the viewer any reference for the subject's depth.

In the interim 180 degrees between backlighting and frontal light, you have a plethora of side lighting options. This angle of light exaggerates depth and is defined by the long, horizontal shadows crossing the frame. The resulting high levels of contrast create ideal conditions for revealing fine texture in surfaces.

🗕 Parisian post

Close-up shots with strong side lighting make the surface texture obvious and tangible, and shadows running horizontally across the frame lend a graphic quality.

Suitably majestic

The long telephoto focal length means that, without strong shadows cast by this blackwinged kite to anchor it to a particular environment, this shot feels like it is hovering in space—particularly suitable for its avian subject. 115

Clouds & Light

116

Almost everything we've discussed so far about the role of daylight in photography has ignored a major factor: clouds. On a perfectly clear day without a cloud in sight, you can use the previously described rules and patterns to predict exactly where and when a certain kind of light will shine with reasonable accuracy. Clouds, however, are giant floating variables that literally change with the wind and will consistently keep you on your toes. Sometimes a blessing, sometimes a curse, clouds interact with light in several key ways, and understanding these interactions is essential. Overcast days with uniform cloud cover are commonly (and unfairly) perceived as dreary and bland. Some of this is simply human perception, which associates bright white light with natural beauty. Beyond that, without any point-source light in the sky, there is nothing to cast distinct shadows, and scenes can easily appear flat with little detail. However, imagine your giant outdoor studio again, and recognize that by spreading and softening the sunlight, the clouds are acting as an immense diffuser in the sky. The resulting soft light means you can take a portrait almost anywhere without worrying about unflattering shadows or high-contrast exposure problems. Indeed, it means you have a lot less to worry about in general, as the entire landscape is evenly lit with a consistent light that won't be dramatically changing from hour to hour. And while colors won't pop with the same intensity that they do under direct sunlight, the soft light does make it much easier for your sensor to capture subtle and nuanced color variations in your subject.

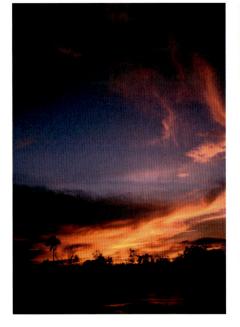

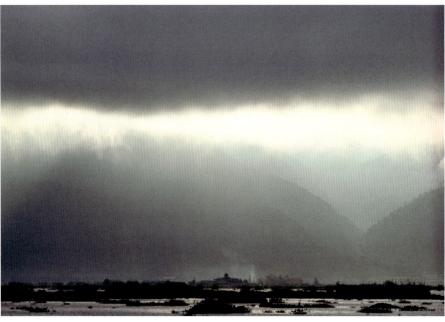

Saturated Skies

The vivid colors of a sunset are best captured by a bit of intentional underexposure, which will in turn render objects on the earth as silhouettes.

Looming clouds

Besides casting everything below in a diffuse light, heavy clouds like this can also become a major part of the composition itself.

Broken Cloud Cover

In between a perfectly clear day and a heavily overcast one, there are days of mixed daylight, in which a bright blue sky is interspersed with clouds of varying shapes and sizes. Compact and dense clouds (called cumuliform) can dramatically alter a scene for brief periods of time as they pass in front of the sun. In an open scene, the blue sky reflection (10,000K) is usually overwhelmed by the intensity of the sun (5200K); but by blocking and lowering the intensity of the direct sunlight, a cumuliform cloud will momentarily equalize the color temperature to around 6000K, delivering a brilliantly lit foreground that keeps the deep tonality of a blue sky overhead. Of course, these dense clouds also cast quite distinct shadows of their own, particularly if they are low in the sky, which can create highcontrast exposure situations if those shadows are kept in frame.

Clouds as Reflectors

At certain angles, tall cumuliform clouds that extend vertically upward in the sky can even act as light sources themselves, reflecting the light of the sun onto a scene below. Huge banks of such clouds can fill in shadows and help even out the exposure particularly if the sun is shining upon them from the opposite side of the sky, as in mid-morning or mid-afternoon (earlier or later and the sun is already too low in intensity to have much effect). Even if the light reflecting off these clouds is not enough to completely fill in all of the shadows, it can still lower the color temperature of the shade and bring it closer to

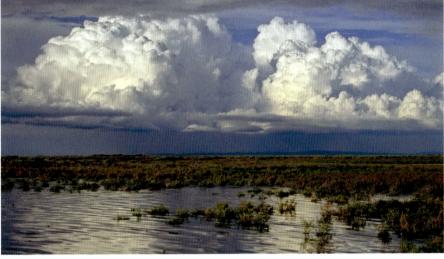

Cumuliform composition

These tall cumuliform clouds reflected enough sunlight to evenly illuminate the marshes below, and are also reflected themselves in the water, where they emphasize the textural qualities of the ripples along the surface.

Breaking through

Clouds can create truly spectacular lighting effects depending on their interaction with the sun. Here, strong edge lighting gives these clouds a radiant outline; and they in turn transform the sunlight into radiating beams of light, which would otherwise be invisible against a clear sky.

the temperature of the surrounding daylight, making these shadows appear less blue.

Broken clouds are often unpredictable in the way they scatter light, and this can make them more exciting and also more complex to photograph. This complexity is exacerbated in situations when different layers of broken cloud hang at varying depths throughout the sky. A scene with distant mountains, for example, could have a bank of heavy cloud hanging in the distance, but scattered lighter clouds in the foreground.

Weather Extremes

Extreme weather can be hard on your camera but simply because it's extreme and less usual, can offer good opportunities for strong imagery. Simply take the necessary precautions against water, sand, condensation or whatever else, and look for one-of-akind images.

Foreboding contrast

A momentary break in cloud cover fully illuminated this old Cape Town hotel, contrasting strongly with the heavy, morose storm clouds above. A few seconds earlier or later and the whole scene would have simply looked dull and dreary, with no point of comparison to illustrate the power and magnitude of the weather conditions.

Storms

The default lighting condition of rain or thunderstorms is basically the same as that of an overcast day, only darker. Even though the clouds themselves may look vast and intimidating, they require a contrasting light source to illustrate their contours and bring the scene to life. This happens during momentary breaks in the cloud cover, when the sun cuts through as a strong, directional spotlight that illuminates a single subject amidst a sea of darkness. You must act quickly to seize such opportunities, as the natural windy conditions of the storms mean they will be short-lived.

Approaching storm clouds on the horizon can make for a dramatic landscape, with massive, multilayered cloud formations looming over and contrasting with an otherwise tranquil scene in the foreground. A successfully captured bolt of lightning is also a dynamic element to add to a scene, but unless you get lucky, you will need a long shutter speed to negate the uncertainty of when it strikes. Fortunately, the dark conditions of heavy cloud cover make such long exposure times feasible—provided you use a steady tripod.

Snowfall

The pristine conditions of a fresh coat of snow make for idyllic imagery, and present a unique lighting condition in which every available surface acts as a reflector. The abundance of white befuddles the camera's metering system, which will interpret the snow to be neutral gray and render the scene accordingly. To prevent this dull underexposure, add one or two f-stops of exposure compensation while keeping an eye on your histogram, until the scene appears correctly on the LCD. On the other hand, you should have little to no problem with unflattering shadows cast on your portrait subjects, and can photograph freely even in direct, midday sunlight.

Cold Batteries

Extreme weather conditions can take their toll on your equipment, and cold temperatures in particular will sap battery strength quickly. Keep a spare battery warm inside your jacket and periodically switch it out with the one in use to extend the life of both batteries.

Mist and Fog

Thick mist or fog swathes a scene in vapor particles that scatter the light and act like a ground-level diffuser cloud. Like most weather extremes, these conditions are usually fleetingparticularly the mist formed overnight by still air cooling over wet ground, which quickly evaporates in the morning sun. Fortunately, you needn't worry too much about exposure, as these scenes are typically low in

contrast and easily captured by the sensor. Indeed, you even have some wiggle room—exposing for the whites of the fog will make it glow and appear luminescent, while less exposure will deliver gloomy, eerie results. Shooting through mist introduces a strong element of depth into your image, with objects gradually appearing paler and less detailed the farther they are from the camera.

Nowhere to hide

With properly calibrated white balance, a snow-covered scene serves as an ideal backdrop for showing off vivid colors and textures, such as this European red fox's fur coat. The fox is also evenly lit on all sides by the reflected sunlight.

Ethereal early mornings

Early morning fog, just barely illuminated by the rising sun, creates dreamy, otherworldly environments. To get subjects in sharp focus, you must be physically close to themshooting across a distance with a telephoto lens introduces too much atmospheric haze for crisp results.

Your Choice of Rain, Fog, or Snow

Moody backlighting

Sometimes you just know certain areas will look fantastic in heavy fog. Next time you wake up to a thick early-morning mist covering the ground, grab your camera and head to that spot. This challenge might entail getting your feet wet—but not your camera! Step one of any inclement-weather shot is properly protecting your gear. If it's just a light drizzle, you might be safe just keeping your camera guarded underneath a raincoat, and taking it out only once you've found a good subject. But don't take any risks. If it looks like it's going to pour, it's worth investing in a good camera cover which will also be just as handy if you're out trekking in the snow. But the point is to embrace the weather and capture a shot that shows off these less-than-comfortable conditions in all their photographic glory.

🛛 Linda Bucklin

→ Fade into the distance

In heavy fog, look for repeating subjects leading away from the camera, as the fog will gradually obscure them, adding both depth and mystery to the image.

Challenge Checklist

- → In cold weather, bring extra batteries, and keep the extras secure in a warm place.
- → Be alert and ready to grab a shot when it presents itself—fog and rain are particularly ephemeral conditions, and if you wait too long to set up a shot, the light may have changed by the time you fire the shutter.
- → If you can position yourself high up on an overlook or some other vista with a wide view, you'll be able to capture an all-encompassing feel of a weather event—a thundercloud over a valley or a city submerged in fog.

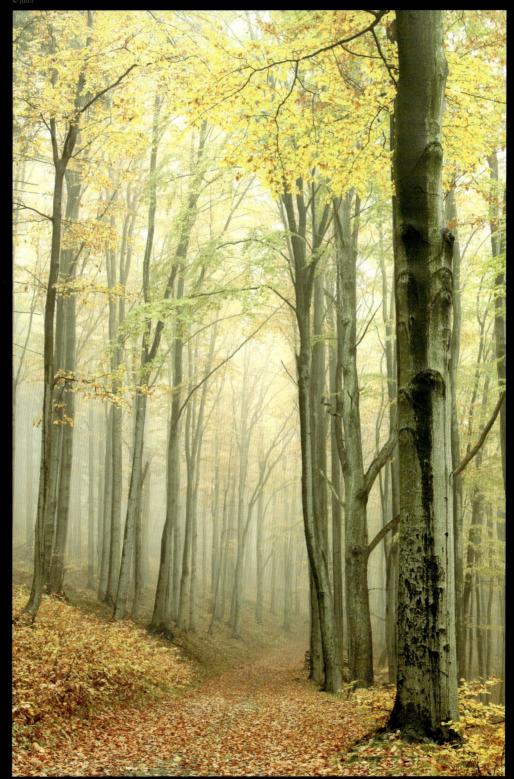

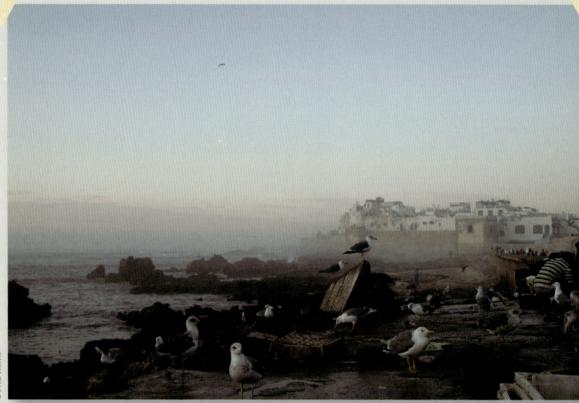

It took a while for the mist to clear enough to see the city in the background, and less than an hour later it was all cleared up and the sun was shining. This was the best time for the shot, with an interesting foreground against a misty, ethereal background. Sven Thierie

Excellent evocation of mood, and perfect timing for the light. The low camera position places that seagull very well against that light band below the buildings, and the other seagulls help the foreground. It might have been better without the figure at the right bending away-either by a slight re-framing or by cropping. Michael Freeman

LIGHT & LIGHTING

123

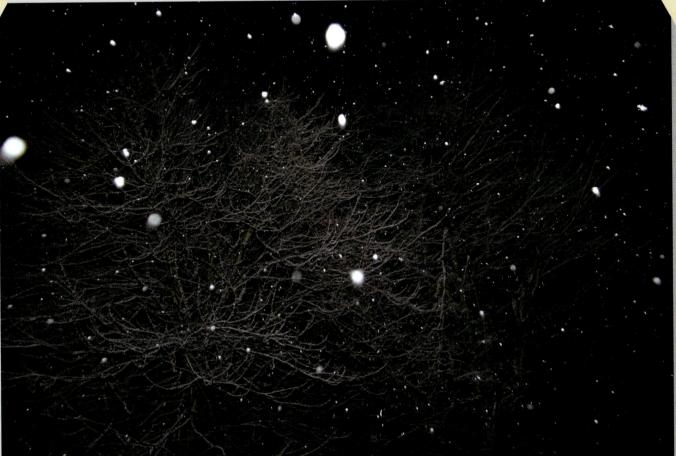

Shot with Nikon D300 and sunpak flash using the tops of the trees as my background. The flash helped me catch the snowflakes even though the snowfall was relatively light. Jennifer Laughlin

Quite a nice way of turning a problem (flash on foreground elements, in this case snowflakes) into a slightly unusual image spare and understated. It would be interesting to know how many frames were shot to get this one. *Michael Freeman*

12/

Incandescent Light

Anything that emits light as a result of being heated is said to be incandescent. Fire is the most obvious example of this type of light, and the warm glow of a flame is its signature color. Today, the most common light source used in interior spaces is still traditional incandescent light, but candles and gas lamps have been replaced by tungsten bulbs. These are the classic light bulbs containing a tungsten filament encased in a sealed glass bulb, which is heated by an electric current that warms the wire to a bright glow. The resulting orange/ yellow color is (counter-intuitively) relatively cold and falls at the bottom end of the color temperature spectrum.

This method of generating light is exceedingly inefficient, however, as a great deal of energy is wasted in the production of heat rather than light. As a result, numerous sources of incandescent light are required in order to fully illuminate a space, which means a greater likelihood that those light sources will appear within the frame of any given interior shot. The resulting high dynamic range means you will have to approach your exposure with a discriminating eye either leaving the area nearby the light sources overexposed, or filling in the shadows by adding your own light to the scene.

Incandescent decorations

This decorative screen in a restaurant was diffusing the light from several tungsten lamps on the other side. Another color would have been far less interesting, but the same warmth that made the restaurant feel comfortable and inviting makes this image evocative and exotic.

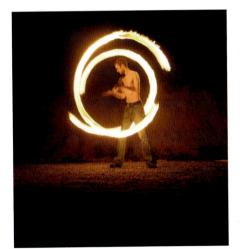

← ↓ Three takes on color correction The flames twirled about by this fire dancer cast a quintessentially incandescent light. The picture on the far left shows how strong the resulting color cast can be if not corrected. Auto white balance, shown in the middle, gets the white balance almost perfect, but the result lacks ambience and feels (ironically) artificial. The custom white balance set for the image below strikes a good balance, and appears verv much how the scene felt at the time.

125

Incandescent Color Correction

As with any artificially lit scene, it is imperative to keep a close eye on your white balance settings to avoid unwanted color casts. Your digital camera's incandescent/tungsten WB preset is usually around 3200K, but this is calibrated for studio lamps. Domestic light bulbs have no such standard color temperature—a 40-watt tungsten bulb is cooler than a 100-watt one, and candlelight glows at an even lower temperature than either. To completely eliminate the orange-yellow color cast, you will need to manually dial in a lower white balance setting, or set a custom white balance.

However, you may find such precise adjustments unnecessary and even undesirable, as a perfectly balanced incandescent scene can often appear sterile and artificial. Our eyes are long accustomed to incandescent light, and associate its orange color cast with warmth, familiarity, and comfort. It can lend a sense of intimacy to a group shot, and make an interior feel inviting. A delicate touch is still essential.

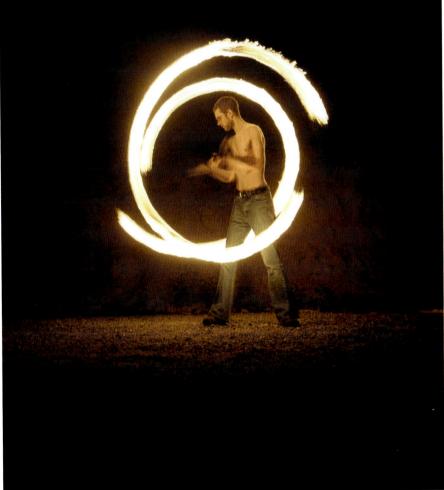

Fluorescent Light

More common by the day, fluorescent light is far more efficient than tungsten bulbs, using less energy to create brighter light. They work by passing an electric charge through a gas encased in a tube, the interior of which is coated with phosphors that excite in reaction to that charge and emit light. Due to their efficiency, fluorescent lights have been popular in industrial and commercial spaces for decades, and are now making their way into energyconscious domestic homes as well.

126

This is all well and good for the environment, but rather unfortunate for photographers, as fluorescent light has never been considered particularly flattering. Besides the fact that we've come to associate it with sterile. commercial spaces, this type of light is also completely unnatural—in fact, it had to be shoehorned into the part of the color temperature spectrum between early morning/evening and afternoon sunlight. This was done for the sake of convenience, but in reality fluorescent light is not continuous the way incandescent or sunlight is. Rather, it is comprised of distinct spikes in blue and green channels, with gaps in the reds. Your mind does a good job of filling in these gaps such that a fluorescent-lit scene is perceived normally, but imaging sensors have a harder time of it.

That said, the fluorescent bulbs used in modern domestic residences have come a long way from the long tubes used in schools, offices, and other dreary public spaces. Special care has been taken to make their phosphors

Tokyo underground

Public spaces like this underground station are often lit with cheap fluorescent lamps. In such locales, getting the white balance absolutely perfect isn't always necessary, as long as the color cast isn't overly distracting.

emit a hotter light that closer approximates natural white daylight, and their power-up mechanism is smoother, preventing the headacheinducing flicker so loathed in regular fluorescents. These newer compact fluorescent lights (CFLs) are so-called because their tube is wrapped up in a spiral or loop, making them much smaller and able to fit in traditional tungsten lamps.

Tungsten vs Fluorescent

The graph below illustrates the continuous spectrum of tungsten light, and the fact that it is comprised of all the different colors of light means it can accurately illuminate each of those colors in an image. Fluorescent light's spectrum, on the other hand, is broken and discontinuous, with sharp spikes in cool colors and hardly present at all in the warmer ones. Among other things, this is why fluorescent lights are so unflattering for showing off skin tones (which are themselves mostly comprised of reds and yellows).

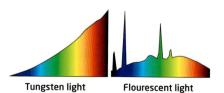

Fluorescent Color Correction

As usual, your first tool in compensating for the green hues of regular fluorescent lights is your camera's corresponding WB preset (usually around 4000K). But even if you set a custom white balance specifically for a given fluorescent lighting condition, the gaps in that light may nevertheless result in a scene with slight deficiencies in color accuracy that remain perceptible to the viewer. Fortunately, the spaces in which you typically encounter such light are often expected to be rendered with those characteristic green hues-the viewing public has simply grown accustomed to perceiving light in these spaces this way.

Domestic residences in which you typically find daylight-balanced CFLs, on the other hand, need special care to avoid casting an otherwise inviting home in a lifeless, impersonal light. Newer digital cameras often have a separate WB preset specifically for these lamps called Fluorescent H, which is slightly warmer at around 4500K. But given the unpredictable and inconsistent quality of these lights (the color of which can even change based on the currency of the mains outlet into which it is plugged), your safest bet will still be to set a custom white balance with a gray card and shoot Raw, enabling the most leeway for finetuning adjustments in post-production.

A happy medium

The camera initially rendered this warehouse interior with an unappealing green color cast due to the fluorescent lights above. Auto white balance, applied in postproduction, went too far in the other direction, with too much magenta. In the end, a custom white balance set for a cool blue cast was preferable, as it speaks to the industrial feel of the scene.

127

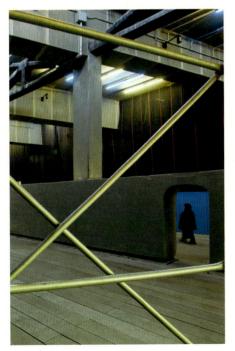

Vapor Discharge Light

Illuminating large, outdoor spaces like city streets, parking lots, and football fields requires a high-intensity light source beyond the capabilities of tungsten or fluorescent lamps. Vapor discharge lamps meet this challenge by creating a powerful arc of electricity between two electrodes housed inside a sealed tube. Once the arc is formed, it

128

evaporates metal salts that are contained in the tube, creating a luminescent plasma. The color of the resulting light is dependent on the metal salts used. Because it takes time for the metal to evaporate, these lights initially cast one color when they are first turned on, gradually shifting to another as more metal is evaporated.

Color science fiction

This technological display was illuminated by mercury vapor lamps, and the uncorrected blue color cast suits the subject well, communicating a futuristic and alien atmosphere.

↑ A scene on the Seine In the streets and sidewalks where sodium vapor lamps are most common, the light is often quite localized, with discrete patches of illumination that can serve as excellent compositional elements.

Mercury Vapor Lamps

These are the most common vapor discharge lamps, and their glowing mercury emits a broken spectrum of light much like fluorescents. Though perceived as a cool white by the human eye, their color starts off as a strong green before shifting to a bluer hue. The intensity of these blue-green spikes is even greater than that of fluorescents, and is more difficult to correct.

Sodium Vapor Lamps

The light emitted by plasma-state sodium starts as a strong orange before shifting to yellow, with severe deficiencies in all other color channels. As a result, they cannot be colorcorrected to perfectly balanced white, because there is no other color to recover. These are the most common light sources in urban areas like city streets—so common, in fact, that their

cumulative effect is what makes cities shine yellow at night when seen from far above, in an airplane or from space.

Multi-Vapor Lamps

By combining several different metals, these lamps can emit a cold white light that, in certain contexts, appears quite natural—even to an imaging sensor. For this reason, multi-vapor lamps are also used as studio photographic lights when high-intensity light is needed. They are also used on football fields and sports stadia, where sports photographers need them to capture accurate white balances.

Vapor Discharge Color Correction

With the exception of multi-vapor lamps, getting accurate color from vapor discharge light is usually a photographic nightmare. Your camera probably lacks a WB preset for these types of light, so setting a custom white balance and shooting Raw is your best bet for color correction. However, in the conditions in which you typically encounter vapor discharge light, perfect rendition of color isn't always necessary. We've grown accustomed to viewing street subjects in the strong yellow hues of sodium vapor; and industrial settings often benefit from the greens and blues of plasma-state mercury. So consider what is appropriate for your given subject.

La Grande-Place

The intricate architecture of Brussels' Grand Place deserved better treatment than the limited spectrum of yellow sodium vapor lamps could afford. Of course, nothing could be done about it at the time this was shot, but in post-production, the yellows were isolated and shifted to a warmer, more grandiose hue.

129

Mixed Light

130

Now that you have an understanding of how the particular types of light interact with a scene, you must combine that knowledge and tackle the real world—which is rarely lit by a single, uniform light source (day-lit landscapes notwithstanding). Rather, many spaces reflect light from multiple different sources, each with its own color temperature and characteristics.

Generally, there are three approaches to dealing with mixed lighting, the easiest being to simply set your camera to Auto white balance and let it determine an average color temperature for the scene. Depending on how diverse the various light sources are, this can work quite well grays and whites may be skewed a bit, but no single color will be completely off-target. Or you can go the opposite route and set your white balance for only one particular light source, leaving all other colors to shift accordingly. This can be a good approach if one light source is dominant, and the inaccurate colors aren't too distracting. The final and best option for color correcting mixed lighting involves adjusting each light source separately, and can be done only in postproduction. There are a few different approaches here, but the most effective is to use the Replace Color tool (in Photoshop: Image > Adjustment > Replace Color...). This allows you to isolate one particular color and shift its hue, saturation, and lightness independent of all other colors, bringing it into harmony with the rest of the scene.

Balancing window light The important element of this scene was the interior space, which needed to feel warm and inviting. Therefore, the original white balance was set for tungsten, disregarding the daylight shining through the windows (above). However, the resulting blue color cast on the right side of the frame was too distracting; so in post-production, that particular blue light was isolated and then desaturated to a neutral white (right).

City Lights

City lights can be considered the ultimate style of mixed lighting. Vapor lamps are now a common choice to light municipal areas, and require a deft diagnosis of which variety is being used. In combination with this, a shop-lined street will often shine forth a row of tungsten-lit frontages, while neon is used overwhelmingly in certain other districts.

Commercial Spaces

The light within shops, malls, and other commercial buildings is meticulously designed to encourage consumers to linger, persuade them to move on more quickly, or plot a particular course through a retail space. For this reason, the current trend is to use a mixture of incandescent, vapor discharge, and fluorescent lighting to achieve the desired effects, and this must be accounted for by the photographer. Fortunately, the effort put into the lighting design pays off with a well composed and delicately balanced scene, which is often simple to photograph. Indeed, high-end shops and galleries go to great lengths to ensure their ambience is worthy of their expensive goods and services, offering up lush photographic subjects.

Arcades interiors

One of the world's first shopping arcades (and the precursor to the modern indoor mall), the Galeries Royales Saint-Hubert in Brussels is illuminated by daylight through its gigantic glass roof. The mix of warm sunlight from above and artificial lights in the shop windows makes for a dynamic and grandiose subject.

Diverse cityscapes

121

Fluorescent in the office windows, tungsten and vapor discharge at street level, all interspersed with radiant neon signs—the bombardment of light within a city is all part of the appeal. This diversity is what makes them so photogenic, and the innumerable color casts are testament to the excitement and randomness that characterize a metropolis.

Camera-Mounted Flash

This type of flash can refer to two things: either the built-in flash that is a part of your camera, or an external flash unit mounted in the camera's hot shoe. Built-in flashes are by their nature extremely limited, and are designed almost exclusively for portability and convenience. They can illuminate only a relatively short distance in front of

132

the camera, and their close proximity to the lens axis means a strong, frontal light that is unflattering for many subjects—particularly portraits. External flash units, on the other hand, overcome many of these limitations and add a number of features as well—though these depend on the particular model used. Professional external flash units are considerably more powerful, able to illuminate wider angles and reach farther distances. They are also positioned much higher above the lens axis, and can be rotated up or down and side to side in order to facilitate bounce flash.

> **Strobe head** This section rotates up or side to side.

How Flash Works

Flash units consist of a power source (batteries, usually), a capacitor, and a gas-filled tube. When the flash is activated, the capacitor builds up a rapid charge from the battery; and when the flash is fired, the charge is released into the tube, where it creates a brief arc of electricity that emits a "flash" of light. The duration of the flash is extremely short, which becomes a problem when using fast shutter speeds with a camera that has a focal plane shutter, like a DSLR. Such shutters are composed of two curtains that travel across the sensor in sequence-the first curtain exposes the sensor, and the second (or "rear") curtain covers it back up. The time it takes for the curtains to cross the sensor falls well below the full range of shutter speeds necessary for most images; so for faster speeds, the rear curtain will start covering up the sensor before the first curtain has finished its crossing. This means that only a sliver of the sensor is exposed at a time. If a flash were to fire at such high shutter

speeds, only that sliver between the two curtains would capture its light. For that reason, the fastest shutter speed at which the sensor can be fully exposed is called the camera's Flash Sync Speed, and is the upper limit at which you can fire a flash at full power (often between 1/180 and 1/300 second).

To get around this limitation, external flash units often have a feature called High Speed Sync, which fires several bursts of flash during the course of an exposure-the idea being that the sensor can be fully illuminated by the flash in increments, with one flash per sliver of exposed sensor area. This works well, and allows the use of high shutter speeds with flash; but there's a trade-off: In order to fire such a rapid succession of flash bursts, the intensity of each burst is decreased, so the overall power of the flash is diminished. Fortunately, this is usually an acceptable compromise, as the use of fast shutter speeds typically indicates an abundance of light anyway.

Speedlite

This professional flash unit has a positional head that can be rotated up or side to side, greatly increasing its usefulness. It is also powerful enough to reach far distances. It is common sense that light gradually decreases in intensity (or "falls off") as it travels greater distances. If you're going to be adding your own light to a scene, it is essential that you be able to precisely predict that degree of fall-off to make sure your subjects are adequately lit. Toward that end, flash photographers work according to the inverse square law, which states that the intensity of light falling on a subject is inversely proportional to the square of the distance from that source. While that may sound like a mouthful, in reality it's quite straightforward. For example, if you have two subjects of equal size, one of which is twice as far from a light source as the other, the more distant subject will receive only 1/4th as much light as the closer subject. In lighting terms: Doubling the distance cuts the light down by two f-stops.

brightness = intensity of light at source

distance²

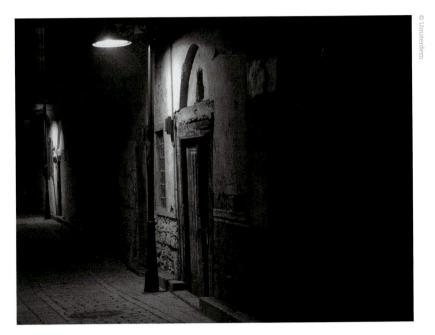

Streetlight falloff

While the inverse square law may seem mathematically complex, its principle is quite familiar. You're aware how quickly light falls off around a lone street lamp like this one; it's just a matter of measuring that falloff to accurately predict how your flash will function in a given scene.

Red Eye

This well known effect occurs when the flash bounces off the retina of a human subject, and increases in likelihood as the angle of flash approaches the axis of the lens. An automated solution is to fire a series pre-flashes in advance of the main flash in order to make the subject's pupils contract. This Red-Eye Reduction feature is generally both annoying and disruptive, causing your subject to squint and announcing to everyone nearby that you are taking a picture. It is further negated by the ease with which red eye can be fixed in post.

133

Smaller equipment

Built-in flashes are undeniably handy, and can be made even more useful with simple accessories like this miniature diffusion screen. This will prevent both the red-eye effect, and soften the light output, avoiding the deer-in-headlights look so characteristic of these flashes.

Balancing Flash to Ambient Light

134

Camera-mounted flash really comes into its own when used as a supplement to ambient light, rather than having to be the primary light source itself. We covered this to some degree in our discussion of decreasing the dynamic range of certain highcontrast scenes so that all the light can fit onto your sensor. Backlit subjects, for example, can have the strong shadows cast toward the camera brightened up to give a well rounded, balanced light. This is called fill flash, because you are "filling in" the shadows by introducing another light source to the scene. You will need to set your flash to a Forced Flash or Manual mode in such conditions, as any of the auto modes will read an abundance of light and disregard flash as a necessity. A light touch usually goes a long way—you want to delicately balance your flash to the existing light conditions without overpowering them. An appropriate ratio of flash to daylight, for instance, is around 1:3 or 1:4.

Interior festivities

Restaurants, reception halls, and other indoor event spaces are frequently quite dim, and rarely conducive to setting up a tripod. Fortunately, they do offer a giant reflector card in the form of a ceiling, off of which you can bounce your flash to cast a diffuse, flattering light on your subjects below.

Bounce Light

In dimly lit interior spaces, your flash is a handy way to augment the ambient light; and by their nature, interiors give you an abundance of reflective surfaces with which to work. By angling your flash up toward the ceiling or to the side at a nearby wall, you can bounce your flash off of those surfaces and back toward your subject. The results are far more flattering than normal frontal light, both because of their angle and the fact that they are diffused into a softer light along the way. Of course, the light now has to travel a farther distance before it reaches your subject, particularly in a large room or reception hall. Therefore, high-powered, professional flashes are preferred, and typically used at full output. Another issue is that the angle

of the light may now cast shadows on your subject, and you can't fill them in with your flash because it's already being used for bounce. A quick fix is a bounce card—a reflective surface that need be no bigger than a playing card. This attaches to the back of the flash head and reflects some of the light forward, while still allowing most of the output to radiate up for bounce.

Rear-Curtain Sync

From our discussion on page 132, you know that the two-stage nature of focal plane shutters affects the role of flash at high shutter speeds. You also have the option for slower shutter speeds: You can "sync" the flash to either the first or second curtain, so that the flash fires at either the very beginning or very end of the exposure. First- or front-curtain sync is fine for stationary subjects, but if there is any movement in the frame, it means a sharp subject, captured crisply at the start of the exposure, will be obscured by motion blur that overlaps the initial capture. The solution is to sync the flash to the rear curtain (rear- or second-curtain sync)—the very end of the exposure. With motion subjects this is ideal, as the flash will capture a sharp moment that overlaps any blur. The resulting trails of motion blur are quite dramatic and effective. Rear-curtain sync isn't only about communicating motion though; it is also a method of including distant backgrounds in a dark scene with a nearby main subject. Capturing a sense of place and environment is often essential, and helps avoid the isolating, black backgrounds so typical in poor flash shots. It takes some practice to perfect this rear-sync technique, but the results are often stunning.

There's a lot of both camera movement (from left to right) and subject movement (in the street background) in this shot, but the woman crossing the frame stands out sharp amid it all—the trademark look of rear-curtain sync.

Motion trails

The blur of motion on the left of this photo was captured without flash, while the ballerina was moving from left to right. When the flash fired at the end of the exposure, she was momentarily fully illuminated, and the resulting sharp image was the last bit of light captured by the sensor. The result clearly indicates horizontal motion, and was particularly appropriate for the subject.

135

Bounce, Diffuse, or Sync your Flash

A flurry of action

Don't look for too much exact precision when using rear-sync flash—the motion blur is all part of the spirit of the shot. There's nothing particularly sharp in this photo, but the subjects are identifiable and the motion trails following behind the runners' legs communicates motion nonetheless. Now it's time to show off your technical mastery of basic flash techniques. The point is to avoid the dreaded strong frontal light of uncreative, automatic built-in flash and show the range of applications a camera-mounted flash has for your photos. Indoor events will be an excellent place to employ these techniques, as the light is dim and you are surrounded by reflective surfaces that can serve to bounce and diffuse your flash beam. Additionally, you may want to try out a flash accessory, like a diffuser, to soften the direct light and avoid harsh shadows behind your subjects. Finally, if your subjects are in motion, try using your camera's rear-sync feature to communicate that sense of movement while still preserving the ambient lighting.

© Frank Gallaugher

→ Flash for fashion

If you know you'll be needing flash as a primary light source, be sure to bring along a diffuser to prevent every shot from being flat with obvious shadows.

Challenge Checklist

- → You'll likely be in dim lighting conditions where focus is always a challenge. If you can predict where the action will occur, try manually focusing in advance checking that you got it right on the LCD—and then waiting for the action to come to you. Then, when you fire the shutter, there won't be any delay.
- → An external flash unit will always be more useful, but don't shy away from using your built-in flash if it's all you have available—and you can still use diffusers to soften its light.
- → Even if you plan on using rear-curtain sync, a steady hand is important, as it will ensure that the part of the scene exposed by the ambient light still stands a chance of being rendered sharply.

138

Popping an external strobe helps me capture the action in roller derby, a sport often played under difficult lighting conditions. Tracking the skater first and locking focus helps keep the subject clear and up front. Strobe is directly behind me; the skater is right in front. *Kelly Jo Garner*

While the use of flash was necessary for exposure, as indoor sporting events are often low-light affairs, the creative choice to use rear sync was excellent: A regular flash wouldn't have captured the blurred background, but this image benefits from those motion streaks to add a sense of dynamism and movement. *Michael Freeman*

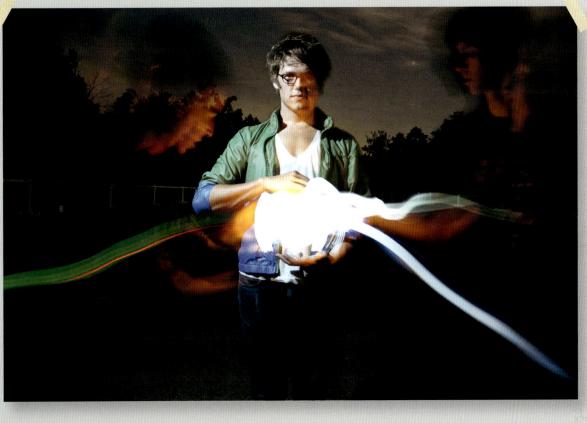

This shot required the coordinated cooperation of several friends. The one in the center remained (mostly) still while the others painted in the glowing orb with LED lights. I particularly like the residual ghost images they left on either side of the center figure. Adam Graetz

Quite a creative use of rear sync. Light painting alone is a fun technique to explore, but by freezing the center subject sharply at the end of the exposure with a flash burst, the image becomes even more striking. *Michael Freeman*

Studio Flash

140

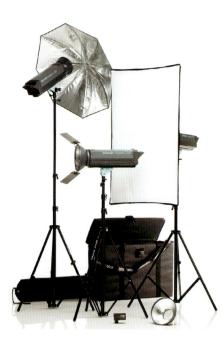

Tools of the trade Professional studio lighting is versatile, powerful, and reliable.

It is also invariably expensive.

Support mechanisms

Elaborate setups can be built by assembling these arms, brackets, and bars into whatever configuration is required. Lights can then be clamped on wherever they are needed.

Whereas on-camera flash is used to make the most out of a difficult lighting situation, studio flash gives you total control over how your subject is illuminated. The trade-offs are obvious: You will need space to set up your flash equipment, and time to test and balance its effect. But for optimal lighting, there is no substitute.

Studio flash can begin by taking your camera-mountable flash unit, attaching it to a tripod or some other light stand, and controlling it from the camera. High-end digital cameras can, in fact, control several external units at a distance, letting you adjust the intensity of each from the camera's LCD screen. But that is, of course, just the beginning. Dedicated studio flash equipment comes in every shape and size, and gives you the ability to choose exactly the right kind of lighting appropriate for the shot.

🗅 Extra reach

Superbooms like these can extend high above a subject, facilitating top lighting without the need for climbing up a ladder.

Winch mechanism

The wheels on the bottom of this stand make large adjustments in position easy—they can be clamped down once placed to prevent them from drifting around.

Try Before You Buy

While the cost of professional studio equipment may seem prohibitive, there are alternatives for photographers on a budget. Some studios will rent lighting setups by the day (or even hour) so you can try out equipment for a fraction of the purchase price. If you're just starting out, this lets you get a feel for which equipment you'd find most useful, without committing to buy.

Lighting Supports

As with all photographic lighting, studio flash units must be precisely positioned according to the needs of each shot. Beyond that, because there is a definite trial-and-error component to working with flash, the units need to be easily adjustable as well. Toward that end, proper and sturdy supports are just as important as any other piece of studio equipment.

1/11

Modeling Light

Calculating and visualizing the effects of studio flash can be difficult, particularly as you add multiple units, because their light can't be seen until the shot itself is taken. Obviously, the instant review option of digital cameras mitigates this hassle to some degree, but professional studio flashes also include a feature to help you see their effects in advance. A small incandescent lamp, called a modeling lamp, is often imbedded in the unit, right next to the flash tube, and it can shine continuously while you set up your shot. They don't always shine at the exact intensity of the flash itself, but they are a huge help in deciding the angle and distance each flash unit should be from the subject.

Typical Studio Flash Equipment

Ringlights

Though technically still on-camera flash, the light from a ringlight is completely shadowless, as it is evenly emitted from all angles around the lens. These are excellent for macro photography, and also portraiture.

High-power heads

So powerful that they often have their own cooling fans built in, high-power flash heads can shine across great distances, or diffuse across a wide open space. They can even compete against sunlight in outdoor setups, and are purpose-built for large shots. In smaller setups like macro, they are usually overkill.

↑ Striplights

Ideal for illuminating large backdrops, striplights produce a very even light along their entire length—usually around 3 feet (1 m).

> Small heads

These discreet flash units can be hidden behind objects within the frame, allowing you to shine light in places where a larger piece of equipment would intrude into the shot.

Continuous Light

These light sources work according to the WYSIWYG principle (that is, What You See Is What You Get). You can observe their effects in real time as you move and adjust them into a proper configuration. This eliminates the guesswork and inverse square law

142

calculations that are necessary in flash photography, and can allow for much more precise and nuanced setups. A lot of this technology was developed in Hollywood, for the obvious reason that a continuous, multiple-frames-persecond movie can't be lit using flash.

Working with continuous lights can be a much more satisfying experience than flash. Because it is a constant presence in the studio, the light tends to take on a more tangible and palpable quality. It starts feeling like a set piece. Additionally, you can walk throughout your setup and observe its effects from all angles, rather than only through the captured image on an LCD screen as with flash.

Any discussion of continuous studio lighting will overlap with much of what we discussed in the pages on artificial light, as these lights are incandescent, fluorescent, or vapor discharge. The difference, of course, is that they are purpose-built for photography, and their color temperatures are precisely calibrated to emit a specific, predictable kind of light.

Light banks

Long fluorescent tubes are well suited to creating large light banks for even distribution of light. They are commonly used in product photography where the product needs to stand alone, without any obvious or distracting shadows. While large-scale equipment like this is probably out of your budget, it's worth seeing how the pros work so that you can mimic their results with the gear you have on hand. A sheet pulled tight across a large window would function quite the same—so long as there is adequate sunlight.

Incandescent

Simple, rugged, and foolproof, incandescent studio lights are the easiest continuous light sources to work with. Their continuous spectrum means they can be balanced to other light sources with the use of filters, and are easily shaped by accessories to offer either soft, diffuse light or a tight, focused beam. However, they do have a significant and even dangerous drawback: heat. On the surface, this can simply be an inconvenience. Portrait subjects can start sweating, makeup can melt, and a long day's work in the studio can get quite uncomfortable. Beyond that, their heat can gradually vellow and char an otherwise white surface like a painted wall; and if extreme caution isn't taken in their setup, they can even set fire to any accessories attached to them. Toward this end, if you plan on working with extensive incandescent setups, safety is essential: Keep fire extinguishers handy, and in a studio, make sure all fire escapes are accessible.

Fluorescent

If designed with photography in mind, fluorescent lamps will include coatings matched to the spectral sensitivities of digital imaging sensors that cast precise, easily captured color temperatures. The long tubes commonly used for this type of light are also ideal for light banks that evenly illuminate a large area—often used for still life and product photography. To augment this natural tendency toward diffusion, concave reflectors can be placed behind a row of lamps to further the spread of light. The other side of the coin, of course, is that fluorescents are not easily shaped into focused, directional light. And while they are much more energy-efficient than incandescents, they tend to cost more up-front-particularly replacement lamps. Finally, they do not emit a great deal of heat, and so the associated worries of dissipation and fire need not be a major concern.

HMI

Vapor discharge lamps designed for photography use Hydrargyrum Medium-arc Iodide (HMI) as the metal salt, and the resulting light is a clean, pure white. This is ideal for balancing with ambient daylight—such that these lights are commonly referred to in the industry as Daylight lamps. They can be powerful enough to use outdoors in direct sunlight, and you needn't worry about their heat dissipation. The nature of their technology, however, requires that they are bulky and cumbersome not to mention expensive.

Lighting Accessories

A studio light source, be it flash or continuous, is just the beginning of light in a studio scene. Between the source and the subject, that light can be manipulated in any number of ways. On page 107, we discussed using reflectors to bounce natural light and fill in shadows. In the studio, large, flat

144

reflectors can be used similarly—in fact, the typical studio is painted pure white, allowing the wall, floor, or ceiling to be used as a reflector. When it comes to studio lighting accessories, however, reflectors take on a different role and allow you to work with a great degree of precision.

r Reflector shapes

Each reflector, mounted to the front of a light source, determines a distinct angle at which that light will shine on the subject.

The parabolic dish works a bit differently from other reflectors, allowing the light source itself to be moved closer to or farther from the center of the shape. The quality of the light changes according to its position.

Umbrellas

Commonly seen in portrait studios, umbrellas use the same principle as bounce light discussed on page 134. The light source is pointed away from the subject itself and into the parabola of the umbrella interior, which reflects that light back toward the subject across a wider area. The result is a softer light, flattering for portraits. The light also takes on the qualities of the material used in the umbrella interior silver for the strongest light, golden for warmth, or white for the softest effect. And just like a rain umbrella, these accessories collapse for easy storage.

• Not meant for rainy weather

Extremely effective at creating soft, flattering light, umbrellas are easy to work with, as their light is diffuse enough that precise positioning isn't as necessary as with other point-source lighting equipment. They do require a tripod on which to be mounted.

Reflector Dishes

Attached directly to continuous light sources, a reflector dish molds the light at its source, preventing it from spilling over at the edges and focusing its output at a definitive angle (commonly called "spill kill"). The reflective inner surface augments the strength of that light, depending on its color—shiny silver produces a strong, hard light; matte white weakens the light, making it softer.

Softboxes

These accessories catch the light from a single-point source within a confined, reflective space, and then transmit it out across a defined surface. They can be quite small, appearing rather like a household shelf lamp, or extremely large, becoming the primary light source and mimicking the powerful but soft, diffuse light of a sunlit window. They can also have any number of materials attached to their front, which will impart certain characteristics or textures to the light as it shines on a subject.

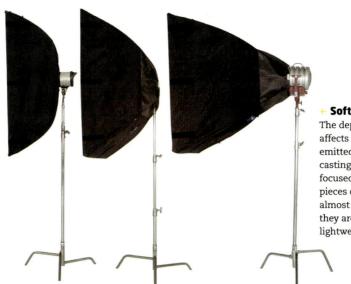

Softbox sizes

The depth of the softbox affects the angle of light emitted, with deeper boxes casting a narrower, more focused light. Though these pieces of equipment look almost comically bulky, they are in fact extremely lightweight and collapsible.

↑ Bigger is better As you might expect, the bigger the diffuser, the more effective it is at spreading out a nice, even light.

Narrow your flash beam

The snoot pictured here is mounted to a flash unit, but they are also available for continuous light sources of all shapes and sizes. This particular model has an extendable arm, allowing you to control the focus of the beam without having to reposition the flash itself.

External Flash Unit Diffuser

A trademark of the paparazzi, these portable accessories attach to an external flash unit to soften the harsh, directional light characteristic of this light source. They still allow the flash to be rotated, and can thereby be used in conjunction with bounce light. While available in a variety of shapes and sizes, the most effective ones are quite bulky, and can be cumbersome to work with in tight spaces.

Snoots

A funny name for a funny-looking piece of gear, the snoot turns your light source into a spotlight, funnelling its light into a narrow beam.

piece source light

© LumiQuest

145

146

LIGHT & LIGHTING

Home Studio

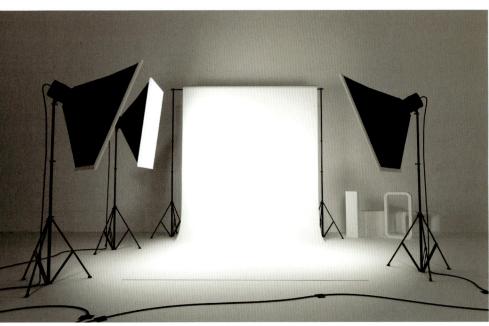

A Typical Studio

It may surprise you how easily you can mimic the results of a giant studio with tens of thousands of dollars worth of high-end equipment. This studio, for instance, is really quite simple: nothing but white, nonreflective surfaces and a few softboxes. Replace the whitewash paint with some bedsheets, set it up next to a northern window (which has the most even light throughout the day), and you're most of the way there.

LIEL JIM

A professional studio can easily cost a small fortune to set up, but they are designed to accommodate any possible assignment and spare no expense in the process. Setting up a small studio in your home need not be such a colossal task, nor is it prohibitively expensive. It is entirely possible to build a highly functional studio on a budget, which will provide you with a great base from which to experiment.

Keep it Simple

It's easy to get lost in the many options for equipment and setup, but when designing your own home studio never lose sight of the most important issue: Control of the light. Studios are all about total creative control, and managing the variables that affect the light is key. Windows are great for natural sunlight, but they should have black curtains to limit their effect. Any colored surface will contribute a color cast as light reflects off of it; but if you're not feeling up to a big paint job, white bedsheets can go a long wayjust be sure they are stretched tight enough to prevent any textural shadows. Overhead lighting can be useful for setting up a shot, but be sure that when it is turned off you still have enough light in which to work. Finally, keep a keen eye out for any other variables that may exist-for instance, even the breeze from a ceiling fan, while irrelevant to the light, can disturb a delicate still life and introduce motion blur.

Improvise

Before you run out and spend your paycheck on high-end gear, it can be a valuable experience to assemble a photo studio with items on hand. Household tungsten lamps can be fitted with quality bulbs of varying intensities to become continuous incandescent light sources—though if you are using multiple lamps, be sure the bulbs are of the same make and model. Bedsheets can be backdrops, and posterboard can be used for reflectorsparticularly if you wrap one side with aluminum foil. Experiment with what you have available, and see what you can achieve-but of course, safety always comes first. Don't get anything too close to your lamps, and if anything starts feeling too warm, cut the power and let everything cool off.

Equipment

When you have experimented with improvised setups enough and are ready to commit to buying your own professional equipment, start small and make sure you make the most of each piece of gear. If you feel comfortable with the nuances and calculations involved in flash photography, external flash units are a good place to start. For one, they are useful out of the studio as well, as they can be mounted to the camera and taken on the road with ease. Also, many DSLRs act as a fully functional control panel, allowing control of multiple flashes by infrared or radio waves. You will still need to acquire quality tripods with flash mounts, of course, as well as some diffuser accessories.

If you plan on making your home studio a dedicated photographic space, however, it pays to take the dive and start purchasing professional continuous lights. As with most things, you get what you pay for in the world of photographic lighting, so the particular type of lamps can correspond to your budget. Two lamps is a good place to start, as together they offer you an enormous range of possible lighting setups. You will also want a way to diffuse them, so at least one softbox or umbrella will let you achieve any soft light required by your subjects. A roll of black cinefoil is also an inexpensive and extremely versatile tool that will let you mold the light exactly the way you want it. Cinefoil is made of completely nonreflective material, and feels rather like aluminum foil, meaning it can be bent and formed into any shape you require. Roll it into a simple tube, attach it to the end of your flash, and you've got a

snoot. Mount four separate sheets on the sides of your continuous lamp, and you've got barndoors. It can also serve as an ideal backdrop, as you needn't worry about any distracting reflections.

Still-life setup

Still lifes are an excellent subject to shoot when you're first starting your studio, as inanimate objects are considerably more patient than models in costume and makeup. This simple setup uses a large softbox positioned above and to the left of the figurine, which is then balanced by placing a small reflecting card very close on the right.

Finished miniature

After some light postproduction work, the finished shot is worthy of inclusion in any fine-art catalog. LIGHT & LIGHTING

Positioning the Light

With a thorough understanding of all the different sources of photographic light, you can now consider their use in composing a shot. No longer limited to a single light source (be it a built-in flash or the sun in the sky), you must think in a three-dimensional, comprehensive manner, and choose both the angle and intensity of the light as it falls on every side of your subject. Using the diagram on the opposite page, you can imagine an infinite variety of lighting setups. The key is to decide which is best for the scene you want to create. Do you want to accentuate texture and add drama with a strong side light? Or do you want to completely eliminate shadows by combining diffuse frontal light and backlight, making your subject appear free floating and weightless? While experimentation is essential, and can indeed be a lot of fun, you will save yourself hours of work if you decide in advance what you want to achieve, and then calculate an appropriate approach to that end result.

148

Frontal Light

We know from our discussion of built-in flash that this is the least flattering angle of light, chiefly because the resulting lack of shadows means our eyes have no reference for depth, and the subject appears flat and dull. However, frontal light is invaluable in combination with secondary or tertiary light sources, wherein its obvious directionality makes it easy to adjust in order to balance the other lights.

Three-Quarter Light

The most common lighting position of all, three-quarter light has the source slightly above and to the side of the camera. From this angle, light can lend a sense of depth without casting obvious shadows. Building on this fundamental setup, you could add a second light at a three-quarter angle on the opposite side of the camera, and adjust the intensity of each to achieve a precise balance. Then you could add a reflector underneath the front of the subject to bounce up the light from the two sources, filling in any unwanted shadows.

Right-Angled Light

Light shining directly on the side of your subject will cast shadows across the frame, unless it is balanced by a stronger frontal light—excellent for revealing textures, but distracting in most portraits.

Backlight

Alone, backlight gives you silhouettes and edge lighting. But balanced with a frontal light, backlighting can give your subject a well rounded appearance, excellent for emphasizing contours.

- Classic portrait

The three-quarter setup described above was used for this portrait subject. By making the right light slightly stronger than the left, a hint of shadow is cast across the left side of her face—just enough to add a sense of depth.

POSITIONING THE LIGHT

Lighting in the round

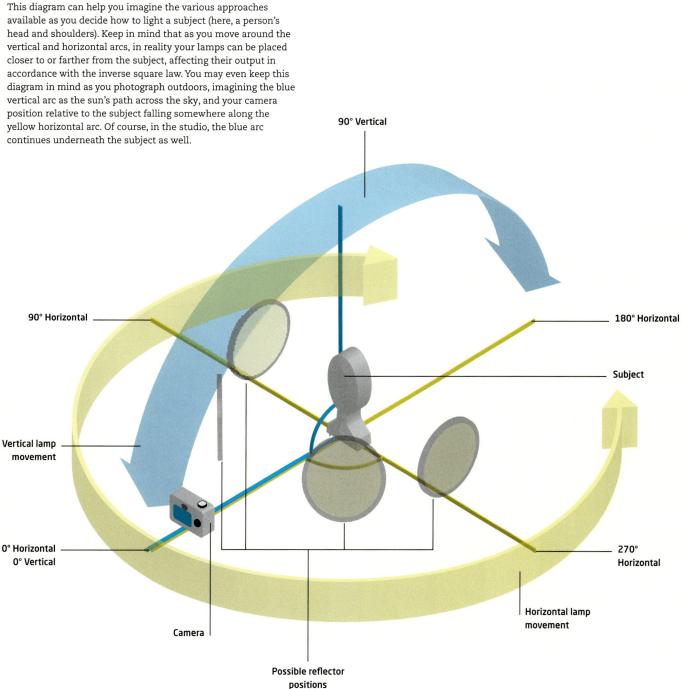

149

Light a Portrait

An engaged subject

What was in fact a carefully set up outdoor shot will appear candid and spontaneous with the judicious use of diffusers and fill flash. We've discussed portraiture in several places already, and you may have taken a portrait or two for some of the previous challenges. This challenge, however, is all about specifically setting up and controlling the light for a portrait. This may not necessarily mean you need to build a studio and coordinate multiple

different light sources—you may want to use the soft light of a northern window to naturally light your subject. The point is to think specifically about light in terms of portraiture, and to position your subject in that light so that they are captured flatteringly.

nring off to the side

iture is just as much positioning your model s about positioning your —indeed, what was a ight becomes a frontal or -quarter light as soon as model turns their head.

Challenge Checklist

First off, you'll need a portrait model. With any luck they'll be patient while you experiment with different angles and adjust your lights.

Keep your model comfortable and at ease while you are vorking. Conversation goes a long way toward making them relax, and a relaxed model will always photograph better than a nervous one.

While diffuse light is usually the name of the game, if you feel the urge to try out some more iramatic lighting such as a strong side ight for a dramatic shadow—indulge that creative instinct.

Review

I used a Nikon SB-800 strobe off to camera left without a diffuser to create some very dramatic lighting that would accentuate the model's left half, creating a stark, vertical line to divide the frame. Adam Graetz

While going against normal, flattering portrait lighting, it works because of the urban setting. Definitely an edgy and striking shot—supported by the composition, with the subject's face at the vanishing point of several lines from different angles. *Michael Freeman*

153

© Jennifer Laughlin

This photo was taken at a fruit/ veggie stand late in the afternoon with a Nikon D300 and overcast skies as my only light. I used a giant reflector card to get the fill on her face. Jennifer Loughlin

A good decision to break out the big reflectors, to avoid the usually drab effect from an overcast day. It takes a bit more effort and planning, but it's well worth it for reliable results, like this pleasant portrait. *Michael Freeman* LIGHT & LIGHTING

Soft Light

154

Be it from sunlight diffusing through clouds, flash bouncing off an umbrella, or multiple incandescent lamps evenly illuminating an interior space, soft light is characterized by its lack of obvious directionality and the evenness with which it illuminates a subject. Indeed, soft light is most effective when it is hardly noticeable at all—which is to say, when the light itself is not an essential compositional element of the photograph. First, let's look at how light is transformed from hard to soft, and then explore the right times to use it. Light almost always originates from a point-source, meaning there is a single point from which the light radiates outward. Because of the nature of light to travel in a straight line, this means that the direction from which the light is shining becomes obvious as it falls onto a subject; the shadows will all orient at the same angle, and the viewer's mind is keenly able to reconstruct where the light originated. Decreasing this obviousness so the light seems to come from all around is the essence of soft light.

To achieve this, the simplest method is to introduce distance between the light source and the subject. As the light travels across a greater distance, it has more time to spread out. You can observe this in large interior spaces, where a strong point-source light hanging from a tall ceiling can evenly illuminate the area below it. However, each individual beam of light is still traveling in a straight line; it can't turn around a corner to shine into crevices or give a rounded quality to smooth contours.

And this is why we have spoken so much of diffusers and reflectors throughout this section. Introducing a translucent material (a diffuser) between the light source and the subject will scatter the vectors of light, such that they are no longer all radiating out from a central point. What was a series of straight lines becomes a jumble of different angles of light, some of which can illuminate one side of the subject, while others from a different angle can light the other side. In effect, the light can now turn those corners and fill in every shadow, resulting in an evenly lit subject. Reflectors, working from the other side of the subject, achieve the same thing-reflecting the light so it can shine into spaces that would otherwise fall into shadow.

Diffuse close-up

With no harsh shadows to give obvious directionality to the light source, this bundle of flowers seems to float effortlessly, and at this close distance one can imagine that they go on endlessly outside of the frame.

155

It is also worth noting that, in terms of exposure, soft light is much easier to work with—provided it is properly set up for the scene. By its nature, this lighting style is low in contrast, meaning you have quite a bit of room to maneuver between the highlights and the shadows. It is still important to make sure that your mid-tones fall at the center of your histogram, but you needn't worry too much about the dynamic range exceeding the capabilities of your sensor.

Soft Light for Portraits

When you remember a human face, you are recalling its shape, the position of its features, its complexion, and so on. The image in your mind does not include deep shadows under the eyes, or a single bright beam of light across a forehead, because such elements are not an inherent part of the face itself. Generally speaking, most portraiture seeks an idealized representation of the subject, in which the person's face is allowed to speak for itself. You would no more let a distracting shadow obscure half of their face than you would let them wear a ski mask for the shoot. It's all about showing them in the best possible light, which for portraiture, is soft light.

Because it can shine around corners and doesn't accentuate hard edges, soft light hides wrinkles and helps your subject appear if not younger, then at least less weathered and aged. Likewise, you must position and diffuse your lights such that their eye sockets are just as illuminated as the rest of their face, and their chin isn't casting shadows down along their neck and chest.

Simple softbox setup

This classic head-and-shoulders portrait, softly lit from the right by a softbox, just barely indicates the direction of the light with subtle shadowing on the left side of the face—just enough to add depth to the image without obscuring the face or becoming distracting. 156

LIGHT & LIGHTING

Enveloping Light

Taken to the extreme, soft light can be set up to completely surround a subject, bathing it in total, diffuse light that fills in every nook and cranny, eliminates every shadow, and makes the subject appear lightweight and buoyant. This enveloping light is a particular style, and not necessarily suitable for all subjects. For instance, you may think that if soft light is ideal for portraits, then completely suffusing your subject in an abundance of soft light is all the better; but that can too easily result in overly surreal and unrealistic portraits. Keep in mind that enveloping light is rarely found in nature, and your eye will recognize it as exceptional.

That said, there are many cases when enveloping light benefits a subject, and it is a useful tool when dealing with particular lighting problems. For instance, if you are photographing a highly reflective object, it may be impossible to set up the shot without having studio equipment appearing in the frame, reflected off the object's surface. For this reason, enveloping light is often used for still lifes and close-up shots.

The easiest way to cover a subject from all angles with soft, diffuse light is to use a light tent. These lighting accessories are a simple affair, and involve surrounding the subject with a diffusing material of some sort—white fabric is the most common, but any translucent material will do. Arranged correctly, the light tent will diffuse any light coming from outside the frame, meaning you can use point-source

lights and move them freely around the set until the desired effect is achieved. The lights must be positioned far enough away that they do not create perceptible hot spots on the tent's surfaces, but still close enough to give enough illumination for an adequate exposure. This is particularly important with macro and close-up photography, which often use narrow apertures for an abundance of depth of field, at the expense of available light. Additionally, once the light is diffused inside the tent, it continues to reflect across all the interior surfaces, further evening the spread of light on the enclosed subject.

←↓ Home- vs ready-made

The definition of a light tent is not strict; any structure will do so long as it results in a complete diffusion of light from all angles in its interior. The portable light tent below, designed by Creative Light, collapses down for easy transport into the field, and comes with a selection of translucent backdrops that can attach to the interior with Velcro.

© Creative Light

Light tents aren't limited to studio work, however. They can also be set up in the field, where they can diffuse otherwise harsh sunlight. This is particularly suitable for capturing small insects or flower specimens as you encounter them in the wild. By surrounding them in artificial material, they will lose their sense of environment; but the effect can also evoke the classic look of natural history illustration, with its clean, idyllic portrayal cast against pure white. Light tents in the field may also simply be a necessity for capturing subjects that you could not otherwise move into the studio—for instance, many gardens don't look kindly on you plucking out their prized orchids or stealing their wildlife.

Improvised light tents are simple enough, you need only a clean white sheet and a stand from which to hang it. Circle the sheet around the subject, and poke your camera through the slit where the two ends meet. However, for best results that avoid any textured surfaces, a dedicated light tent is the way to go. These come in a variety of sizes, and are collapsible, making them much easier to take in the field.

No reflections

Anything less than completely encircling this gold bar with diffuse light would have resulted in clearly visible reflections of the surrounding studio equipment in its shiny, polished surface. For contrast, a black backdrop was used at the base of the light tent.

Precious stones

These gems, shot from directly above and scattered across a white velvet background, still indicate a slight directionality of the diffused light coming from the upper left, but only just enough to give them a sense of place and show off their polished surfaces with a slight glare. The velvet itself was dense enough to soften and absorb most of the shadows.

Bathe your Subject in Soft Light

Uynamic B&W

High-key enveloping light is another lighting style that is well suited to black and white, as your eye doesn't mind and even expects to see large areas of uniform white. For this challenge, you really want to go over the top with soft light, and envelope your subject in it as much as you can. This will lend itself well to the use of a light tent, discussed on the previous pages, which will let you evenly distribute light all around your subject without hassling with a number of different diffusers and reflectors. However, in the right conditions, you may be able to find an abundance of available soft light out in the field. Wherever you find your soft light, use it to show off the subject in all its glory, completely illuminating every surface and eliminating as many shadows as possible.

A light touch

Food dishes often benefit from a full, enveloping light, as there is something unappetizing about heavy shadows falling across your plate.

Challenge Checklist

- → Diffusers, reflectors, and/or a light tent will help with still-life subjects, and you should try to highlight the natural colors, shapes, and contours.
- → You may try for an ethereal portrait much like the previous challenge but striving for even more diffusion of light.
- → Or you can try thinking big and search out a full landscape on a heavily overcast day, perhaps using mist or fog to further diffuse the light and add a mystical quality to your image.

I used three hot lights with magenta gels to light the white wall for the background. I clipped the rhubarb at the end with a backdrop clip to make it stand up. After setting this up there was one hot light with a diffuser placed to the right front of the subject. White reflector cards were used to achieve the even lighting. Jennifer Laughlin

The minimal shadows work well here, giving just a hint of modeling to the (distressed!) rhubarb. I also like the classical counter shading between the rhubarb and the background. *Michael Freeman*

Review

This was an improvised macro shot. I found this dead but perfectly intact butterfly on a particularly cloudy day, scooped it up on a sheet of white paper, and photographed it right there on the sidewalk. There's still a bit of shadow along the left side, but considering the quick setup, I think I got pretty lucky with this one! *Sven Thierie*

A good testament to the usefulness of the soft light cast by an overcast sky—these results are pretty close to what you'd get with a light tent in a studio. And the soft shadow helps lift the butterfly. *Michael Freeman* LIGHT & LIGHTING

Hard Light

162

If soft light is the absence of obvious lighting effects, it follows that hard light establishes in a photograph a prominent and palpable presence of light in the scene. This is when light takes on a material quality, either in its strong reaction to a subject or as a compositional element in itself.

Hard light generally indicates a lack of obstruction between the light source and the subject—no clouds, no diffusion screens, and no reflective surfaces bouncing the light around. Light strikes the subject at a definite angle, indicated by shadows falling in a common direction. Thus, it becomes apparent that hard light is just as dependent on the subject as it is on the source itself, for if the subject offers no edges or contours to cast shadows, there is no way for a photograph to indicate the directionality of the light.

By definition, hard light is going to increase the contrast of a photograph. Some areas of the frame will be brightly lit, with others falling into dark shadows. Careful calculation of proper exposure is therefore all the more important, as the higher dynamic range means you must keep a close eye on the histogram to ensure that your sensor captures detail throughout the full range of light intensities. On the other hand, you can make a creative decision to accentuate this contrast by completely losing detail in the shadows or highlights (or both). We discuss this chiaroscuro approach in the following pages.

Finally, because hard light gives the eye more clues as to the direction of the light source, it also gives a photograph a corresponding sense of time and place. We discussed the flattering aspects of golden light on pages 114–115. Whether you realize it or not, you recognize long shadows as occurring early or late in the day.

→ **Georgian lighting** Architecture often benefits

Architecture often benefits from a hard light, where it throws structural elements into harsh relief and accents the design of the building. For instance, the circular orientation of the Circus in Bath, England is accentuated here, where hard, angled light progressively falls into shadow as the building curves around up and to the left.

© Frank Gallaugher

163

Graphic Design

By emphasizing hard edges and bringing shapes into stark relief, hard light gives you the tools for creating photographs that emphasize form and design over content—meaning they are less about an accurate rendition of the subject itself, and more about lines, shapes, colors, and contrast. Letting the geometry of the composition take precedence over its underlying subject can give a surprising, exciting, and energetic feel to your photography.

This style requires you to see past the face value of a scene—to deconstruct that scene, as it were, into its constituent parts. Where a casual observer may simply see the side of a

Gobos for Patterns

You can add a graphic or textural quality to the light yourself by using a type of stencil called a gobo, which stands for GOes Before Optics (they are alternately called cookies or flags). These patterned screens throw a certain shadow onto your subject, depending on their design. They occur naturally as well—you can consider the skyscraper, the graphic stylist sees a line of repeating squares, angled at a diagonal from the low perspective, with beams of light cutting through a neighboring structure and punctuating the building's surface with negative space. Telephoto lenses often help with these kinds of photographs, as they can isolate particular elements out of their natural surroundings, which can assist in discarding the material subject's preeminence. Seeing the world this way can become quite addictive, and while it is hardly appropriate for every subject, it gives you the chance to infuse even the commonplace with a dynamic and robust style.

Texture designs

A small sample of different gobo designs. These can be small enough to fit on the end of a flash unit, or large enough to cover a window.

1 Molten light

There are two gobos at work here: the window frame is casting the strong, crisscrossed lines diagonally across the frame; and the imperfections in the glass are changing the quality of the light itself into a wavy, fluid pattern.

Shapes, lines, and shadows

In viewing this image, your eyes register the design elements first: obvious diagonals, permeated and reinforced by verticals, all reflected symmetrically across a horizontal axis. These elements were emphasized in postproduction by increasing contrast and clarity. Only secondarily does the reality of the subject itself come into play.

LIGHT & LIGHTING

Chiaroscuro

Shadow play

Black-and-white photography lends itself well to the chiaroscuro lighting style, as your eye concentrates only on the subtleties of gradation from light to dark without getting distracted by color.

A beautiful Italian word for a beautiful lighting style, chiaroscuro literally means light-dark. It is a Renaissance art term, pioneered by the painter Caravaggio, in which shapes are created not by outlining their edges, but by using subtle gradations of light and shade to create rounded, threedimensional forms. By nature of its high contrast, it is a type of hard light, but a very delicately implemented one. A single, point-source hard light will fall off too sharply at the edges of a shape, and the definitive lines it casts are not the defining characteristic of this lighting style.

Rather, chiaroscuro is something of a balance between hard and soft light. It must be hard enough to cast deep shadows, in which you may choose to completely lose all detail and create large blocks of black, out of which the subject rises. And it must be just soft enough that the edges and contours of the subject are apparent, with the light gradually falling from the highlights off into the shadows.

Mood and drama are inseparable from chiaroscuro lighting. An otherwise mundane still life of a bowl of fruit on a table will, when set against a pureblack backdrop with obvious side lighting, take on a timeless and painterly quality. It can also contribute a sense of dread and foreboding, as the mind is forced to speculate as to what may lurk in the deep shadows that constitute a large part of the composition. Consider the lighting style typical of film noir, for instance, where the cynical and deviant themes of crime drama were illustrated by consistent chiaroscuro lighting, making a half-lit character appear shifty and untrustworthy, and the shadows cast across a room insinuate foul play and hidden agendas.

In the studio, chiaroscuro lighting is relatively simple to achieve, as it embraces the contrast and deep shadows that other lighting styles seek to eliminate by employing copious diffusers, reflectors, and multiple light sources.

For the simplest setup, place your subject against a black backdrop, and light it from a three-quarter angle with a strong point-source lamp with a diffuser attached. The light will reach the backdrop at different distances, creating a gradation from light to dark against which your subject can stand out.

Depending on the effect you want to achieve, you may rotate the backdrop so it isn't perpendicular to the camera, which will create a gradient along the length of the background itself.

Metering a chiaroscuro setup can be tricky, given the abundance of contrast. Spot metering off the highlights is the simplest approach, provided you want to lose detail in the shadows. That said, it is often a safer bet to capture as much detail as possible throughout the dynamic range of the scene, as shadows and highlights can always be pushed down or blown out in postproduction. Try spot metering first off a shadow, then off a highlight area, and use your camera's exposure readout to find a happy medium between those two extremes.

Dark profile

Chiaroscuro works well with profiles, and the setup for this shot couldn't be simpler: A single light source shining from upper left, and a distant, pure-black background that's not picking up any detail at all. The weathered, textured face and beard of the subject suits the lighting style, giving lots of detail in which to see the progressive darkening of tones as the light falls off.

Emerging from the dark

To capture chiaroscuro lighting outside of the studio, keep an eye out for single light sources in otherwise dark environments. This painter was working by a small spotlight during an intimate music concert, and by spot metering off the canvas, the surrounding falls off sharply into shadow.

Kick It Up a Notch with Hard Light

Dune shadows

The dynamic range between the sun-facing right side of the dunes and the shadows on the left required a careful exposure, with one eye firmly on the histogram. For this challenge, you should embrace a strong, directional light source and feature its effects at the forefront of your photo. As you've seen on the previous pages, there are a few different approaches to making the light a preeminent element of the image—you can zoom in on particular detail and compose the shot so that it has an obvious graphic quality, or you can spotlight a subject and experiment with the delicate craft of chiaroscuro lighting. If you have the time and control, try cutting out your own gobos and capturing their effects as their shadows fall on a particular subject.

→ Salisbury in the sun

On angular subjects like buildings and towers, you'll easily see the contrast created by hard light, which fully illuminates one side while letting the other fall into shadow. Rather than battle this effect, I even upped the contrast in post-production to exaggerate it a bit, as it adds to the grandiosity of this subject.

Challenge Checklist

- → You'll need to start, obviously, with a hard light source. If you're setting up the shot, this can be a straightforward lamp of any variety.
 Otherwise, mid-morning and late afternoon will give you plenty of long, dramatic shadows to play around with.
- → Watch your exposure, as always, but don't be afraid to let some of your shadows block up into pure black if that's what you envision.
- → This might be an excellent time to try your hand at black-and-white photography, as it speaks completely through light alone and doesn't let your viewers (or you) get distracted by irrelevant color information.

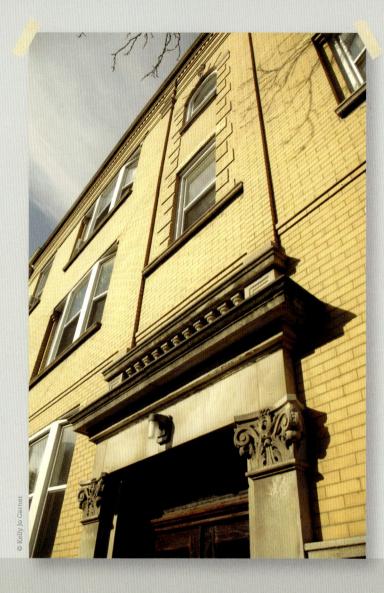

On my second trip to Chicago, I was fortunate enough to stay with an old university friend in the Boystown district. His building was luminous in the early morning light when I snapped this shot. Kelly Jo Garner

Shooting at this angle to the light makes the most of the shadows and catches some reflection from the brickwork, enhancing contrast. I'd suggest cropping the top to lose the branches and capitalize on your treatment of the architecture. *Michael Freeman*

168

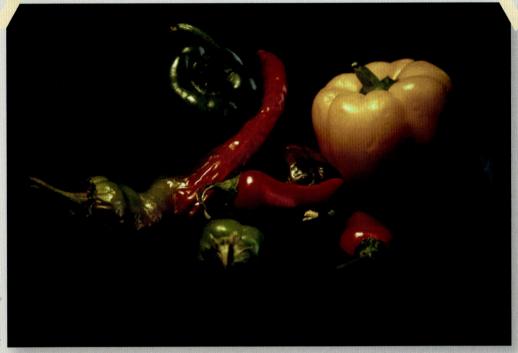

This photograph was shot using a "painting with light" technique. Using only a flashlight, I set up a shot of these vegetables, turned the lights off, and "painted" the subject with a flashlight. Jennifer Loughlin

A successful experiment. Lighting painting is definitely one technique that you can expect to deliver chiaroscuro. Digital cameras certainly help by giving instant feedback, as you're literally working in the dark and the results can otherwise be difficult to predict. *Michael Freeman* LIGHT & LIGHTING

170

Side & Edge Lighting

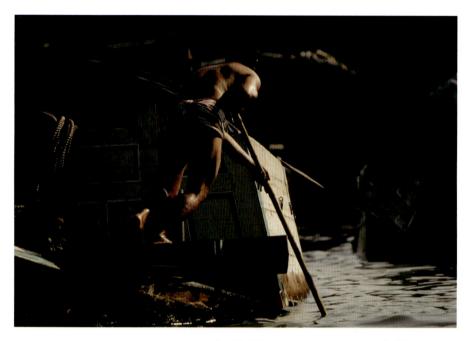

Leaning into the light

The distant setting sun serves as a strong edge light cast against the side of this boat, and molds around the contours of the sailor's taut muscles to communicate his physical exertion.

> Side-lit Luxor

The monumental form of the columns and statues is best brought out by the strong side lighting of the rising sun. A careful exposure was required to keep detail in the shadows.

The long shadows typical of strong side lighting are evocative, dramatic, and highly effective at showing off fully rounded shapes. This lighting style is most apparent when the light source is shining at an exact right angle to the camera axis; but you can experiment with slight variations on that angle to see how the light interacts with your subject. It may be necessary at times to fill in strong shadows, which is often an easy task and requires only a reflector on the opposite side of the light.

As a point-source side light moves farther away from the subject, it gradually dims such that only the very edges are illuminated in a sort of outline. This is when side light becomes edge lighting, and is most effective with dark backgrounds that won't compete with the thin slivers of illumination. Likewise, it is best if the edge light doesn't have to compete with any other ambient light sources. Generally speaking, the simpler the shape and contour of the subject, the cleaner and clearer its outline will be when edge-lit. Too many different elements at varying distances to the camera will each pick up their own edge light and obscure a clear, underlying shape.

Texture

Being a two-dimensional representation, a photograph must use a number of tricks to communicate depth. Chiaroscuro lighting does this with very fine gradations of light to dark, which is excellent at communicating full shapes and figures; but textures are a much finer and smaller affair, and require strong side light at a very shallow angle to the subject's surface in order to cast a myriad of tiny shadows on a micro scale.

Toward that end, getting closer to the subject, either physically with a macro lens, or by zooming in with a long telephoto, makes it easier to discern the fine textural details brought out by a strong side light. Emphasizing texture also helps render a common subject in a more interesting way—what may look like just another concrete wall can, in the right light, reveal intricate patterns of crumbling masonry, chipped paint, weathered surfaces and so on.

Texture from afar

As distance between the subject and camera is increased, the intensity of the side light must also be increased if there is to be any discernible texture in the image. A diffuse light would have lost all the sharp detail in the blades of grass in these rice terraces.

Grandiose doorway

There are two types of shadows here: the larger, graphic one cast by the enormous doorway; and the infinite tiny shadows falling in all the indentations in the surface of the wall. A frontal light would be unable to illustrate those fine textural details, and the wall to the right would become an uninteresting component of the composition. As it is, however, you feel quite as if you could run your finger across the page and feel each groove and bump.

Bring Out the Texture

Pastel close-up

Contrasting colors can impart a textural quality to a photograph all their own, and often the side lighting does not need to be terribly strong in order for them to take on an effective, threedimensional appearance. Most subjects can be said to have some degree of texture, but it's not always easy to capture it in every lighting condition. Strong side lighting will be the most apt lighting style for this challenge, which you can create in the studio, or find out in the field—either from artificial lamplight or from a low-angled sun early or late in the day. But unlike your challenge to capture golden light, the lighting itself is not the most important element of this challenge; rather, it's all about finding the right subject that will show off its three-dimensional qualities and come alive under the right conditions.

72

→ Love locks on a bridge

Bringing out the texture often means taking something that might otherwise be busy or overly complicated and making it the center of attention. This would have been a terrible portrait backdrop, for instance, but as a subject in itself, this wall of padlocks gives the eye a myriad of nooks and crannies to investigate.

Challenge Checklist

- → Macro and close-up shots lend themselves well to textural studies, and you can add a side light by either positioning a lamp in the right place, or by using an external flash unit attached by an accessory cord, which you can hold with one hand off to the side.
- → Longer, telephoto focal lengths are the natural inclination for textural shots, but keep in mind that most wide-angle lenses let you focus quite closely as well, and you may be able to get an interesting composition that pits large foreground elements against an expansive background.

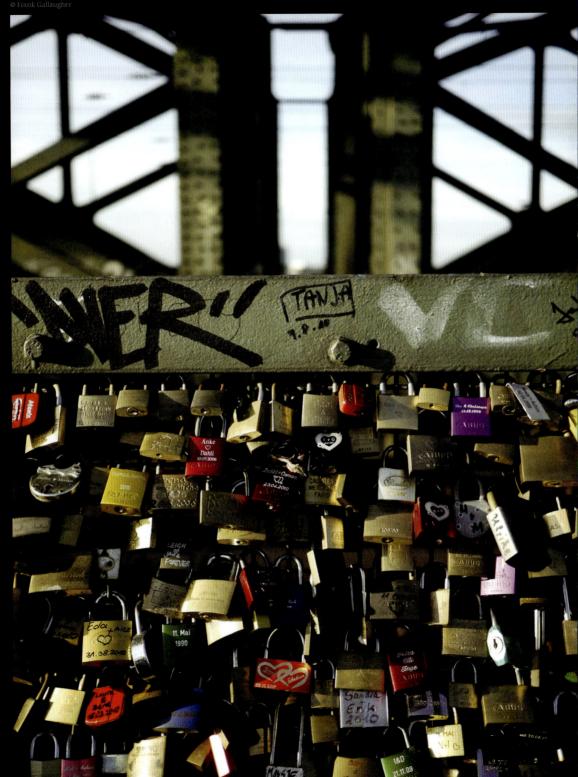

174

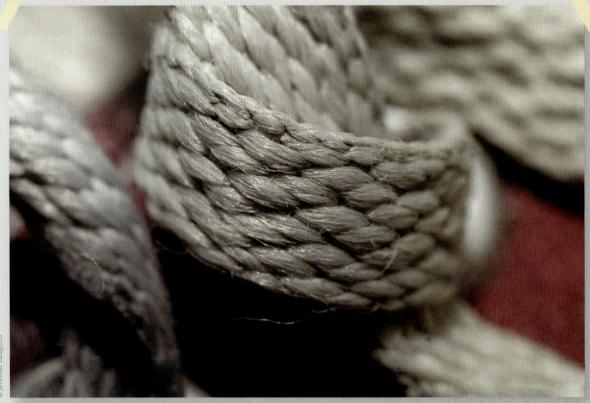

This photo was taken using a 55mm macro lens with an extension tube. Lit from the left of the subject with an external flash unit on an extension cord. Jennifer Laughlin

You've got the off-camera flash in just the right position (left and above) to show the texture of the part in focus-not too hard and raking that the shadows are dense, but enough to reveal each strand of fiber. Michael Freeman

175

I do a lot of urban exploration, always with my camera in hand. This abandoned machinery, with its peeling paint and coat of rust was a great find—and the light coming from the side gave it just enough microcontrast to bring out the details. Adam Graetz

Very attractive lighting! The slight pooling of light with shading on the lower right seems perfect for this machinery. Good location finding, as well.

Michael Freeman

Personal Lighting Styles

176

While a competent photographer is familiar with all the different lighting styles and equipment, they are unlikely to use all the skills and techniques discussed throughout this book in equal measure. It is only natural that, over time, they feel more and more comfortable working in a certain medium, and gradually that familiarity can blossom into their own unique lighting style. Sometimes it's called a "look," sometimes it's just a certain consistency across their portfolio (a quality much desired by many clients).

Some photographers call themselves "natural light photographers" and never touch a lamp or flash unit, seeking only to capture the undisturbed lighting conditions as they are found in the field. Others are dedicated strobists, always on a quest to bend and manipulate the light to their own end. Regardless of how it takes shape, a personal lighting style is the natural next step after learning all the concepts we've covered so far.

Developing a personal light style can seem intimidating to those newer to photography. The notion often encourages comparisons with photography masters who engage lighting in highly individualized and stylized methods. But a personal lighting style doesn't have to revolutionize the whole world of photography; in fact it rarely does. The key is simply to keep it personal, consistent, and loyal to your own vision—this is about what motivates you to take photographs.

The fact is that you already have a photographic style whether you are aware of it or not. Find it, embrace it, and explore it to its fullest potential.

Shaker box

It's important to keep in mind the importance and relevance of color when thinking about your lighting style. Sometimes this means anticipating and visualizing what the results will be, particularly if you want to stray from a perfectly accurate representation of the scene.

Drawing Inspiration from Others

Other photographers can work to inspire your own style, although ultimately they should inform rather than dictate your approach. In particular, studying the work of others will help you understand the kind of style you are most drawn to, and this will help you settle on your own approach. It may be as basic as realizing which times of day give you the most appealing light, or as complex as delving deeper into how a photographer sets up their lighting rig. Browse through your photography books and magazines, and when a photo strikes you, take the time to study it. Where is the light coming from? Do you think they stumbled upon this shot, or did it require some particular piece of equipment? Probing beneath the surface of the image will spark your imagination and encourage you to experiment yourself.

Colors and shapes

The studio is an excellent place to experiment with your lighting styles, as you can move at your own pace and have complete control over how the light affects the image. 177

Find Your Own Personal Lighting Style

Low-contrast mist

A personal lighting style will be adaptable to each different subject that you encounter. For instance, this high-elevation shot was kept at very low contrast in order to preserve the dreamy and ethereal qualities that I found significant at the time. This challenge, coming at the end of this book, is really just the beginning the quest to discover your own unique lighting style will continue throughout your photographic career. Consider it a push out into the open. Take what you've learned and delve deeper. If you like arranging lighting rigs, try experimenting with building a grand setup and see what effects you can create. Maybe you want to explore different color casts for different subjects, and push the limits between representation and reality. You've learned a lot of rules in this book, and now that you understand their roles and why they exist, feel free to break them if that's what you need to do to achieve your vision.

Catching the light

In lively city environments, I often embrace a highcontrast lighting style, as it communicates the excitement and energy of the scene as I remember it.

Challenge Checklist

- → Feel free to break the rules, but do so with a purpose in mind.
- → Don't be afraid to fail; just be ready to try again.
- → Feel free to take inspiration from other photographs—but build on them or interpret them yourself.

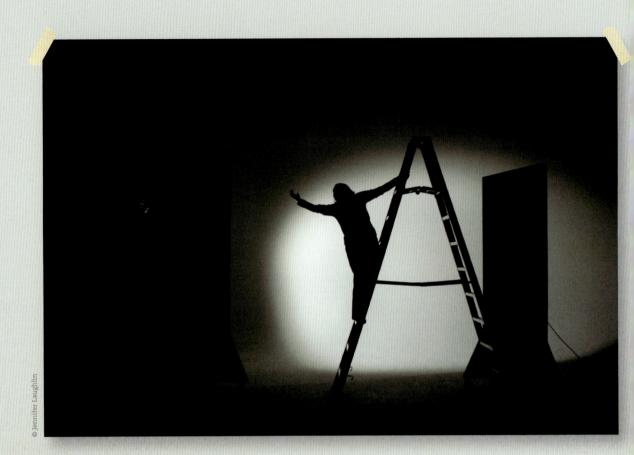

This was my setup for my Biocommunications portrait project. The assignment was to have our subject pose in 12 different positions (six masculine & six feminine). This was taken with a Nikon D200 using hotlights. Jennifer Laughlin

Everyone can appreciate a bit of meta-commentary on photographic lighting. This is a great spotlit silhouette, with interesting props and a main subject in a captivating pose. *Michael Freeman*

LIGHT & LIGHTING

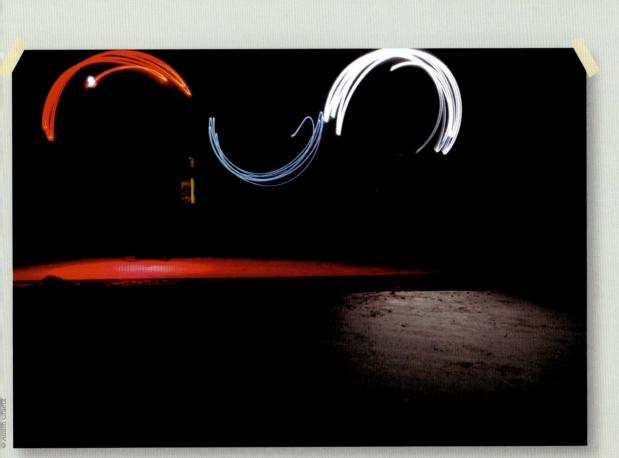

Here I wanted to experiment with different-colored LED lights, and tried to keep their painted shapes as defined as possible. It took several tries—fortunately, digital makes this kind of experimentation very easy (and quite enjoyable). Adam Graetz

Light painting is a lot of fun, and with practice it gets easier to predict and control the results—definitely a worthwhile style to explore. I particularly like the compositional balance between the curved painting in the upper part of the frame and the spotlight in the foreground. *Michael Freeman*

REVIEW

COMPOSITION

182

Like so many other creative pursuits, photography is the fusion of creative vision and technical skill in order to produce something beautiful. One without the other might produce a good photograph, but the chances of it being great aren't so high. Someone who understands precisely how their camera operates and knows the physics of a perfect exposure, but can't imagine how a scene will look in their mind's eye, or cannot spot the moment that will make a photograph, will struggle to produce a meaningful image. Likewise, it's all very well being able to envision the perfect photograph, but if your technical ability doesn't allow you to translate that to reality, then you still won't have an image.

Bringing together these two aspects of photography is, for many photographers, part of the medium's appeal. The challenge to produce the perfect image is ongoing; it involves the constant search for the ideal subject and the perpetual acquisition and development of skills and knowledge. Photography is inspiring and demanding; it is fun and it can also be frustrating. It is definitely eye-opening.

Ask any photographer if they have ever taken a perfect photograph and the answer will likely be "no." The perfect sunset photograph is always just over the horizon. But we are always striving for it. What this means then is that the critical factor behind any photograph is always going to be the photographer; it won't be the camera. It's easy to get caught up in megapixels and sensor sizes and processor capacity, but they mean nothing without the person clicking the shutter. Seeing as you're reading this book, that means you. Your photographs are the result of the application of your technical skill to your creative vision.

Although ideally you've recently acquired your first DSLR—maybe a 50mm prime lens, too—and are keen to make the most out of it, composition pertains to every photographer using any type of camera. Most of what's in this book will apply to you and your photography regardless of the camera in your hands. It won't matter if you're snapping something with the camera in your mobile phone because that's what you have to hand, or if you've progressed to the dizzying heights of a medium-format camera: The theories behind composition remain the same, and they are the foundation of taking stunning and meaningful photographs.

← Saffron skins

Beyond shapes, lines, and framing, composition is also about how you capture color and texture.

183

A photograph is your interpretation of an event or scene; it's your expression of a story. Consequently, the basis of a good photograph is its composition, or how you—the photographer—bring together everything that you are trying to say and relate it effectively as a whole. If a photograph is a narrative, then it relies on a strong composition to be conveyed.

Just like photography itself, composition is the synthesis of the technical and the creative. It's where geometry and artistry collide head on and in the resulting explosion they make something gorgeous. If you haven't studied math since high school and the idea of geometry strikes fear to your core, don't worry. When you look at it in the context of taking a photograph and can see how it helps to elevate your images from something ordinary to something special, it's not nearly that daunting.

This section on composition has been designed as a progression. It builds on theories, skills, and techniques as you go along, and gives you the opportunity to put them into practice, too. Of course, if you just wanted to check on a theory, there's nothing to stop you from doing that. All the same, the idea is to have you taking better-composed, beautiful photographs by the end of the section.

↑ An avian hourglass

It's not enough to simply record evidence of having seen something. You must keep an eye out for the other elements that, when framed and captured in a photograph, augment and enhance the scene. © Daniela Bowker

Pick Your Subject

The fundamental "point-and-shoot" process of taking a picture is so direct and instantaneous that questioning yourself as to what the subject is or should be is, at first glance, superfluous. The subject of a portrait is the person in it, right? And the building is the subject of every architectural shot. This "whatever is in the middle of the frame is the subject" approach can be quite deceiving, however. For one, it can be

184

easy to get distracted by everything else occurring in and around the image, and for the subject to get lost. One of the most common photographic critiques is simply, "What am I supposed to be looking at?" What seems obvious to the photographer—who was there at the moment of capture and knows why the shot was taken in the first place—needs to be communicated elegantly and straightforwardly to the viewer, and the

© Daniela Bowker

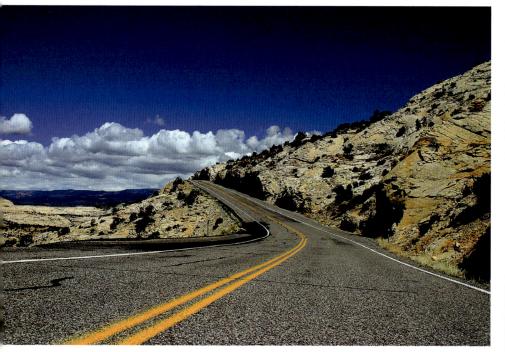

mechanism for this communication is where composition comes into play. So your first question should always be "What am I photographing?" If you think of your photograph as a story or narrative, you'll be better able to determine what it is that's the focus of your image because you'll know exactly what it is that you're trying to express through it. It doesn't matter if the subject is vast and sweeping or intricate and detailed, there should be something in the photograph that is speaking to its audience.

The images below are very different subjects captured in different ways, but they both drive a narrative and have a sense of purpose. Remember: Without a firm idea of what it is that you want to capture, you won't be able to create a strong, purposeful, and meaningful photograph.

🛛 Daniela Bowke

↑ Open road, open interpretation

Let's start with a vast, sweeping subject. Here, there are narrative themes of openness, possibility, but also of emptiness and being lost. It conveys a sense of isolation or maybe even loneliness. Anyone looking at the image can get a feeling of being the only person in the world, and that the road heads onward, unending and deserted.

→ Delicate close-up

An intricate and detailed picture might focus on the patina of some antique furniture, and through it convey the passage of time. When someone looks at the picture, they should be feeling the age of the furniture and wondering what it has been through to acquire those marks and scars.

Enhancing the Subject

When you've established your subject and what story you are telling through your photograph, you can then determine what is essential to your image, what is the background, and what is superfluous. By working out these key elements and how they interact—for example, how the background accentuates the subject you will ensure that your photograph is saying just what you want it to say and everything will harmonize toward that end. You will be on your way to composing better images before you've even released the shutter.

We can think about this in a bit more depth by going back to the example of the sweeping, lonely road on the opposite page. If the photograph had a train of cars heading along the road they would detract from the feeling of emptiness and change the overall narrative. You might even find that the cars then become the subject itself. rather than the road. But an isolated building or a solitary car might contribute to the sense of desolation. They're not exactly background imagery, but you might think of them as a "subplot," giving weight to what it is that you are trying to say. The key here is that whatever you place in an image should be contributing to the story and complementing the subject, not diminishing it. Sometimes it might mean hanging around for a bit to get the perfect shot, or changing where you stand to take your photograph; but it will be worth it.

Making something the subject of a photo isn't just about placing it in the center of the frame and clicking your shutter. There is an entire gamut of

techniques and tricks to draw the eye to the subject of an image, techniques that we'll explore throughout the course of this book; but the starting point is where to place your subject in the frame. While it might seem to make sense to place the subject of your photo slap-bang in the middle of the frame to ensure that it's the center of attention, this doesn't necessarily make for the best photo. First of all—and very bluntly—this sort of composition is boring if you use it repeatedly.

$\uparrow \rightarrow$ Two takes

What's the story here? The individual drops of water, clinging to an arch that forms a graphic image? Or a more literal presentation of forlorn furniture left out in the rain?

© Daniela Bowke

Filling the Frame

For the moment, let's disregard a vast number of other possible types of images and concentrate only on one: a single, obvious, self-apparent subject positioned directly in front of the camera. How to frame it? Already there are two choices: to close in tight so the photograph is dominated entirely by the subject; or to take a wider view that incorporates the surroundings. The first option gives you the opportunity to capture much more detail in the subject, and is easier to compose if the subject is large enough to fill up the frame. It is also better suited to subjects that are self-evidently interesting or unusual—such as a rare bird or an exquisite work of art. The second, wide-view option, on the other hand, invites a study of the relationship between the subject and its context, and so the surrounding environment must be relevant somehow. Perhaps the subject needs some other point of comparison so the viewer can judge

its relative size, or maybe there is other action occurring that contextualizes the subject's movement or expression. Neither of these approaches is superior to the other; it's about what you prefer aesthetically, what you want to communicate, and what best suits the circumstances. Don't be afraid to experiment and shift your precise focus, but do know exactly what it is that you want the picture to communicate.

Keeping in mind the questions of how much of the frame to fill and with what is what differentiates the thoughtful photographer from the casual shooter. You should continually ask yourself these questions, and they will eventually become second nature as you learn to consider both your subject and its environment simultaneously, and decide how much of each to fit into frame. In any case, the bottom line is to maximize the amount of meaningful information in the shot—there

↑ Frame of reference How big is this piece of stained glass? The close grop provider

How big is this piece of stained glass? The close crop provides nothing to act as a reference, but the impact of the striking colors would be lost in an environmental photograph.

shouldn't be anything extraneous in the scene. Whatever you see in a picture should be accentuating the subject, not detracting from it.

© Daniela Bowker

←→ Get closer

What's the subject? The flowers, of course. But while the image on the left shows the overall shape of the plant and includes a bit of its surroundings, that's not the original intent of the image, which was to isolate the fine detail within the buds and flowers—which is better illustrated by a tighter crop as shown right.

© Daniela Bowke

Organizing the Frame

By introducing some tension into your image not only do you make it more aesthetically interesting, but you also create a relationship between your subject and background. Tension is something that will continue to come up throughout this book, but in this particular case, tension is what we mean by capturing the interaction between subject and background, which then introduces some direction or movement into your composition. This will draw your eye into the image so that it doesn't feel static.

Diagonals and strong divides that run through your photographs, together with your subjects' eye-lines (see page 197), can all contribute to tension. If you're aiming for an environmental photograph, the relationship between subject and background is allimportant. The background provides context for the subject and they need to work together in order to tell the story of the image.

If you've never tried off-center focusing with your camera, it isn't nearly as scary as it sounds. If you're using manual focus, focus first on the subject of your image and then recompose the frame to set the subject in relation to the background. When you use autofocus, first focus on your subject by half-pressing the shutter button, and then, while still keeping the shutter button half-pressed, recompose your frame as you see fit, finally fully pressing the shutter button once you have your desired composition. Your camera will remember where you focused as long as you keep the shutter button half-pressed, even if that subject isn't in the center of the frame anymore. (It is worth noting that many cameras, including most DSLRs, allow you to customize various buttons in order to facilitate this focus-andrecompose method in different ways.

For instance, sometimes you can press the AEL/AFL button to acquire focus, and half-pressing the shutter button has no immediate effect. Consult your particular camera's manual for details.)

187

↓ Find the story in the scene

Across these three photographs, we can see the way that getting closer to your subject changes the feel of the resulting image. Farthest away on the left, the scene feels busy and cluttered. The girl is probably the subject—or is it the other woman behind her? Zooming in tight on the little girl in the image on the far right makes the subject obvious—too much so; the photograph has lost its sense of environment and context. The middle photo is a happy medium—close enough to clearly indicate the subject, but still providing enough clues for the viewer to understand the surrounding scene in which the subject is set.

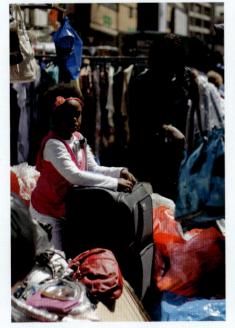

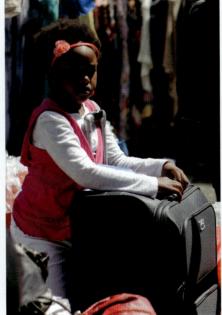

© Daniela Bowker

Horizontals & Verticals

Human vision is binocular, meaning that we have two eyes that happen to be positioned adjacent to rather than on top of each other. As a consequence of this, our eyes are predisposed to scanning things along a horizontal plane rather than a vertical one. It's no surprise then that we're more inclined to capture horizontally oriented pictures. The vast majority of cameras have been designed around this fact, and thus have a default horizontal orientation. And as an extension of that camera design, simply rotating the camera into a vertical position is just uncomfortable enough that it's quite easy to eschew, particularly during casual shooting or when dealing with rapidly developing action.

188

But it isn't just a matter of laziness. Often the orientation is directly dictated by the subject—landscapes and portraits being such obvious examples that they have lent their names to the horizontal and vertical formats, respectively. In a typical landscape, the stretch of the horizon is such a powerful element that it begs to maintain as much length as possible. Plus, when surveying a scene, there is typically more to see and capture by scanning from left to right than from top to bottom (unless you're standing on top of a towering cliff with an unobscured view of the scene unfolding below). The horizontal orientation may be the default, but it is also the most natural and effective means of portraying the landscape subject.

Likewise, human subjects are taller than they are wide, and their figures are naturally suited to a vertical format. This isn't only a matter of fitting whole bodies or faces into frame—there's also the fact that the subject of their attention is often at arm or waist level, which can create an effective tension between the face's expression at the top and the action occurring at the bottom of the frame.

∠↓ Subject-dictated orientation

London County Hall is considerably wider than it is high, so the horizontal orientation was the best means of capturing this straightforward shot. Likewise, the vertical orientation was the best means of capturing the tension from top to bottom of the shot on the left, as this woman looks down attentively at her tea.

A Creative Choice

While much of the time it will feel obvious when you're taking a photograph whether you should be using portrait or landscape format, other times your subject will present you with a compositional dilemma. For instance: In a landscape with a clear mountain range extending horizontally, but with towering trees reaching up vertically in the foreground, which is the more dominant element? Or, to phrase it even better—which orientation best accommodates the elements you find to be important, and displays them for maximum effect?

Going beyond, your creative choices regarding orientation do not always need to take a problem-solving approach. It is well worth challenging your natural inclinations as to how a given shot should be framed simply for the sake of experimentation and exploration. This isn't to say you should start chopping off essential elements of your subject, and wasting vast swathes of the frame on useless empty space. Rather, you should allow yourself to take the time (as permitted) to fully consider all your options once you've recognized a subject as having potential for a good composition. Move around, rotate your camera, tilt it at a stronger angle or position yourself so the light or shadows are falling differently. Look for other elements that might make a vertical orientation purposeful in a landscape—they may be dominant (like a mountain) or subtle (like a lone bird occupying the corner of the frame against an otherwise empty sky). In any case, the point is to make sure you're not missing out on any novel or captivating compositions.

←↓ Two takes

Of these two seascapes, the horizontal format is probably the more traditional approach, as the wide horizon is allowed to stretch across from left to right. While the subject is the same in both shots, the vertical shot resists a traditional approach and introduces a stronger graphic quality, with greater tension between the upper and lower parts of the frame. What is important to recognize here is that one is not particular or objectively better than the other, but rather that they appear quite distinct and have different effects as a result of their framing, regardless of their common subject.

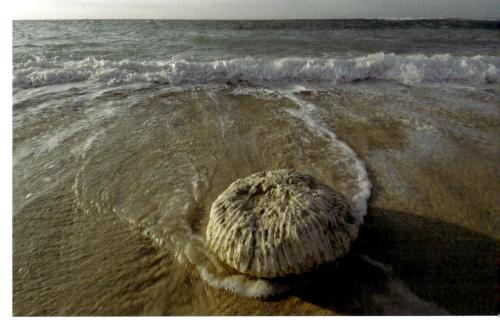

Subject Placement

Earlier we discussed the concepts of both off-center framing and the inclusion of environment and context in your frame. Combining these principles presents you with the question of subject placement: If dead-center is boring, flat and dull, then where else should the subject be?

190

The answer is not simply "anywhere else." The subject needs a dynamic and engaging position within the frame, but even more importantly, it needs a meaningful one. Position without purpose comes off as sloppy, or just confused and unfocused. If every shot in your portfolio has the subject far in the corner of the frame, the effect will be just as monotonous as if they were all centrally framed. Viewers will recognize and respond well to thoughtout, well justified compositions, which can in fact give you much greater leeway for extreme or eccentric compositions than if you sought them out just for eccentricity's sake.

A number of factors will come into play as you choose where to position your subject. The subject's size is significant, insofar as larger subjects do not have nearly the room for dramatic off-center positioning as do smaller ones.

You should also keep an eye out for secondary points of interest nearby. Perhaps a flock of birds in the sky or a tall tree can be positioned on the opposite side or corner of the frame from the main subject, inviting some degree of tension between them. In some cases, this secondary point of interest need not even be visible in the frame at all. If your subject is in motion, or even simply staring off in a certain direction at something out of frame, you can compose them such that they are looking or moving across the frame, into open space. Besides giving meaning and purpose to that empty space, it is also generally more effective to have your subject moving or looking into the frame rather than out of it.

↑ Wandering eye

Confronted by a static rectangle, the eye doesn't just fixate in the middle—it tends to explore the edges and wrap around the space. Accordingly, a centrally placed subject won't hold the eye's attention completely; it will be more interesting if there are other elements to investigate.

∠↓ Head-on vs off-center

The photo on the left is a straightforward documentary shot—and quite uninspired. It feels static and obvious. But moving the boat to the bottom right of the frame invites the viewer to think about the open water stretching across the rest of the frame—all the way to the edges, which suggests it continues on interminably. Suddenly this lone dinghy has a story and a relationship to its surroundings, all by moving the camera slightly up and left.

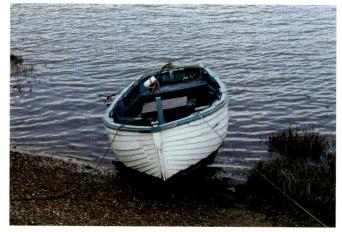

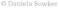

Horizon Placement

The horizon endures as an inescapably significant element in a great many photographs, so it's worth considering its placement specifically. Just as you have a natural inclination to position your subject in the center of the frame, it is also all to easy to allow the horizon to cut directly across the middle of the image, splitting it into two obvious parts and diffusing the composition of any sense of movement or tension.

Having the horizon on the lower third will often feel more natural as it will give the image a sense of being grounded. However, you shouldn't feel that you can't place a horizon on the upper third. If the most significant element of your landscape is below the skyline then it makes sense for it to dominate the image by placing the horizon along the upper dividing line. Not only that, but you can create some dramatic pictures by placing the horizon higher in the composition. In a sense, there's nothing new here, just the same old rule: Composition depends on what you want your subject to be, and what you want the photograph to communicate.

→ Beware obvious bisections

If you look at this pair of pictures taken of Edinburgh's skyline just after a storm, you can see how the one that's been manipulated to have the horizon running across the middle of the image looks flatter and less inspiring than the picture where the horizon is lower in the frame. The latter is also more effective and showing off the eerie yellow sky with the buildings silhouetted against it.

© Daniela Bowker

The Golden Ratio

While it may seem like you have some serious decisions to make regarding subject placement, you'll be glad to hear a variety of helpful guides have been invented throughout the ages to help you choose how to arrange and distribute elements throughout your frame.

192

Perhaps most famous of these guides is the Golden Ratio, which you might hear referred to as the Golden Section, the Golden Mean, Phi, or Divine Proportion. It is similar to, but mathematically different from, the rule of thirds. It's something that appears in nature and has been hijacked for use by architects and artists for millennia (the Parthenon was built on the principles of the Golden Ratio), so photographers following suit shouldn't be a surprise.

The Golden Ratio is an irrational number equal to approximately 1.618, denoted by φ —the Greek letter Phi (hence the rule also being called "Phi"). If you divide a line unevenly into two sections—(a), a longer part, and (b), a shorter part—the ratio of those two sections will conform to the Golden Ratio if (a) divided by (b) is equal to the sum of (a) plus (b) divided by (a).

Of course, it's all very well knowing the math behind the Golden Ratio, but how does it apply to your photographs? If you subdivide your frame according to the Golden Ratio, similar to how you'd divide your frame if you were using the rule of thirds, with two a-length sections separated by a b-length section on each side, and place

key elements of the image along the dividing lines or where they intersect, you'll have a photograph that conforms to a principle that humans find naturally attractive.

Proportional arrangement

This could easily have been a straight-on frame-within-frame composition, as the window composes the exterior well enough. But a slight shift in the composition to align the window with the golden rectangle gives the scene a more dynamic presentation.

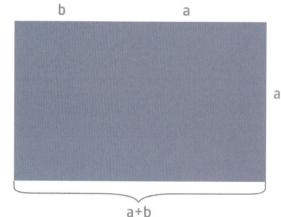

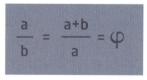

Classical elegance

The compositional guidelines of the rectangle function regardless of their specific orientation—you can flip it or rotate it to suit your subject.

The Golden Spiral

Another aesthetic principle that you can use to place your subjects is the Golden Spiral. It is based on the Fibonacci series of numbers, but is probably easiest to understand if you think of it as a series of joined-up quarter circles that have been drawn inside decreasingly smaller squares that have themselves been drawn inside a rectangle that conforms to the Golden Ratio. The center of the spiral is where your photograph's subject should be and if you allow the spiral to dictate the rest of your composition, you'll find that you have a strong image.

There are many different ways of dividing up your frame so that your picture conforms to various sets of theories that we find proportionally comfortable. We've looked at a few here, but the unifying factor behind the effectiveness of all of them is that they are internally consistent. Where the key elements of the image are placed is proportionally the same, whatever the size or shape of the frame. And of course, they're not dead center.

Knowing how to compose your images according to these mathematical principles isn't something that you'll necessarily be able to do immediately by eye; but the more that you practice, the more natural it will feel. And if all else fails, there's editing software to help you crop later.

↑↓ Picture the spiral It's a busy street scene, but your eye is drawn to the figure leaning against a pillar, watching the world go by.

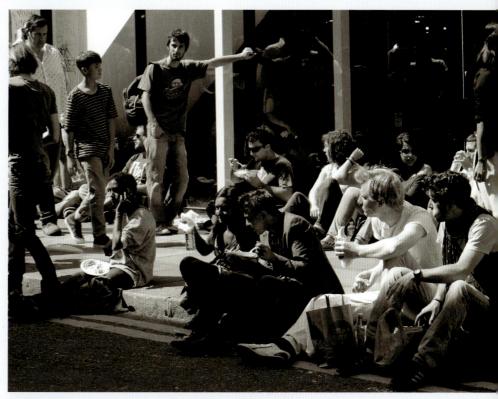

© Daniela Bowker

Using Lines to Pull Attention

194

Lines—horizontal, vertical, diagonal, curved, or imaginary—are an important tool in your compositional arsenal. We already touched on horizons when we looked at subject placement, and we covered lines that draw the eye across the image and give it a sense of movement in the section on organizing your frame. There are also lines that are referred to as "leading lines," which act as pointers and direct the viewer's eyes to the subject of the image. Different types of line have different properties that they will lend to your composition. It's worth remembering that a single line or a series of lines doesn't necessarily have to be formed by solid objects running through the image. A series of points that the eye naturally links together can create the perception of a line, while light and shadow also produce beautiful and subtle lines in photographs. Similarly, even if you don't set out to deliberately photograph an image composed of lines, you need to remember their potential impact on your composition, keeping in mind how they will influence viewers later on.

↑→ Straighter, stronger The diagonal of this wine glass isn't strong enough to

be intentional, so it comes off as weak and sloppy. But by aligning the stem of the wine glass with the vertical side of the frame, the image suddenly becomes much more refined.

Horizontal lines tend to feel solid and stable, which is no surprise given their association with the ground and gravity. They're also expansive, and will broaden the feeling of your scene as well as make it appear deeper. Where horizontal lines feel calming and restful, vertical lines are pretty much the opposite. They will elongate the frame and can give an impression of energy as they work against gravity; but they can also feel imposing and confrontational, especially if they run as a uniform series across the frame. Imagine the strength and power exhibited by a regiment of soldiers in battles lines, for example.

Whether your photograph features horizontal or vertical lines, it is important that they are aligned with the frame. A wonky line is instantly noticeable and will grate on you as you look at it. Of course, if you manage to take a slightly off-kilter photograph, it's nothing that can't be fixed in postproduction. We'll cover that on pages 278–279.

195

In the pages on frame orientation, we looked at how the subject of your photograph normally dictates whether vou shoot horizontally or vertically. As a general rule, scenes featuring horizontal lines should be framed horizontally to allow the lines to work with the longer side of the frame; likewise, photographs with strong vertical lines usually translate well in portrait compositions. This isn't always the case, though. Sometimes, you can actually reinforce strong horizontal or vertical lines by using a portrait or landscape format, respectively. The picture of the remains of a colonnade on the Decumanus Maximus (the Roman equivalent of a Main Street) in Volubilis shows just that. The columns are incredibly strong vertical lines, but if I'd taken the photograph vertically it would have lost all of its impact. Its compositional strength comes from the repetition of the columns and this is reinforced by the landscape format.

Leading Lines

Lines can give your image an overall feeling or they can direct the eye across the photograph and out of the frame. However, they can also draw your eye toward your subject with an effect that's verging on the hypnotic. A good leading line is just as effective as, and definitely more attractive than, a flashing neon sign screaming "The subject is here!"

Finding good leading lines isn't as hard as you think it might be. People's arms or legs can often be positioned to draw attention to their faces, and a flower has a perfect leading line in its own stem.

↑ Connect the columns (top) The colonnade of the

Decumanus Maximus at Volubilis: full of strong vertical lines and diagonal movement.

↑ Dovecote (bottom)

Even with the strong shaft of sunlight in the center of the image, the lines ensure that your eye is drawn immediately to the peak.

Diagonal, Curved, & Imaginary Lines

196

The colonnade photograph on the previous page is also a starting point for looking at diagonal lines. Your eye is immediately drawn to the foremost column on the right hand side, but it is then led downward and away to the left by the diagonal line of the colonnade. This is a good example of your eye being drawn out of the image, which contributes a feeling of movement and stops the image from coming across as dull-something that we touched on in the section that covered subject placement. If the colonnade had been perfectly aligned horizontally, the result would have been incredibly confrontational and felt static.

Whereas vertical or horizontal lines provide a sense of solidity or order, diagonal lines are far more dynamic because they aren't constrained by the image's frame. You can think of them as nonconformists, if you like. This means that they're great at giving a sense of implied movement and at accentuating actual movement in an image.

However, because they are such nonconformists, there are some points you should be aware of when you use diagonal lines. If you include too many conflicting diagonal lines in an image it can feel chaotic. Your subject can then get lost amid the chaos and your

← Follow the tracks

The human subjects are quite tiny, but their walking action is just recognizable enough to give meaning to the other, dominant elements in the frame: the levees stretching diagonally across the frame. These lines carry the movement of the human figures across the full expanse of the frame, while also providing valuable context as to their environment.

resulting image can feel weak. Diagonals also have a wonderful potential to introduce a sense of instability to an image, as their direction conflicts with the more natural stability of horizontal and vertical lines. While this can be highly effective in a photograph, it can also be disorientating and uncomfortable if left unchecked. In some cases, this could be just what you are looking for in your image; but at other times, it might work against your composition. So while diagonal lines are incredibly dynamic, always sound a note of caution when you include them in your images.

It's also worth remembering that parallel lines shot at eye-level and running off into the distance will appear to converge and therefore become diagonal lines. Of course this is the result of perspective, but it's another thing to think about when introducing diagonal lines into your photographs.

Implied or Imagined

So far, most of the examples of lines that we have looked at have been actual lines evident in the image. What we haven't considered yet are implied lines, or lines that we can somehow sense in the image even if they aren't there physically. One of the most obvious implied lines is an eye-line. We're curious by nature, so when we see a face in an image, we're likely to follow where it's looking. This may be a single subject looking out of frame, or a large group of people all oriented toward a common point, drawing the eye toward that apparently significant object or element. And it's not just human subjects-the way in which wildlife interacts with its environment can likewise lead a viewer's eye toward some other element in or out of frame. Eye-lines are powerful components of composition, as they work entirely by implication without having to make a definitive action or have a physical presence.

Curves

Whereas vertical and horizontal lines suggest stability and diagonal lines lend dynamism to an image, curved lines are far more sensual. They are smooth, inviting, and elegant. Just imagine the undulations of gently rolling hills or the silky curvature of a lover's neck. By using curved lines in your images, you'll lend them a softer, almost seductive appeal. They can also feel graceful and elegant, which you can use to play off otherwise stiff and rigid straight lines elsewhere in the frame.

↑ Real vs imaginary

The imaginary eye-line between the man's head and the book he's reading runs perpendicular to the diagonal shadows in the rest of the frame. The resulting tension adds an element of interest. In addition, the head, shoulder, forearm, and book make an implied curve that follows the frame edges.

Undulation

Although curved lines occur everywhere in nature, they will invariably contrast with the unnaturally stiff and rectangular frame imposed on every scene by the camera. In this case, the abundance and exaggerated quality of the curving wall would almost have been too much if not for the human figure in the foreground, who grounds the undulated wall and gives it a sense of perspective and scale.

Lead with Lines

Striped

The contrast between the twisting, organic branches and strong diagonals of the shadows makes the bonsai tree pop out from the wall. In this section we've looked at how lines can reinforce composition, and also at how they can lead you to your image's subject or give a sense of movement to a photograph. Your challenge this time around, therefore, to take a photograph that uses leading lines to draw your eye straight to your subject. Of course, you shouldn't be using leading lines in isolation. You should be using all the other skills that we've covered in this section and practiced in challenges so far. Think about your point of focus and the narrative of the photograph. Where are you going to place your subject; how will you divide the frame; and what orientation will work best with your composition? What sort of aperture will you need to use to get the right effect for your shot?

Challenge Checklist

- → Identify your point of focus.
- → Use one or more lines to draw the eye to the subject.
- → Ensure that the lines are working to emphasize the subject and not overwhelm it.

↑ Framing a triangle

Lines can also wrap around and give form to otherwise empty space, giving your eye something to follow and trace across the frame in the process. 200

This is a familiar angle of view to any cyclist, but not something you'd normally think to take a shot of. I was about to pedal away when I noticed the parallel lines of my bike and the side of the street, and liked the feel of the composition. Adam Graetz

Good observation and use of lines to guide the eye through the frame. My only quibble is that the parallel lines of the bike and street are neither quite aligned to the frame edges nor definitely diagonal. I would have gone for the latter, rotating the camera view counter-clockwise. *Michael Freeman*

© Jennifer Laughlin

This photograph was taken with a Nikon D300. I held the flash to the side of the camera to illuminate the detail of the ribbon being threaded down the dress. Jennifer Laughlin

I very much like this both for composition and lighting. The flow of the cross-ties (if that's what they're called) leads the eye down, aided by the edge of the dress, while the hands and ribbon halt the direction and concentrate the attention in the lower center. *Michael Freeman*

Seeking a Balance

A fundamental part of composition, and something we'll be discussing at length and in many different ways, balance is arranging the elements of the frame such that tension is both created and resolved. Balance is not only about things being exactly the same in some scientific sense—that is veering into the idea of symmetry, discussed later on. You're not necessarily aiming for perfect and literal equality in every section of the frame; balance is much more suggestive than that, less exact and more implied.

202

One way of approaching balance is finding an image's "visual center of gravity" and proceeding to organize its compositional elements around that point. That visual center can be a mass of color, a high-contrast area, and arrangement of shapes with particular directions, the list goes on. What's important is that you compose your images so that the eye wants to move across all of the frame. Although it might be directed to the subject, no part of the image feels under-used or superfluous. Rather, everything is working in harmony to create a whole. The vital element governing the sense of balance in an image is the interaction between the subject and the background. By creating a subtle tension between them, the scene will have a point of focus, a feeling of movement, and a sense of direction. Even if the subject comprises only a small portion of the overall image, by ensuring that there's a strong relationship between it and the background, the subject won't look overwhelmed and the composition won't be lopsided.

← Room for rain

This photograph was taken at an outdoor theater performance when it rained from beginning to end. The subject might be the actor's feet, but it's the puddles of water on the stage that make the image. Harmony is created between the puddles and the feet in order to communicate the feel of the scene.

Daniela Bowker

In a portrait, if you choose a placement that puts the model far over to one side of the image and leaves the other side a blur of background, it could be easy for that photograph to become horribly unbalanced. The portrait can still work, however, if the model's eye-line or positioning directs you across the empty portion of the frame. The gaze or orientation creates a tension, which in turn creates a feeling of balance. Similarly, by not having such a blurred background and leaving some object to complement the model in the emptier side, the image will balance out.

If you're photographing in strong light, try using a shadow to give balance to the composition. A shadow that falls so that it replicates the shape of the subject can add an interesting dimension to your image. Alternately, shadows can be used to elongate or widen the subject, drawing the eye down or across the frame.

Don't feel as if you must balance your images only between left and right or horizontal and vertical. We've looked at how diagonal lines provide a strong sense of movement in a composition, and balance works just as effectively on a diagonal, too.

Balance can come in many different forms in an image. You might want to counterpoint contrasting colors, or position your skyline high up in the frame so that it feels as if it's cascading downward, for example. By being certain of the story that you're trying to tell, thinking carefully about your subject placement, and having a feel for movement and direction, you'll be able to find the right elements to create balanced and satisfying images.

→ Diagonal distribution

This window, with its decorative shutters, could have been captured head-on for a symmetrical, but static shot. Shifting the subject slightly down and to the left livened up the composition, but it would have felt slightly lopsided were it not balanced out by the strip of highlights forming a triangle at the upper right.

↓ Not-so-empty space

In this clear and straightforward presentation of compositional balance, the elements at the top left and bottom right of the frame not only complement each other, but are also pulled together into harmony by the subtle diagonal lines in the blue background.

Symmetry

204

full steam ahead

A close crop coupled with bilateral symmetry (which itself is further emphasized by directional light casting the left side in shadow) makes this boat feel like it is about to splash right through the page. ✓ Church facade The church is aligned symmetrically, but there was nothing to be done about the clouds. • **One or the other** Almost, but not quite there: The flames are aligned, but the holders aren't.

© Daniela Bowker

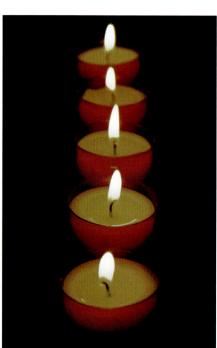

A particular kind of balance, symmetry takes the principles of balance that we discussed on the previous pages to the extreme. Whereas more dynamic sorts of balance are an art of creative positioning of abstract weights and shapes, symmetry is much more of an exact science, with all the demand for perfection that a scientific approach suggests. It's a powerful effect in its own right, one that flouts the off-center approach to create punchy, graphic images. Of course, it isn't always possible, as some subjects simply aren't symmetrical and can't be photographed as such. Man-made objects are often well suited for this compositional approach, as the design of their construction often embraces symmetry as a guiding principle. But keep an eye out for natural subjects that can be captured this way as well, as their organic structure makes the symmetry all the more impactful.

If you're aiming for a symmetrical image, in the vast majority of cases it's important that it's perfectly, literally symmetrical. The human eye has an incredible ability to recognize and finely evaluate geometric organizations, and if there is even a stray hair out of place in an otherwise perfect symmetry, that out-of-place element will gnaw at the viewer and steal the focus of the image. It will take time to align all the elements and place them properly in the frame—a tripod helps here, as does a spirit level. Keep a close eye on the edges of the frame, and make sure that lines and elements are falling evenly across opposing sides.

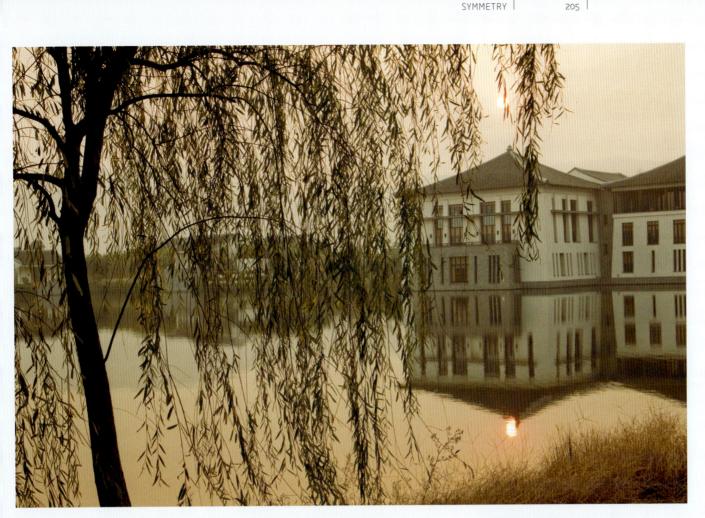

There is a particular beauty to something that is a perfect mirrorimage; it can feel restful, ordered, and simple. This is, of course, in contrast to asymmetric images, which feel dynamic and complex, and sometimes even chaotic. And it's why symmetry should be used sparingly, as it grows boring and inert quickly.

Natural Reflections

Photographs that feature reflections are examples of symmetry that work especially well. This is true for several reasons. First, a perfect reflection in a lake is an awesome sight; it's the sort of picture that, if done well, can be breathtaking. Second, the line of symmetry in a reflection usually, but not always, runs along the horizontal plane. As we're naturally disposed to read images horizontally, we aren't immediately struck by the symmetry and we'll be inclined to look for the movement in the asymmetry of the left and right halves.

Through the trees

Lake reflections are so idyllic as to often be a cliche—but that can be avoided by including additional elements, like this tree in the foreground.

In addition to lakes, there are quite a few other things that can be photographed symmetrically. Portraits can work a treat if composed symmetrically, and some architecture can make strikingly symmetrical images. Just remember: It has to be perfect, and you might need to employ the help of some photo editing software afterward to make it look as good as it should.

Strengthening with Triangles

206

We've already looked at how pinpointing your subject is essential to producing a strong composition, and how organizing your frame effectively is a vital part of achieving this. So far, we have concentrated on images that have one particular point of interest, for example a person, an insect, or the sunset. But not all of your pictures are going to be simple constructions of solitary portrait subjects or gorgeous vistas with an obvious point of focus.

When your subject is interacting with other elements of the scene, making sure that the various points of interest have a definite shape and are somehow ordered within the frame will prevent your photograph from descending into a disorganized and chaotic sprawl. One of the most simple and effective means of doing this is to use a triangle. Triangles also have the advantage of being simultaneously stable and Daniela Bowker

dynamic: Their edges can bring a sense of solidity to a composition, while the convergence of their points brings a natural sense of movement. Triangles also come with their own leading lines. And unlike circles or rectangles, which require exact ordering and straight lines, triangles are much easier to create out of constituent elements, and more forgiving in their configuration

Imaginary triangles

Constructing a triangle is simple: It requires only three points and three lines between them. They can be configured in almost any format and the lines don't even have to be tangible—they can be implied or imagined, like an eye-line. This makes them easy to introduce into your particular photographic compositions, and as a consequence bring order to your frame.

(they achieve their strengthening effect regardless of their orientation, and their sides need not be of equal length).

If you are photographing three people, arrange them so their faces become the points of a triangle. This will give the image a sense of structure and also avoid the predictability of having three faces in a row. With more than three people in a composition, think about placing them so that they create either one large or several smaller triangles.

S Durrend DOWAGE

Two lines plus a side make three

If properly composed, a subject can use one of the edges of the frame as part of its triangular organization. This image has two obvious lines: one rising up toward the center top, and one falling down toward the bottom right. The eye completes the triangle using the bottom of the photograph, and the result is a self-contained, stable structure, with a strong sense of movement emphasized by the angle at which it was shot.

Giving a Sense of Movement

A tall building photographed from below will give the impression of creating a triangle—it's a natural result of perspective as the vertical lines converge (see page 243 for more details). This sort of pyramid structure is very stable, and because it encourages the eye to move along the building, from bottom to top, it's also dynamic and offers a different perspective on an otherwise rigid structure. An inverted triangle won't have the same sense of stability as a pyramidal one, but it does still have a strong sense of direction and movement. By using its intrinsic leading lines, it will serve to direct focus toward something that is small or doesn't necessarily catch the eye immediately.

Dividing the Frame

As well as arranging three subject points into a triangle, you can also divide your frame into triangles to give it a sense of order. If your composition involves multiple objects-for example a bouquet or bed of flowers—this technique can work to encourage the eye to look toward the point of focus. You can also use triangles to bring a sense of balance to an image by emphasizing contrasts within it. Your triangles can consist of different colors, textures, shades of light, or any other distinguishing characteristic. This can work very well in bringing order to an otherwise busy and cluttered scene. Dividing the frame in this way is simpler than you may think. Remember you need only three lines to build a triangle, and one or two of those lines can be the edges of your frame.

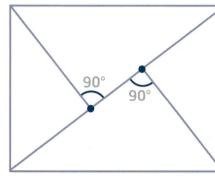

←↓ Off-kilter composition

The portrait works because each element of the subject's face falls along the lines and points of interest according to the Golden Triangle.

The Golden Triangle

There is also a more rigid division of the frame into triangles that is based on the law of the Golden Ratio, which we looked at earlier. This is, perhaps unsurprisingly, called the Golden Triangle. The theory behind it divides the frame into two right-angled triangles along the frame's diagonal. These two triangles are then subdivided again, by lines running from the other corners and each intersecting with the original diagonal line at right angles. Where the lines intersect, you have your points of interest.

If you're thinking of creating a triangularly oriented composition, then the Golden Triangle is something to bear in mind to help give it a sense of balance and a point of focus. And it is certainly something to be added to your collection of triangular shots.

Balance Your Composition

Balance by density

This composition makes use of the openness of the bottomright exterior, complemented by the vase on the tabletop with its opening diagonal lines, to contrast the density of the rapidly repeating woodwork occupying the upper left of the frame. Now that we have examined balance and the various methods of achieving it, this should be something that you think about every time that you raise your camera to your eye. You might even find that it's the balance in a scene that inspires you to take the picture in the first place. Pay close attention to the relationship between your main subject and other elements. For this challenge, you need to produce a balanced image where the subject is positioned high in a corner, or far over to one side of the frame. There is a wide range of options open to you to help you create a balanced image, but whatever you choose, remember that the success of your image is going to be dependent on no part of your frame feeling redundant.

→ Balance by shadow

Careful shadow placement immediately makes a clear balance between the upper and lower regions of this minimalist shot. But at the bottom of the frame, just the tip of the doorway is all it takes to anchor the full frame and balance out the other windows farther above.

Challenge Checklist

- → The subject of your image should be in an off-center or unusual place.
- → Ensure that the image is properly balanced.
- → Consider using triangles, symmetry, or some other compositional tool.

210

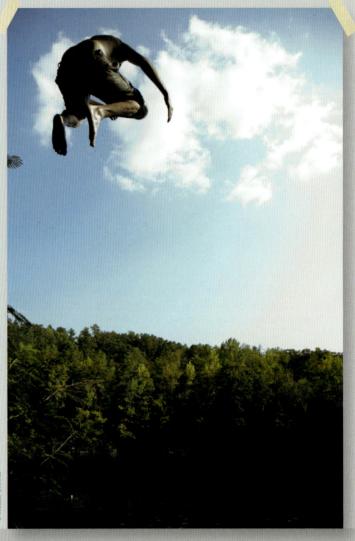

Timing was everything with this, of course. The shutter speed was fast enough to freeze the subject not only against the sky and clouds, but also in an interesting pose–I don't think people usually think about how they look when they're jumping off a high cliff into the water. Adam Graetz

Quite a dynamic shot, and immediately engaging. The open sky is a great backdrop for the leaping figure, and the tension between the upper and lower parts of the frame is what draws attention so effectively. And as you say, timing is all–great position of the figure, and the back perfectly fitting the cloud. *Michael Freeman*

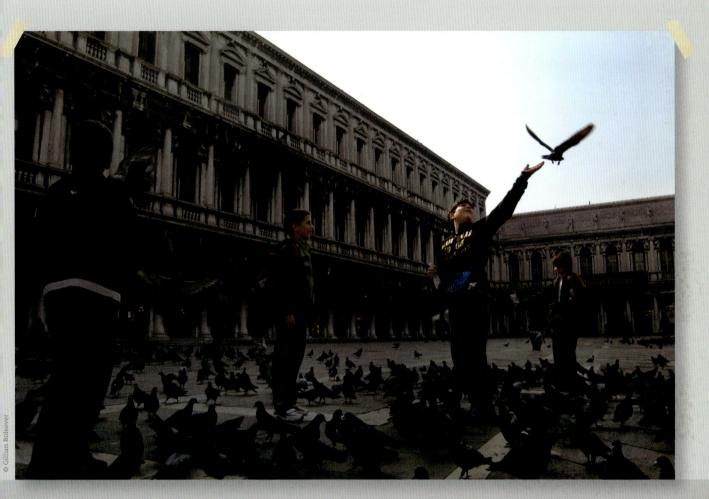

I composed this photo for the action I hoped would happen, the boy reaching out toward the pigeon. If you only compose for what you see, you will miss the moment. You have to think ahead and predict what might happen. *Gillian Bolsover*

Excellent anticipation, and the composition works well dynamically, taking the eye across the frame from left to right, then flying out to the sky at the decisive moment. To this end, in the processing I would suggest opening up on the figure at far left, to help the eye travel across the full frame. *Michael Freeman*

Color

It should come as no surprise that colors elicit certain emotions. Red, being the strongest and densest, feels energetic, hot, and vital. Yellow, the brightest of all, feels cheerful and vigorous. Blue is of course quiet, contemplative, and subdued. Green, so abundant in nature, suggests growth and youth. Violet is quite rare in nature, and so has a mysterious and superstitious quality to it. Orange, which coats every landscape during sunrise and sunset, is festive and inviting. While these emotive responses are useful in working color into your compositions, it is also important to pair them with precise descriptive language for how color is constructed.

Two takes on nature

These images are both nature subjects, but with their different color palettes, they create two completely different feelings.

© Daniela Bowker

The Construction of Color

Digital photography gives us exact terminology for both describing and manipulating color: hue, saturation, and brightness. Hue is what most people mean when they say "color," as it identifies the specific wavelength that corresponds to, say, blue, yellow, or green. Saturation is the strength, purity, or intensity of a particular hue (or lack thereof—as a completely

Endless possibilities

This particular representation of the color wheel illustrates the almost infinite number of hues that exist under the broad categories of blue, green, yellow, orange, red, and purple.

desaturated color appears as a shade of gray). Brightness is simply how dark or light the hue appears. Of these three terms, you can see that hue is the most significant, with saturation and brightness being constituent parts. Hue can also be measured in 360 degrees as it moves around the color wheel, shown left. At any point, the color 180-degrees opposite on the color wheel is that hue's complementary color, which gives a naturally pleasing contrast that enhances the quality of both colors and creates harmony in the image. This is yet another role of balance in composition, which we began to discuss in the last chapter, except rather than discussing lines and weight, we now also have to consider the way in which color can create-or disrupt—harmony in your photography.

While single colors can have an overwhelming effect, multiple colors can work together to contrast or harmonize and create a sense of balance in a photograph. Just as a large object at one end of the frame can create tension with a smaller one at the opposite end, complementary colors both create and resolve tension in a photograph, and can bring disparate elements together in a meaningful and satisfying way. Of course, it isn't all plain sailing; colors can work against each other

and make an image look boring or chaotic. If the subject isn't placed carefully, too many different colors in one scene can detract from it. If vou have two competing and noncomplementary colors in the frame, the eye won't necessarily know where to look (tension is created but left unresolved). Then again, if you don't use a big enough range of colors, there's a possibility that the photograph will come across as flat and uninteresting (though, as you'll see, there is a place for subdued color palettes, depending on your particular subject and the mood you want to convey.)

You have to ensure that there is enough variety to create something that's stimulating. Sometimes this is a subtle art—whereas orange will always play strongly off blue, and red off green, you can also use gradations of a single hue to introduce variety into your shots. As you study and learn to appreciate the nuances of color, you will gradually recognize that large swathes of uniform color are, in fact, quite rare. Usually you will find understated colors delicately playing off each other in the details.

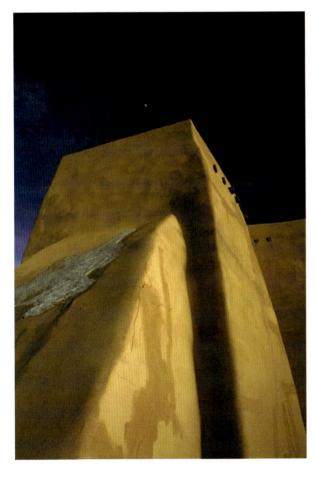

Hature's palette

Absent fine detail, this image relies heavily on the rich color of the adobe church, which complements the dark blue sky in such a way as to both accent the shape and contours of the church's structure, and pull the lower and upper elements together into harmony.

← Subtle shades

How many different shades and tones of red can you name in this image? When you take a photograph that makes use of analogous colors you want it to be a challenge to name all the different tones, shades, and tints of a color that are flooding through it.

Accentuating Color

Saturated colors are stronger than muted ones, both literally in the intensity at which their hues are displayed, and also figuratively in the impression they give to the viewer. We naturally respond more to bold, punchy colors, as they attract the eye and speak loudly. But this absolutely should not

214

mean you need to ramp up the global saturation in all your images. Doing so spoils the effect and your other compositional choices can get lost in the noise. It is much more effective to choose specific colors and increase their saturation selectively, so they can play off softer tones in the frame.

© Daniela Bowker

When and What to Saturate

There will be times when color is the dominant element in your image, and you will need to bring out that color to its fullest possible effect. Sunsets are a classic example: The fact that the sun is on the horizon is not what is particularly thrilling; it happens every single day. What is exceptional about a sunset scene is the radiant skies that take on vivid tones and transforms what was, just a few hours ago, a solid blue sky into a whole canvas of warm, glowing tones. In such situations, you have a lot of leeway in the amount you can boost the saturation.

But not every scene relies so much on color to communicate its themes. In fact, while we expect to see a variety of colors everywhere in our day-to-day life, the natural world offers far fewer bold colors than we may realize. Just try going out on a nature walk and capturing all six strong colors (as described on page 212). If you come across some exotic flowers, you might luck out, but otherwise you're likely to find lots of soft greens and browns, some pastels and slate blues, and plenty of grays. This natural color palette is not necessarily something you should fight against. If you want to communicate the peaceful, pristine

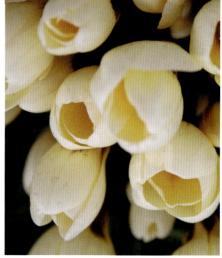

aniela Bowker

↑ Bold attraction Your eye is drawn immediately to the bolder, red-orange pollen rather the plain white petals of these crocii.

← Emerging from shadow

It's not just complementary colors that accentuate each other; black and white can intensify or mute other shades, too. By placing a color on a black background, you'll embolden it; and white will make it seem slightly more dull and subdued.

conditions of a babbling brook or a rolling countryside, adding color isn't going to suddenly achieve that for you. Rather, you will need to lean on your other compositional tools and techniques. If, on the other hand, you want to communicate the dynamism and hectic commercialism of a metropolis, vivid colors will be just the ticket, and you will have no trouble finding examples of them in man-made environments. Yet again, it is simply a matter of recognizing the right tools for the job, and implementing them in such a way as to both achieve your creative vision, and adequately (if not accurately) represent your subject.

Color Intensity and Light

If you're shooting in low-light situations, it's important to remember that colors from the blue and green family will appear brighter to your eye than reds and yellows. This is known as the Purkinje Shift, and is a result of the transition from using mostly conebased color-sensitive vision during the day to rod-based light-sensitive vision at night. Cones detect yellow light better; rods pick up blue light more effectively, hence the eye finding blues and greens brighter at twilight. Of course, our cameras don't have rods and cones, which means that they'll detect the colors differently than our eyes. What you see at the time might not be quite the same as what your photograph shows later.

Multiple Colors

Just because too many colors can make an image chaotic, it doesn't mean that you can't use them. Flooding a picture with a host of different colors can be extremely effective. A lot of it depends on how it is done. You might find that in this situation it's the range of color itself that is the subject of the photograph.

From Black and White to Color, and Back Again

The first photographic images were all black and white. It was Eastman Kodak who introduced color photography to the masses when they released the now-discontinued Kodachrome film in 1935, which soon became the photographers' film of choice for its vibrant colors. Still, it took until the

Daniela Bowker

1980s for many newspapers to print in color. As effective as color is for eliciting emotions, there are times when only black and white will do.

Black and white can be especially good for portraits. It gives them a timeless quality and, most flatteringly for the subject, evens out skin tones. Black and white can also save a slightly-too-noisy color photo from the trashcan. If you've been shooting in low light and find that your images are riddled with digital noise (random flecks of color where it should be smooth, coupled with an unpleasant graininess), converting them to black and white can help to bring back some of their definition and salvage a photograph. The color versus black and white decision is a creative and stylistic choice as well as a compositional tool. The best way to learn just what sort of impact it can have on your images is to go out and experiment.

215

← The rainbow approach

If the intention had been to accurately represent the shape of a pinwheel, or to take a still life in a toy store, the abundance of colors seen here would have been inappropriate. As it is, the colors themselves are of primary importance, and are bright and diverse enough to speak for themselves.

↓ With and without

The color version is warm and inviting, but there's a timeless elegance about the black-andwhite version that elevates a snapshot to something more.

© Daniela Bowker

Compose with Color

↓ Dominant reds

Letting one color consume the frame will give your photo a punch. Color has the most dramatic potential for your images. It can change the entire mood of a photograph; it can bring life to an image; it can accentuate the subject in a way that simple placement can't; it can even form the subject of a photograph itself. So for this challenge, you need to go and experiment with capturing color. Make color the most significant aspect of your photograph—superseding the particular shapes and lines of the subject. Of course those elements will still be there, but what's important here is that you get a feel for the primary impact that color can have on your images.

> Up, up, and away

On the other hand, including multiple colors gives the eye some contrast and invites comparison among different parts of the frame.

Challenge Checklist

- → Train your eye to see color first and foremost, and compose around either one color, or the interplay of several.
- → Identify the contrasting and analogous colors in your scenes.
- → Use color to bring balance to your photographs.

I was surprised when I reviewed this photo later, as it looks almost like a very shallow depth-of-field macro shot. But in fact it was just a lamp casting this beautiful rainbow against the ceiling. It made the whole interior decoration of this restaurant quite lovely. *Sven Thierie*

Yes, that was my immediate reaction, too. Delayed recognition that these are reflections adds to the interest. Good choice of positioning, with the diagonal direction from fitting to lamp tip making a cross with the orientation of the subject and the background. *Michael Freeman*

219

The jellyfish had such an incredible color, contrasting with the blue tanks, I had to shoot it. I used a pretty long exposure, so it took me several shots to get a sharp one. I couldn't use flash due to the reflection it would create against the glass. Jennifer Laughlin

These rich, saturated, contrasting colors work fantastically together. The shape of a jellyfish is always interesting anyway, and its body is all the more accentuated against that bold blue background. My compositional eye, however, wants to shift the view a little to the left–less empty blue on the right. *Michael Freeman*

220

Pattern & Repetition

There's a wonderful French expression, "metro, boulot, dodo," that's used to describe the humdrum of working life. You commute to your job, you work, you sleep; the next day, you get up and do it all over again. What it describes is mundane, but the way that it describes it isn't. There's a rhythm and delicious melodiousness to the words that makes them attractive, and saying the phrase several times over doesn't diminish it. When it comes to imagery, repetition by itself can be monotonous; yet there is also an appealing stability, an attractive flow, and a captivating charm to a pattern.

Hacking up for perspective A section A sec

A side-by-side shot showing only two of these boats wouldn't suggest a pattern, as there is plenty to distinguish them up-close. But as with many other subjects, backing far enough away causes the eye to look for similarities rather than differences. In other words, pattern can be a matter of scale. Sometimes, altering your vantage point can help you to spot a pattern that you otherwise might not have noticed. For example, looking down from a tall building can give you the possibility of rooftops, of cars, of people, maybe even a sea of umbrellas if it is raining. Try looking up for architectural patterns or bark and leaves on trees. If you get in close, you can see the patterns in fruit skins, tire treads, and even the weave of fabric. Once you start to look for patterns, you'll spot them everywhere.

↓ Everywhere you look

Patterns come in both man-made and natural forms, and you don't have to look very far to spot one. Bricks in a wall form a pattern, as does the veining on a leaf. Man-made patterns tend to be regular and this can make them feel quite constrained and formal, whereas natural patterns usually have irregularities and feel more relaxed.

Consistent Patterns

If you isolate a pattern from its environment, you can induce the sensation of the infinite in your image. The pattern has no beginning and no end, and for all that the viewer knows, it could go on indefinitely. This is the sort of photograph for which using a longer telephoto lens, or even a macro lens if you have one and are focusing on a very small area, is helpful. But don't think that it isn't possible if you've only a limited lens selection: Get in as close as you can, and if you have enough resolution, you can crop in even closer afterward © Daniela Bowker

© Daniela Bowker

Broken Patterns

Spotting a break in a pattern—or even creating one deliberately if you have to—can be the focus of an effective photograph. The break can take almost any form: There could be a gap in a row, an aberration in a consistent flow of color, a change in texture, and so on. The key is that it inserts something arresting into the frame that draws the eye and forms the point of focus in the image. Patterns coming into conflict with each other are a slightly different take on the idea of a broken pattern. Two or more different patterns may create an unpleasant dilemma for the eye, so the point at which they clash should be the focus of the image.

Patterns and Color

There is often a strong relationship between pattern and color. In a monochrome image, it might be tonal differences in that one color that comprise the pattern. If you photograph a broken pattern, the break in the sequence might be something of a different color. The balance created by multiple colors in a sequence can prevent a pattern from looking too static and monotonous. Just because something is repetitive, it doesn't mean that it has to be boring.

Pattern and Placement

You will often find that the constituent parts of a pattern, whether they be lines or the points at which an inconsistent pattern breaks, create natural compositional indicators. If you have strong horizontal or vertical lines, these will automatically suggest your frame orientation. A break in the pattern would be an ideal focal point and something to be positioned carefully (possibly off-center, to create tension). Knowing what it is that you are trying to convey in capturing a pattern—the odd one out, the feeling

of the infinite, or the sense of consistency—will help you to decide on the ideal placement as story and

↓ Multiple volumes

composition combine.

If you want to create a dynamic image, think about setting the pattern on a diagonal. If you look at this photograph of shelved books, setting their spines square and head-on in the frame could well have made it too static and confrontational. Instead, the diagonal orientation induces a feeling of movement and continuity as the books head out of the frame.

© Daniela Bowker

←← Color coding

+ Hides to dry

are spread out.

This photograph is almost entirely different shades of yellow, but it's those different shades and the unusual shapes that give it interest. Furthermore, there is a repeated textural contrast between the smoothness of the hides and the roughness of the ground on which they

A row of red-orange jars alone would have been somewhat unexceptional as a subject, but contrasting those lines with yellows above and below, further separated by the dark brown shelves and punctuated by the white lids, all come together for a nice variety.

Follow a Pattern

Three in a row

Patterns don't have to stretch on into infinity—sometimes a simple arrangement is even more effective. Patterns really are easy to come by and they can either contribute to or create a beautiful photograph. Whether you spot a man-made pattern, capture a natural pattern, or even create one yourself for the purpose of this challenge, that's what you're going to photograph. It doesn't matter if you decide on a consistent or a broken pattern, either of those will create plenty of opportunities to practice the skills that we have covered already in the book. Just keep an eye out for repeated subjects, and consider carefully how you want to frame them up.

© Daniela Bowke

222

Challenge Checklist

- → Take a photograph that features a pattern.
- → Consider your subject placement to ensure that you have a dynamic, balanced image.
- → Think about the aperture you will use and how much background blur this will create.
- → Take into account the impact of color on your photograph.

↑ Textural close-up

Cropping in tight on an ongoing pattern will invite a close study of its detail. Daniela Bowker

The diversity of bold colors shown here drew my attention from some distance away. I took a few shots looking straight at them, but they didn't look nearly as interesting as this angled shot which leads off to the right. Sven Thierie

An acute angle usually gives more dynamism to a pattern shot like this, as you rightly say. It will also usually leave you with a decision about where to crop at the far end. Here you have more depth, but at the slight cost of corners that prevent the pattern from filling the frame completely. Michael Freeman

COMPOSITION

This is a photograph of betta fish bubbles. My betta would make nesting bubbles at the top of his bowl. Using only window light and a small reflector card for lighting, I used a 55mm macro lens with an extension tube to shoot their pattern. Jennifer Laughlin

Excellent lighting setup, as the gradation from light to shadow adds interest and also more and more catchlights in the bubbles as you move down the frame. Also a good example of how moving in close and eliminating any context makes patterns feel endless. *Michoel Freeman*

REVIEW

225

226

COMPOSITION

Natural Frames

← Frames within frames

Architectural design often takes into consideration how certain views will be framed as one moves through a building, so keep an eye out for these cues and take advantage of them as they present themselves.

Viewfinders aren't the only things that can frame a scene. Far from it. If you keep an eye out for them, you will find innumerable "natural frames" that you can capitalize on to aid in your composition. Despite the word "natural," they don't have to be organic in substance; it's just that they happen to be there in the image already-a frame-within-a-frame. They serve as great compositional tools to direct the eye straight to the subject of the photograph. They're also valuable because they can bring perspective and a sense of three-dimensionality to an image. It's as if you're looking through one layer of the image and on to another. We also tend to find images that use natural frames attractive because it brings order, in the same way that using triangles helps to organize scenes with multiple subjects. A frame puts a limit on the scene and provides it with some boundaries.

Almost anything can serve as a natural frame: windows, doorways, and arches are obvious choices, but trees, fences, and cave openings work as well. They don't have to be complete frames, either. You might find that the trunk and over-hanging branches of a tree create a frame on only two sides of an image, but it is enough to create a feeling of depth in the photograph and direct the focus to the subject.

When you're composing a photograph using an existing natural frame, it's important to think about how the frame is going to interact with and affect both with the subject it's containing and also the photographic frame of the image itself. You'll need to pay attention to the lines that the image is creating, and how they are going to emphasize the subject and maintain a sense of dynamism.

↓ Singapore sights

Natural frames work best when they bear some thematic relationship with the subject they are framing. This shot combines two iconic Singapore landmarks—the Singapore Flyer (the ferris wheel) and the Skypark (a skyscraper with a huge pool on the roof)—and in doing so, identifies itself strongly with the whole city.

© Daniela Bowker

Just because the image has a natural frame that is bringing focus to the subject, you shouldn't ignore other compositional theories—for example, the Golden Ratio. By combining these techniques, you'll be able to create a great image, not just a good image.

Think carefully about the depth of field that you'll want to use in your image, too. If your subject is at a different distance than the frame you want to use, and you intend for both frame and subject to be sharp, then you will need a small enough aperture to give you adequate depth of field. Alternately, sometimes a natural frame can still serve its purpose without being in sharp focus, and you can isolate only the subject in a shallow depth of field. In the portrait to the right, for instance, the dark shadow of the tree does the job of framing the little boy while being nothing but a blurry amorphous shape. Indeed, details in the branches or trunk likely would have only distracted the viewer.

If you're inside a cave or tunnel, shooting out through its opening to capture a subject that is brightly lit by exterior light, you might find that you will have to compensate the exposure in order to use the opening as a natural frame. If you are using a matrix metering mode, you can ensure the exterior is not overexposed by dialing in some negative exposure compensation. Another approach is to use spot metering to measure only the light falling in the exterior. On the other hand, if you want to capture the full dynamic range of both the interior frame and the exterior subject, you can take two shots—one for the shadows, one for the bright outside subject-and combine them in post-production.

Finally, a note of caution: Using frames within frames is so effective that it can be easy to get carried away and try to use them to solve all your compositional problems. One natural frame in a portfolio is clever; a dozen is cliché. Just because a potential natural frame exists doesn't mean it is the best way to compose the shot—ideally it should still bear some relationship to the main subject.

↑ Partial framing

The frame isn't complete the tree trunk and branches form only two sides of it—but it nevertheless manages to place the subject. Coupled with the position of his eyes in accordance with the Golden Ratio, this portrait ends up with a strong composition.

Negative Space

228

In the first chapter we looked at the idea of "filling your frame," or getting in close, and how if you can't justify why something is in your scene, then it shouldn't be there. An extension of this idea is negative space, or quite literally having areas of nothing in your photographs. It might seem counterintuitive to talk about "filling your frame" and "negative space" in the same sentence, but it's more helpful to think of them as two sides of the same coin.

Placid water, empty frame

Because the majority of this frame is empty, the few elements that remain are further emphasized and given greater focus.

If you have a complex subject that's detailed and busy, contrasting it against a blank area will bring some balance to the composition. It helps the eye to find a point of focus and to prevent the image from presenting itself as chaotic. The negative space itself, however, needs to be absolutely barren and as uniform as possible in order to maximize its effectiveness. Consistency of tone and color can support the main subjects without offering any distracting elements. Heavy fog can achieve this very well, as can blank architectural walls. The negative space may be a complementary color, but most often it's a simple neutral.

A Sense of Space

We've already looked at how to create the illusion of the infinite by filling your frame with a pattern or repeating subject and denying any sense of a boundary. You can create a similar feeling of infinity by surrounding a solitary subject with negative space. For example, you could photograph a sailboat on a lake and include the shoreline, but that limits the feeling of space and gives a boundary to the water. By composing your image so that you capture just the sailboat on a negative space of water, it is suddenly sailing on an infinite sea.

Creating Atmosphere

Negative space can contribute to the atmosphere that you want to create in your photographs. Dark negative space (i.e., shadow—something that we'll cover in more depth on the following pages) can imply brooding and foreboding. Negative space in certain colors can lend a particular feeling to an image; blue is calming, for example, while yellow is uplifting. Light-colored areas of negative space work toward a feeling of airy positivity.

Accentuating the Subject

When there is nothing else to look at except the subject in an image, that's exactly where the eye will go. Placing the subject in a sea of negative space will accentuate it. Obviously this is ideal for product photography, when you want a \$50,000 diamond ring to be the center of attention; but you can also use it to make dramatic or slightly surreal images that aren't intended to sell something. The first option is to photograph your subject on a plain background. If you don't have a professional backdrop, a scarf or a sheet of uniform color and texture will work, too. However, you can also use lighting to surround your subject in negative space. You can either light your background so strongly that you "blow it out," or overexpose it to the extent that the sensor cannot detect anything in that area; or you can light the subject with something significantly more intense than the ambient light, so that it will look as if it is emerging from the darkness.

↑ Double negative

The black outlining the windows forms one negative space, and the light coming through the window and highlighting the detailing of the latticework creates a second.

Enhancing Patterns and Shapes

Our eyes and brains are constantly searching out and recognizing patterns and shapes. Think about gazing up at a bright blue sky, and how we look out for cloud formations that resemble faces, animals, and countries. The interaction of positive and negative space in a

photograph, especially a minimalist black-and-white composition, creates similar opportunities to create and/or discover different shapes. You just have to look out for the interplay among objects, or between light and shadow. High-contrast renditions will further enhance the effect, which can be done in post-production.

The flower is beautiful enough that it would make a good subject even against a typical green, natural background. But by draping a black cloth behind it and using the sun as a strong spotlight, the flower takes on a kind of grandiose elegance, rising as it does from nothingness, first with its soft, white petals, and then with its delicate but radiant-orange stamens. The negative space is just as much a part of the finished photograph as the subject itself.

Of Light & Shadow

The word "photography" is a composite of the Greek words phos ($\varphi \tilde{\omega} \varsigma$ —light), and graphé ($\gamma \rho \alpha \varphi \dot{\eta}$ —drawing). It is, therefore, quite literally "drawing with light." Without light, we wouldn't be able to make a photographic image, and with this light comes its inseparable counterpart: shadow.

230

There can often be some kind of terror associated with shadows in photography, as it is true that the perfect image can be ruined by a misplaced or completely obscuring shadow. While this is an entirely legitimate concern, it is easy to forget that shadow doesn't always have to be a negative in your photographs. Shadows can make bold statements or cast subtle hints in your images. As we saw on pages 164-165, chiaroscuro (literally "light-dark"), describes using the contrast of light and shadow to shape the main subject. Shadows are definitely not something of which you should feel afraid. If you approach your photograph from a different angle, you might find that a shadow, far from ruining a composition, can help to make it succeed.

In fact, light itself can often be the main subject of your photograph. Perhaps the light streaming through a window is casting beautiful shadows on a row of bottles sitting on the

→ The light comes first

In this shadowy Italian cathedral, it was the contrast of the shafts of light slicing through the shadows that caught my eye. The ornate architecture is really just a backdrop (granted, a very nice one).

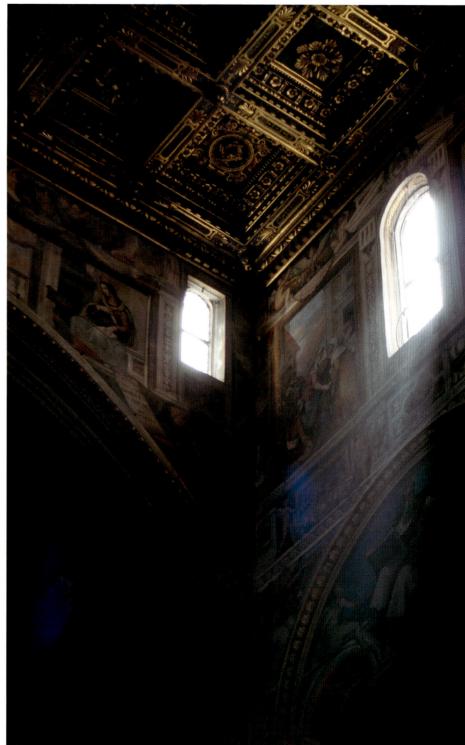

© Daniela Bowker

windowsill across the wall. Or maybe it's the interplay of light and shadow falling through a tree canopy that is creating an image that deserves to be captured.

A silhouette can work as a main subject as well, though it isn't strictly a shadow. Rather, it's the outline of something unlit in the foreground against a more brightly lit background. If you have a beautiful, burning red sunset sky, it can make a stunning background for the twisted shapes of tree branches, or of a couple walking hand-in-hand on a beach.

Shadows that Conceal

Occasionally, what a photograph doesn't show can be just as effective or telling as what it does show. By letting the shadows dominate your frame and inserting an abundance of negative space, you can create something moody, atmospheric, and evocative. If dark tones are the prevailing feeling from your photo, then you've likely created a low-key image (see pages 88–89).

Although often ripe with shadows, low-key images don't have to be sinister and brooding; they can be enticing and intriguing, too. It will all depend on what it is that you're photographing and what you place in the shadows. The light cast into a shadowed room by a door left ajar can evoke a feeling of intrigue; light coming through shuttered windows might make an image feel more constrained. A half-lit face with a coy smile is potentially seductive; a half-lit face with a glare can suggest menace,

Shadow performance

Strong directional lighting always casts obvious, defined shadows. You can either keep an eye out for natural shadows created by nearby objects, or use that lighting to pose a subject for an interesting shot.

and this effect can be emphasized depending on the angle from which you photograph your subject, too.

If you are having a go at nude photography, shadows are a highly valuable tool. First, they are suggestive and emotive, and can be used to hint at what is going on in the scene, piquing the viewer's interest without being explicit. Overall, shadows contribute to the atmosphere by resonating with the hidden depths and secrets of the subject. And they can also provide some anonymity for the model.

People

Just about everything that we have looked at so far can be applied to photographing people. In most cases, we have explored how much of an impact a particular theory or technique, whether it's the rule of thirds or high-key lighting, can have on a portrait. But photographing people is very special (it's not for nothing that some cultures liken it to stealing souls), and it deserves a closer look.

272

Like any photograph, a portrait tells a story, and you have to be certain of that story when you take the picture. It doesn't matter if you're having a go at street photography, capturing a spontaneous moment at an event, or working more formally, there will always be something that you are trying to convey. Maybe it's the mischievous glint in someone's eye, the hunch of their exhausted

shoulders, or their sassy strut down the street; it's all a story—a personal and individual one.

The Eyes Have It

For nine portraits out of ten, the most crucial element will be getting the eyes in focus. Even if the subject isn't looking at you, which is going to be the case for a good many spontaneous photographs as well as some posed ones, the eyes still need to be pinsharp. Good communicators always make eye-contact in order to build a connection between them and their audience or conversation partner, and that's applicable to photography as much as verbal communication.

Candid and Momentary

Lots of people are nervous around cameras; it's not that they object to having their portraits taken—which is an entirely different situation—but that they simply find it unnerving. If you're taking photos at a party or among a group of people, you can help to alleviate their anxieties by reassuring them that they don't need to pose and that they don't even need to look at the camera. They can concentrate on having a good time and you can concentrate on documenting it.

← Cute and candid The model is looking down, but her eyes are still in focus. This sort of candid photography has the advantage of putting people at ease as well as presenting you with plenty of opportunities to take photographs that capture a moment. It might be a look or a laugh, but it will be the perfect expression of events. It's also the sort of photography that you are likely to practice out on the street or when you're traveling, capturing the fleeting instant when something catches your eye that is the visual realization of your experience.

As you practice more, you'll find that your eye will become attuned to seeing things that make excellent photographs—people's reactions and expressions, the effects of light, shadow, color, and shapes—and that you will be able to compose on the fly. The vital factors to remember are to get the eyes in focus, to orient the frame to support the image, not to center the subject, and to get in as close as you can. The more pictures that you take, the better you'll become!

Formal vs Posed

"Posing your subject" has connotations of ghastly school portrait sessions, stiffly and grudgingly sat for in front of murky gray backdrops and then shoved into cheap cardboard frames. Of course, it doesn't have to be like that at all. Asking someone at a party to move slightly because you want to catch them against a complementary background isn't formal, but you are still posing them. A holiday snap can become something so much better if you take a moment to ask your subject to move into the shade or turn their face into the light. Indeed, you may be surprised how often a subject will welcome a bit of instruction—it takes the burden of proper posing off their shoulders and puts them at ease.

© Daniela Bowker

A photo shoot in your garden doesn't have to be formal, but it can certainly be posed. This sort of directed portraiture will help give you the opportunity to compose your shots more completely, taking into consideration the light, subject placement, lines, color, and shape. Just remember to give plenty of feedback to your model, showing them what you've done and explaining to them what it is that you are trying to achieve. If the atmosphere is relaxed, your subjects may insist on seeing the results on your camera's LCD. I'll leave that decision of whether to share or not up to you, though in my experience, people are inclined toward humility and tend to dislike the initial results. Sometimes it's better to save show-andtell until you've had a chance to touch up the portraits in post-production.

233

© Daniela Bowker

→ Look for their eccentricities

There is a time and place for stiff portraits, with makeup and hair styling and all the trimmings. But candid portraits often do a better job of telling a story and giving a sense of time and place. Keep an eye out for hand gestures, facial reactions, or funny and energetic movements in your subjects. Anticipating such actions will give you time to angle and compose other elements in the shot.

Capturing Couples

Capturing an individual's personality in a photograph can be challenging enough; doing it for a pair can be downright intimidating. When you're taking spontaneous or candid photographs, you have to be on the lookout for the moment of interaction between two people that comprises their story. When you're starting out, you'll be more inclined to focus on capturing the moment—the quiet look, the raucous laugh, the gentle touch—than anything else. After all, this is what makes the photograph special and meaningful.

234

If you've only a split-second to take the photograph, spending too much time worrying about composition will doubtless mean that you'll miss what it is that you want to capture. The more photographs that you take, the more naturally composition will come to you. Keep in the back of your mind the fundamentals of eyes-in-focus, frame orientation, off-centering the subject, and getting in close, and you'll be fine. If you have the opportunity to photograph two people in a more structured way, you'll benefit from having more time to compose every shot, but you will need to be careful that you don't lose the intimacy between your subjects as you direct them. Whatever their relationship may be—lovers, siblings, parent and child, friends—each photograph will still be about their interaction, so think about what it is that you're trying to convey first, then set about achieving it.

There's an old saying that the eyes of one of the subjects should be on the same plane as the mouth of the other, to make sure that there's a sense of movement in the image and it doesn't come over as flat and dull. While you should focus on capturing their relationship and the vibrancy between them rather than worrying about such compositional rigidity, it is indeed an effective technique if you have time to implement it.

↑ Speaking with shapes

While this couple was goofing around and enjoying themselves, there was just enough time to move such that they were in between the camera and the sun, and then expose for the sky to render them in silhouette.

Aperture causes a few problems when they're first having a go at couple's portraiture. Obviously you want both people in focus, but you probably don't want to have an abundance of background too sharp. Keep your couple close together, get in as close as you can, and try something between f/4.0 and f/5.6. After that, it's all about having fun with different angles, with eye-lines, with negative space, and getting the balance right. Yes, the operative word here is fun.

← The eyes tell it all

Talking to your subjects will always set them at ease, and with couples, their conversation will eventually take off on its own, giving you time to work and observe their interactions. This was shot during a split-second pause as the woman reacted to her boyfriend's comment.

Groups

Much the same as photographing couples, photographing small groups of people is going to be about capturing the relationships among them, and you'll want to approach it in the same way.

Photographing large groups of people can all too easily become more of a tribulation than something fun. Someone is always reluctant, there's always at least one person playing the clown, and it can feel as if you're attempting to herd cats. Aside from recruiting the services of a Sergeant Major, there are a few things you can do to make life easier. Try photographing them from an elevated position, whether up a step-ladder, from a balcony, or even leaning out of a window (carefully, of course)—this makes it easier to direct your subjects. Alternatively, turn that situation on its head and have the group stand on a staircase with you at the bottom of it.

Arranging taller people at the back and shorter people at the front is an obvious one, as is staggering the arrangement of rows, giving everyone an individual space for their head. Taking many, many photos will increase your chances of having at least one where all your subjects are smiling, looking in the right direction, and have their eyes open.

Bear in mind that you might need a smaller aperture for a deeper depth of field as more people are introduced into the frame. An aperture of around f/II will require plenty of light for the exposure, too, because it will be coupled with the fast shutter speeds needed to freeze the action of so many people.

↑ The whole family

Outdoor group shots on uneven ground will be made easier if you can climb up a small step ladder (being careful to keep your balance) to ensure that your subjects don't have their feet cut off by a rolling hill. As you organize the group, speak loud enough to be heard by all, but be sure to keep it fun and light-hearted.

A Couple's Portrait

A simple gesture

Sometimes faces aren't needed to communicate an intimate moment.

Seeing as you might already have photographed one person for earlier challenges, and large groups of people willing to have their pictures taken aren't readily available, this challenge will focus on capturing the interaction between two people in a photograph. Whether you would like to try a more directed shoot or something spontaneous is up to you; the important thing is to clearly identify the relationship between the two subjects and bring it to life in a meaningful and flattering way.

© Daniela Bowke

@ Daniela Bowker

Different heights help

Capturing a moment between two people can be something very small and very delicate.

Challenge Checklist

- → Capture a moment between two people.
- → Think about the aperture you will need to use to ensure that both sets of eyes are in focus.
- → Use the right frame orientation and get in close to bring out the best in your subjects.

I wanted to capture this couple in a natural setting using only daylight. I liked the idea of the sun filtering in through the trees. We waited until late afternoon to get the nice golden light for the photograph. Jennifer Laughlin

The lighting quality is very goodwarm but not too directional, hazy and late in the day. The color palette is restricted and subtle. Expressions are good and affectionate, and my only slight criticism is that they seem to be neither quite standing nor quite walking. Michael Freeman

238

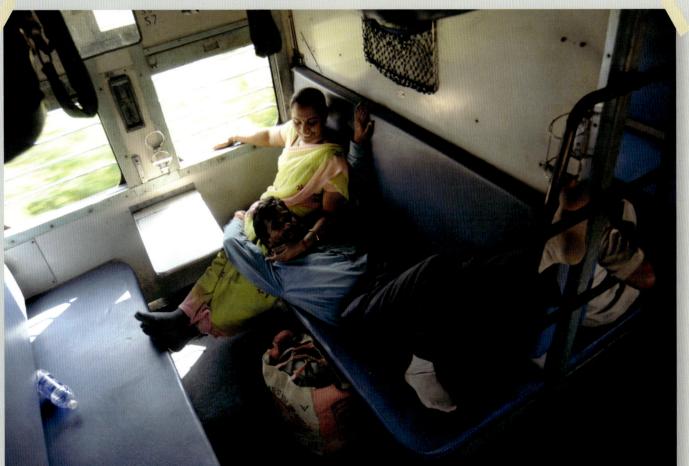

This is a photo that preserves my memories of Indian sleeper trains, the friendly Goan couple I shared my journey with, and the bright countryside I could barely see flying by from the perspective of my top bunk. *Gillian Bolsover*

There's a great sense of relationship here, with relaxed body langauge and expressions. Excellent choice of camera angle, too, nicely angled to make use of the diagonals for energy—I know those multi-tiered Indian sleeper carriages well! *Michael Freeman*

REVIEW

239

Focal Length

240

Your camera's lens works by refracting the available light from a scene and converging it at a single focal plane on your sensor to create an image. How much of a scene a lens is able to bring into view depends on its focal length which is measured (in millimeters) as the distance between the lens and the imaging sensor.

You will hear lots of figures and jargon bandied about in relation to lenses, and have probably already heard terms like "35mm equivalent," "full frame," and "crop factors." It's important to establish our terms now in order to avoid a lot of confusion in our discussion of focal lengths: Rather than repeatedly write out the various equivalent focal lengths relevant to each individual camera and it's corresponding sensor size, all the discussions of focal lengths in this book are referring to the angle of view that such a lens would have on a traditional, 35mm camera. If your camera has a 1.5x crop (i.e., an APS-C sensor), just divide the focal lengths given here by 1.5, and you'll have your camera's equivalent figures.

Prime and Zoom Lenses

Your DSLR probably came with an 28–85mm kit lens (or something in that wide-to-short-telephoto range). It has a variable focal length, and is therefore a "zoom" lens. You can change the focal length between 28 and 85 millimeters, which alters the angle of view. Another popular, but very different kind of lens would be a 50mm "prime" lens,

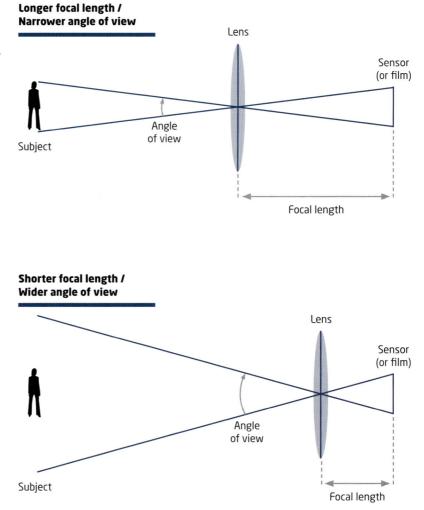

meaning that it has a fixed focal length and its angle of view doesn't alter. If you want to change the size of the subject in the frame, you have to "zoom with your feet," that is, move physically closer to or farther away from it. Prime lenses exist for almost every practical focal length, and they induce a very different way of shooting than what is common with zoom lenses. One tends to be more contemplative, paying closer attention to the edges of the frame and with a keener eye for potential compositions. There's nothing inherent in the design of a fixed-focallength lens that makes a photographer act differently, and indeed a zoom lens can facilitate precisely the same degree of contemplation. It's simply a matter of restriction breeding creativity.

FOCAL LENGTH

241

Another advantage of using fixed focal length lenses is that you learn to gain appreciation for the differences particular focal lengths have on your shot. Zoom lenses tend to make wide angles function simply as a means to "get it all in," whereas telephoto lenses end up being a means of bringing faraway objects closer. These are indeed true benefits, but they do not take into consideration the dramatic differences in perspective that changes in focal length will create. For instance, we've already discussed how wide angles tend to introduce strong diagonals in a composition, which may or may not be your intended effect. Regardless of whether you use a zoom or a prime, you should always be sensitive to the effect of the focal length on your scene.

Rough-and-Ready Guide to Focal Lengths

The exact focal length you use will depend on your personal preference. For example, you might like to work with the traditional 85mm for headand-shoulders portraits, but your friend favors a 50mm lens to include some context in his portraits. Still, this rough-and-ready guide to what you might want in different situations is useful. Note that the examples of lenses shown here are just thatexamples. They by no means cover the full range of available lenses from all manufacturers. For each focal length range, a zoom is pictured on the left, while a prime is on the right—you can see there is a significant size difference.

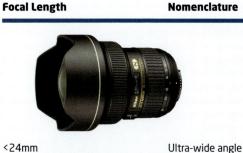

<24mm

Wide angle

Standard or normal

24-35mm

35-70mm

70-200mm

Architecture

Landscapes

Street, documentary, some portraiture

Portraiture

Super Telephoto

Sports and wildlife

Wide-Angle Lenses & Perspective

Wide-angle lenses greatly affect our perception of depth in an image which, remember, is essentially a visual illusion, as a photo is only ever a two-dimensional representation. So while the viewer is not able to physically reach into a scene and explore its depth and dimensionality, you can use an exaggerating perspective to draw them in visually by capturing a wide angle of view. So the question is, what is responsible for the exaggerated perspective? And how does one use that exaggeration to maximum effect?

242

Technically speaking, the emphasis on depth is a matter of spacial distortion,

in that the space and distance between objects seems much greater as your angle of view widens. Of course, this depends on your viewpoint and what is in the frame. If you are shooting off the edge of a cliff without including any foreground elements, all the elements of the composition will be far away and there will be hardly any effect on the perspective. But if you include some object closer to the camera, the space between it and the distant landscape features will seem immense. Additionally, the size of that foreground element will appear quite large comparatively, as it will take up much more of the frame compared to more distant elements.

While this all seems very technical, the visual effect is quite subtle, insofar as it simply suggests that the scene extends beyond the frame, giving the viewer a sense of "being there," in the middle of the scene or amid the action of the moment. For this reason, wide angles are a trademark of photojournalism, in which it is critical for the viewer to feel a connection to the scene, and to give them a sense of participation. Shooting a crowd with a telephoto from across the street feels flat and voyeuristicyou won't be able to include as many elements, and they won't extend around the edges of the frame in the way a wide angle lens does when it is thrust into the middle of the action.

Although the lamposts nearest the camera are only a few feet away, the stonework foreground manages to constitute a full third of the complete frame. The effect is such that you can very much imagine yourself standing there in the courtyard, with the building continuing along the right and left of the scene. Additionally, note how far apart the first pair of lamposts seem from the second, which themselves are about midway between the camera and the archway at the far end of the courtyard. Although the second pair bisects the distance almost exactly, it appears as if they are much closer to the archway because the foreground distance is so heavily exaggerated.

Unflattering Foregrounds

If you take a portrait with a wide-angle lens, the subject's nose looks comically large and their chin juts out absurdly far. This is because by the time you fill up a wide-angle frame with a face, you are mere inches away from it, and as you now know, as objects get closer to the frame, their size becomes exponentially exaggerated. Relative to the rest of the face, the nose and chin are going to look huge, and the ears will be tiny specks on either side. This same effect will be responsible for making the base of a building appear absurdly large and the entire structure look ridiculously tall if you shoot it up close and from a low angle. Being so close emphasizes the foreground, while the increased angle of view brings more of the building into the scene. But what works well for buildings doesn't necessarily translate into a successful portrait, so it's wise to keep a safe distance when photographing people with a wide-angle lens, and make it an environmental portrait.

Enclosed Spaces

If you're taking photographs in an enclosed space, using a wide-angle lens will ensure that you can fit everything or everyone into your scene without having to resort to demolishing walls, which you'd have to do if you were using a normal or telephoto lens. It also makes interiors appear spacious and comfortable, and as such they are well suited for indoor events and real-estate shots.

Converging Verticals

Owing to perspective, parallel lines will gradually appear to converge toward a vanishing point as they approach the horizon, regardless of the lens that you use. However, this effect is far more noticeable with a wide-angle lens as it takes only a very small adjustment of the camera to move the vanishing point quite significantly. If you want to avoid this effect, however, it's best to aim your camera perpendicularly to the front of the building, and crop out the bottom later to make it more attractive.

↑ **Unflattering portraits** Granted, this statue already had a fairly large beard, but the wide angle further exaggerated its jaw, making it appear almost twice the size as the rest of his head.

Keystone correction

This shot on the left shows how strong the converging verticals (an effect also called keystoning) appear if the upward angle is too sharp. On the right, the same photograph has been adjusted in post-production (using the Filter > Lens Correction > Vertical Perspective tool in Photoshop) so that the verticals are all parallel, but it required cropping out extensive areas on the side and at the top.

© Frank Gallaugher

243

Broaden your View with a Wide-Angle

Close and wide

Most wide-angle lenses let you focus quite closely, giving some of the benefits of a macro lens, but also letting the scene retain a sense of the surrounding environment. If you don't already own a wide-angle lens, don't feel as if you have to go out and buy one because your photographic arsenal will be incomplete without it. Maybe you can borrow a lens from a friend, or rent one for a weekend to get a feel for it. If you decide that you like it, then you can think about investing in one. As part of your experiments with wide angles, try to compose a photograph that makes use of the emphasis that they place on the foreground. Perhaps try a fun, nontraditional portrait that has disproportionately large features, or attempt an immersive shot where you feel as if you're right in the middle of your scene.

→ Leaning lines

Don't be arraid to induce strong angles and converging lines—it's not a perfectly accurate representation, but that's not always the point of the photograph.

Challenge Checklist

- → Work through a series of different focal lengths to examine their varying impacts on your composition.
- → Try focusing on some vertical lines and see how they converge when you alter the position of your camera.
- → Use a wide-angle lens to distort the proportions of subjects in the foreground of your scene.

These countless concrete objects lining the beach caught my eye, and I thought they'd be an interesting foreground for a seascape. I had to stop down to a narrow aperture to make sure everything was in focus. Sven Thierie

What would've been just another ocean shot is definitely enhanced by including a lot of interesting foreground shapes. And getting low and close to those concrete objects gives a near-far sense that relates them to the distance. The band of sky, though, is too featureless to merit a quarter of the frame. *Michael Freeman*

The wide angle let me include enough foreground to contrast with the faintly lit horizon, and also by holding the camera upward, the towers appear to lean backward, following the power cables into the distance. *Adam Graetz*

Keystoning, coupled with the lines of the power cables, does a good job of pulling your attention into the image, and makes the scene more imposing than would a higher viewpoint. The exposure is also effective—moving up the frame passes from shadow to light and back to shadow again. *Michael Freemon*

REVIEW

247

Telephoto Lenses

248

Roughly speaking, telephoto lenses (also called long lenses) have focal lengths beginning at around 70mm, and going as high as 600mm (at least in terms of normal photography—there are telephoto lenses that reach well into the thousands of millimeters. but unless you operate a stellar observatory, you're unlikely to ever get your hands on one). This is an immense range that exhibits diminishing returns the higher you go-not in image quality, necessarily, but rather in visible effect. Whereas the 10mm difference between a 28mm and an 18mm wide-angle lens is extremely noticeable, the difference between 300mm and 310mm is barely perceptible (such that no 310mm lens exists—instead, manufacturers tend to make leaps from 300mm to 400mm to 500mm, etc.).

When people think of telephoto lenses, they automatically have visions of wildlife or sports photographers with obscenely long lenses protruding from their cameras, because they are wonderful for bringing distant subjects closer. But that isn't their only function; and you needn't be on the sidelines of the football field to consider adding a long lens to your arsenal.

Shorter focal length / Less compression

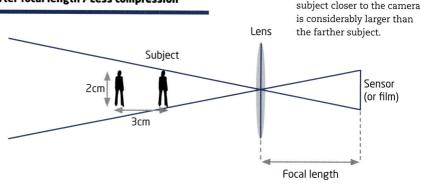

The wider angle of view will

give the impression that the

each other, and that the

subjects are farther apart from

Longer focal length / Greater compression

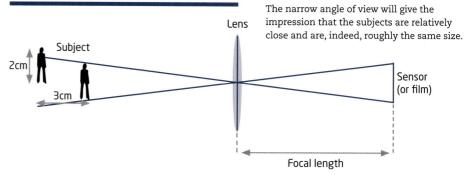

Normalizing

The narrow angle of view from a telephoto lens will create an impression of scenes being compressed and flattened, with distance between objects made less obvious. This is excellent for portraiture, ensuring that all parts of your subject's face are represented in equal proportion to each other. The narrow angle of view means that objects in the background of a scene take up proportionally more of the frame, making them appear roughly the same size as things in the foreground, even if they should be considerably smaller. This is known as the "normalizing effect."

Camera Shake, Magnified

Whatever you do when you use a telephoto lens, be aware that even the slightest movement of the camera will be magnified massively. This makes it very easy for your point of focus to be a blurry smudge instead of a crisp image, especially because telephoto lenses tend to be heavy and fairly unwieldy. The easiest solution is to use a tripod, but if that isn't practical, keep your shutter speed as fast as you can manage. The general rule for finding the slowest shutter speed appropriate for a given lens is to divide I by the focal length of the lens. So a 200mm lens should use a minimum 1/200 second shutter speed. and a 500mm lens shouldn't venture below 1/500 second. That said, your telephoto lens may have a stabilizing feature (called Vibration Reduction, Image Stabilization, or other names depending on the manufacturer) that compensates for varying degrees of perceived motion. These features can be highly effective, though it is important to be aware that their effectiveness is often unpredictable. Unless absolutely required by low lighting conditions, you should always try to keep your shutter speeds as high as possible. Also, be sure to deactivate the stabilizing feature if you mount the lens on a tripod, as it can overcompensate and induce blur itself.

Density

The impression that telephoto lenses give of compressing scenes and bringing subjects closer together as well as normalizing their relative sizes means that you can increase the apparent density of your subject, and make it look as if there is more happening in the frame. You could photograph a moderately busy high street with a telephoto lens and the compression effect will make it look bustling and full of people. A flower bed can look positively overwhelmed with flowers as you keep the relative sizes of the flowers approximately the same and the distances between them look as if they've been reduced.

Layering

Far too often its taken for granted that a landscape must be captured with a wide angle lens. While that is an effective way of representing wide open spaces, a telephoto approach opens up many other compositional possibilities for a landscape. If you emphasize the idea of different layers in a photograph, with clear foreground, mid-ground, and background elements fit tightly into frame, you can create remarkably effective landscapes with strong graphic qualities that emphasize the shapes and textures of the various elements, giving them an opportunity to contrast with and play off of each other

> St. Paul's to scale

A short telephoto perspective retained the sense of scale: The people in the foreground are small, the cathedral in the background is huge.

→ Dense down below

Shooting this city street from far above with a very long telephoto pulls all the elements of the scene into a very tight, compressed composition that, coupled with the technique of letting the elements reach all the way to the edges of the frame (as discussed on page 220), makes the scene feel crowded, busy, and energetic.

© Daniela Bowker © Kropic

Reach Out with a Telephoto

© Daniela Bowker

As with a wide-angle lens, if you don't already own a telephoto lens, don't feel compelled to splash out a serious chunk of cash right now because you're somehow not a real photographer without one. For a start, your kit doesn't define you as a photographer, it's the photographs that you produce from it that count. And secondly, gobble up gear in haste and you can repent at leisure. Try borrowing or renting a lens first. Get a feel for it, have a go at this challenge, and make use of a few other long-lens opportunities. Think about how it will contribute to your photographic life, then make the decision.

Experiment with compressing and increasing the apparent density of your subject by using a telephoto lens. You can pick anything as your subject, but the idea is to get a feel for how a telephoto lens can be used creatively—not just for bringing distant subjects closer.

← **Closing the distance** Wildlife is obviously well suited to telephoto focal lengths, giving you plenty of room to work without disturbing your subject.

2

CHALLENGE

→ **Compressed composition** By using a telephoto lens, the distance between each of these mountains was made

less obvious, creating a layering effect all the more accentuated by the fog gradually obscuring them as they move farther away.

Challenge Checklist

- → Use your telephoto zoom lens at different focal lengths and distances to explore the effect.
- → Alter the aperture you use to see how the depth of field seems to decrease as the subject is magnified.
- → Check your shutter speed and stance to make sure that you get a sharp image.
- → Take a photograph that uses the compression effect to increase the apparent density of the subjects in your scene.

There's no shortage of photos of the iconic Epcot, so rather than fit the whole structure in frame like all the postcards, I zoomed in close on just one section. I ended up being more interested in the color and texture of the surface than the overall shape. Adam Graetz

Telephotos are excellent for cropping in tight on architectural elements, often giving more interesting results than trying to fit the complete structure in frame. The rich colors also play nicely off the pure black negative space on the right. Glad to see you set the aperture small enough to render it all focused. Michael Freeman

COMPOSITION

REVIEW 2

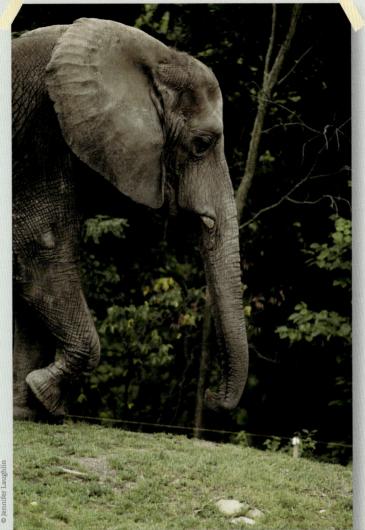

This photo was shot with a 300mm telephoto lens at the Pittsburgh Zoo. On the practical side, I wanted a closer shot of the animals than what my 18-135 mm was offering, but I also liked the tight, compressed compositions I was getting with it. Jennider Laughlin

Getting in so close with a telephoto emphasizes the interesting shape of the elephant's trunk and head, which work well in the vertical orientation. And by capturing the animal midstride with one leg up, the image feels more alive and energetic. Good timing. Maybe could be cropped in a little tighter? *Michael Freeman*

253

COMPOSITION

Panning

To be honest, panning is one of the more difficult photographic techniques to get right, but the results are so impressive when you succeed that it makes the frustration worthwhile.

254

The trademark of a panned image is a subject in sharp focus, cast against a motion-blurred background (as opposed to a simple shallow depth-of-field shot in which the background communicates no sense of motion, and is blurred by being out of focus). The contrast makes the subject feel as if it is leaping off the page, as its orientation is in the opposite direction of the motion blur. The effect is achieved by tracking your moving subject across a plane, and using a shutter speed that is just low enough to blur out the background as you pan across it, but still fast enough to freeze the subject before it moves too far out of frame. The subject has to be kept exactly in the same position within the frame—which is particularly difficult as the viewfinder will black out as soon as the exposure begins. It takes practice, anticipation, and steady hand-holding technique (a dollop of good luck doesn't hurt either). When you first start panning, you will likely have a pile of photographs in your trashcan that are no more than blurry messes or have subjects that are half in the frame, or even missing from it entirely. However, the process and technique does gradually become intuitive, and the skill of tracking your subject translates to other types of photography as well.

Forward panning

Once you master the panning technique, you can apply it to other scenes beyond those passing from left to right directly in front of you. It gets more difficult, of course, but you need only capture part of the subject sharply for the effect to be readily apparent.

Shutter Speed

Obviously you need a relatively slow shutter speed, as this will create the background blur that provides the sense of motion. So that you won't have to worry about aperture but you have control over the shutter speed, set your camera to Tv or S mode, and a shutter speed around 1/30 second should give you sufficient blur. If 1/30 second is a little too slow for you at first, try something a bit faster, maybe 1/60 second. At this speed the background blur will be less pronounced, but you will get a feel for the technique. As you improve, you can slow down the shutter speed more and more, which will increase the blurriness of the background and make it look as if the subject really is whizzing past you.

Subject

The faster your subject moves, the harder it will be to capture it; so starting off your panning practice at a Grand Prix will likely result in a lot of frustration and not very many usable photos. Planting yourself on a street corner and starting with bicycles is ideal. When you feel that you've mastered those, you can try motorcycles and cars, too—not to mention dogs, horses, and runners.

Stability

Using a small, light lens, with elbows held tight against the torso, feet shoulder-width apart, and left hand underneath the lens for support, you should have the stability needed to capture a shake-free shot. Often this is even more useful than a tripod with a swivel head. If your lens or camera has an image stabilization feature, either deactivate it, or switch to one of its panning modes, so it doesn't interfere.

Composition

Aim to keep the subject in the center of the frame-at least at first as this will be easiest—and don't obsess about the image feeling flat or dull. The idea is to capture a sense of motion, and if you're successful, it will still feel dynamic regardless. You will, however, want to get in as close as you can so that you can photograph the detail of the subject but still have some background to give the feeling of movement. If your camera's autofocus is fast, you shouldn't have any problems focusing on the subject by half-pressing the shutter release button and allowing it to focus just before you take the shot. Otherwise, you will need to pre-focus manually on something that's the same distance away from you as your intended subject.

Technique

You've chosen your position so that you can track your subject, set all your camera settings, and braced yourself for stability. You're ready to go. When you've spotted your subject, position it in the center of your frame and track it with your camera, moving at the same speed by rotating your torso. Make sure that you use your viewfinder rather than your LCD screen, so that there is no delay (however fractional) between what the subject does and you seeing it. As your subject begins to pass in front of you, gently release the shutter and keep following it with your camera at the same speed. Follow through with the movement even after the shutter has closed again. The more you practice, the steadier you will be able to track your moving subjects.

↑ Street scene practice

Make sure that you're able to move your camera in parallel to your subject and that nothing is going to obscure your view. You want to be able to track your subject smoothly as it approaches, passes in front of you, and then moves off. Even though your shutter won't be open for all of this motion, the fluidity and follow-through will help you to capture a better image. 256

COMPOSITION

Motion Blur

While blur may be the enemy of sharpness, it is not necessarily the enemy of good photography. This may take some getting used to, as sharpness is typically seen as a sort of prerequisite for an acceptable shot. In most cases this is perfectly logical, but when it comes to communicating motion, the rules change a bit. No longer are you necessarily seeking to freeze a moment in time, because motion is an extension of that moment. and a sharp, frozen representation isn't necessarily an effective way to communicate that. Blur, on the other hand, can extend that moment and preserve a sense of time and motion within a single, still frame. Like so many other creative decisions in photography, whether or not this particular technique is a success is a matter of intent. A viewer can easily tell the difference between a blurry shot resulting from sloppy handholding technique and one that uses that blur for a self-evidently creative purpose.

The classic shot that makes use of motion blur is probably the rear lights of cars streaking into the distance. It might have been done a million times or more, but there's a reason for that: It looks fantastic. It's evocative and expressive, and the colors work. It also happens to be an easy introduction to long exposures and motion blur; the cars don't know that they're being photographed, and if the location is busy enough to ensure a constant stream of cars, you can take your time in setting up the shot and experimenting with different exposure settings and compositions.

Any kind of light captured in motion can produce eye-catching, energetic images—fairground rides, fire dancers, sparklers and fireworks, the list goes on. There's very little chance of any of these images feeling static and dull, so with a little creative subject placement, you're easily on to a stunning photograph. What will make all the difference, however, is how you manage to control and compose around the rather chaotic nature of many of those subjects. Moving water—waterfalls especially—is another commonly blurred subject, and one whose motion is easier to predict. The water takes on the appearance of a shimmering silver haze, and as the background doesn't move, its sharpness contrasts with the silky contours of fluid motion to great effect. The same principle applies to water splashing up against the shore. A tripod is usually essential for giving you the greatest range of creative options.

© Daniela Bowker

The individual, separate dots of blue light are the results of an emergency vehicle passing beneath the bridge from which this was shot. Dancers, musicians, and other performers all exhibit a vitality and spirit that lends itself very well to motion blur. The swish, sway, sparkle, and color of dancers in motion can look just as effective in motion blur as a shot that freezes the action and depicts their shapes. The key, as with many other motion subjects, is to still capture some sharp element off of which the blurred areas can contrast. This will also help ensure that your subject is identifiable, and keep it from descending into total abstraction.

If you're out and about and spot some street performers juggling, use a slower shutter speed and try some shots that emphasize their movements. The same goes for sports photography. Sport is all about movement, so capturing that in a photograph makes sense. Think about using the lines from the motion blur so that they act as leading lines, or work with the frame orientation. The actual motion in the image will help to prevent it from feeling dull, and by studying the action and anticipating the climactic moment but by nailing your placement.

Long Exposure

Apart from your subject actually being in motion, your shutter speed will be the critical factor in achieving a photograph that captures motion blur. As a consequence, you will want to set your camera's exposure mode to either Manual or Shutter Priority (Tv or S, depending on the make of your camera).

There's no definite formula that dictates how long your shutter needs to remain open. The slower your

shutter speed and the faster your moving subject, the more blur you'll see. If you're aiming for any kind of motion blur from a snail, you might need a shutter speed of several times longer than you would from a moving car. The car's motion blur you could probably achieve within a few tenths of a second. Really, it will be a case of playing around to discover what works best in the situation.

If you're concerned that having your shutter open for a long period is going to overexpose your image before you can capture some motion blur, even with a small aperture, then you might want to consider using a neutral density filter. These filters work by reducing the intensity of all wavelengths of light equally as they pass into the lens, so that the colors aren't altered, but excessive brightness is reduced. A neutral density filter can be incredibly useful on a bright day, even if long exposure work isn't something that you're thinking of doing, as it will allow you to use a larger aperture for creative purposes without having to use a super-fast shutter speed.

There is something of a difference between motion blur and a blurry photograph; one is creative and the other is, well, a blurry mess. Your shutter is going to be open for a relatively long period of time to allow you to capture your subject in motion. This will, however, lead to the entire photograph being blurry owing to camera shake if you don't stabilize your camera. Using a tripod is probably the easiest way to ensure that you get the photograph that you want, but depending on where you are and what you're photographing, a beanbag or a flat surface can suffice, too.

← Just a touch of blur

The motion blur is made all the more effective by contrasting against the sharply captured faces and other figures in this shot. The two elements reinforce each other to communicate the festive spirit of the occasion.

Communicate Movement through Blur

Urban dynamics

Street scenes are filled with motion, and benefit from a touch of motion blur here and there. Movement happens all the time, all around us, so there's no reason why you shouldn't be able to capture it effectively in a photograph. It will help to tell your story and to give your image a feeling of dynamism. The key is to ensure that any instances of motion blur look deliberate, and not just an accident of sloppy photography. You want enough blur to give a sense of movement, but not so much that the image is just a mass of streaks with no obvious subject. As well as thinking about your shutter speed and ensuring a good exposure for your photographs, you must consider the direction and flow of the blur and how that will have an impact on your composition. Primarily, you will probably want to think about leading lines and frame orientation, but just about any other compositional factor can come into it, too.

© Daniela Bowker

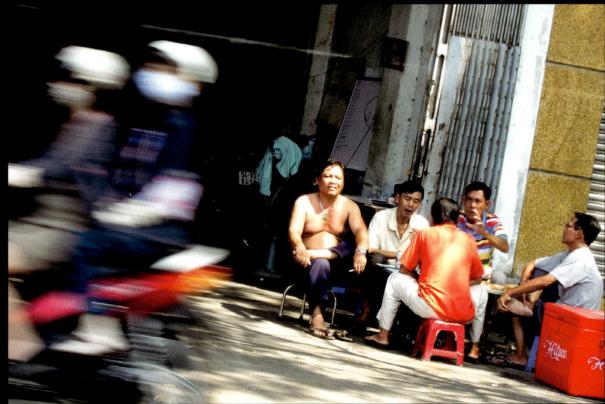

258

→ Energetic and spirited Action, be it an athlete running across a field, or a dancer performing, is easily represented by some well controlled motion blur.

Challenge Checklist

- → Use a range of different shutter speeds to identify their effects on motion blur.
- → Take care not to overexpose your image.
- → Compose your frame carefully to make the most of the blur.
- → Use a tripod or other stabilization mechanism so that the only blur in your photograph is from the subject in motion, not camera shake.

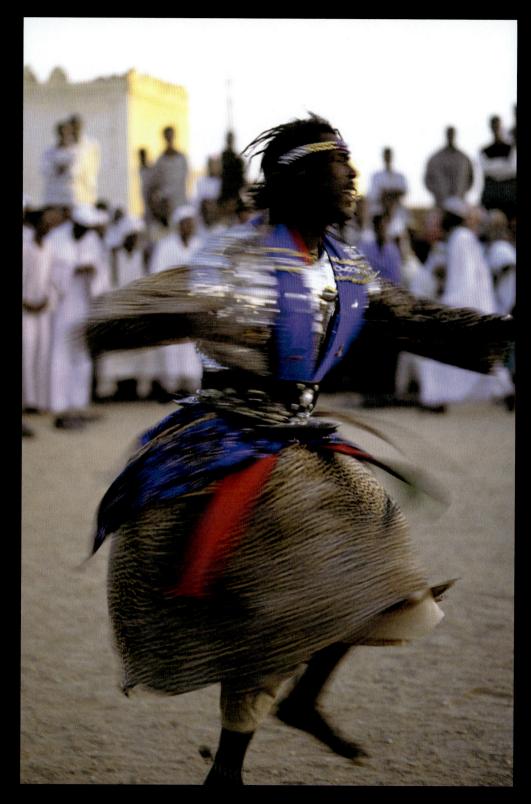

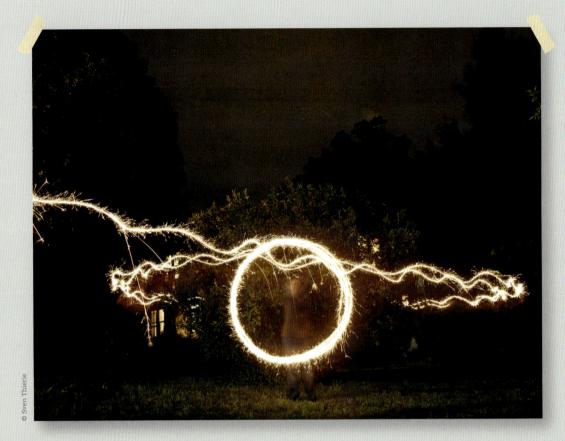

A 20-second exposure, with one figure standing center bottom rotating her sparkler in a circle, and another (myself) that ran from camera left out and around the tree, making two laps before the exposure ended. It was just shot for fun, but I was surprised how sharp the individual leaves on the tree were captured. *Sven Thierie*

An imaginative interpretation of blur. Experimentation is a good way to develop ideas and techniques. You didn't say whether this was successful on your first try. In any case, it's an idea that I'm sure you can continue working with. I wonder what it might look like with the central figure both more and less evident. *Michael Freeman*

COMPOSITION

I wanted to take this shot of the line of dancers in the parade. I must have spent several minutes running by their side, camera held over my head composing the picture, before I found a frame I thought could work. *Gillian Bolsover*

I like the limited blur in this shot, confined mainly to the bottom right, to which it draws attention. Angling the camera favors the position of the dancers, though personally I would crop at left to keep it *all* dancers—but that's just a matter of taste. *Michael Freeman*

DIGITAL EDITING

Editing and post-production work is often a polarizing part of digital photography. Everyone has an opinion: Some say that any departure from a completely faithful and untouched reproduction of the original subject is fraudulent; others say the sky is the limit, and you can do whatever you like to any image. As usual, the truth lies somewhere in the middle.

262

For one, there is no such thing as a completely faithful reproduction—the process of capturing photons, converting them into digital information, and displaying that information in a twodimensional format requires various levels of creative interpretation at several steps along the way. And on the other hand, the more digital enhancement that goes into an image—particularly as you begin introducing special effects and adding elements that weren't in the original scene at all, such as with composites the closer you get to crossing a line between a photograph and a work of digital art.

This section will cover the space in between these extreme interpretations Starting with an overview of the image-editing programs available to today's photographer, we will spend two chapters thoroughly covering your various options for image optimization—and that word is used quite intentionally. Even in more creative and subjective techniques like black-and-white conversion, the methods covered concern themselves primarily with making the most out of the latent potential within each image. The final chapter, on the other hand, covers the more open-ended topics of digital editing, in which you'll be combining separate images into one composite, removing unwanted objects from the image, stitching together panoramas, and other techniques that delve deeper into the creative tools available in pixel-level editors.

Some of these techniques will resonate with your personal photographic style and workflow, others will likely not. However, for all the techniques discussed herein, whether or not you use them in your own photography is not nearly as important as the fact that you will be able to if needed or desired—that you recognize and are familiar with the various tools and

This relatively straightforward landscape has, in fact, had the sky desaturated, the greens and yellows saturated individually, and the contrast reduced by a curves adjustment. And yet, the resulting image is more faithful to the original scene.

options available, so that you can make the right decisions for each image that crosses your desktop. That is also the idea behind the Challenges scattered throughout the book: They are not meant to necessarily convince you that, say, Curves is the best tool for adjusting your shadows and highlights, or that HDR is the only technique for dealing with high-contrast situations. Rather, they are meant to get you familiar with possible courses of action, and prepare you for the wide range of photographic possibilities that you will encounter.

→ Clean representation

Even completely "faithful" photographs like those used in art catalogs often require some degree of optimization in post-production.

The Digital Workflow

Before we begin to look in detail at the tools and practices of digital photo editing, it's worth spending just a brief moment or two discussing the concept of the digital photography workflow, as this will help you see where image editing fits within the broad scheme of creating a digital image.

264

In the context of digital photography, "workflow" describes the entire process of producing a digital image -from capture and importing, organizing and reviewing, through Raw processing and post-production, to distribution and backup. If you're unfamiliar with any of these terms: Capture essentially means the action of taking the photograph; importing is simply transferring the image files to the computer; organizing and reviewing involve creating appropriate folders, ranking, and making a selection of your images; Raw processing and post-production (often grouped together) are concerned with optimizing the image so that it looks as good as it possibly can; distribution is primarily about preparing the image for either print or viewing on-screen; and finally, backup refers to the process of safely archiving and storing your images. Although there's no single specific workflow for all photographs, there are definite considerations that must be taken before an image is ready for display.

Out of the workflow just described, the two areas that are of specific relevance to photo editing are Raw processing and post-production. For the purposes of this book we'll use the term Raw processing to describe all aspects of optimizing the Raw image file once it has been downloaded to the computer; post-production, on the other hand, we'll use to describe any aspect of optimization once the Raw file has been saved as a TIFF or JPEG. As you'll see later, this does have a bearing on the type of software you'll use for certain tasks.

The Raw Format

To understand Raw processing, you first need to be familiar with the Raw format. "Raw" is the generic term for the unprocessed file format available on all digital SLRs and many advanced compacts-whether Nikon's NEF, Sony's SR2, or Canon's CR2 format, to name just three. The benefits of shooting Raw are well documented, but are essentially concerned with capturing the most amount of image data possible. This data, rather than being processed automatically and indiscriminately by the camera as a JPEG, can instead be downloaded onto the computer, where you can manually process it using more powerful processors and software than are available in-camera. The end result, particularly with images shot under challenging lighting conditions, is improved tonal quality, sharper detail, and more accurate colors. Of course, you can process JPEGs instead, and much of the time JPEGs will provide perfectly good results. But when things get tough, you want as much data as possible in order to get the optimum result.

The dramatic improvement in Rawprocessing software in recent years has allowed more optimization to take place at this initial stage than at the post-production end of the workflow. The benefits of optimizing at the Raw stage are: You have the greatest amount of leeway when correcting aspects such as exposure or color; and Raw processing is nondestructive-i.e., although on the surface you're altering how the image looks, the alterations are being relayed by a series of instructions (or "parameters") that simply overlay the original image data. which itself is left untouched and can be accessed again whenever you want. Post-production software, on the other hand, such as Photoshop or PaintShop Pro, alters the tonal and color values of the image's pixels themselves (hence the term "pixel editing," which you may have come across), and while up to a point you can track back and undo changes, saving the files is permanent.

Increasingly, therefore, it's good practice to perform as much optimization as possible in Raw processors. However, as we shall go on to discover, there are certain things that Raw-processing software can't achieve, and that's when you have to turn to post-production software.

Bearing in mind the distinction between these two optimization processes, the first few pages of this section deal with Raw processing, the tools and techniques, while later pages cover post-production, paying attention to what can be achieved only in post-production software.

265

A Digital Photography Workflow

Organize and Review

Backup in progres 1 View Details 😚 Back up now MATSHITA DVD-R UJ-875 ders for all users Files in libraries and per Every Sunday at 7:00 PM You can Prestored Select our files that were backed up on the current location.

Raw processing

Distribution

Backup

Raw-Processing Software

266

Along with the development of more efficient image sensors and the ability to shoot video on DSLRs, another of the more significant advances in digital photography—certainly for those photographers who enjoy the editing process—is the development of Raw-processing software.

Early examples of Raw processors, such as the first releases of Adobe Camera Raw (ACR)—a plug-in that became available in 2002 with Photoshop 7.0.I—did not offer a great deal of freedom when it came to the adjustments that could be made to Raw files. Exposure, white balance, and color adjustments were well catered for; but other features, such as sharpening, noise reduction, and fixing chromatic aberration were in their infancy, while yet more features such as lens correction, adjustment brushes, and spot removal didn't even exist.

As the true value of Raw processing became increasingly apparent in terms of the image quality it provided, software developers, such as Adobe, Apple, and Phase One to name just three, worked hard at developing Raw-processing software that was capable of an ever-broader range of adjustment. Camera manufacturers, such as Nikon and Canon, also developed their own Raw processors that were designed specifically to work with their proprietary Raw formats. This was often bundled on CD-Rom with the purchase of the manufacturers' cameras.

Today's Raw-processing software has come a long way since these early examples. As the software has evolved it's become possible to undertake more and more image-editing tasks at the Raw-processing stage of the editing process. Processes such as sharpening, noise reduction, and fixing lens distortion and chromatic aberration are now performed by powerful algorithms that are capable of producing excellent results. These developments, together

← Adobe Camera Raw (ACR)

This processor ships as a plug-in with Photoshop and Photoshop Elements, and is an extremely powerful Raw processing package in its own right. It features an almost identical image-editing toolset to Lightroom (in fact, it shares the same processing engine), only arranged and presented in a different way. As a plug-in, it works seamlessly with the rest of Photoshop or Elements. with the advent of localized adjustment in the form of spot removal, editable adjustment brushes, and control points have almost rendered post-production software obsolete for certain types of photography. Many professionals today who shoot and edit large numbers of images, such as wedding or sports photographers, will often use only Raw-processing software to optimize their images. However, as we shall discover later, for other types of photography or for certain specific image-editing tasks, using postproduction software such as Photoshop or PaintShop Pro is the only option.

Along with increasing the functionality of Raw processors, software developers have also taken the opportunity to develop programs that mirror the digital workflow. Taking the example of wedding or sports photographers again: Everything they need for their images, from importing and selecting, to optimizing and distributing, can all be achieved within the same program.

Adobe's Lightroom illustrates this perfectly. The program features seven discrete modules or sections-Library, Develop, Map, Book, Slideshow, Print, and Web. Images are imported into the Library, where you can create and organize folders, and add keywords and ratings. Optimization takes place in the Develop module. The Map section allows for geocoding, while in the Book module you can generate files to create illustrated books. The Slideshow mode allows you to create resentations, to share as JPEG, PDF, or video slideshows. In the Print and Web sections you can prepare your images for both delivery methods. Other Raw processors have similar modes, hence they are often referred to as "workflow software."

↑ Lightroom's Library module

This module behaves like a dedicated image database. Here you can view, compare, rank, organize, and add captions and keywords to your images. It's also possible to view the EXIF data embedded in the image.

Apple's Aperture

Like Lightroom and Phase One's Capture One, Aperture is an extremely powerful Raw processor. It has a built-in image database, sophisticated editing capability, including localized adjustment tools, and a useful slideshow feature. It's even possible to send images to sites such as Facebook and Flickr at the touch of a button.

267

Post-Production Software

268

The history of post-production software is much longer than that of Raw processors, which are in fact relative newcomers in comparison.

It's no surprise that such software started with Adobe Photoshop. Photoshop, and the other programs that followed, were initially conceived of as general graphics packages. Photoshop's ability to create and manipulate vector graphics using features such as Paths and the Pen and Shape tools, together with the Text tool, reveals its identity as a graphics program. However, it also supports pixel-based, or raster, graphics, and as digital photography (with its pixel structure) has developed over the last decade or so, software companies have spent time developing tools for their

pixel-based image editors that photographers find useful, such as Healing and Spot Removal brushes. However, unlike Raw processors that, with their workflow structure, are clearly aimed at photographers, Photoshop and most of the other pixel-based editors have a much broader audience. In fact, there are vast sections of Photoshop that are of limited use to photographers.

However, we can't be too dismissive of the program that most professional and many amateur photographers have embraced; and, of course, it's not just Photoshop. Photoshop Elements, PaintShop Pro, and the myriad other post-production programs are extremely powerful, versatile tools that many pros couldn't do without. The ability, should you so wish, to manually change each individual pixel in an image to whatever you want provides an unparalleled level of control. This powerful versatility, coupled with features such as layers, adjustment layers, masks, channels, and filters, ensures that, given enough time and with sufficient skills, you can make an image appear pretty much however you want. For professional photographers, notably in the fashion or advertising industries, the ability to edit at pixel level is essential. For such professional photographers, Raw-processing software—although perhaps initially useful for organizing and conducting a first edit—simply won't provide the comprehensive tools they need to create the final image.

In terms of workflow, unsurprisingly, complex programs such as Photoshop, which was developed before the concept of a digital photography workflow was a reality, cannot compete with the more recent Raw workflow software which has been developed with one eye always on workflow. Photoshop does, however, ship with a dedicated browser—Bridge—which is a perfectly adequate image organizer, and from which you can access Photoshop directly.

Adobe Photoshop

Photoshop has evolved from a primarily graphics-intensive program into a comprehensive image-editing workhorse.

Less complex post-production software, such as Photoshop Elements and PaintShop Pro, have been redesigned over time to take into account the digital workflow approach. Elements, for example, has discrete workspace modules called Organize, Fix, Create, and Share, while PaintShop Pro takes a similar approach with its Manage, Adjust, and Edit workspaces.

Which Software Do You Need?

So the next obvious question is which type of software do you need? Well, that depends largely on what you shoot, the amount you shoot, and what your intended end use is. Most professionals will have both Raw processing and post-production software—and this is the ideal scenario; but for most amateurs this is probably not necessary. If you shoot a lot of images, but don't want to spend hours retouching them, and you're not too bothered about adding text or special effects, then Raw-processing software is likely to be most appropriate for your needs. These programs are generally quicker and more intuitive to use than pixel editors, and better at creating image libraries. And remember, although they're called Raw processors, you can edit JPEGs and TIFFs using the same nondestructive methods-the only difference is you won't have the benefit of the extra data you get from Raw files.

If, however, you enjoy manipulating images, such as merging elements from different photographs, and adding text or other special effects, then you'll need post-production software such as Photoshop, as Raw processors simply can't perform such tasks. And just as Raw processors will allow you to edit JPEGs or TIFFs, most pixel editors will allow you to process Raw files to a lesser or greater degree, before you convert to a TIFF or JPEG to complete the image editing.

↑ Elements import window

Photoshop Elements, while not quite as comprehensive as the full version of Photoshop, offers most of the features more commonly used by photographers, and also offers a complete workflow setup—beginning with this Import window.

Corel PaintShop Pro

While Adobe certainly dominates the field of image-editing software, alternatives do exist. PaintShop Pro is a fully competent option, and one that has been around almost as long as Photoshop itself. Here, the workflow is divided among Manage, Adjust, and Edit modules.

Raw-Processing Workspace

270

With workflow being just as important to Raw-processing software as image editing, it comes as no surprise to discover that most Raw processors have more than one workspace. Lightroom, for example, has seven, while Apple's Aperture and Phase One's Capture One—two other popular Raw processors—have similar environments but with fewer modules. The broad approach of all these programs being: organize, edit, and share.

↓ Apple Aperture

Here, the program offers three discrete modules: Library, Metadata, and Adjustments. The digital photography workflow begins with importing, and with most Raw processors simply attaching the camera or memory card to the computer and launching the software will prompt an import routine. At this stage you can create a folder in which to place the images, add keywords that are common to all the images, apply preset or customized picture settings, and embed metadata—which may include information about the photographer, any copyright notices, the date and location of the shoot, and so on. Getting into the habit of organizing your photos into folders and embedding keywords and other

metadata during the import routine will help you maintain a coherent image library later down the line. Once the images have downloaded to the Library you can quickly go through the collection ranking or deleting images, and making an initial selection of your favorites. With the selection made, you can add keywords that are specific to the individual images. If your intention is to sell your images via any of the numerous micro picture libraries that have cropped up on the Internet in recent years, keywords are essential as they help people search for your images.

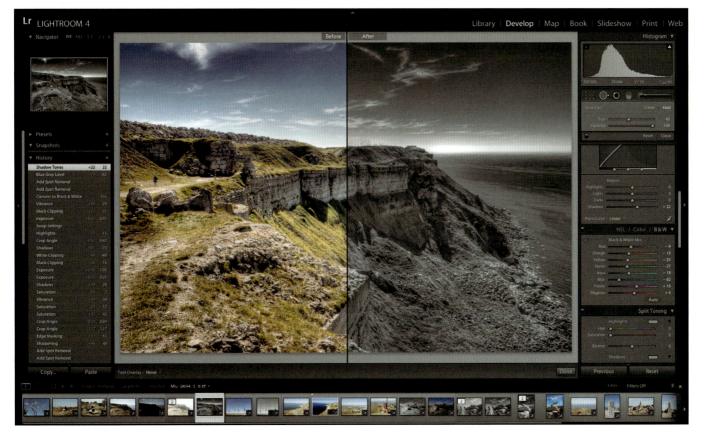

Develop

Lightroom's Develop module, like Aperture's Adjustments, is where all the image editing takes place. The Develop workspace is arranged into four main areas. Running down the left-hand side you'll find an extensive list of Lightroom preset photo styles, including a variety of black-and-white, cross-processed, and sepia-toned options, to name a small selection. These can be applied to an image simply by clicking on the preset name. Beneath these presets are Snapshots. This allows you to record the imageediting actions you've undertaken on one image and apply them to another. The History tab details the editing actions applied to the selected image. You can use History to retrace your steps and return to an earlier phase of the editing sequence.

The main image view located in the center of the screen shows a preview of the image. Naturally this updates as you apply different image-editing commands. You can toggle through the appearance of the preview using the icon found directly under the main view.

The right-hand panel is home to Lightroom's extensive range of imageediting tools. We'll look at these in greater detail later, but it's worth noting here that the tools are grouped together and organized into discrete palettes. Each palette relates to a specific area of editing, whether dealing with tone, color, or sharpening, for example. Like most of Lightroom's controls, the image-editing palettes can be expanded and collapsed by clicking on the small triangle next to its name.

↑ Before and after

By clicking on the icons underneath the image preview, you can call up a Before & After viewscreen, which gives you excellent perspective on the degree of adjustment you are making to the original image.

Beneath the main preview runs the filmstrip. This shows thumbnails of all the images in the selected folder. The filmstrip appears in all of the modules and provides a way of accessing images without having to return to the Library each time. The Slideshow, Print, and Web modules all have a similar workspace, with control panels on either side of the main view, and the film strip running below. Although we've described in some detail the Lightroom workspace, as suggested earlier, other Raw processors share a similar structure.

272

DIGITAL EDITING

Raw-Processing Tools

Although by no means identical, the similarity between the tool panels of much Raw-processing software is clear to see from the three examples shown here. Individual palettes or panels, each with readily identifiable names such as Exposure, Detail, Highlights & Shadows, and Lens Correction, feature a number of labeled sliders that can be accessed by clicking on the arrow that expands the palette. For the most part, it's clear what each of the sliders does-Brightness and Contrast, for example, are self-explanatory; and in less obvious cases, a slider's functionality is quickly learned by experimentation and observation. Because Raw processors, unlike many postproduction pixel editors, have been designed from the ground up with photographers in mind, the palettes and their individual sliders are all closely associated with specific digital photography issues, and that's one of the things that helps to make Raw processors so intuitive.

With the majority of Raw processors, the sliders make adjustments in real time. In other words, as you move the Brightness slider, for example, the

∧→ Aperture vs Lightroom

Aesthetic differences aside, it is easy to see the common tools that exist across various Raw processors—some of these tools even appear in the same order moving down the toolbar. Of course, the Lightroom toolbar shown right is cut off—it goes on for some length below; but each discrete palette can be collapsed when not in use, making it easier to scroll through all the various tools and sliders.

RAW-PROCESSING TOOLS

273

image will become lighter or darker corresponding to the movement of the slider—as opposed to the adjustment being made once you release the slider. This allows you to achieve the exact look you want instantly, rather than by trial and error. Although real-time image adjustment is not unique to Raw image-editors, it reinforces such software's user-friendliness. It is worth noting that the speed at which the software will display your adjustments depends on the capabilities of your particular hardware. If your computer is particularly stressed by running multiple applications, or if it doesn't have sufficient RAM, there may well be a delay between making your adjustments and the preview being updated to reflect them.

As well as making adjustments using the sliders, it's also usually possible to input specific numeric values in boxes next to the sliders. Although you're unlikely to make many adjustments this way initially, it can be useful if you're attempting to replicate specific settings between two different images.

As you progress through this section, you'll become increasingly familiar with what each control slider does, and the occasions when you'll use it. And over time you'll discover that there are some panels, palettes, and controls that you'll use frequently, while others that you'll barely utilize at all.

Keyboard Shortcuts

As I'm sure you are aware, nearly all computer programs have keyboard shortcuts that you can use instead of clicking on menus and commands with the cursor—and Raw processors are no exception.

As you become increasingly familiar with the program you're using, you'll find that you'll automatically begin to learn the more common shortcuts. It really pays to try to remember these they increase the speed of your workflow considerably. For the time being, however, the most important shortcut to remember now is Ctrl/Cmd + Z. If you're not already familiar with this life-saver, it's "Undo" in most programs. So if you make a mistake, hit these keys to take a step back.

Phase One's Capture One

While Phase One is primarily a high-end, medium-format camera manufacturer, they have also developed an impressive Raw processor called Capture One that is in most cases just as robust as other options from Adobe and Apple.

Post-Production Workspace

Photoshop is the undisputed king of the post-production pixel editors. It was the first image-editing software to have a truly global impact, and as such, most other editing programs have emulated it in regards to its tools, functions, menus, architecture, and commands. For this reason most of the terminology in the post-production parts of this section will have a bias toward Photoshop—although for the reasons stated on the previous pages, it should be clear to users of other programs which tools or menus are being referred to. It's probably also fair to say that if you've mastered Photoshop, it won't take you long to master other pixel-editing programs.

Despite being the heavyweight of image-editors, Photoshop is certainly not a big-hitter when it comes to efficient workflow (of course, it was never intended to be). Before the arrival of the Bridge plug-in, Photoshop had no form of browser or image organizer at all. And even now, in comparison with Raw-processing software, jumping between Bridge and Photoshop is still slow and rather cumbersome.

In terms of workflow, the less powerful, but often perfectly satisfactory pixel editors such as Photoshop Elements or PaintShop Pro are more useful, certainly for the amateur photographer. These emulate the workspaces of Raw processors, such as Lightroom and Aperture, by having discrete modules

PISODID PISODID <t< th=""><th></th></t<>	
CONTINT PILCON	
Image: Signed	Ma - Ma 60
NYZ SUZ SUZ <thsuz< th=""> SUZ <thsuz< th=""></thsuz<></thsuz<>	
NYZ SWZ S	
M72 M	
JNZ J	A
F1050020 F1050020 F1050021 F1050021 <td< td=""><td></td></td<>	
NUC NUC <td></td>	
NUC NUC <td></td>	
MQ BVZ	
NUC NUC <td></td>	
F10500H0	
F10500H0	
F1030040 RV2 F1030040 RV2 F1030042 RV2 F1030043 RV2 F1030043 RV2<	
PI050103 PI050140 PI05042 PI050142 PI050042 PI050042 PI050047 PI05047 PI05047 PI05047 PI050048 PI050047 PI050048 PI050047 PI050048 PI050047 PI050048 PI050048 PI050047 PI050048 PI050048 <th< td=""><td></td></th<>	
RV2 RV7 RV7 RV2 RV2 <thr2< th=""> <thrv2< th=""> <thrv2< th=""></thrv2<></thrv2<></thr2<>	
No. Plosopsis Plos	U KGB
PI050490 PI050950	38.RW2
P1050040 P1050950 P1050951 P1050951 P1050953 P1050955 P1050955 P1050957 P1050956 P1050956 P1050957 P1050956 P1050957 P1050958 P1050957 P1050958 P1050957 P1050958 P1050957 P1050958 P1050958 P1050957 P1050958 P1050958 P1050958 P1050957 P1050958	
P150049 P120951 P120951 P120953 P120953 P120953 P120954 P120955 P120957 P1205957 P1205968 File 52ce 12.93 RNZ RNZ RNZ RNZ RNZ RNZ RNZ RNZ RNZ RNZ	
Dimensions 4128 III Depth 16	
Culor Profile Unitage	ed
The second	
P1050959 P1050960 P1050962 P1050963 P1050964 P1050966 P1050966 P1050966 P1050966 P1050966 P1050967 P1050968 Creator RW2 RW2 RW2 RW2 RW2 RW2 RW2 RW2 Creator: Job Title	
RWZ	
Creator-City	
THE THE THE STATE OF A	
Creator: Country	
P1050969 P1050970 P1050971 P1050972 P1050973 P1050974 P1050975 P1050976 P1050978 P1050979 Creator Phonels)	

in which you can organize, edit, and share your images. Although switching between the various modules is not as seamless as it can be with Raw processors, you do at least have all the tools you need to create, edit, and share images from an image library.

Turning to the main image-editing workspace of post-production software, what is immediately obvious is that there's a great deal to take on. While with many Raw processors you can find your way around on your own in a relatively short space of time, with pixel editors and certainly with Photoshop, delving into the program without prior instruction is likely to result in mental meltdown. It's exactly for this reason that "consumer" versions such as Photoshop Elements have readily accessible tutorials that help you learn your way. Photoshop has none of these, so you really need to spend some time learning the basics before you can begin to reap the rewards of the powerful software. Photoshop's main workspace is relatively clutter free. However, this belies the sophisticated toolset that accompanies the software. Shown opposite are images of Photoshop's and PaintShop Pro's Edit workspace, showing how similar they are.

Adobe Bridge

You can customize this main screen to offer a wide variety of additional information, or clear it of everything but your image thumbnails to get a light-table workspace.

274

275

↑→ Photoshop vs PaintShop Pro

There are quite a few commonalities to be seen between these two imageediting programs. The main toolbars are both arranged along the left side, with tool options stretching horizontally from the upper left. The right side is dominated by a series of palettes, with Layers being the most significant feature.

276

DIGITAL EDITING

Post-Production Tools

Ø

Compared with Raw processors, post-production pixel editors are rather less intuitive and have a more complex toolset to learn.

Much of the complexity of postproduction pixel editors is due to the fact that, unlike most Raw processors in which the tools are primarily grouped together in one long panel, pixel editors have a whole host of tools, dialogs, commands, and menus dotted around the workspace. It's true that many of the mid-level editors such as Photoshop Elements and PaintShop Pro now feature user-friendly wizards and tutorials that help you perform specific tasks, but you'll find that when you come to perform an editing task, rather than reaching for a single slider, as you more often than not are able to do with Raw processors, with pixel editors you may find you have to open and use a number of various tools, commands, and dialogs to achieve a similar result.

However, once you've learned your way around one piece of post-production software, you'll begin to appreciate how powerful these pixel editors are—as mentioned earlier, there are things you can do with pixel post-production software that are simply not possible with Raw-processing software.

† Tool options

As well as the main Toolbox, to which you'll turn in order to select specific tools, pixel editors also tend to feature Tool Options bars. Here you can adapt the functionality of the tool, or its size and shape, for example, to make it more suitable for the task in hand.

← Learning tool names and hot keys

With most post-production programs, hovering the cursor for a second or two over a specific tool will usually cause the name of the tool to appear. This is certainly beneficial when you're learning a new application. Note that the keyboard shortcut often appears next to the name.

Type Tool (T)

← Photoshop toolbar Many of the tool icons utilized by postproduction pixel editors are now almost generic. The Crop tool, Eyedropper, Type tool, and many others are the same across a number of applications. This certainly makes it easier when switching between programs.

↑↓ Look for the similarities

Although the many adjustment panels, dialogs, and palettes make learning imageediting software such as PaintShop Pro and, in particular Photoshop, a lengthy process, it is precisely these controls that make such software so powerful and adaptable. Layers and Curves, for example, as you'll discover later, are key to many of the editing tasks you'll be undertaking using pixel editors. Fortunately, as with the tools themselves, there are many cross-overs when it comes to the fundamental way in which pixel editors work. Layers and Curves are just two commands that you'll find in most mid-level and professional pixel-editing software.

←↑ Sidebars and palettes What many users new to post-production software find confusing is that, in addition to the numerous tools and tool options (which in themselves take time to learn), there is also a seemingly endless collection of palettes and other adjustment controls that have to be mastered.

277

Rotating & Cropping

One of the first assessments you're likely to make of an image before progressing with other editing tasks is deciding whether or not the image is straight. Depending on the particular shot, this may not be too critical, but if there are distinctive horizontals or a horizon visible in the shot, you'll want to ensure that the frame is properly aligned with these linear elements contained within it.

278

Cropping an image—essentially, removing any unwanted part of a composition—is another simple editing task, and yet potentially one of the most effective ways of ensuring a photo has the greatest possible impact.

Naturally, we should always be thinking of composition when we're framing our photos, but often we're shooting at speed or grabbing a shot under rapidly changing lighting conditions, and it's not until later, when we have time to fully assess an image on a computer monitor, that we can see how the composition of the image can be improved. It may also be the case that there are some alternative crops we'd like to try to see which works best.

Another reason for cropping is that the image size and shape is dictated by something outside of our control. Perhaps the final image requirement is for a square shot, in which case you'll need to crop a landscape or portrait format to suit.

Lightroom's crop palette

This palette is found near the top of the Develop module under the histogram. To reveal the various tools associated with the Crop Overlay mode, click the dotted rectangle (or press R).

Straighten Slider control

↑ Grid overlay

Having selected the Crop mode, a grid will be displayed over the image. At the corners of the image and in the center of each side are bounding box handles.

Grid options

Above we've selected the Thirds grid, but other options include Golden Ratio, Triangle, or Golden Spiral, all of which are intended to help with composition (though they are all doubtful formulas to apply without careful thought.) ✓ Grid Thirds Diagonal Triangle Golden Ratio Golden Spiral

> Cycle Grid Overlay O Cycle Grid Overlay Orientation ☎O

↑ Rotate options

There are a number of ways to rotate an image. If you place the cursor near a corner box handle it will turn into a doubleheaded arrow. Move the cursor up or down and the image will rotate. However, a more accurate method is to select the Straighten tool. On the image draw a line along the horizon or horizontal line that you're using as a point of reference. As soon as you've drawn the line and released the mouse button, the image will automatically rotate. Notice also, that the image is automatically cropped to accommodate the rotation.

↑← Cut out distractions

To tidy up the image and improve the crop, using the Thirds grid the left-hand control point was dragged to the right so that the slightly distracting tree at the edge of the frame is cropped out, and so that the remaining solitary tree sits on a rule of thirds line. The top handle was then dragged down so that the ocean horizon is in the middle of the frame, giving the final image a better sense of balance.

Steve

279

Correcting White Balance

280

As we've learned daylight can actually change color during the course of the day, from an orange hue just after sunrise, through the purer, almost blue white light of midday, and then warming up again as the sun sets. But the color temperature of light is also affected by atmospheric conditions such as clouds, or more dramatically by artificial light sources such as streetlamps or even lightbulbs.

To ensure that white objects always appear white, no matter what the ambient color temperature, your camera has a variety of white balance settings-these usually have names such as Daylight, Cloud, Shady, Tungsten, Incandescent, Flash, and so on. And, in fact, most cameras will perform adequately if left on the Auto setting. However, every now and again you may come across a shooting situation that has the camera fooled -a mixture of natural and artificial light, for example, which results in an image that exhibits some odd-looking color casts.

Shooting Raw is the best way to ensure that you can freely adjust the color balance when editing your images. If you shoot Raw, no matter what the camera's white balance setting at the time of shooting, you can alter this to give a more (or less, if you want a creative interpretation) neutral result without impacting on image quality in any way.

↑ Not quite blue enough

Although the lighting (daylight) in this shot of a Greek monastery was neutral, the Auto setting has produced a slightly orange image. The sky isn't as blue as it should be and the overall effect is a muddy appearance.

A neutral target

With the Raw processor's Eyedropper tool selected, click on a neutral gray pixel—try to get the red, green, and blue values as close as possible.

Blue sky restored

As soon as you select a neutral-gray area, the software automatically balances the colors in the image, and the result is a photo free from the orange color cast.

Avoid clicking on an area that's too white or bright, as one of the color channels may be clipped (exhibiting only the maximum intensity of the color with no detail), resulting in an inaccurate white balance measurement, which in turn could produce an inaccurate color adjustment.

If for some reason using the Eyedropper doesn't produce a result you're happy with, use the Raw processor's Temperature and Tint sliders to manually adjust the white balance. Raw processors even have some presets that might provide you with the result you want.

← <↑ Creative white balance

You can use the Raw processor's white balance sliders in a creative rather than purely prescriptive way. White balance can be subjective, with no actual right or wrong result, so use the sliders to cool down or warm up the image for very different results. 281

Adjusting Exposure

Of all the benefits of shooting and editing in the Raw format, perhaps the greatest is the level of adjustment that can be made to the image's exposure long after you've pressed the shutter release. In most cases it's possible to increase or decrease the exposure setting by around two stops in Rawprocessing software—making a total possible adjustment of up to four stops—without affecting the quality of the image. Furthermore, the adjustment doesn't necessarily have to be made to the image as a whole. It's possible to make only certain

282

↑ Mostly underexposed

Shot outside in dappled, contrasty lighting, a spot-meter reading from the guitarist's face has ensured the most important element of the image is not overexposed, but has left the rest of the image too dark. areas brighter while holding (or even reducing) the exposure in other areas although care needs to be taken to ensure that such an adjustment doesn't result in an unrealistic image.

Adjusting exposure is a key aspect of image optimization—the process of making an image look its best—and involves ensuring that the image has the fullest possible range of tones. The golden rule of optimization is to avoid overly clipped highlights. When highlights are clipped too much you lose important detail; however, if they

↑ Global exposure increase

Using the Raw processor's exposure controls, we can globally increase the exposure by a couple of stops. This has improved the overall exposure, but the face now looks overexposed. are not bright enough the image can appear dull and flat.

As well as setting the highlights or white point, you'll also need to set the black point. This determines how much detail remains visible in shadow regions. This is less crucial than setting the white point, as our eyes are less drawn to pure black in an image than they are pure white; and much of the time setting the black point is a matter of personal taste.

↑ Highlight clipping warning

Activating this feature indeed shows that parts of the musician's face are in fact blowing out they've become pure white and have lost detail altogether. It's essential that we fix this if the image is to be successful.

↑ Recovery/Highlights slider

The Recovery or Highlights slider, an essential part of most Raw processors, will darken highlights and (with any luck) add back some lost detail. Holding down the Alt or Cmd key, depending on the Raw processor you're using, while moving the slider will reveal the elements of the image that are clipping against a black

background. Here, the blown highlights on the face have been recovered, and the only ones now clipping are the specular highlights of the guitar's white edge. These are acceptable. Returning to the main preview, we can see that the face is no longer overexposed.

↑ Setting the black point

Using the Black or black-point slider, and again holding down the Alt or Cmd key, move the slider until the shadows are just beginning to clip. This will give the image a richer appearance with better contrast.

© Steve Luck

← Shadow fill

The ability to open up shadows in an image without affecting the highlights is another relatively new aspect of Raw editing. Lightroom's and Aperture's Shadows slider (sometimes called the Fill Light slider in other programs) both perform the task exceptionally well. Here, we've used a Raw processor to lighten the interior of a room in the Communist museum in Prague without losing detail around and outside the windows.

Basic Image Optimization

Low-contrast original

Challenge

Intentionally shooting with low contrast and low saturation levels is often a wise choice—it lets you concentrate on the essential qualities of exposure and composition without getting distracted by trying to make the image "pop" straight out of the camera. Such inclinations are best left to dedicated post-production software. Now that you are shooting Raw, it's time to get in the habit of making those initial, essential adjustments to your images as soon as you open them up in your Raw processor. Is the image lined up with the horizon? Is the white balance accurate? And even if it is, do you want to portray this subject accurately or creatively? As this is all nondestructive editing at this point, feel free to experiment. Sometimes it would never occur to you to warm up an image's tones until you slide the Temp scale a bit to the right (just for an example). And finally, take a look at your exposure—maybe with the highlight/shadow warning activated, and see if there's any detail you want to recover hidden away at the far sides of the histogram.

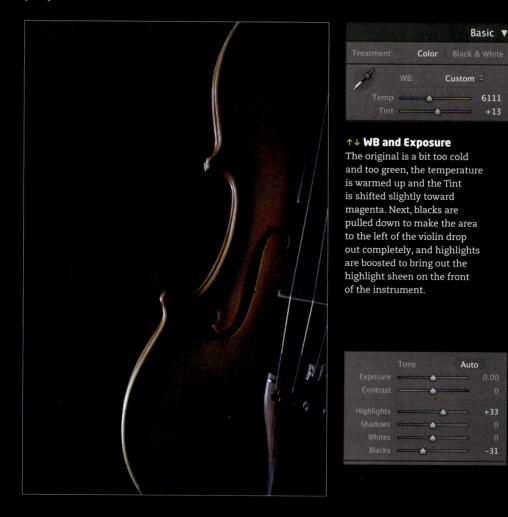

© Dmitri MIkitenko

Optimized and ready

Sometimes all it takes to find a backlit shot is changing your angle—in this case, looking straight up. Careful positioning and composition is key.

Challenge Checklist

- → Even if you set an exact custom white balance, check that there isn't some other possible, more flattering color cast by experimenting with your Temp and Tint sliders.
- → Your highlight and shadow clipping warnings can be invaluable—often its difficult to discern the exact levels of exposure with the naked eye.
- → When you're finished, save the image as a Tiff, but always archive the original Raw file for future reference.

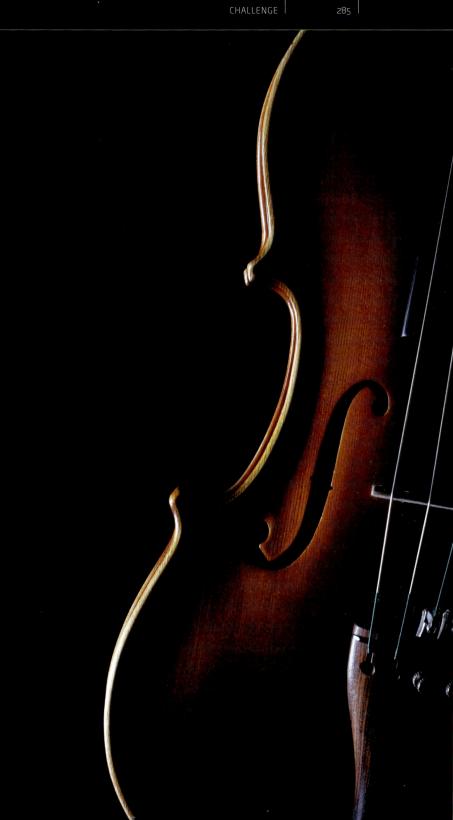

Review

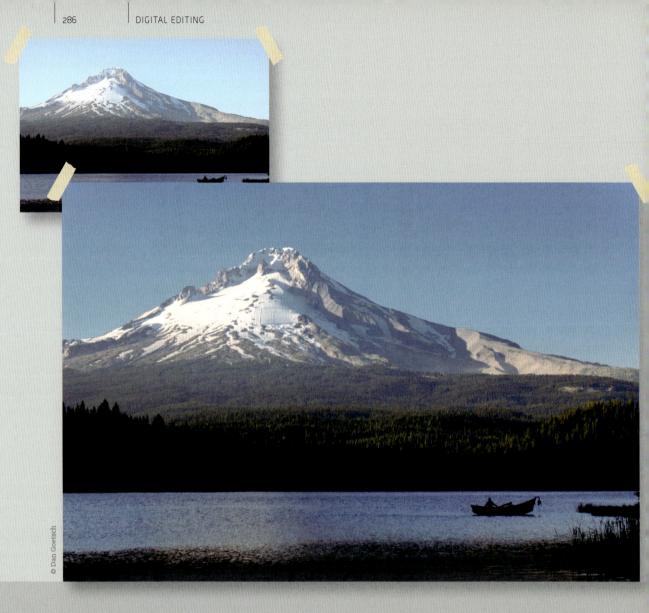

While Trillium Lake was beautiful, the sunset on Mount Hood was a bit of a let down. The position of the sun was washing out some of the deep blues. In Photoshop, I brought the blues back in with the color balance, and set it up with different layer masks to affect only the sky. I did the same to bring back some of the yellows and greens for the tree line, then merged the layers and adjusted vibrance to make it look natural and closer to what I was seeing in person versus what the camera saw. Dan Goetsch

Well-executed recovery, particularly of the blue sky, which can end up looking false and/or banded if carelessly done. More than that, this is a good example of the need to rely on your own perception of what the image should look like, because you were there and knew what you wanted. *Michael Freeman*

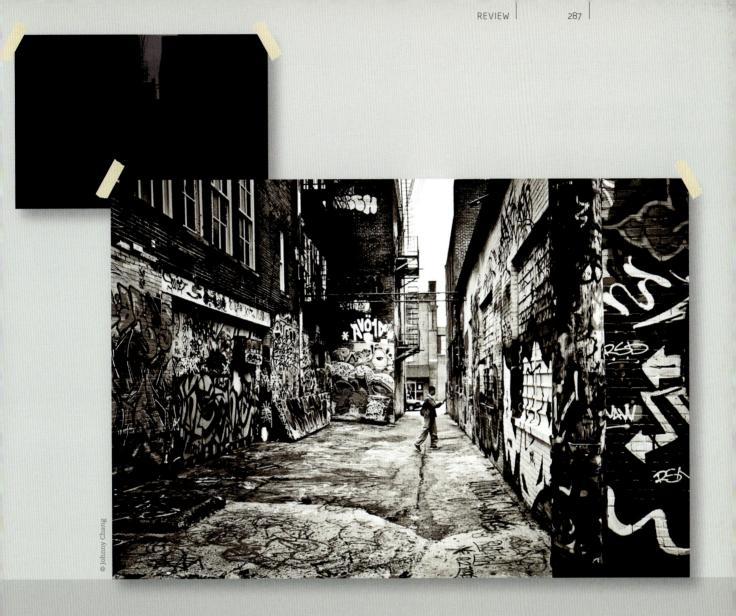

To combat the underexposure, I added almost 4 stops to the entire photo. Then, I wanted to make the graffiti artist blend into his work by making him and his surroundings appear more graphic novel-esque, so I converted to black and white and worked on increasing the contrast. Then I manually added vignetting with the adjustment brush to focus in on him. I then dodged and burned various parts of the image to my taste. I also played with grayscale mix to get the right blend of each color. Johnny Chang

A lot of work went into this, and successfully given your aim. I like the idea behind it, and that you included the ground in the treatment. I'd be interested to know why you underexposed so strongly, according to the attached original. *Michael Freeman*

Removing Spots & Blemishes

288

Many of the spots you see on digital photographs are caused by dust on the image sensor. This primarily affects DSLRs, and occurs when dust enters the camera body—when a lens is being changed for example—and settles on the sensor's surface. Fortunately, such spots are only really noticeable in areas of flat color, such as blue skies. Getting rid of most spots is quick and easy, although with others, you may have to work a bit harder to remove them.

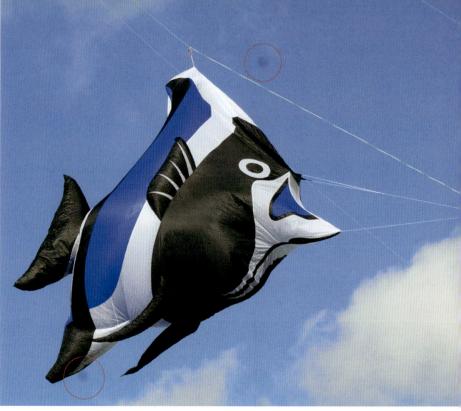

© Steve Luck

↑ Select the dust spot

Select the Spot Removal tool or Retouch brush Check that the tool is in Heal mode. Adjust the size of the tool or brush so that it fits neatly over the dust spot. There are usually keys you can use to adjust the brush size—it's quicker and more accurate than using the slider.

↑ Sample a separate area

With the tool fitting neatly over the dust spot simply click the mouse. The Raw processor will automatically choose a sample area (usually adjacent to the target area) that it uses to blend with the pixels from the target area, so removing the spot.

A clear sky regained

In a matter of moments, the ugly dust spot has disappeared, and we're ready to move on to the next problem area.

Here, the dust spot is located close to a dark

edge of the kite. Let's see what happens if we

use Spot Removal or Retouch brush in Heal

mode, and simply click the mouse button.

As before, the Raw processor automatically selects a sample area to blend with the target area.

However, here the result is unsatisfactory. First, because the sample circle hasn't aligned with the target circle. Second, because in Heal mode the Removal tool uses pixels from the edge of the target circle when blending with the sample.

↑ > A case for cloning

↑ 7 Trickier edges

Where the spot is near an edge, change to Clone mode, in which the Spot Removal tool doesn't attempt to blend the surrounding pixels. This provides a more clearly defined blending edge. Here, we've selected the sample and dragged it away from the kite to a cleaner position.

Moving the sample area to a more appropriate position has resulted in a better alignment, while the Clone mode creates a cleaner result.

↑ Applied to a portrait The Spot Removal tool or R

The Spot Removal tool or Retouch brush, when in Heal mode, is an ideal way to remove skin and other blemishes. DIGITAL EDITING

Sharpening

290

We've learned a lot about sharpening digital images over the last few years and software manufacturers have too. Sharpening procedures and tools have become increasingly sophisticated, and this has continued as Raw processors have also developed and improved.

Recently, distinctions have been made between capture sharpening and output sharpening. Capture sharpening is the sharpening applied to a Raw image file during Raw processing. The idea behind capture sharpening is that it counteracts the softening effect of the low-pass or anti-aliasing filter that sits directly in front of the camera sensor. When shooting Raw, no incamera sharpening is applied as it is with JPEGs, therefore you need to sharpen an image so that it looks crisp on-screen; and that is what we're going to cover here—how far to apply it, and what to avoid.

Output sharpening, on the other hand, takes place at the end of all other post-production tasks, and is essentially concerned with preparing an image for print or screen display. Output sharpening is mostly automated through the Raw processor's preset controls when you go to print or save an image for the web, and is not particularly in the remit of this book.

>→ Straight from the camera

This image of an old tractor has been reproduced straight from the Raw file, and although optimized for color and tone, no capture sharpening has been applied. You can see from the close-up view that the image is soft, and the abundant texture of the metal is not rendered as sharply as it could be.

© Steve Luci

The aim of capture sharpening is to get the image to look pleasingly sharp on-screen. Don't sharpen the image so much that it begins to exhibit ugly halos or visible noise.

Most Raw processors have one main sharpening slider that applies an overall sharpening effect. In the side-by-side comparison shown right, Lightroom's Amount slider has been increased from the default 25 to 70 (on the left) and the maximum 150 (on the right). It's clear that the maximum setting has oversharpened the image, as there are visible artifacts. At a setting of 70 the image is visibly sharper, and although the artifacts are less obvious, there is still some noise visible in the flatter areas of the image.

↑ View at 1:1

Before you begin to sharpen any image, it's essential that you view the image at 100%, 1:1, or actual size (different terms for the same thing). Viewing the image at a smaller scale won't provide you with an accurate preview of the sharpening effects.

← Grayscale preview

With Lightroom, holding the Alt/Opt key while adjusting any of the sharpening controls renders the preview as a grayscale image. This essentially makes it easier to see which part of the image is being affected by the particular adjustment.

DIGITAL EDITING

Sharpening

292

←↑ Sharpening controls

Lightroom's Radius slider controls how sharpening is applied to details. With a low setting (as on the left) sharpening is applied only to fine details. Increasing the Radius setting applies sharpening to larger details (as on the right). Generally, a high Radius setting will often result in ugly artifacts. As a rule of thumb, if you're sharpening an image with a lot of fine detail, a Radius setting between 0.5 and 1 is usually sufficient.

← Combatting halos

Lightroom's Detail slider helps to reduce halos—unnaturally light or white edges, usually along a high-contrast area. A low Detail setting (on the left) ensures that sharpening is applied only on the very edges, while a high Detail setting (right) results in sharpening being applied to much more of the image. Here we want the Detail setting to bring out the texture of the rougher metal but to hold back sharpening artifacts on the smoother metal. Like most adjustments, a trial-and-error approach is the best method—simply move the slider until you strike the most appealing balance between detail and artifacts.

SHARPENING

293

↑← Mask out smooth areas

Lightroom's Masking slider, like the Detail control, is a way of suppressing the two active sharpening commands. A low Masking setting (left) applies almost no mask at all, resulting in almost no change to the sharpening effect. A high setting applies a mask on everything but high-contrast edges. This is a good way of ensuring that sharpening is applied to edges but not to flat tonal areas, where noise is often more apparent.

Sharpening complete

The final image following capture sharpening is much crisper and shows more textural detail without the introduction of halos, noise, or other sharpening artifacts. This image is now ready for further post-production work, if necessary.

Sharpen Up a Shot

Cathedral interior

This straight-from-the-camera Raw file is clearly soft, both because sharpening was set to 0 and because a high ISO was used, and the resulting noise needs to be smoothed over a bit—further softening the shot. As we know, if you're shooting in the Raw format images will appear soft when first viewed onscreen. The challenge this time around is to take a Raw image, preferable one with lots of fine detail, and using your preferred image editor, sharpen up the shot so that all the fine detail really "pops." Experiment with the various controls that you have at your disposal and push them to extremes to see exactly the impact they have on the image. Pay particular attention to "flat" featureless areas to see the effect of extreme sharpening here. Ultimately you want to reach a happy medium with sharp halo-free details and flat regions free of sharpening artifacts.

	Sharpening	
Amount	- <u> </u>	28
Radius		0.8
Detail	A CONTRACTOR	25
Masking	C	

← v Soft to sharp

While it may look acceptable at a distance, zooming in to full 1:1 magnification makes it clear that the delicate ridges of the architecture are not being rendered nearly as crisply as they should be. As these are very fine details, a relatively small radius is set; and as most of the frame contains intricate architectural textures, the Detail slider is left at a safe 25. The Amount slider is simply increased little by little until the magnified view looks crisp on-screen.

29

→ Ready for processing

After the capture sharpening is applied, the rest of the editing workflow consisted of a simple tweak to the colors and saturation levels. But it's the sharpening that really brought this shot to life, and the abundance of fine detail it now exhibits draws the viewer in without introducing any ugly artifacts or grain.

Challenge Checklist

- → It's best to use a light touch at first, and always keep an eye out for distracting sharpening artifacts that may start to appear in empty areas of the frame—a clear sign you've oversharpened.
- → If your image has a mixture of empty areas that don't need much sharpening, and intricate details that would benefit from a relatively strong sharpening, make use of your Detail and Masking slider to strike a pleasing balance across the frame.

After assembling each photo in Photoshop, I merged the layers together so they were all on the same layer. I went into the Filter menu, down to Sharpen and selected the Unsharp Mask. Setting the radius to 2.9 pixels at 105% gave me a crisp and clear image that would be ready for large printing. *Faith Kashefska-Lefever*

© Faith Kashefska-Lefe

Sharpening for printing is different from sharpening to compensate for loss of crispness in capture, hence the high radius here, I assume. It's all about appearance, and that looks the right amount for this example. I'm also assuming that you archived the original file without sharpening! *Michoel Freeman*

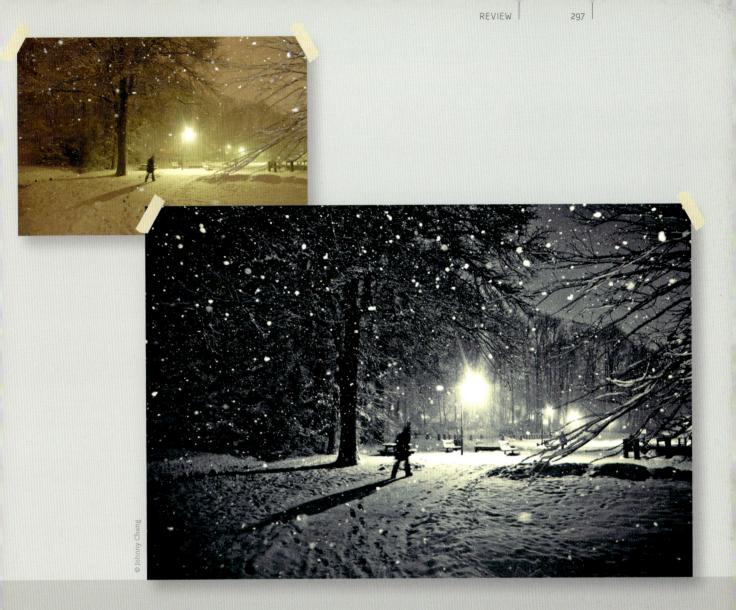

The sodium vapor lamp robbed any semblance of color and added an unappealing tone, so I converted to black and white. To finish, I tweaked the tone curve, sharpened, added vignetting, split toned the highlights/ shadows, removed larger distracting snowflakes and cropped a bit off the top of the frame. Johnny Chang

The abundance of fine detail in this image, from the tips of the tree branches to the textured footprints throughout the snow, to the very snowflakes themselves, definitely calls for sharpening to bring it all to life. Crisp is the word, and turns the soft original into an engaging shot. *Michael Freeman*

© Steve L

Noise Reduction

298

No doubt you're all too familiar with the issue of noise in digital images. Noise manifests itself as ugly-looking clumps of pixels and a graininess that is particularly apparent in larger areas of a single, flat tone. It's also more prevalent in shadow regions, and the problem is exacerbated at high ISOs.

There are two principal types of noise: luminance and chroma (or color). Luminance noise is likened to the static you see on a television station with poor reception—it is grainy and, if particularly bad, may appear as vertical or horizontal stripes (or bands) across darker areas of the frame. Chroma noise, on the other hand, appears as discolored blotches, and is usually more unnatural looking (and therefore more important to reduce).

With many Raw processors the noise controls are located directly beneath or at least near to the sharpening commands. This makes perfect sense, as the more you sharpen an image, the more apparent the presence of noise becomes. In most Raw-processing workflows, capture sharpening is swiftly followed by noise reduction.

As with sharpening, noise reduction has become increasingly sophisticated and effective as software algorithms have evolved. Even with the noisiest images, today you can often expect to end up with a usable image. All Raw processors offer noise reduction, but some have more controls than others.

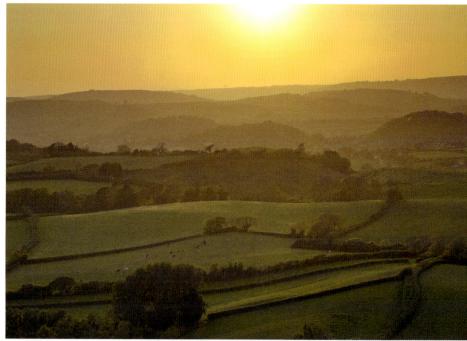

←↑ Too small to notice

Printed at this small size, the noise in this image may not be particularly visible (and it's worth bearing in mind that some print processes are very forgiving). However, the detail shown left clearly reveals there is significant luminance and color noise present.

Chroma vs luminance

With Lightroom and Capture One, you have the option of tackling either the luminance or color noise individually, using the relevant sliders. Other Raw processors reduce both types of noise at once. If you have the option, I find dealing with color noise first makes it easier to judge the more subjective task of luminance noise reduction. Here, the Lightroom Noise Reduction Color slider was set to 50.

↑ Not-so-fantastic plastic

Having dealt with the chroma noise, it's time to look at reducing the luminance noise. It's tempting when reviewing an image at 100% to set a noise reduction value that eradicates the noise altogether. However, this will result in an unrealistic, plastic-looking image (seen above).

↑ A touch of texture

You want to retain some of the luminance noise as it gives the image an essential photographic textural quality. Here, the Luminance slider was set to 27, and the Detail to 85. The Detail slider provides a good way of fine-tuning the amount of noise left in the image.

↓ Ready for output

The finished image retains enough detail without including any obvious or distracting areas of noise, and can be printed at a much larger size as a result.

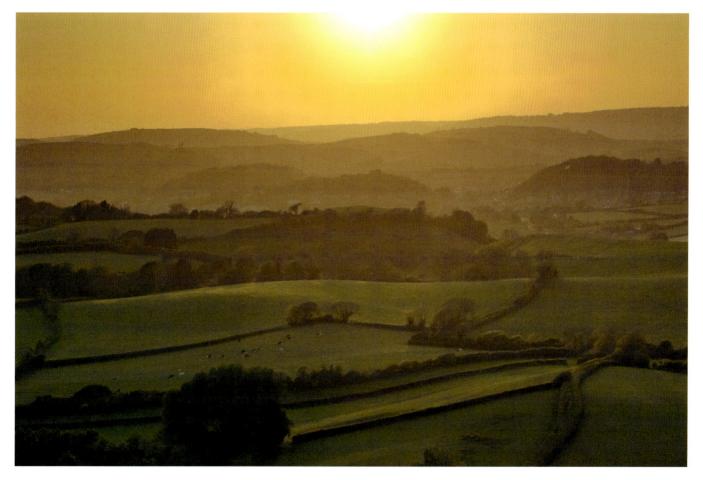

DIGITAL EDITING

Clean Up a Noisy Shot

↓ Low light, high noise

The high-ISO required to get this narrow-aperture, low-light shot may not be terribly obvious at first, but becomes readily apparent upon closer inspection. It's a fairly even balance between chroma and luminance noise, and definitely needs to be cleaned up before this image is ready for output. If you're shooting with the latest and greatest camera gear, you may have great confidence in your camera's ability to shoot a clean high-ISO file; but this doesn't mean you never need to worry about noise. Far from it, if you're shooting Raw, you're still in charge of your noise reduction. Even if you tend to stick closer to your base ISO, subtle post-production work like lifting shadows can often introduce noise where there was none before. This is another time when you'll want to zoom in close and inspect your images with a fine-toothed comb to see if they can benefit from a simple clean up. And with what you now know about noise, you may be able to go back in your archives and salvage a noisy shot that was thrown out.

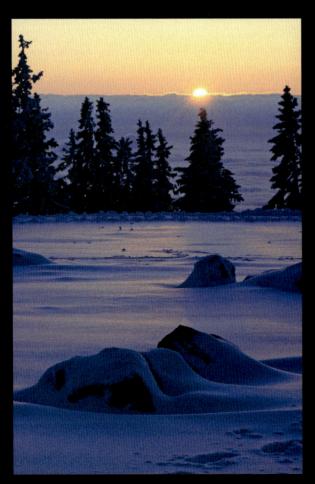

Noise Reduction	
-	33
-	
•	
	19
	-

← v Strike a balance

It's easy to get carried away with noise reductionparticularly when you're zoomed close in and losing the bigger picture of what the final, full image will look like. With a high enough setting on your sliders, you can indeed obliviate all the noise in most any shot; of course, you'll also be destroving all the fine detail. Here, the Luminance slider was slowly increased until the noise was low enough to not be seen at a normal viewing distance, but still high enough that the details in the trees still stand out.

→ Clean as the snow

Just a touch of noise reduction salvaged this shot and struck a fine balance between texture and noise. There's still some luminance noise left in the shadows, but only if you zoom in very close, and it doesn't detract from the final image.

Challenge Checklist

- → Push yourself to shoot at a higher ISO than you're usually comfortable with, and see if you can clean it up to a degree with which you're happy.
- → Don't lose sight of the big picture—literally! Switch back and forth between a 1:1 magnification and a full-image view, and make sure your image doesn't take on too much of a plastic appearance.
- → Know when to call it quits. By all means, try your best to clean up a shot, but sometimes the end of the workflow is recognizing that there's simply too much noise in the image to make it presentable.

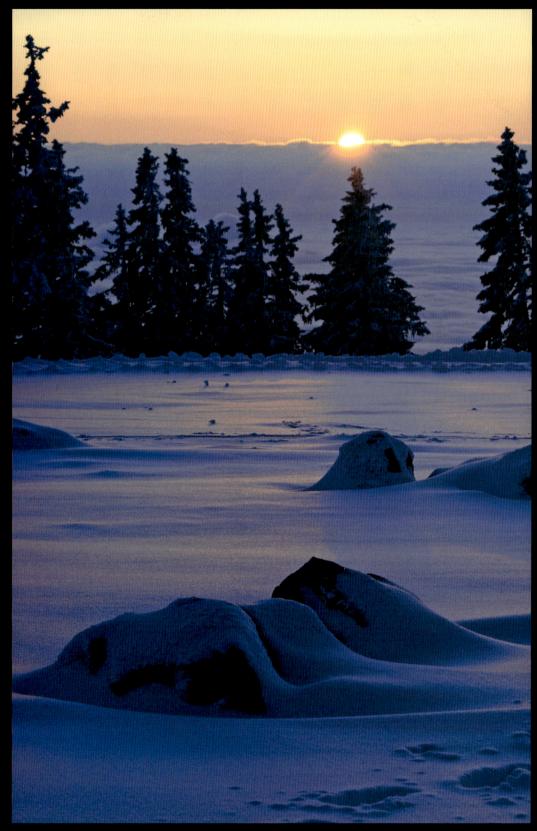

This picture was shot at night, with a long shutter speed to make the water very smooth. In Lightroom, I started with changing the color temperature toward blue/magenta. Then I changed the lighting and contrast, and used the selective color adjustment tool to get the colors I wanted. After that I used to noise-reduction, with Luminance set fairly high and detail and contrast very low. After this I used a mask to make the pole sharper and brighter, as it had lost too much detail in the noise reduction. I finished it all off with a soft vignette. *Guido Jeurissen*

I'm assuming that you did use the camera's noise removal option for fixed-pattern noise but that some still crept in over 2 minutes. The result looks perfect, and my only question is why you sharpened the pole afterwards rather than apply noise removal to a selection that excluded it. *Michael Freeman*

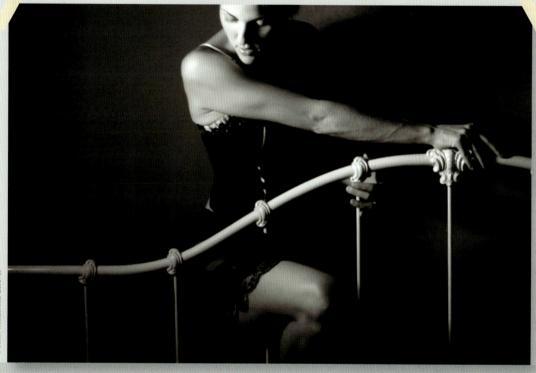

I took this photo when I was just starting out. The light was low and my ISO setting was set high, resulting in a very grainy and noisy photo. Though some may like this effect, I wanted a softer look. Using the noise reduction tool in Lightroom, I set Luminance to 100%, which created a beautiful softness. *Faith Kashefska-Lefever*

Like you, I find it hard to love noise in the same way that I could accept graininess in film, and this is an image that wants to be softer rather than gritty. Here's a good case of image editing coming to the rescue, but I guess you'll be avoiding the noise in the first place in future! *Michael Freeman* DIGITAL EDITING

Tone Curves

304

A tone curve is a visual representation of the relationship between the highlights, midtones, and shadows in an image. Tone curves appear in the form of a graph, in which the horizontal X-axis represents the original tonal values (or input), while the vertical Y-axis represents the adjustments made to the original values (or output).

Tone-curve commands are found in a number of applications, both in Raw processors such as Lightroom and Aperture, and in post-production pixel-editing programs such as Photoshop, Photoshop Elements, and PaintShop Pro.

Tone curves provide a powerful and extremely versatile means of adjusting the entire range of tones present in an image by dragging points on the tone-curve line. Broadly speaking, the lower third of the line represents the shadows, the middle third reflects the midtones, and the upper third stands for the highlights.

By default, the tone curve forms a straight diagonal line (because no adjustments have yet been made, so each input value on the X-axis corresponds exactly to its equivalent on the Y-axis). Adjusting the shape of the curve alters the relationship between the various tones in the image. 🕽 Steve Luck

←↑ Histogram overlay This example of a default tone curve overlays the image's histogram—a graph representing the image's distribution of tonal values. Like the tone curve, the histogram moves along the horizontal X-axis from shadows, to midtones,

to highlights.

←↑ Midtone brightening Clicking on the central point of the line and dragging it upward will brighten the entire image, but primarily the midtones. Note that by dragging the curve, you pull up not only that particular segment of the curve, but also all the rest of the curve which is to say, Curves adjustments are global, affecting the entire image.

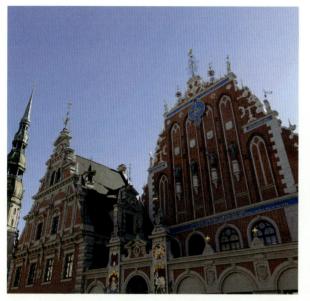

←↑ Midtone darkening

Clicking on the central point of the line and dragging it down will darken the entire image. Again, it is primarily affecting the midtones, but all other areas are also affected, with the adjustment gradually becoming less significant as you move away from the midtone areas.

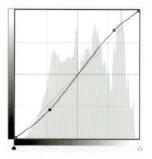

←↑ The S-curve

A common curve adjustment is the "S"-shape curve. This is formed by clicking in the highlight region and moving the point up, while at the same time selecting a shadow point and moving it down. The resulting high-contrast image adds greater detail in the midtones, but loses detail in the highlights and shadows, which become brighter and darker, respectively.

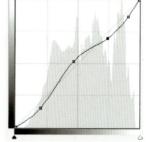

←↑ Multiple adjustments Here, a highlight point has been selected to darken the highlights in the top right of the image, while other points have been added to create extra contrast in the rest of the scene.

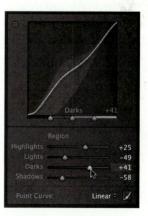

↑ Lightroom's Tone Curve

Here, this command also features sliders that can be used to alter the shape of the tone curve. This is helpful for users who aren't familiar with making adjustments via points on the tone curve.

DIGITAL EDITING

Color Correction

Having set the white balance and optimized the image's tonal values, it's likely that the colors are now pretty accurate (or at least appear so). However, there are a number of reasons why you may want to further adjust the colors in an image, ranging from a simple overall color boost to localized adjustments to a specific color.

Raw processors have sophisticated color-correction tools that allow you to adjust color in a variety of ways. Although the adjustment tools themselves may vary, Raw processors generally rely on hue, saturation, and luminance (HSL) to determine the source and target colors. Hue determines the color shift (wherein, for example, you can make oranges appear red, or blues appear purple). Saturation controls the color level (where you can specify how far from gray your color should be represented). Luminance darkens or lightens the color without affecting the hue or saturation.

⁹⁶	HSL / (Color / B&W	/ 🔻
Hue Sati	uration	Luminance	All
			0
Orange		- A	0
			0
Green			0
Aqua		-	0
	Grandstates	- A	0
		•	0
Magenta			0

↑ Hue/Saturation/Luminance panel

Rather than using the traditional primary additive (red/green/blue) and subtractive (cyan/magenta/yellow) colors for correction, Lightroom's HSL sliders utilize colors that are more meaningful to photographers.

↑↑ Hitting the saturation sweet spot

If you're shooting Raw, it's likely that the camera will produce images with muted colors, giving you the opportunity to add color in a more controlled way during Raw processing. Most Raw processors have a Vibrance as well as Saturation slider; both increase the overall color in the image, but the Vibrance slider works in a nonlinear way, increasing the saturation of muted colors before already saturated colors. This provides a more realistic color boost, and helps to preserve skin tones. © Steve Luck

© Steve Luck

Ya Sli Ccc W Li (fd Ad W dd m ex Lu re th m cc ef

← ∠ Hue adjustments

Many wildflowers are delicately colored, and their color can change depending on whether they are photographed in sunny or shady conditions. If you don't have a gray card off of which to set an accurate white balance at the time of shooting, you may find flowers such as these bluebells are not quite the color you expected when you open the image. However, color control in Raw processors is sufficiently versatile to allow subtle shifts in the hue of specific colors. Here, a hue adjustment was made to the blue slider to obtain a more accurate color.

≯→ Lightroom Target Adjustment

Lightroom has a useful feature that allows you to edit specific and complex tones, such as that of skin. The Target Adjustment tool is activated by clicking on the small circle at the upper right of the HSL panel. Then, you can click and hold anywhere on the image, and by moving the mouse up or down, you will adjust only the sample in that particular area.

An excellent example of this tool's usefulness is in adjusting skin tones. In the top image, the skin tone is too pink. By clicking on the shoulder with the Target Adjustment tool, and dragging it upward, the oranges and yellows it samples are increased, thus reducing the overall red tint.

←← Darker, richer skies

You can use the Luminance slider to darken any of the colors in your image. This works better than the Lightness slider in Photoshop (found within the Image > Adjustments > Hue/Saturation window), which tends to desaturate colors when making them darker. In this example we've reduced the luminance value of blue. This renders the blue sky darker so that the minaret stands out more. Used in this way, the color adjustment mimics the effect of a polarizing filter.

307

DIGITAL EDITING

Black & White Conversion

308

Another positive aspect of shooting digitally, and in particular when using the Raw format, is that when reviewing your images you're likely to find a few that potentially lend themselves well to a monochrome treatment.

Converting images to black and white at the Raw-processing stage utilizes the full 16-bit Raw data for maximum image quality; and as the conversion is nondestructive, you can revert back to color at any stage during the process should you so wish.

Raw processors utilize color sliders that allow you to adjust the tones in the black-and-white image once the basic conversion has been made.

An appropriate subject for B&W

This street shot of a man in profile passing in front of a colorful mural has an interesting composition, strong graphic qualities, and lots of different colors to play with.

Initial conversion

When you select the B&W mode in the Raw processor, the program uses the grayscale information in the red, green, and blue channels to create the black-and-white version. The Auto conversion is an accurate version of the color image, and is fine as such; but we can make more of an impact with some quick adjustments.

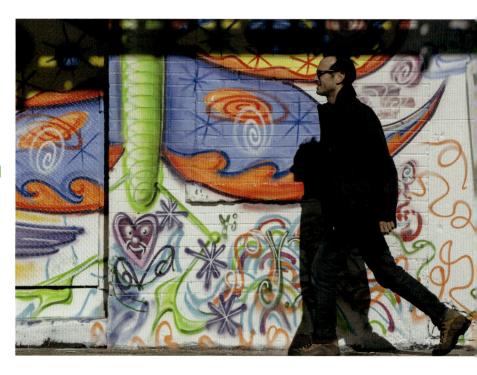

←↓ Selective luminance adjustments

Between his dark coat, his shadow, and the bold blue and red-orange on the mural behind him, the main figure is getting a bit lost in the dark. To enhance the contrast and make him stand out more, we can selectively brighten the colors behind him by using the Target Adjustment (upper left corner of the B&W panel below). Simply click on the colored area and, while keeping the mouse button pressed, move the mouse up slightly to brighten that particular color (or balance of several colors).

Conversion complete

With the main figure now adequately pronounced, the rest of the colors are darkened to add interest throughout the rest of the frame. The finished shot has a classic street feel to it, and makes an excellent graphic statement.

Convert to Black & White

↓ Mountain vista

The bold, blue sky cast against the white snow, with foreground shadows in the river, all come together to make this a color shot with great B&W potential. The initial conversion, set to Auto, is quite conservative, resulting in a mostly gray image that doesn't really inspire. To add drama, the tones are pushed farther apart, upping the contrast considerably. This challenge begins with finding a shot that has lots of potential for a black-and-white conversion. You're looking for something with contrasting colors—too much of the same tone and all you'll end up with is a gray image. Once you make your selection, you still have a lot of options in terms of how to render your subject in grayscale. If it's

a portrait, you probably don't want to push your contrast too hard, and you'll want to keep your color sliders relatively close to each other. On the other hand, if you're going for a more dramatic look, see how far apart you can spread your tones in various parts of the frame for a final image that delivers a big impact.

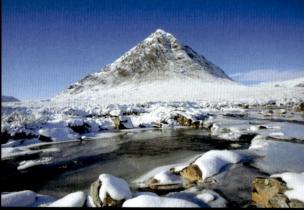

Tint Tint	Custom
Reds:	-70
Yellows:	-22
Greens:	127
Cyans:	-92
Blues:	-25
Magentas:	-25

Challenge Checklist

- → Start by using your editing program's automatic conversion, just to set a baseline from which to explore other possibilities. You may also experiment with some of the presets.
- → Contrast is the name of the game, and you will have to decide not only how much or how little, but also where you want your contrast, and which tones best play off each other in grayscale.
- → Remember that you can specific colors to adjust by clicking and holding on that area of the frame, then sliding your mouse up or down to make your luminance adjustments.

Dark skies, bright snow

The high-contrast final image, with the blue skies pulled into almost pure black, contrasting strongly with the bright whites of the landscape but complementing the foreground shadows, is bold, impactful, and effective.

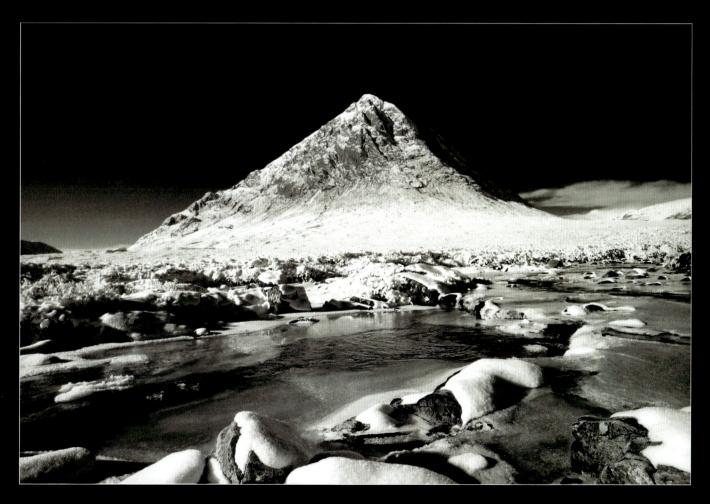

The first thing I did was try to amplify my idea of casting the shadow of the gate onto the ground—my strobe was not strong enough in the daylight to do this. Then I played around with Curves and dodging/burning parts of the stairs and wall to get a frightening image that led the eyes up the stairs to what almost seems to be headless a zombie at the top. After that, I adjusted the blue grayscale mix amount to give a dramatic sky, and added a slight tilt to give it a more uncomfortable feeling. Johnny Chang

It's extreme processing, but justified by your intention of making an unsettling image. The unexpected shadow certainly contributes to this (how far was the flash off-camera?). Good choice of method for darkening the sky at the top, which gives the image a tonal completion. Michael Freeman

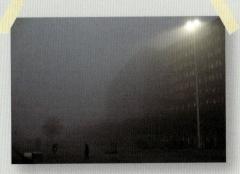

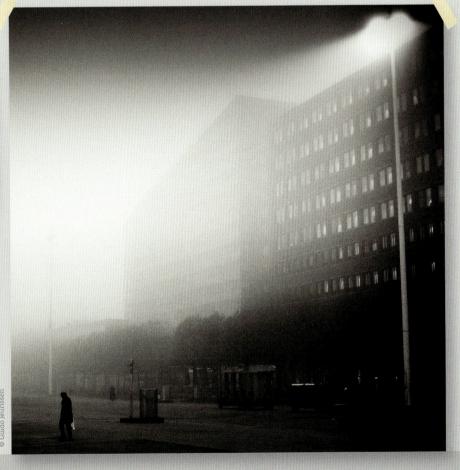

I really liked the composition, so I scaled the image to a square frame to eliminate all the distracting objects in the periphery. Top right—the light; bottom left—the man. I liked it. Next I used the NIK Silver Effex Pro to convert the image to B&W. I played with the filters until I found one that I liked, added contrast and sharpness to make the walking man stand out more, then gave it some noise by adding an llford 400 film simulation. I gave it a custom vignette to finish it off. *Guido Jeurissen*

Good composition and smart cropping at left to make a meaningful diagonal from the flaring streetlight to figure, with a clear contrast between the foggy distance and the grainy shadows along the bottom. Black and white concentrates the attention on the shapes and the man, with no distraction from the sky. *Michael Freeman* DIGITAL EDITING

Dodging & Burning

314

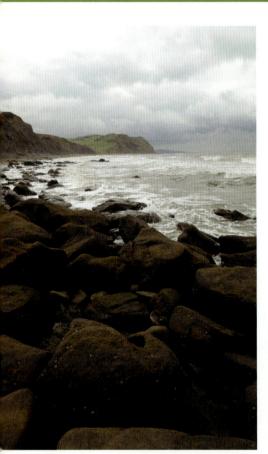

Dodging and burning is a well established photo-editing technique that dates back to conventional darkroom processing. The technique involves making local exposure adjustments to specific parts of an image to make that particular area brighter (dodging) or darker (burning).

When dodging in the darkroom, a piece of card is used to mask a specific area from the light of the film enlarger. The

Dodging and burning tools exist in Raw processors in the form of the adjustment brush, which can be used to selectively lighten or darken specific areas of the image.

Select the skies

Select the adjustment brush and either select the Burn option or reduce the exposure setting of the brush. Zoom into the sky region and start painting over the clouds. You'll notice the clouds become darker as you paint over them.

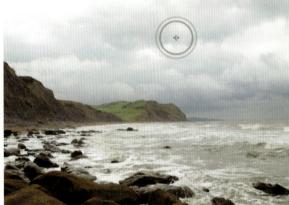

© Steve Luck

Unadjusted original

Trying to achieve a balanced exposure without the use of a graduated neutral density filter in this scene has resulted in a sky that doesn't do justice to the glowering nature of the clouds, and foreground rocks that are underexposed. There are various options we can use to fix this, but one method that provides a good level of control is to use the adjustment brush to dodge and burn the exposure where needed.

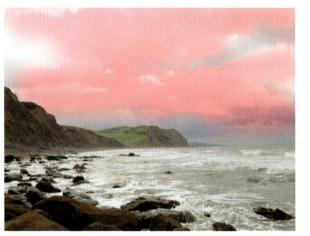

Mask overlay

All Raw processors, when using a selection tool, will allow you to view the selection as a color overlay. This is helpful, as it shows you exactly the areas that have been selected. Notice how the darker cliffs have been carefully avoided.

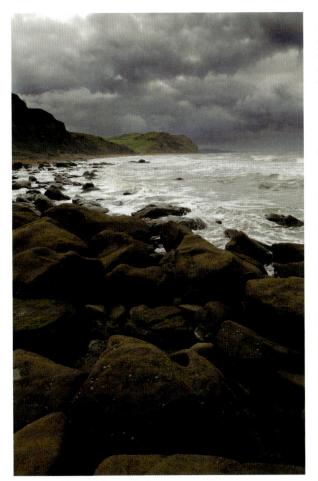

↑ Brightening the foreground

Next, repeat the process on the underexposed rocks. The Dodge brush was selected for this, but you can alternately increase the exposure setting of the adjustment brush—the effect is the same. With the sky region selected, you can fine tune the exposure to whatever you want using the adjustment sliders. Here, we've reduced the exposure of the sky so that the clouds more closely resemble how they were. Once the proper exposure setting is found, press enter to clear the mask and make the adjustment.

Converted to B&W

315

With the sky darkened and the foreground rocks brightened so that they draw in the viewer's eye, the final stage was to convert the image to black and white and sharpen it to ensure the textures stand out in stark relief.

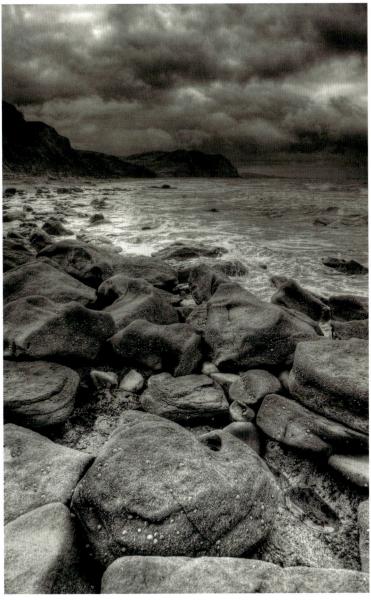

DIGITAL EDITING

Levels

The Levels command is one of the key ways in which to adjust the overall tone in an image. Although it is not as versatile as the Curves feature (see pages 304–305), the Levels dialog is still one of the first places to go when post-processing an image (particularly if the image hasn't been through a Raw-processing stage).

316

The Levels command is centered around the histogram. Histograms are graphical representations of the tones present in the image. Running along the horizontal or X-axis are the tonal variations ranging from black at the left to white at the right, while the vertical or Y-axis represents the number of pixels with a specific tone. Histograms are an excellent way in which to quickly judge an image's tonal distribution, which is why they are available to view on almost all digital cameras, and why they are a key reference in all imaging programs.

The main function of an initial Levels adjustment is to set the black and white points, in other words to ensure that there are a number of pixels that are both pure black and pure white. This ensures that there is a full range of tones distributed throughout the image.

→↓ Low-contrast original

This image was shot under diffused natural lighting and the overall tones are flat and gray. The lack of contrast is clear to see in the accompanying histogram, which is displayed when you call up the Levels command (under Image > Adjustments > Levels in Photoshop). There are almost no pixels recorded at either the dark shadows (left) or bright highlights (right).

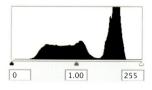

→↓ Setting the black point Here we've clicked on the Black Point slider and moved it right to align with the left-hand group of pixels, darkening the image. Notice that the central Gray Point slider moves relative to the black slider. This indicates that the midtones are adjusting in proportion. If you notice a color cast in the deep shadows, go to the channel of that color in Levels. If the pixels are not closed up to the left, dragging in the Black Point slider for that channel only will neutralize the cast.

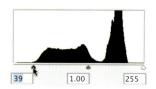

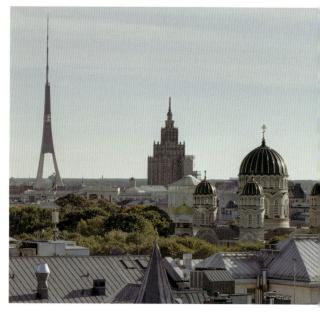

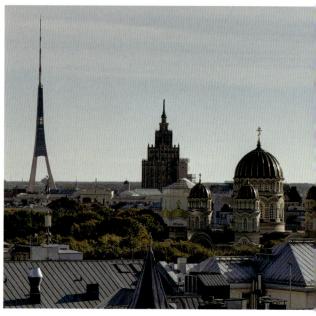

LEVELS

$\uparrow \rightarrow$ Setting the white point

The next step is to repeat the process, but this time with the White Point slider at the right of the histogram. Drag the slider left until it sits under the group of pixels at the right of the histogram. Again, you can hold down the Alt/Option key to show the parts of the image that will be clipped to pure white as you move the slider. This should also be kept to a minimum.

→↑ Midtone adjustment

Although the image now has a full range of tones from white to black, the midtones are a little dark. This is easily addressed by moving the midpoint or gray slider left toward the black point so that more of the midtoned pixels are grouped at the white end of the scale. This has the effect of brightening the image. Moving the midpoint slider to the right would have the effect of darkening the midtones in the image.

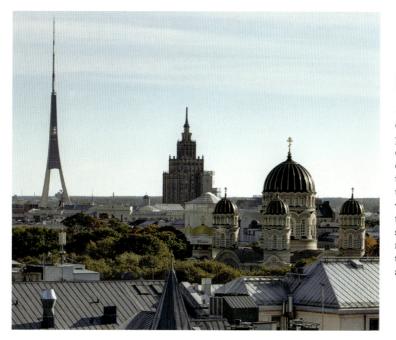

317

↑ Updated histogram

Once the black and white points have been set, if you close and reopen the Levels command, the histogram will then be refreshed to illustrate the new distribution of tonal values. Here, you can see that the image covers a greater spread of tones, and also has much more contrast because the shadows and highlights are farther apart.

Levels Adjustment

When it comes to essential adjustments to apply initially across the whole image, Levels is right up there with Curves in terms of importance and value; so it's time you start getting familiar with how to set your White/ Black points and Midtones. Levels will be your first step for many shots, particularly those that feel rather flat and lack contrast. Such images often have a perfectly fine exposure, they just need the luminance information redistributed between the shadows and highlights. So for this challenge, pick a shot that may seem a bit ho-hum at first, and see how much impact you can give it while restricting yourself to only the Levels command.

← ¥↓ An Edinburgh exposure

This very bright image has a fine composition and plenty of detail in the highlights and shadows—too much detail, in fact. To make it a bit punchier, the highlights are pulled back just a touch, and the black point is set to 9, letting the shadows particularly those under the tree at the bottom right of the frame—drop out and anchor the whole scene with some much needed contrast. Finally, the midtones are shifted every so slightly darker, resulting in a much more dynamic finished image.

3

Fulling the shadows

This shot had to endure some overexposure in order to capture the glare of the sun (which is still slightly blown out—but in a way that works just fine in livening up the scene). Consequently, the shadows had to also be raised, and the resulting contrast is quite low. In Levels, the White Point is left alone, but the Black Point is set significantly higher, and then compensated for by pulling the midtones back toward the peak in the middle of the histogram. The finished shot is much more effective as a result.

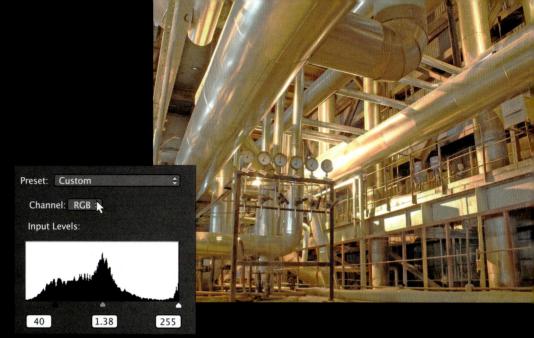

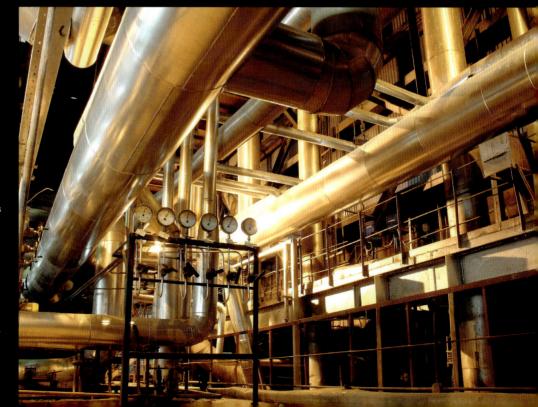

Challenge Checklist

- → Begin by looking at the extremes of the image: Are the highlights bright enough? Are the shadows dark enough?
- → Limit yourself to Levels, even if you know there is another, more familiar tool that could achieve your desired result. The point of this challenge is to recognize the potential of the Levels command, and explore how much you can achieve in this one single window.

Review

Using Levels I brought some brightness and contrast back into this image. I brought the sliders back into the part of the histogram where the slopes started and evened things out. After that was done all that was left was to bring back a bit of the vibrance that was lost from increasing the brightness. Dan Goetsch

Levels were a good choice for an image that contains no real tonal problems and for which centerweighted mid-tone adjustments will work perfectly. And it's good to use Vibrance rather than Saturation, as it protects against clipping. *Michael Freeman*

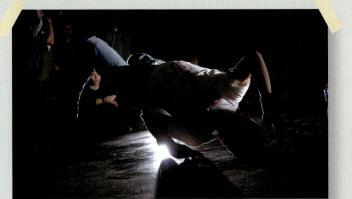

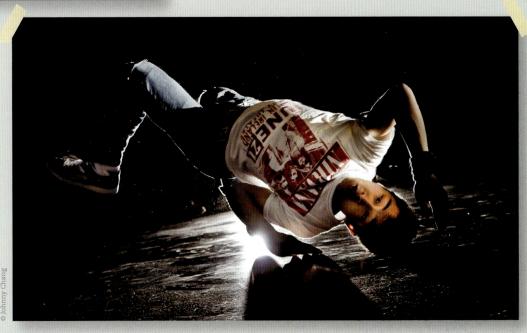

REVIEW

321

First, I dodged his face to see how much detail I could get back—it was very dark because there was no strobe at this angle (they were constantly moving around relative to my lights). I then cropped in to give tighter framing, burned some of the elements in the background that were distracting, and dodged parts of his leg and other areas that were not standing out enough from the background. Johnny Chang

Yes, that was my first reaction—how you brought up the face and the T-shirt successfully. It's a well-caught moment, and careful processing makes it into an effective shot. It's also an example of how different procedures are often needed together—here, Levels plus dodging. *Michael Freeman*

DIGITAL EDITING

Color Adjustment

Color changes in post-production pixel editors are made in much the same way as they are in Raw processors, in that colors are specified by their hue and saturation, as well as lightness (although this is called "luminance" in Raw processors, which as we shall see is significant). In addition to being able to adjust all the colors at once (for, say, an overall saturation increase), postproduction editors also allow you to adjust individual colors—usually red, green, blue, cyan, magenta, and yellow.

As mentioned, where Raw processors and pixel editors can differ is that the former use a "Luminance" slide while the latter a "Lightness" slider. This may sound a trivial difference, but it is important. You'll find that reducing the Lightness value of a specific color in Photoshop, for example, will also desaturate the color rather than just darken it. To successfully darken a color in Photoshop without desaturating it you may need to experiment with all three sliders to get the result you want—for example, decreasing Lightness while compensating with a saturation boost.

↑ Fresh from Levels, but lacking in color This image of a former medieval monastery, Forde Abbey, England, has been tonally optimized using the black and white points in the Levels dialog, but the colors still look dull.

∠↓ Global saturation boost

Using the Hue/Saturation command to increase all the colors (Master) has definitely given the image a color boost, but the sky still appears a little washed out.

←↑ Selective saturation boost

To increase saturation in the sky only, select Blues from the pull-down menu bump up the saturation. It's easy to overdo blue skies, to the point where they look quite unnatural, so use the preview button to switch between the original and adjusted preview, in order to see its effect.

Yellows	\$
Hue:	0
Saturation:	+17
Lightness:	0
<u> </u>	

$\uparrow \rightarrow$ Add a touch of sunshine

Although this image was shot at the height of summer, that isn't particularly apparent. To add some warmth to the image, try increasing saturation levels in the Yellows.

© Steve Luck

DIGITAL EDITING

Color Adjustment

↑→ Colorization

Some of the image editors that have a Hue/ Saturation dialog also feature a Colorize button. When selected, Colorize automatically turns the color image into a monochrome one.

↑→ Experimenting in monochrome

Once the image has been converted into a grayscale version, you can use the Hue, Saturation, and Lightness sliders to set a specific tone.

↓ Changing specific colors

As well as the Hue/Saturation control, which allows you to adjust all colors together or the primary colors individually, a number of programs have a Color Range or Color Changer control that allows you to be much more selective about the colors you want to adjust.

↑↑ Select a color

Find the Color Range/Color Changer command in your editing program, then use the Eyedropper tool to select the color you want to adjust. The dialog box allows you to set a higher or lower threshold to determine the extent of the selected color range. Only what appears white in the preview panel will be selected the remaining black areas are left untouched. Below, you can see the dotted outline around the flowers, indicating the selection of that particular shade of red/orange.

↑↑ Red-to-yellow shift

With the gladioli flowers on the left selected via the Color Range command, I then opened the Hue/Saturation window and shifted only their color from red to yellow.

Adjust Your Color

As an extremely subjective component of photography, color will always involve some creative decisions on your part. Indeed, your personal color preferences are likely to become a major component of your photographic style. Do you like bold, saturated colors, or a more muted, nostalgic effect? Which is more visually pleasing: a warm, glowing cast or a cooler one

🔸 🖌 Torii Gate, Miyajima

Like most sunsets, this image gives a lot of leeway in terms of how far you can go in your saturation levels. However, a straightforward global saturation increase mostly affected only the oranges and reds in this image, which isn't quite the intended look. In the Hue/Saturation (or HSL) window, only the yellows were selected, their hue was shifted so that they occupied more of the image, and finally they were selectively saturated. tending towards blues? Ask yourself these questions as you begin to explore your color adjustment options in this challenge. The particular image you choose to process will, of course, have its own unique demands. As usual, it's a mixture of visualizing what you want to achieve in advance, and then experimenting with other options along the way.

Challenge Checklist

- → It's exceedingly easy to get carried away with your saturation levels particularly if you've been staring only at HSL sliders for hours. So start conservative and move up from there. What seems edgy and impactful one minute might be revealed as simply gaudy the next.
- → Selective color switching is not only fun, it can be a necessary part of color management. Not all colors are created equal when captured by your sensor, so don't hesitate to adjust a particular color's hue if it doesn't represent the original scene as you remember it.
- → Don't forget the colorization option that is also offered by the HSL panel. Particularly if you are already considering a B&W conversion, colorization can be both fun and effective at communicating a certain mood or ambience.

Stronger and yellower

The final image is now suffused in golden tones that, while not completely wful to the original scene, do a much more effective job of creating an evocative look.

Review

DIGITAL EDITING

328

-

I used two 800W halogen film lights (RedHead) fairly close to the subject to avoid shadows on his face. I shot at f/3.5 for a slightly blurred background. After white balance and sharpness adjustments, I used Lightroom to edit the colors. The HSL tab in gave me a lot of control over each separate color. I tried to make his skin as dark as possible, and the colors as bright as possible. Then I used split toning to make it a little bit cooler. It also gave the background a blue color, which I really liked. *Guido Jeurissen*

That's a lot of work from your notes, yet the result, though vibrant, does not look over-cooked. I like the attention to detail in your processing, aimed at a well thought-through and obviously personal interpretation. *Michael Freeman*

925

Due to unmatched strobe lighting, I had turned my other shots to B&W; but for this one I wanted to bring out the team colors. I played with the fill light, black point, contrast, and vibrance, while reducing saturation. Then I selectively dodge/burned and cropped what I didn't want to be the focus, and added a sepia tone. Johnny Chang

Definitely a good moment, and not one to be spoiled by the hot color of the lighting. Good choice of process in not only opening the pack of skaters up, but restraining the color so that the team shirts don't totally overwhelm the image. *Michael Freeman* DIGITAL EDITING

Layers

Layers have been a feature of imageediting programs since 1994. These powerful tools allow you to create composite images made up of individual elements held on layers that can be "stacked" on top of each other, and which can be moved, resized, tonally amended, and so on—independently of one another, but also merged when necessary. You can also use Layers to enhance a single image, with adjustments applied to duplicate layers of the original. In this way you can optimize an image while leaving the original untouched—though this function has largely been replaced by Adjustment Layers (see page 332).

330

As nondestructive Raw-processing controls have grown increasingly more versatile, particularly in terms of the localized adjustments that you can now make with them, in some ways Layers have become less significant, at least in terms of "standard" photographic image editing. However, if you're looking to combine images to create a montage, for example, or replace one element of a photo with that from another, or add text or special effects, it's essential that you know how Layers work.

←↑ Beginning with two distinct images

Using these two shots—one skyscape of dusk over the Catskill mountains, the other a NASA model of the moon —we can make a simple layer-based montage to show how layers work and interact with one another.

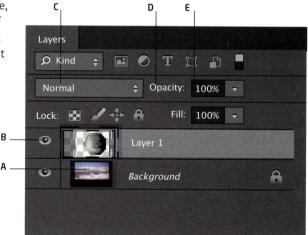

- A Layer thumbnail and name
- B Visibility eye
- C Blending mode
- D Opacity slider
- E Controls for adding new layers, deleting layers, adding effects, and creating layers masks

LAYERS

↑ Place moon on top

The first step is to make a selection of only the moon (dropping out the surrounding black) and place it in its own layer on top of the background. Then the moon is resized and positioned over the clouds at the right spot. The skyscape is also flipped horizontally for better composition.

↑ Layer reversal

Next, switch the layers to bring the clouds forward, and blend the two layers to weaken the moon.

331

↑ Touch-up

The cloud background is then duplicated and selectively brushed to strengthen the clouds until they appear to overlap perfectly.

↓ Massive moon

By combining these shots using layers, we're able to achieve a surrealistic shot of an enormous moon on the horizon. These same blending techniques are applicable to a wide range of potential composites.

DIGITAL EDITING

Adjustment Layers

Just as layers can be thought of as comprising individual image components that combine together to make up the composite image, so adjustment layers can be considered as comprising individual image adjustments that together create the finished image. And just as layers are independent of one another and can be amended at any time during the creation of the composite image, so too are adjustment layers.

332

Although there are many similarities between layers and adjustment layers, they differ in one important respect: Layers contain image objects made up of actual pixels, just as in any digital image, whereas adjustment layers don't contain any pixels; instead they comprise the information that shows how the image will look when the adjustment is applied. The adjustment can be anything from a Levels or Curves command, to a Hue/Saturation boost, to a Dodge or Burn. This means that you can make and view any number of adjustments to the original image without altering the image itself. In this respect, adjustment layers are comparable to the nondestructive edits made during Raw processing.

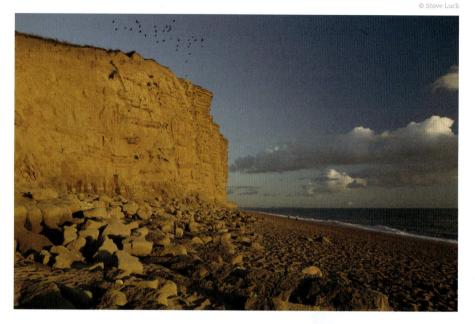

↑ Sandstone cliffs

This image of a coast in southern England has potentially strong colors, an attractive sky, and some pleasing graphic qualities. However, it's underexposed, lacks contrast, and the colors are initially a little dull.

∠↓ Levels adjustment with an adjustment layer

When you create a new adjustment layer (Layer > New Adjustment Layer) you'll be presented with the corresponding dialog. Here, we've created a new Levels adjustment layer to set the black and white points; the Levels adjustment layer will appear as a new layer in the Layers palette (below left).

333

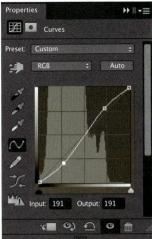

↑ A second layer for contrast

The next step is to add contrast by creating a Curves adjustment layer, and setting a characteristic "S" curve. Adjustment layers behave just like normal layers; you can use the visibility eye to gauge its effect, and even use the Opacity slider to alter the strength of the adjustment.

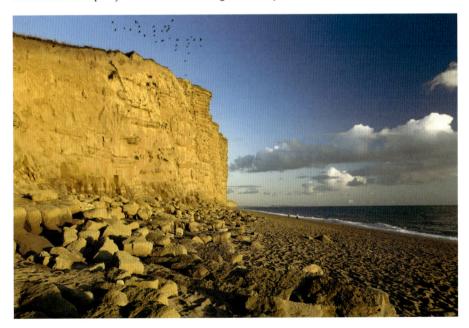

Reds Hue: 0 Saturation: -60 Lightness:

↑> Finishing touches

In our example, the last adjustment layer added was Hue/Saturation. In the Hue/ Saturation dialog, I selected Red and reduced the Saturation setting; I then increased the Blue saturation. To finish, I double-clicked the Levels layer to bring up that dialog, and moved the midpoint slider to the left to brighten the midtones. DIGITAL EDITING

Blending

Blending modes are another powerful editing feature associated with layers. Essentially, they offer numerous ways layers can interact with one another based on the color and luminance values present in the images.

Many post-production image editors offer a variety of blending modes, and they are similar across the various programs. Blending modes have a vast number of photographic uses, too many to go into detail here; but the most useful are those that help to control and amend exposure, contrast, and color, and these are the ones on which we'll concentrate.

It's certainly worth spending time applying each blending mode to a couple of images to get a feel for what each does, but for now we'll take a look at some of the more common blending mode applications.

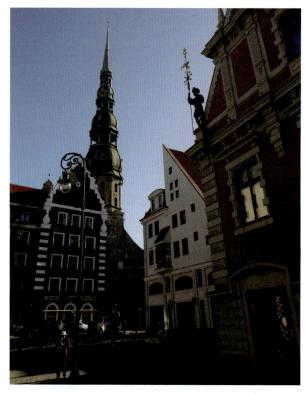

Uneven underexposure

This image is underexposed, but more so at the bottom than the lighter sky at the top—a common photographic scenario. Increasing overall brightness using a Levels command would improve the exposure at ground level but result in a washed out or even overexposed sky.

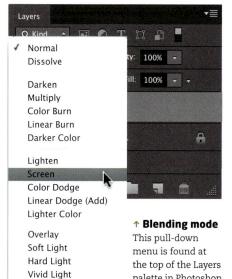

palette in Photoshop.

←↑ Gradient layer

To address the exposure issue, create a new layer and apply a black/white gradient from top to bottom. With the blending mode set to the default Normal mode in the Layers palette, all you'll see on screen is the gradient.

334

↓↓ > Fine adjustment

Although the street level is now much lighter and the sky is darker, there are elements at the top of the image, the building and spire, for example, that need to revert to the original exposure. To do this, add a layer mask to the Gradient layer and paint out the dark gradient. We can also reduce the effect of the gradient by reducing its opacity using the Opacity slider.

335

← ← Blend in the gradient

If, however, you change the blending mode to Soft Light, the background image will appear, but you'll see that it has been altered by the gradient layer. The black of the gradient renders the top of the image darker, while the whiter area of the gradient renders the bottom of the image lighter.

DIGITAL EDITING

Removing Unwanted Objects

Along with making selections and cut-outs, removing unwanted objects from photos is another common post-production image-editing task.

There are innumerable reasons why you might want to delete objects from a photo, whether it's a sign emerging from someone's head or, as is the case here, cables running in front of a building.

Although there are ever-more sophisticated cloning tools and algorithms available, such as Photoshop's Content-Aware option (which is certainly worth trying), you're still likely to have to turn to manual cloning at some point to get the precise result you want.

↑ Healing brushes

If you have a healing brush option, it's certainly worth trying it where you can. Photoshop has two healing brushes: the Spot Healing Brush, which automatically attempts to replace the selected object with pixels of a similar color and brightness value located nearby; and the standard Healing Brush. With the latter you have to sample a source before the tool works.

↑ Spot Healing Brush

With Content-Aware set in the Options bar, this has done a good job of replacing the cables in the sky, but look closely at the side of the building and you'll see that the tool has created two darkly colored blurred areas, where the cables pass in front of the building.

Cluttered with cables

In this example, we're going to use a variety of tools to remove the cables and lamp from this otherwise attractive image of a church.

↑ Clone Stamp

As the area that we need to fix is uniformly patterned, we can't use any auto healing options. Instead, we turn to the Clone Stamp tool, and sample the edge of the building by holding down the Alt/Opt key.

↑ Follow the edge

With the area sampled, simply click on the affected region, ensure it's aligned accurately, and replace it with the unaffected area that we cloned earlier. The Clone Stamp tool works best with a soft brush—a hard brush may result in visible edges. It's also worth experimenting with the Opacity setting in the Tool Options bar. A setting of around 50% means you have to click a few times for the cloning to complete, but it does afford a level of control.

* Keep it aligned

Keep the Clone tool on the default Aligned option. This ensures the source point moves with the brush as you clone over affected areas.

336

↑ Easy cleanup

If you're cloning straight objects, such as this cable, select a source point as usual, click to clone away the cable, but hold down the Shift key. Click at the end of the cable and the tool will automatically replace the entire length of cable.

↑ > The Patch tool

There are number of ways you could remove this lamp. Photoshop's Content-Aware Fill option would do a good job, but here we're using the Patch tool. In Source mode, make a selection of the lamp, then move the selection to a source area and release the mouse. The tool will automatically use the source area to replace the lamp. When replacing such a large object in one go, you'll need to tidy up after with the Clone Stamp tool.

↑↑↑ **Larger brushes for faster work** Don't be afraid to increase the size of the Clone Stamp tool brush when cloning regularly patterned areas. As long as the alignment is true, the cloning will look natural.

← **Uncluttered** The finished image, free of distracting and ugly cables.

338

DIGITAL EDITING

Panoramas

Creating panoramas has never been so straightforward as it is today. In fact, with the sophisticated stitching software that's now available, pretty much the whole process is taken care of automatically once you have the source images.

There are, however, some important rules to remember when shooting panoramas. First, use manual exposure when shooting your source images to ensure consistent exposure throughout the series. Second, it pays to focus manually, so that the camera doesn't inadvertently autofocus on some close-up object as you're panning round. Finally, to be safe, use the most appropriate white balance preset for the conditions under which you're shooting rather than relying on auto white balance. Again, this ensures consistency. (Yes, this is adjustable as long as you're shooting Raw, but it does simplify the process.) If your camera has a Panorama shooting mode, it may implement these settings on its own

Using a tripod will help you ensure the individual source images align, but most of today's software is powerful enough to identify features to create an accurate alignment even if the source images aren't perfectly aligned.

∠↓ Three shots with plenty of overlap

These three images show the Czech capital Prague's historic old town district from the top of Prague's Petřín Lookout Tower (a scaled-down version of the Eiffel Tower). When shooting for a panorama, aim to overlap images by around 40% to give plenty of room to work and line up.

→ Photomerge

After downloading the source files, I launched Photoshop's Photomerge command and browsed to select the images. This particular stitching software offers a number of options: The Layout options provide control if you're creating long panoramas or 360° types. Auto works well in most instances. Select Blend Images Together to create seamless joins between the frames. Vignette Removal helps ensure a smoothly toned sky. Use Geometric Distortion Correction only to counteract noticeable barrel or pin-cushion distortion.

← Stitch them together

Once you've made the various selections, click OK, and then Photomerge will automatically blend the images together to create the panorama. Here, I used the Auto layout option, which produces the optimal result based on the source files.

→ Crop out the edges

Look for any obvious misalignments or poor tonal mismatch in areas of flat color. If this occurs you may need to consider using alternative layout options and the Vignette Removal control. When you're happy, flatten the image and crop out any white space.

↓ Final adjustments

After you've cropped out the white space you can finetune the overall tone, color saturation, sharpening, and so on before saving the final panorama.

© Steve Luck

Stitch a Panorama

Sometimes the world just can't fit into a single frame. And sometimes you want to get as much resolution as you can of a particular scene. Whatever your motivation, a panorama is an essential tool in your photographic repertoire, and once you work through this challenge, you'll be surprised just how easy they are to achieve. The first step is choosing an appropriate subject—typically we think of horizontally wide ones, but vertical panoramas are just as valid. Step two is getting plenty of shots to work with, followed by step three: the stitching. You may have some special effect possibilities built into the stitching software, so feel free to play around and see what your various options are.

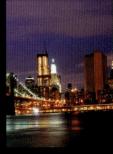

↓ ←↑ **Pre-pano adjustments** This series of shots all needed some slight color adjustments, so they were synchronized in Adobe Camera Raw and adjusted first, before then being ported into Photoshop's Photomerge function via Adobe Bridge.

Local Adjustments

and arranged as a series of overlapping layers. The next step is, of course, to crop rectangle with clean edges out of the roughly stitched full image. At this stage, you must consider your output. Few display options exist for extremely wide images, so while this could be cropped considerably wider, a 16:9 (common HD) aspect ratio was chosen.

 Lock:
 Image: Constraint of the second se

04092...

Challenge Checklist

- → While a tripod is always a useful tool, don't let the lack of one prevent you from attempting a series of shots while you're out in the field. Just get plenty of overlap between each shot, so your stitching program has a better chance at lining things up afterward.
- → Manual exposure mode is a definite requirement. You don't want to be making painstaking adjustments to each image, trying to equalize the exposure across the series. Besides, any slight different will be readily viewable along the joins.

Review

342

DIGITAL EDITING

The sun was going down quick and I didn't want to miss my chance with the great light. I pulled my car off to the side of the road and hiked down an embankment. I took six shots to fit the entirety of the lake into one shot. In Photoshop I used the Photomerge script to create the panorama. Once that was done I used the Lens Correction filter to remove some of the lens distortion from using my wide-angle lens. I also cropped the image to get rid of the uneven parts created while merging the photos. From there I wanted to bring back some of the warm sunset tones that I saw when I was there, so I adjusted the saturation, vibrance, and contrast. Dan Goetsch

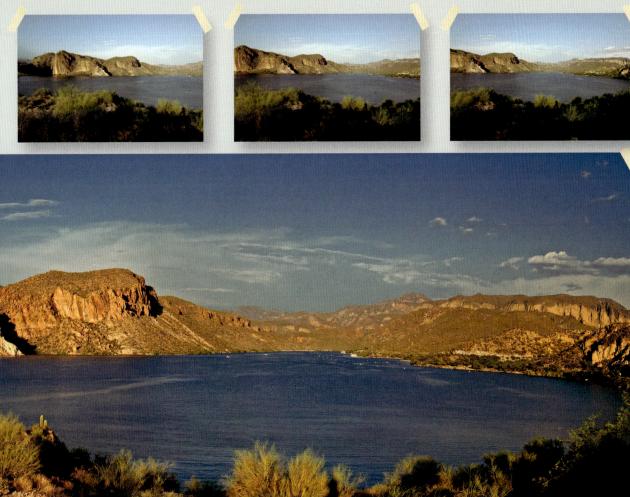

Excellent! You shot for the essential horizontality of the scene, including the capping of the hills by cloud, and a panoramic stitch does it real justice. Nice closure at the right. I can see that you guaranteed the shot by overlapping more than was probably needed for the stitch–which was the professional thing to do. *Michael Freeman* GLOSSARY

Glossary

A Aperture priority mode, as indicated by some camera manufacturers.

344

additive primary colors The three colors red, blue, and green, which can be combined to create any other color. When superimposed on each other they produce white.

algorithm Mathematical procedure that allows the step-by-step solution of a problem.

aliasing The jagged appearance of diagonal lines in an image, caused by the square shape of pixels.

anti-aliasing The smoothing of jagged edges on diagonal lines created in an imaging program, by giving intermediate values to pixels between the steps.

aperture The opening behind your lens that allows light to pass through it and reach the sensor.

aperture priority A camera setting that allows you to choose the aperture while the camera selects the appropriate shutter speed to ensure a good exposure. Some camera manufacturers indicate it with A, others with Av.

application (program) Software designed to make the computer perform a specific task. So, image-editing is an application, as is word-processing. System software, however, is not an application, as it controls the running of the computer.

artifact A flaw in a digital image.

aspect ratio The ratio of the height to the width of an image, screen, or page.

autofocus When the camera lens adjusts the focus to ensure a sharp image.

axis lighting Light aimed at the subject from close to the camera's lens.

backlighting The result of shooting with a light source, natural or artificial, behind the subject to create a silhouette or rim-lighting effect.

backup A copy of either a file or a program, for safety reasons, in case the original becomes damaged or lost. The correct procedure for making backups is on a regular basis, while spending less time making each one than it would take to redo the work lost. **banding** Unwanted effect in a tone or color gradient in which bands appear instead of a smooth transition. It can be corrected by higher resolution and more steps, and by adding noise to confuse that part of the image.

barrel distortion The effect when straight lines appear to curve, as if they've been stretched over a sphere or barrel, seen with wide-angle and fish-eye lenses.

Bézier curve A curve described by a mathematical formula. In practice, it is produced by manipulating control handles on a line that is partly held in place by anchor points.

bit (binary digit) The basic data unit of binary computing. *See also* byte

bit depth The number of bits-per-pixel (usually per channel, sometimes for all the channels combined), which determines the number of colors it can display. Eight bitsper-channel are needed for photographicquality imaging.

bitmap (bitmapped image) Image composed of a pattern of pixels, as opposed to a mathematically defined object (an objectoriented image). The more pixels used for one image, the higher its resolution. This is the normal form of a scanned photograph.

BMP Image file format for bitmapped images used in Windows. Supports RGB, indexed color, grayscale and bitmap.

bracketing A method of ensuring a correctly exposed photograph by taking three shots; one with the supposed correct exposure, one slightly underexposed, and one slightly overexposed.

brightness The level of light intensity. One of the three dimensions of color. *See* also hue and saturation

buffer An area of temporary data storage, normally used to absorb differences in the speed of operation between devices. For instance, a file can usually be sent to an output device, such as a printer, faster than that device can work. A buffer stores the data so that the main program can continue operating.

byte Eight bits—the basic data unit of desktop computing. See also bit

cache An area of information storage set aside to keep frequently needed data readily available. This allocation speeds up operation.

calibration The process of adjusting a device, such as a monitor, so that it works consistently with others, such as scanners and film recorders.

CCD (Charge-Coupled Device) A tiny photocell used to convert light into an electronic signal. Used in densely packed arrays, CCDs are the recording medium in most digital cameras.

CGI (Computer-Generated Image) Electronic image created in the computer (as opposed to one that has been transferred from another medium, such as a photograph).

channel Part of an image as stored in the computer; similar to a layer. Commonly, a color image will have a channel allocated to each primary or process color, and sometimes one or more for a mask or other effect.

chiaroscuro Literally "light/dark," the interplay of light and shadow to create an image.

clipboard Part of the memory used to store an item temporarily when being copied or moved. See also cut-and-paste

cloning In an image-editing program, the process of duplicating pixels from one part of an image to another.

CMOS (Complementary Metal-Oxide Semiconductor) An alternative sensor technology to the CCD, CMOS chips are used in ultra-high-resolution cameras from Canon and Kodak.

CMYK (Cyan, Magenta, Yellow, Key) The four process colors used for printing, including black (key).

color depth See bit depth

color gamut The range of color that can be produced by an output device, such as a printer, a monitor, or a film recorder.

color model A system for describing the color gamut, such as RGB, CMYK, HSB, and lab.

color separation The process of separating an image into the process colors cyan, magenta, yellow, and black (CMYK), in preparation for printing.

color space A model for plotting the hue, brightness, and saturation of color.

color temperature A way of describing the color differences in light, measured in Kelvins and using a scale that ranges from dull red (1900K), through orange, to yellow, white, and blue (10,000K).

complementary color Colors that sit opposite each other on the color wheel, for example green and red.

compression Technique for reducing the amount of space that a file occupies, by removing redundant data. There are two kinds of compression: standard and lossy. While the first simply uses different, more processorintensive routines to store data than the standard file formats (see LZW), the latter actually discards some data from the image. The best known lossy compression system is JPEG, which allows the user to choose how much data is lost as the file is saved.

contrast The range of tones across an image from highlight to shadow.

CPU (Central Processing Unit) The processing and control center of a computer.

cropping The process of removing unwanted areas of an image, leaving behind the most significant elements.

cursor Symbol with which the user selects and draws on-screen.

cut-and-paste Procedure in graphics for deleting part of one image and copying it into another.

default The standard setting or action used by a computer unless deliberately changed by the operator.

desktop The background area of the computer screen on which icons and windows appear.

desktop computer Computer small enough to fit on a normal desk. The two most common types are the PC and Macintosh. **depth of field** The zone of sharpness in front of and behind the subject.

dialog box An on-screen window, part of a program, for entering settings to complete a procedure.

diffusion The scattering of light by a material, resulting in a softening of the light and of any shadows cast. Diffusion occurs in nature through mist and cloud cover, and can also be simulated using diffusion sheets and soft-boxes.

digital A way of representing data as a number of distinct units. A digital image needs a very large number of units so that it appears as a continuous-tone image to the eye; when it is displayed these are in the form of pixels.

digital zoom Many cheaper cameras offer a digital zoom function. This simply crops from the centre of the image and scales the image up using image processing algorithms (indeed the same effect can be achieved in an image editor later). Unlike a zoom lens, or optical zoom, the effective resolution is reduced as the zoom level increases; 2× digital zoom uses ¼ of the image sensor area, 3× uses ⅓, and so on.

download Sending a data file from the computer to another device, such as a printer. More commonly, this has come to mean taking a file from the Internet or remote server and putting it onto the desktop computer. *See also* upload

dpi (dots-per-inch) A measure of resolution in halftone printing. *See also* ppi

drag Moving an icon or a selected image across the screen, normally by moving the mouse while keeping its button pressed.

drag-and-drop Moving an icon from one file to another by means of dragging and then dropping it at its destination by releasing the mouse button. *See also* drag

dynamic range The range of tones that an imaging device can distinguish, measured as the difference between its dmin and dmax. It is affected by the sensitivity of the hardware and by the bit depth.

edge lighting Light that hits the subject from behind and slightly to one side, creating flare or a bright "rim lighting" effect around the edges of the subject.

Ev Exposure Value, how the brightness of a scene is measured.

exposure How much light reaches a camera's sensor.

f-stop The measurement of the variable opening in a lens (the aperture) that allows light to pass through it and reach the sensor or film. *f*/1.4 is a large, or "fast" aperture; *f*/22 is a small aperture.

fade-out The extent of any graduated effect, such as blur or feather. With an airbrush tool, for example, the fade-out is the softness of the edges as you spray.

feathering In image-editing, the fading of the edge of an image or selection.

file format The method of writing and storing a digital image. Formats commonly used for photographs include tiff, pict, bmp, and jpeg (the latter is also a means of compression).

fill flash A technique that uses the on-camera flash or an external flash in combination with natural or ambient light to reveal detail in the scene and reduce shadows.

fill light An additional light used to supplement the main light source. Fill can be provided by a separate unit or a reflector.

filter (1) A thin sheet of transparent material placed over a camera lens or light source to modify the quality or color of the light passing through.

(2) Imaging software included in an imageediting program that alters some image quality of a selected area. Some filters, such as Diffuse, produce the same effect as the optical filters used in photography after which they are named; others create effects unique to electronic imaging.

focal length The distance between the mid-point of the plane of the lens and the sensor or film in a camera.

345

GLOSSARY

focal point The center of interest in a photograph, the area where you focus your camera.

fringe In image-editing, an unwanted border effect to a selection, where the pixels combine some of the colors inside the selection and some from the background.

346

frontal light Light that hits the subject from behind the camera, creating bright, highcontrast images, but with flat shadows and less relief.

gamma A measure of the contrast of an image, expressed as the steepness of the characteristic curve of an image.

GB (GigaByte) Approximately one billion bytes (actually 1,073,741,824).

global correction Color correction applied to the entire image.

golden hour The period after dawn and before dusk that offers a soft, golden light ideal for dramatic photography.

gradation The smooth blending of one tone or color into another, or from transparent to colored in a tint. A graduated lens filter, for instance, might be dark on one side, fading to clear on the other.

grayscale An image made up of a sequential series of 256 gray tones, covering the entire gamut between black and white.

GUI (Graphic User Interface) Screen display that uses icons and other graphic means to simplify using a computer. The Macintosh GUI was one of the reasons for Apple's original success in desktop computing.

hard disk, hard drive A sealed storage unit composed of one or more rigid disks that are coated with a magnetically sensitive surface, with the heads needed to read them. This can be installed inside the computer's housing (internal), or in a separate unit linked by a bus (external).

haze The scattering of light by particles in the atmosphere, usually caused by fine dust, high humidity, or pollution. Haze makes a scene paler with distance, and softens the hard edges of sunlight.

HDRI (High Dynamic Range Imaging) A

method of combining digital images taken at different exposures to draw detail from areas which would traditionally have been over or under exposed. This effect is typically achieved using a Photoshop plugin, and HDRI images can contain significantly more information than can be rendered on screen or even percieved by the human eye.

high-key Low-contrast images that have a feeling of light airiness and positivity.

highlights Technically, the pure white parts of an image, but often it refers to the lightest areas of an image.

histogram A map of the distribution of tones in an image, arranged as a graph. The horizontal axis is in 256 steps from solid to empty, and the vertical axis is the number of pixels.

HMI (Hydrargyrum Medium-arc Iodide) A lighting technology known as "daylight" since it provides light with a color temperature of around 5600K.

honeycomb grid In lighting, a grid can be placed over a light to prevent light straying. The light can either travel through the grid in the correct direction, or will be absorbed by the walls of each cell in the honeycomb.

hot-shoe An accessory fitting found on most digital and film SLR cameras and some high-end compact models, normally used to control an external flash unit. Depending on the model of camera, information to lighting attachments might be passed via the metal contacts of the shoe.

HSB (Hue, Saturation and Brightness) The three dimensions of color. One kind of color model.

hue A color defined by its spectral position; what is generally meant by "color" in lay terms.

icon A symbol that appears on-screen to represent a tool, file, or some other unit of software.

image compression A digital procedure in which the file size of an image is reduced by discarding less important data. **image-editing program** Software that makes it possible to enhance and alter a scanned image.

image file format The form in which an image is handled and stored electronically. There are many such formats, each developed by different manufacturers and with different advantages according to the type of image and how it is intended to be used. Some are more suitable than others for high-resolution images, or for objectoriented images, and so on.

incandescent lighting This strictly means light created by burning, referring to traditional filament bulbs. They are also know as hotlights, since they remain on and become very hot.

incident meter A standalone lightmeasuring instrument, distinct from the metering systems built into many cameras. These are used by hand to measure the light falling at a particular place, rather than (as the camera does) the light reflected off of a particular subject.

interface Circuit that enables two hardware devices to communicate. Also used for the screen display that allows the user to communicate with the computer. *See also* GUI

interpolation Bitmapping procedure used in resizing an image to maintain resolution. When the number of pixels is increased, interpolation fills in the gaps by comparing the values of adjacent pixels.

ISO An international standard rating for film speed, with the film getting faster as the rating increases. ISO 400 film is twice as fast as ISO 200, and will produce a correct exposure with less light and/or a shorter exposure. However, higher-speed film tends to produce more grain in the exposure, too.

JPEG (Joint Photographic Experts Group)

Pronounced "jay-peg," a system for compressing images, developed as an industry standard by the International Standards Organization. Compression ratios are typically between 10:1 and 20:1, although lossy (but not necessarily noticeable to the eye).

KB (KiloByte) Approximately one thousand bytes (actually 1,024).

kelvin Scientific measure of temperature based on absolute zero (simply take 273.15 from any temperature in Celsius to convert to kelvin). In photography measurements in kelvin refer to color temperature. Unlike other measures of temperature, the degrees symbol in not used.

lasso A selection tool used to draw an outline around an area of the image.

layer One level of an image file, separate from the rest, allowing different elements to be edited separately.

LCD (Liquid Crystal Display) Flat screen display used in digital cameras and some monitors. A liquid-crystal solution held between two clear polarizing sheets is subject to an electrical current, which alters the alignment of the crystals so that they either pass or block the light.

leading line A line in an image that draws the eye to the subject.

lossless Type of image compression in which no information is lost, and so most effective in images that have consistent areas of color and tone. For this reason, not so useful with a typical photograph.

lossy Type of image compression that involves loss of data, and therefore of image quality. The more compressed the image, the greater the loss.

low-key High-contrast photographs, usually very dark in tone, that have a feeling of brooding.

luminaires A complete light unit, comprising an internal focusing mechanism and a fresnel lens. An example would be a focusing spot light. The name luminaires derives from the French, but is used by professional photographers across the world.

luminosity Brightness of color. This does not affect the hue or color saturation.

lux A scale for measuring illumination, derived from lumens. It is defined as one lumen per square meter, or the amount of light falling from a light source of one candela one metre from the subject. **macro** A single command, usually a combination of keystrokes, that sets in motion a string of operations. Used for convenience when the operations are run frequently.

mask A grayscale template that hides part of an image. One of the most important tools in editing an image, it is used to make changes to a limited area. A mask is created by using one of the several selection tools in an image-editing program; these isolate a picture element from its surroundings, and this selection can then be moved or altered independently.

MB (MegaByte) Approximately one million bytes (actually 1,048,576).

megapixel (1 million pixels) A rating of resolution for a digital camera, directly related to the number of pixels forming or output by the CMOS or CCD sensor. The higher the megapixel rating, the higher the resolution of images created by the camera. However, megapixel count alone is not a defining factor of image quality.

menu An on-screen list of choices available to the user.

mid-tone The parts of an image that are approximately average in tone, midway between the highlights and shadows.

mode One of a number of alternative operating conditions for a program. For instance, in an image-editing program, color and grayscale are two possible modes.

modeling light A small light built into studio flash units that remains on continuously. It can be used to position the flash, approximating the light that will be cast by the flash.

monobloc An all-in-one flash unit with the controls and power supply built-in. Monoblocs can be synchronized together to create more elaborate lighting setups.

negative space Areas of a photograph that do not contain any subject matter.

neutral density filter A neutral color filter that absorbs light from different wavelengths without altering the overall color of an image, permitting longer exposures or wider apertures when there is too much available light.

noise Random pattern of small spots on a digital image that are generally unwanted, caused by non-image-forming electrical signals.

object-oriented (image, program) Software technology using mathematical equations rather than pixels to describe an image element. Scalable, in contrast to bitmapped elements.

open flash The technique of leaving the shutter open and triggering the flash one or more times, perhaps from different positions in the scene.

overexposure What happens when too much light reaches the sensor or film and a photograph is too bright with too many pure-white areas in the frame.

P Program mode, an autoexposure mode in which the camera chooses both the aperture and shutter speed, but you can manually change the relationship between these variables, and all other camera settings remain available for you to adjust.

panning A photographic technique in which you move the camera in time with a subject in motion to create a image where the subject is sharp and the background is blurred.

paste Placing a copied image or digital element into an open file. In image-editing programs, this normally takes place in a new layer.

PDF (Portable Document Format) An industry standard file type for page layouts including images. Can be compressed for Internet viewing or retain full press quality; in either case the software to view the files— Adobe Reader—is free.

peripheral An additional hardware device connected to and operated by the computer, such as a drive or printer.

347

348

GLOSSARY

photo-composition The traditional, nonelectronic method of combining different picture elements into a single, new image, generally using physical film masks.

pixel (PICture ELement) The smallest unit of a digitized image-the square screen dots that make up a bitmapped picture. Each pixel carries a specific tone and color.

plug-in module Software produced by a third party and intended to supplement a program's performance.

ppi (pixels-per-inch) A measure of resolution for a bitmapped image.

prime lens A lens with a fixed focal length.

processor A silicon chip containing millions of micro-switches, designed for performing specific functions in a computer or digital camera (in which it converts the information captured by the sensor into an editable, viewable image file).

program A list of coded instructions that makes the computer perform a specific task. See also software

Raw files A digital image format, known sometimes as the "digital negative," which preserves higher levels of color depth than traditional 8 bits per channel images. The image can then be adjusted in softwarepotentially by three stops—without loss of quality. The file also stores camera data including meter readings, aperture settings, and more. In fact each camera model creates its own kind of Raw file, though leading models are supported by software like Adobe Photoshop.

real-time The appearance of instant reaction on the screen to the commands that the user makes-that is, no appreciable time-lag in operations. This is particularly important when carrying out bitmap image-editing, such as when using a paint or clone tool.

reflector An object or material used to bounce light onto the subject, often softening and dispersing the light for a more attractive result.

resampling Changing the resolution of an image either by removing pixels (lowering resolution) or adding them by interpolation (increasing resolution).

resolution The level of detail in an image, measured in pixels (e.g. 1024 by 768 pixels), lines-per-inch (on a monitor) or dots-perinch (in the halftone pattern produced by a printer, e.g. 1200 dpi).

RFS (Radio Frequency System) A technology used to control lights where control signals are passed by radio rather than cable. It has the advantage of not requiring line-of-sight between the transceiver and device.

RGB (Red, Green, Blue) The primary colors of the additive model, used in monitors and image-editing programs.

rim-lighting Light from the side and behind a subject which falls on the edge (hence rim) of the subject.

ring-flash A lighting device with a hole in the center so that the lens can be placed through it, resulting in shadow-free images.

rubber-stamp A paint tool in an imageediting program that is used to clone one selected area of the picture onto another. It allows painting with a texture rather than a single tone/color, and is particularly useful for extending complex textures such as vegetation, stone, and brickwork.

S Shutter priority mode as indicated by some camera manufacturers.

saturation The purity of a color, going from the lightest tint to the deepest, most saturated tone.

scrim A light, open-weave fabric, used to cover softboxes.

selection A part of the on-screen image that is chosen and defined by a border, in preparation for making changes to it or moving it.

shutter The device inside a conventional camera that controls the length of time during which the film is exposed to light. Many digital cameras don't have a shutter, but the term is still used as shorthand to describe the electronic mechanism that controls the length of exposure for the CCD.

shutter priority A camera setting that allows you to control shutter speed, while the camera determines aperture to ensure a good exposure.

shutter speed The period of time for which the shutter remains open and allows light to reach the sensor or film.

side-lighting Light that hits the subject from the side, as opposed to the front or back.

SLR (Single Lens Reflex) A camera which transmits the same image via a mirror to the film and viewfinder.

slow sync The technique of firing the flash in conjunction with a slow shutter speed (as in rear-curtain sync).

snoot A tapered barrel attached to a lamp in order to concentrate the light emitted into a spotlight.

soft-box A studio lighting accessory consisting of a flexible box that attaches to a light source at one end and has an adjustable diffusion screen at the other, softening the light and any shadows cast by the subject.

software Programs that enable a computer to perform tasks, from its operating system to job-specific applications such as imageediting programs and third-party filters.

spot meter A specialized light meter, or function of the camera light meter, that takes an exposure reading for a precise area of a scene.

stop An increment of the measurement of aperture.

stylus Penlike device used for drawing and selecting, instead of a mouse. Used with a graphics tablet.

sync cord The electronic cable used to connect camera and flash.

telephoto A photographic lens with a long focal length that enables distant objects to be enlarged. The drawbacks include a limited depth of field and angle of view.

thumbnail Miniature on-screen representation of an image file.

TIFF (Tagged Image File Format) A file format for bitmapped images. It supports CMYK, RGB, and grayscale files with alpha channels, and lab, indexed-color, and it can use LZW lossless compression. It is now the most widely used standard for goodresolution digital photographic images.

tool A program specifically designed to produce a particular effect on-screen, activated by choosing an icon and using it as the cursor. In image-editing, many tools are the equivalents of traditional graphic ones, such as a paintbrush, pencil, or airbrush.

toolbox A set of programs available for the computer user, called tools, each of which creates a particular on-screen effect. *See also* tool

trackball An alternative input device to a mouse, used to move the cursor on-screen. Mechanically, it works as an upside-down mouse, with a ball embedded in a case or the keyboard.

TTL (Through The Lens) Describes metering systems that use the light passing through the lens to evaluate exposure details.

tungsten A metallic element, used as the filament for lightbulbs, hence tungsten lighting.

Tv "Time value," the term used to indicate shutter priority mode on some cameras.

umbrella In photographic lighting umbrellas with reflective surfaces are used in conjunction with a light to diffuse the beam.

underexposure When too little light reaches the sensor or film and a photograph is too dark.

upgrade Either a new version of a program or an enhancement of hardware by addition.

upload To send computer files, images, etc. to another computer. *See also* download

USB (Universal Serial Bus) In recent years this has become the standard interface for attaching devices to the computer, from mice and keyboards to printers and cameras. It allows "hot-swapping," in that devices can be plugged and unplugged while the computer is still switched on. **USM (Unsharp Mask)** A sharpening technique achieved by combining a slightly blurred negative version of an image with its original positive.

vapour discharge lamp A lighting technology common in stores and street lighting. It tends to produce color casts.

virtual memory The use of free space on a hard drive to act as temporary (but slow-to-access) memory.

white balance A digital camera control used to balance exposure and color settings for artificial lighting types.

WiFi A wireless connectivity standard, commonly used to connect computers to the Internet via a wireless modem or router.

window light A softbox, typically rectangular (in the shape of a window) and suitably diffused.

workstation A computer, monitor, and its peripherals dedicated to a single use.

zoom A camera lens with an adjustable focal length, giving, in effect, a range of lenses in one. Drawbacks include a smaller maximum aperture and increased distortion over a prime lens (one with a fixed focal length). 349

INDEX

Index

A

accessory cord 173, 174 adjustment brush 256, 287, 314 adjustment layers 268, 330, 332-333 additive primary colors 306 Adobe Bridge 268, 274, 340 Adobe Camera Raw (ACR) 256, 340 Adobe Lightroom 4 81, 266–267, 270–271, 272, 274, 278, 283, 291, 292, 298, 302, 303, 305, 307, 328 Adobe Photoshop 80, 81, 103, 130, 243, 264, 266, 267, 268–269, 274–275, 276–277, 286, 296, 304, 307, 316, 322, 334, 336, 337, 338 ambient light 66, 134–135, 170, 229 angle of view 240-249 aperture 34-35, 48-49 Aperture Priority mode 51,75 architecture 26, 88, 129, 162, 168, 205 artifacts 109, 291, 292, 295 artificial light 66, 68, 100, 131, 142, 280 atmosphere 23, 104, 108, 128, 228, 231 autoexposure lock 187

350

В

background 35, 50, 135, 185, 187, 229, 249 backlighting 63, 95, 108, 115, 120, 148 backup 264, 265 balance 202-203, 204, 205 barrel distortions 256, 338 bit-depth 102-103 black-and-white conversions 105, 164, 215, 308-309, 310-313 black point 87, 282-283, 316-317, 318 blemishes 288-289 blending 289, 331, 334-335 blur 51, 135, 146, 249, 254–255, 256–257 bounce light 134, 144, 145 bracketing exposure 80-81 brightness 19, 54, 59, 94–95, 133, 212, 272 built-in flash 132, 133, 137, 148 burning 287, 312, 314-315, 332

C

camera settings 18, 108, 255 candid photography 42, 150, 232, 233, 234 Capture One 257, 270, 273, 298 catchlights 225 center-weighted metering 50–51, 75 channels 102–103, 126, 258, 281, 308, 316 chiaroscuro 164–165, 166, 169, 230 chromatic aberrations 266, 340 cityscapes 128–129, 131 clipping 23, 79, 106, 111, 282–283, 320 Clone Stamp 336–337

close-up shots 53, 58, 96, 115, 154, 156, 172, 184 clouds 89, 104, 106, 116–117, 118, 154, 280, 314, 331 see also skies color 66–67, 212–213, 214–215, 216–219 color adjustment 322-329 color casts 66-67, 68-69, 106, 125, 127 color correction 306-307 color temperature 66-67 complementary colors 212-213, 214, 228 composites 106, 262, 330-331, 332 composition 182-261 context 89, 129, 183, 186, 190, 196, 240 continuous light 142-143, 147 contrast 19, 51, 52, 66, 74-75, 80-81, 82-85, 105, 107, 118, 162, 164, 283, 292, 305, 316 couples 234-239 cropping 243, 252, 278-279, 313 Curves 304-305, 312, 332, 333

D

daylight 55, 66, 67, 68, 101, 104-105, 107, 116-117, 131, 134, 143, 280 see also golden light deleting objects 336-337 depth of field 34-35, 36-39, 40, 44, 48, 49, 50, 51, 227, 235 desaturation 130, 212, 262, 307, 322 diffusers 105, 107, 116, 119, 136-137, 145, 147, 150, 152, 154, 159, 160, 165 digital editing 262-343 distortion 242, 256, 338, 342 dodging 314-315 DSLRs 28, 34, 37, 58, 68, 132, 147, 182, 186, 240, 256, 288 dusk 31, 104, 108, 330 dust spots 288-289 dynamic range 19, 24, 51, 52, 61, 63, 64, 74, 80-85, 103, 106, 124, 134, 155, 162, 227

E

edge lighting 117, 148, 170–171 emotion 19, 24, 88, 89, 92, 95, 212, 215 enveloping light 96, 156–157 exposure 16–99 exposure adjustment 314–315 exposure compensation 25, 50, 56, 75, 76–79, 119, 227 external flash units 132, 137, 145, 149, 173 Eyedropper 276, 281, 325 eye-lines 187, 197, 203, 206, 234

F

faces 59, 78, 98, 105, 107, 148, 152, 155, 197, 231, 232-233, 243, 282 file format see Raw and JPEG fill flash 107, 134, 150 fill light 283, 329 filters 37, 53, 68, 81, 105, 106, 257, 259, 314 flare 108, 111, 113 flash 50, 53, 67, 95, 105, 107, 123, 132-141, 146-147, 148-149 flash units see external flash unit fluorescent light 67, 68, 72, 126–127, 128, 131, 143 focal length 34, 36, 40, 45, 115, 173, 240-243, 248-249 focus 35, 184-185, 187 autofocus 16, 44, 254, 338 manual 187 fog 74, 84, 92, 111, 118, 120-123, 228, 251, 313 forced flash 134 foreground 35, 48, 59, 81, 106, 108, 117, 189, 231, 242-243, 249, 315 framing 47, 122, 182, 199, 226-227, 321 frontal lights 115, 132, 134, 148, 171 front-curtain sync 135 f-stops 34-35, 40-41, 54, 119, 133

G

gobos 163, 165 golden light 66, 100, 114–115, 162, 172, 238 Golden Ratio 192–193 Golden Spiral 193, 278 Golden Triangle 207 gradation 102, 106, 164, 165, 171, 225 Gradient layer 334–335 graphic design 163 gray card 57, 87, 127, 307 gray point 316 grayscale 287, 291, 308–309, 312, 324 group shots 125, 235

Н

halogen bulbs 328 handheld meters 51, 54 hard light 144, 162–163, 164–165, 166–169 haze 56, 106, 119, 256 HDRI (High Dynamic Range Imaging) 80–85 Healing Brush 336 high contrast 52, 63, 66, 105, 107, 116, 164, 202, 228, 253, 293, 305, 311 high-key photography 20, 24, 94–99, 158, 238 highlights 18, 20, 22–23, 53, 74, 80, 87, 94–95 High Speed Sync 132 histograms 52–53, 74, 81, 83, 96, 103, 106, 119, 115, 227, 304–305, 316–317 home studios 146–147 horizon 102, 104, 106, 114, 118, 189, 191, 243 horizontal orientation 188–189 hot shoes 132 HSB 306–307 Hue/Saturation 322–325

I

image editors 267–277 importing 264–265, 267, 270 incandescent light 66, 124–125, 146 incident-light metering 54–55 interiors 94, 131, 134, 243 interpolation 102 inverse square law 133, 142, 149 ISO speeds 28–33, 41

J

JPEGs 103, 264, 267, 269, 290

K

Kelvin 66–67 keyboard shortcuts 273 keystoning 243, 247

L

landscapes 22, 56, 58, 87, 105, 130, 188–189 layer masks 286, 335 Layers 268, 274, 277, 330-333, 334, 341 leading lines 194-195, 198-201, 206, 207, 257 Lens Correction 243, 266, 272 lens distortion 266, 342 lenses 240-253 Levels 316-321 lighting 100-181 lighting accessories 144–147 lighting styles 90, 155, 158, 164, 165, 170, 176–181 light meters 18, 51, 52-53, 54-55, 58 Lightness 307, 322, 324 light painting 139, 181 Lightroom see Adobe Lightroom light tents 156-157, 158-159, 161 lines 194-201 curved 197 diagonal 196, 203, 207 Live View 52 local adaptation 81 low contrast 74, 178, 284, 316 low key 24, 88–93, 231 low light 28, 29, 215, 249, 300

luminance 52, 272, 306, 307, 318, 322, 334 see also Lightness luminance noise 298–299, 300

Μ

macro lenses 39, 171, 174, 220, 225, 244 manual exposure mode 51, 57, 63, 75, 338-339 masks 268, 286, 293, 296, 302, 314, 315, 335 matrix metering 58-59, 108, 227 megapixels 182 see also resolution mercury vapor lamps 128–129 metadata 77, 270 metering 20-21, 24-25, 52-65, 75, 80, 88, 105, 108, 110, 119, 165, 227 midday sun 70, 80, 105, 119 middle gray 54–57, 61, 86–87 mid-tones 52, 57, 61, 83, 84, 86-87, 88, 91, 94, 105, 106, 155, 304-305, 316-317, 320 mist 92, 111, 118–119, 122, 178–179 mixed light 130–131 modeling lights 141 monochrome 221, 308-309, 324 see also black-and-white conversions motion 44-47, 50, 51, 75, 104, 190, 249 motion blur 135, 146, 254-255, 256-261

Ν

narrative/story 183, 184, 185, 187, 190, 198, 221, 232, 233, 258 negative space 163, 228–229, 231, 234, 252 neutral density (ND) filters 37, 81, 106, 107, 257, 314 nighttime 25, 28, 29, 30, 42, 43, 51, 72, 100, 128, 215, 302 noise 28–29, 87, 215, noise reduction 266, 291, 293, 294, 298–303, 313

0

off-center focusing 187, 190, 204, 209, 221, 234 Opacity 330, 333, 335, 336 orientation 188–189 overexposure 19, 22–27, 63, 95, 106, 108, 110, 319 overlays 278, 304, 314

Ρ

paintbrush *see* adjustment brush PaintShop Pro 264, 267, 268, 269, 274, 275, 276, 277, 304 palettes tonal 22, 54, 89, 212, 213, 214, 238 workspace 271, 272-273, 275, 275-276 panning 254-255 panoramas 262, 338-343 parallel lines 196, 200, 243 Patch tool 337 pattern 163, 173, 220-225, 228, 229, 336, 337 people 196, 206, 220, 232–239, 243, 249 see also faces and portraits perspective 163, 196, 197, 207, 220, 226, 238, 241,242-255 Photomatix 81,82 pixels 18, 29, 52, 102, 262, 264, 268, 269, 272, 274, 276, 280, 288, 298, 316, 317 plugins 81, 266, 274 polarizers 106-107, 307 portraits 35, 51, 56, 60, 63, 70, 89, 91, 94, 97, 105, 107, 115, 116, 119, 132, 141, 144, 148-153, 155, 156, 159, 173, 184, 188, 189, 195, 203, 205, 207, 227, 232-239 posing 233 post-production 262-343 primary colors 102, 325

351

R

Radius slider 292 Raw files 103, 264, 269, 285, 290, 294 Raw processing software 266–267 rear-curtain sync 132, 135, 136–139 Recovery slider 283, 286 red eye 133 reflected-light metering 54-55 reflectors 98, 107, 117, 119, 134, 143, 144-145, 146-147, 148, 153, 154, 159, 165, 170, 225 Replace Color 130 resolution 220, 340 retouching 94, 269, 288-289 RGB 59, 80, 87 see also additive primary colors rim lighting 108 ring flash 141

S

saturation 20, 22, 82, 88, 106, 114, 116, 130, 212, 214–215, 306–307, 322–325 S-curves 305, 333 selection 264, 302, 314, 331, 336, 337 sensor 18–19, 23, 28–29, 52–53, 54–55, 74, 86–87, 102–103, 132, 240, 288 shadow fill 107, 283 see also fill flash

352

INDEX

shadows 17, 18, 20, 21, 22, 23, 24, 52, 54–55, 74, 80, 87, 88–93, 105, 107, 114, 115, 117, 134, 148, 154–155, 162–169 sharpening 266, 271, 290-297 sharpness 35, 36, 51, 256, 313 shutter 132 shutter speed 40-41, 42-47, 48-49 shutter speed priority 50–51, 75 sidebars 277 side lighting 115, 148, 151, 164, 170–172 silhouettes 40, 61, 104, 108, 115, 116, 148, 180, 191, 231, 234 skies 56, 89, 106, 108, 116, 214, 288, 307, 314, 315, 323 skin tones 56, 126, 215, 306, 307 sliders 272-273 slow sync 135 snoots 145, 147 snowscapes 18, 59, 60, 71, 87, 99, 119, 123 sodium vapour lamps 70, 128–129, 297 soft light 116, 147, 154-161, 164 softboxes 145, 146, 147, 155 spill kill 144 Spot Healing Brush 336 spot metering 61-65, 75, 108, 165, 227, 282 Spot Removal 266, 267, 270, 288-289 still lifes 55, 89, 97, 109, 143, 146, 147, 156, 159, 215 storms 89, 118, 191 story see narrative straightening 278-279 striplights 141 strong sunlight 56, 106–107 studio flash 95, 140–141 studio shots 98, 146-147 style 176–181 subject placement 190 sunset 20, 67, 77, 81, 104, 108, 116, 212, 214, 230, 286, 326 symmetry 163, 202, 203, 204-205, 209 Synchronize Settings 340

т

Target Adjustment 307, 309 telephoto lenses 115, 119, 163, 171, 173, 220, 240–241, 248–253 tension 89, 187, 188, 189, 190, 191, 197, 202–203, 210, 213, 221 texture 20, 23, 30, 76, 86–87, 95, 108, 115, 119, 145, 148, 157, 163, 171–175 three-quarter lighting 148–149 TIFFs 264, 269, 285 tonality 24, 77, 102–103, 113, 115, 117 tonal placement 87 Tone Curve 81, 86, 297, 304–305, 307 tonemapping 80–85 toolbar 272–273 top lighting 140 translucency 95, 154, 156 transparency 107, 112 triangles 199, 203, 206–207 tripods 37, 42, 47, 51, 83, 118, 134, 140, 144, 147, 204, 249, 254, 256–257, 340–341 TTL (through-the-lens) metering 53, 58 tungsten bulbs 56, 57, 68, 69, 70, 71, 101, 124–125, 126, 130–131, 146

U

umbrellas 144, 147, 154 underexposure 19, 20, 22–27, 80, 81, 116, 119, 287, 334 Undo 264, 273 unwanted objects 336–337

V

vapor discharge lights 128–129 vertical orientation 188–189 Vibrance 306, 320, 329 vignetting 302, 313, 338, 339

W

watts 125 weather 67, 91, 118–123 white balance 66–73, 125, 127, 129, 130–131, 280–281 white point 87, 282, 316, 317, 322, 332 wide-angle lenses 36, 102, 106, 172, 242–247, 342 wildlife 157, 197, 241, 248, 250 window lights 23, 130, 225 workflow 87, 262, 264–265, 267, 268–269, 274–275 workspaces 268–277

Z

Zone System 55, 61, 62, 86–87 zoom lenses 34, 240–241